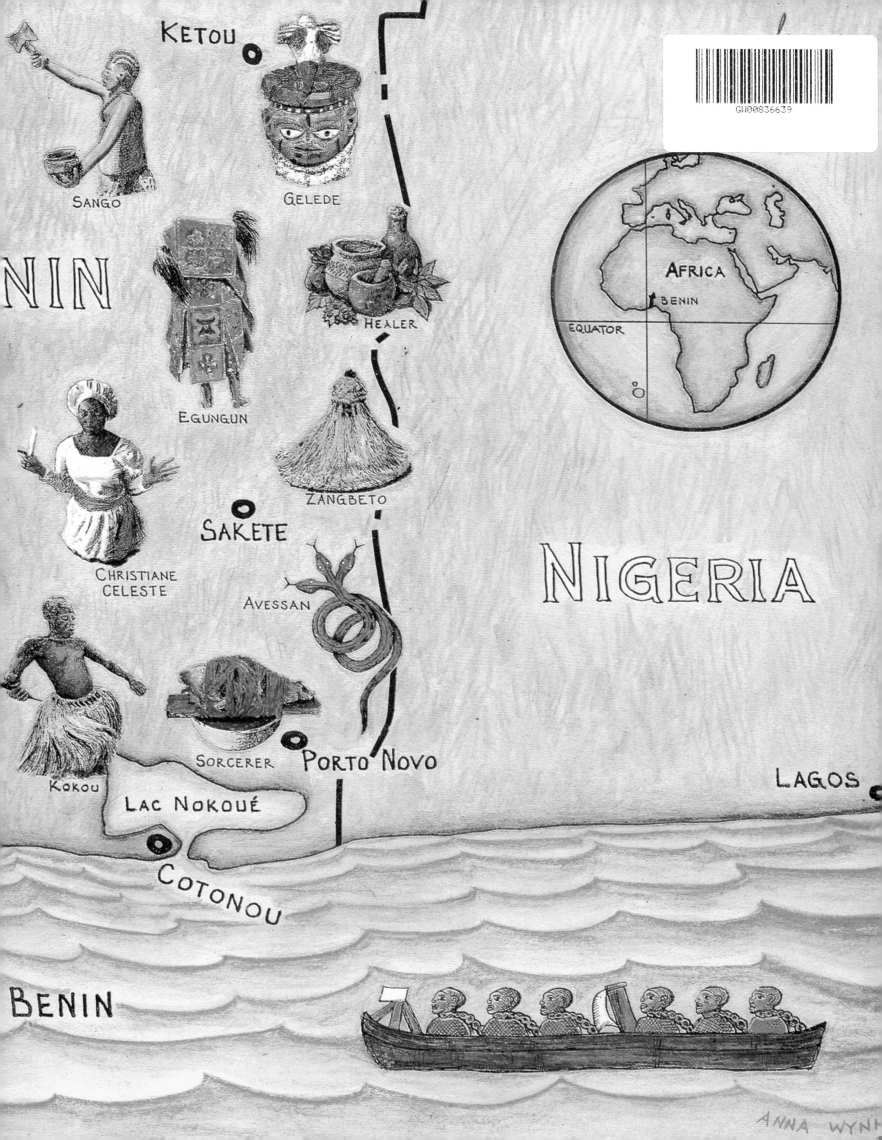

KETOU

SANGO

GELEDE

NIN

EGUNGUN

HEALER

CHRISTIANE
CELESTE

ZANGBETO

SAKETE

AVESSAN

KOKOU

SORCERER

Porto Novo

Lac Nokoué

COTONOU

BENIN

AFRICA

BENIN

EQUATOR

NIGERIA

LAGOS

ANNA WYN

VOODOO

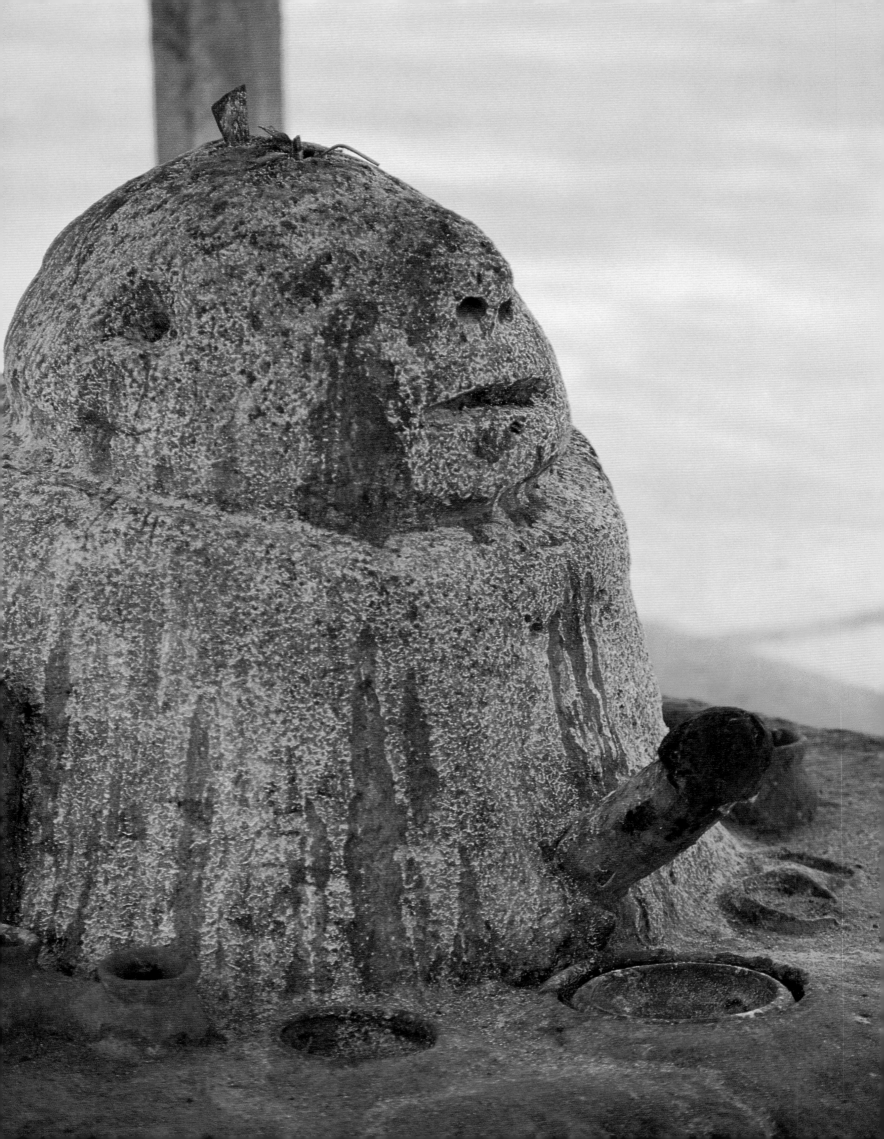

VOODOO

SECRET POWER IN AFRICA

HENNING CHRISTOPH
HANS OBERLÄNDER

TASCHEN

KÖLN LISBOA LONDON NEW YORK OSAKA PARIS

This book was printed on 100% chlorine-free bleached paper in accordance with the TCF standard.

© 1996 Benedikt Taschen Verlag
Hohenzollernring 53, D–50672 Köln

Layout: Schnitzler und Wichelhaus, Düsseldorf
Endpaper map: Anna Wynn, Washington
English translation: Antony Wood, in association with
First Edition Translations Ltd, Cambridge, UK

Printed in Germany

ISBN 3-8228-8649-1
GB

Contents

Africa's magic power

HANS OBERLÄNDER

Sometimes, just a few steps can take you into another world. You leap over a muddy puddle and are suddenly in an archaic past, or enter a market lane and feel you have crossed the threshhold between life and death. It is an eerie sensation.

I was nervous when I turned into the sleepy lane. Everything familiar was left behind: Dantokpa Market, in Cotonou, was a market like any other in major West African cities. Women sold pineapples and yams, detergents and clothes, crockery and Coca Cola. Radios blared out African folk music and Elton John. Hucksters extolled wristwatches and pocket calculators at the tops of their voices. Children scuffled, clattering Japanese motorbikes spewed stinking clouds of blue exhaust fumes. The Marlboro cowboy waved from a gigantic billboard. Even in a country like Benin, the insignia of Western civilization and the twentieth century are ubiquitous.

But when I looked down the lane, I saw an Africa unknown to me until now. The odour of death and decomposition hung in the air. Hesitantly I approached one of the street-stalls. The vendors had covered their wares with grey plastic tarpaulins – a few days ago the rainy season had begun, and now dark stormclouds were gathering once again.

A man came out of a shed built of planks like those from which the stalls were constructed. He looked at us surprised. Evidently *yovós*, white people, seldom entered this part of Dantokpa Market. Paul, our local guide, introduced us and explained our purpose: we were journalists from Germany who wanted to write about the voodoo religion.

The man gave a slight grin. Despite his sunglasses I could see his eyes fixed searchingly on us. Then suddenly he lifted the plastic sheet from his stall – and I started backwards. Bleached monkeys' skulls bared their teeth, bloody goats' and dogs' heads lay next to cattle-bones, lizard-skins were piled up beside handfuls of chicken-feathers. A dead rat with its belly slit open lay by a basket of coiling snakes. Fat black flies buzzed everywhere.

Skulls of dogs and monkeys bare their teeth at the fetish market in Cotonou, the biggest city in Benin. Here voodoo magicians and healers buy the requisites for magic rituals.

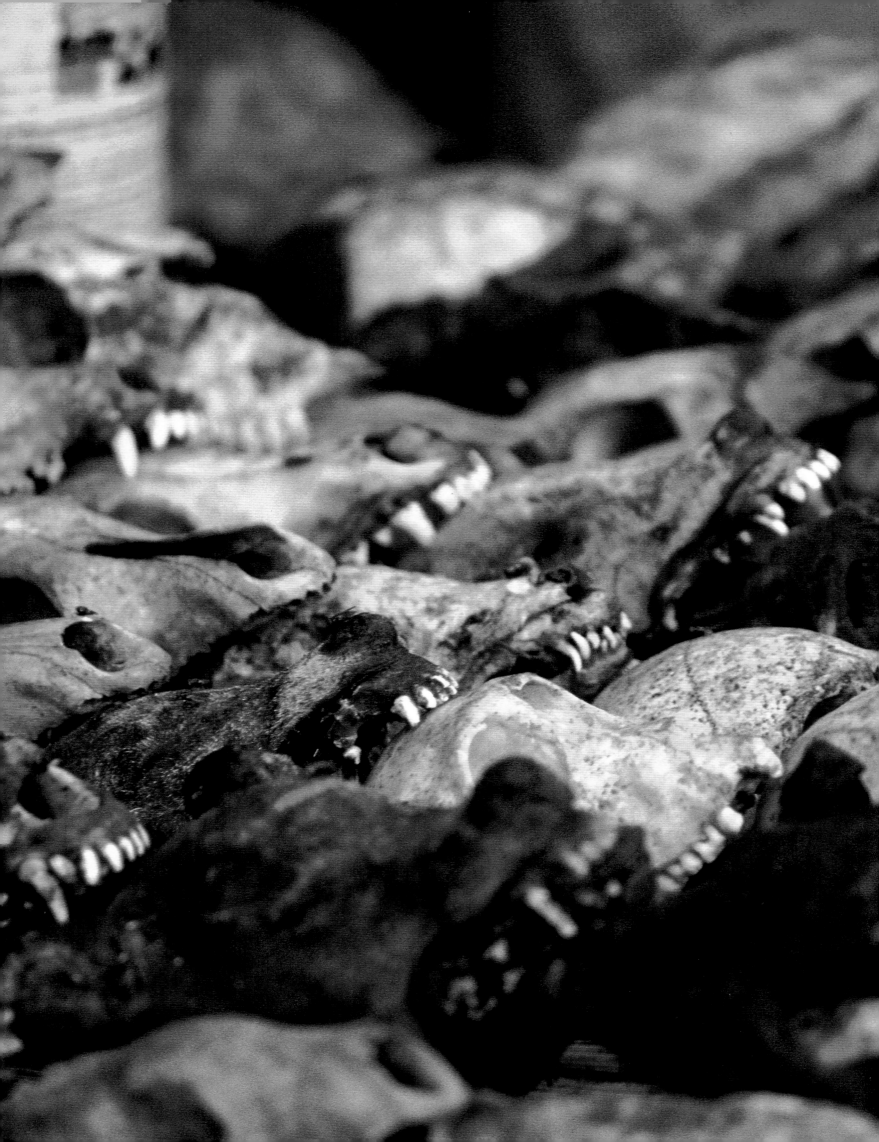

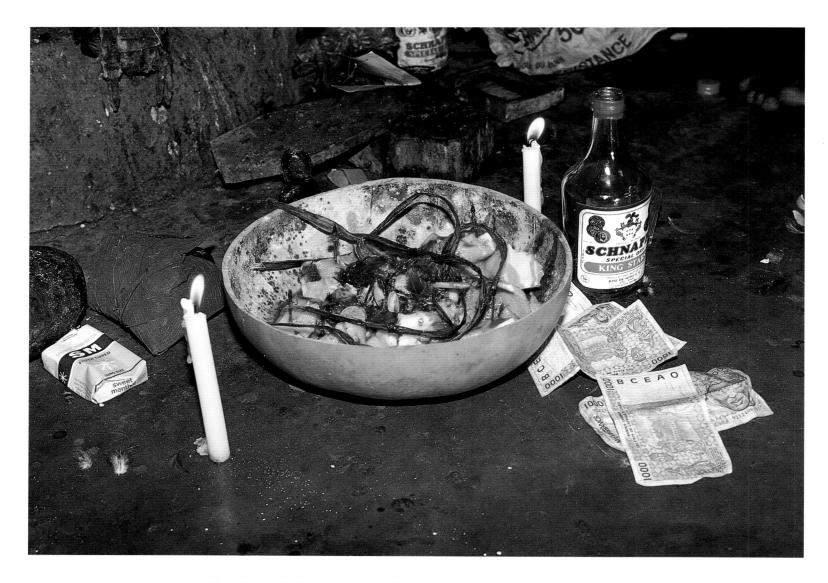

Hastily we followed the vendor into his hut. Over our heads hung herbs; next to me on the wooden bench was a cardboard box containing some dozen chameleons. They gaped sleepily at me with their goggle-eyes, and from time to time one of them would shoot out its sticky tongue after a fly. We exchanged cards. "Dako J. Zorro," I read, "Naturaliste Chercheur" (Naturalist Researcher).

The "naturalist" said he was a specialist in voodoo medicine. Healers and priests could buy from him many things that they needed for their magic ceremonies. He told us he also produced very effective *grisgris* – charms consecrated to voodoo gods which would provide us with reliable protection against the dangers that lurked everywhere.

Typical ingredients for a voodoo sacrifice: a bowl of herbs and a concoction of yam mixed with chicken's blood, two candles, a bottle of spirits, cigarettes and some banknotes – voodoo gods will not provide help for free.

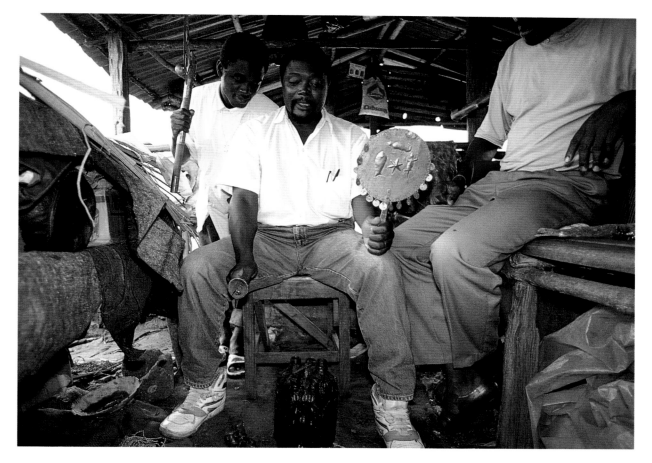

In his Dantokpa Market stall in Cotonou, "naturalist" Dako J. Zorro appeals to the voodoo gods. Ringing a bell, he grips the fan-shaped "message staff" of a voodoo priest. His assistant holds an axe, emblem of the god Shango. On the ground is a fetish. Voodooists believe that divine power is concentrated in such objects.

We nodded. It seemed a good idea to secure the gods' protection before the journey into the unknown world of voodoo. Monsieur Zorro drew two small leather pouches each the size of a coin from a plastic bag. He explained that they contained a magic substance, and that we must always carry these *grisgris* on our person. I was sceptical, and somewhat disappointed. Was it really as simple as that to arm ourselves against sickness and accident?

Monsieur Zorro frowned. Of course it wasn't quite so simple. The *grisgris* must first be consecrated to the gods, otherwise they would be completely useless. We began to negotiate a price. Eventually we agreed on the considerable sum of 30,000 African francs (CFA), the equivalent of about 130 U.S. dollars, all inclusive. As extra free gifts Monsieur Zorro threw in two "thunderstones" which would help against headache and backache. These had a small hole in the middle. They had been pierced by lightning directed by Shango, god of the sky and thunder, Zorro told us. It looked to me as if a human hand had drilled them.

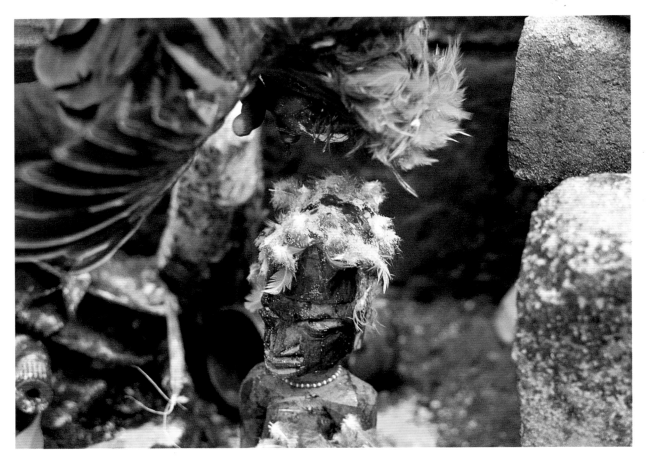

There is no village in Benin without its fetish to the gods' messenger Legba (RIGHT), whose characteristic feature is often – but not invariably – an erect penis. For Legba creates new life, although he does not shrink from destroying it either. Both contribute to the fulfilment of his mission, which is to keep the supernatural and the earthly worlds in active communication – by means, for example, of animal sacrifice (LEFT).

At last the ritual of consecration could begin. An assistant produced a scrawny black chicken and a bottle of "Super Schnapps", as Monsieur Zorro placed an object about 30 centimetres in height on the ground in front of him. Once two ordinary gin bottles, streams of coagulated blood and sticky substances of doubtful origin had welded them together like Siamese twins. The whole was decorated with cowrie shells.

It was a fetish, the indispensable means of getting in touch with the gods. For the voodoo faithful these fetishes, often made of wood, clay or metal, hold a magical power. They are revered very much as the cross is by Christians, for they are regarded as earthly dwelling-places of the gods.

Intoning incantations and ringing a rusty bell, Monsieur Zorro sprinkled gin over the fetish. Then he took a swallow and sprinkled a few drops of "Super Schnapps" on the ground. We followed his example, then, with practised ease, Monsieur Zorro wrung the neck of the chicken and slit its throat with a knife, taking care not to stain his white shirt. The blood dripped over the fetish and our *grisgris.* My back was drenched in sweat.

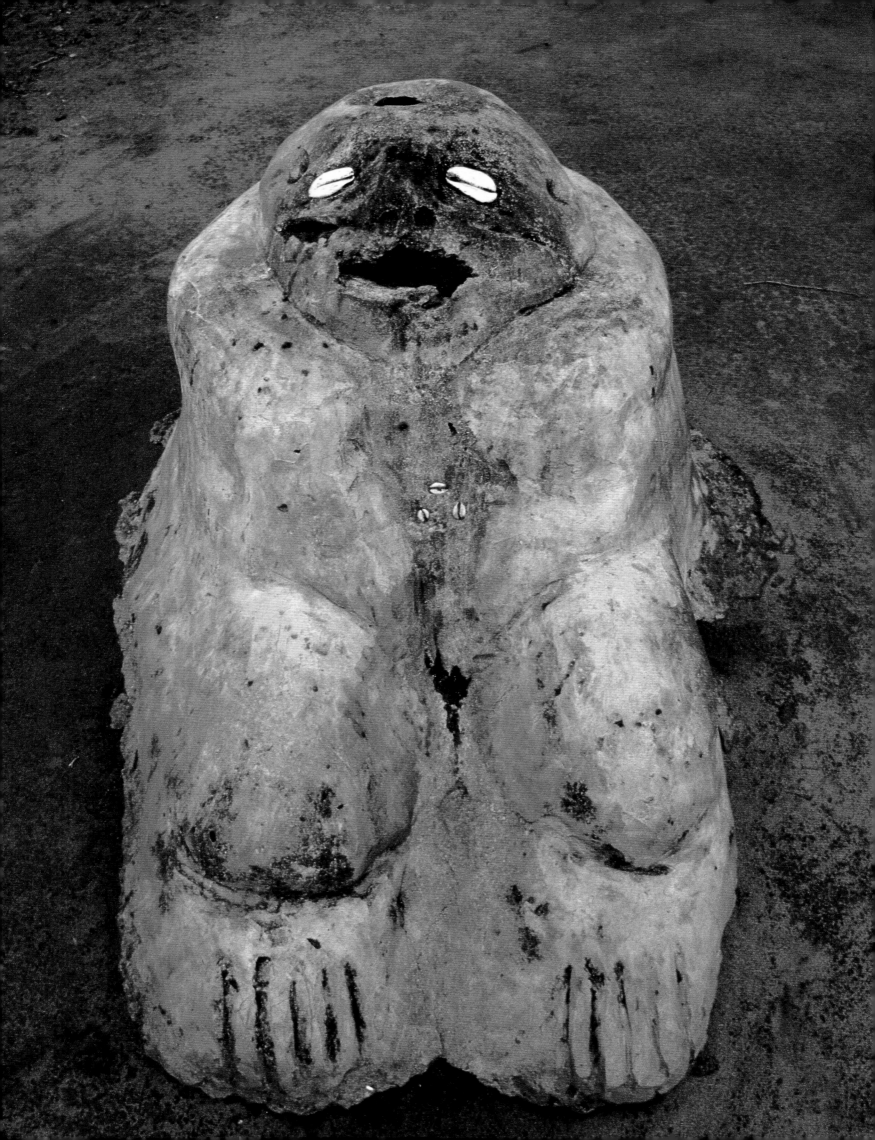

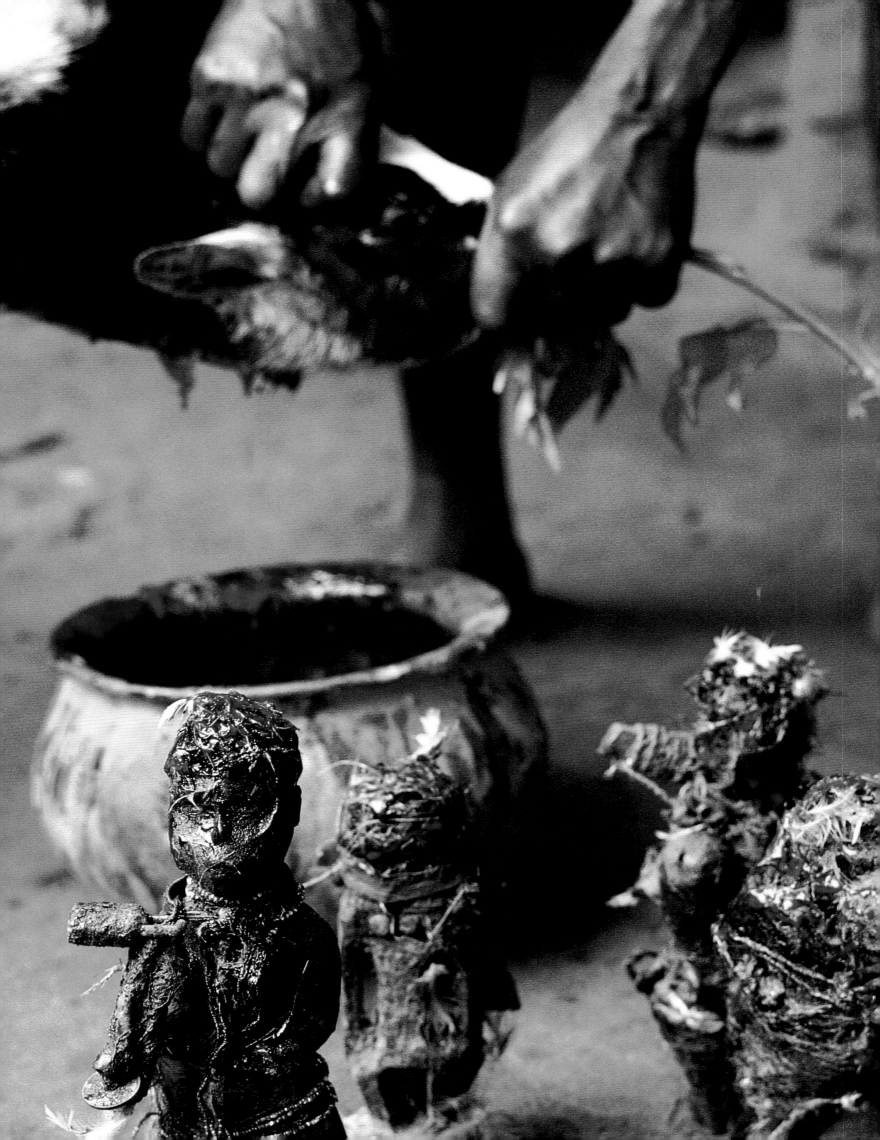

I SLEPT BADLY that night. I kept thinking of bloody animal sacrifices, dolls bristling with needles, and zombies, the dead brought back to life by voodoo sorcerers, groping their way through Hollywood films – in Haiti they are actually supposed to exist.

Cascades of rain drummed deafeningly on the corrugated-iron roof of the hotel bungalow. Giving up any idea of sleep, I browsed through the books, pamphlets and other papers that I had brought from Germany and purchased in the Catholic bookshop in Cotonou. Voodoo – also spelt Wodu, Vodun or Vodoun – is a religion that has more than 50 million believers in West Africa alone. It is also a way of life and a culture with origins going back several millennia. However, in the West little is known of voodoo. "Superstition" and "black magic" are the terms of current cliché and prejudice.

The word voodoo comes from the Fon language. "The ineffable", "the effective power", voodoo is interpreted in many ways, and it may also be translated as "god" or "spirit". Voodoo is an animistic religion; its adherents believe that nature and natural forces are animated by divinities and spirits, and that in ecstatic states, such as trance, it is possible to establish direct contact with them.

European slave-traders who came to West Africa from the sixteenth century onwards, and the Christian missionaries who followed in their wake, saw voodoo as a heathen, idolatrous cult, which they feared and at the same time furiously combated.

In October 1484 two Portuguese caravels anchored in the Gulf of Benin. Ouidah, at that time not large enough to be called even a village, later became a favourite stopping-off place for European ships taking on water and provisions. The English, French and Portuguese established settlements and forts, and began to trade with the people of the coastal region, offering textiles, tobacco, alcohol, weapons and cowrie shells from the Pacific in exchange for food – and above all for slaves. The hard labour on the cotton, sugarcane and tobacco plantations in the American South, in the Caribbean and Brazil, demanded a constant supply of "human material".

FOLLOWING PAGES:
A stone lion guards the palace of the King of Abomey. On the right squats a fetish figure depicting Legba, protected from the sun and rain by a corrugated-iron cover. Between them is a fetish of Gu, god of iron and blacksmiths, who is often represented – here by rusty metal points set into a block of stone.

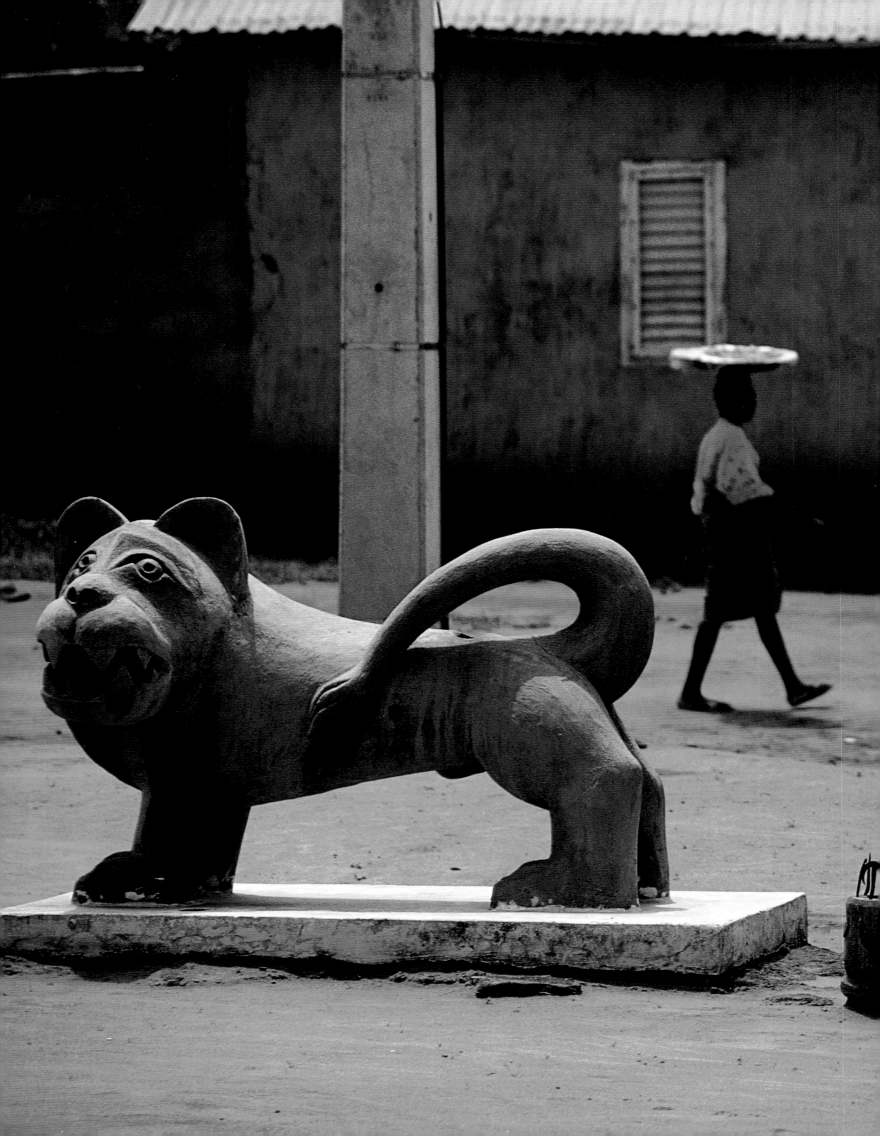

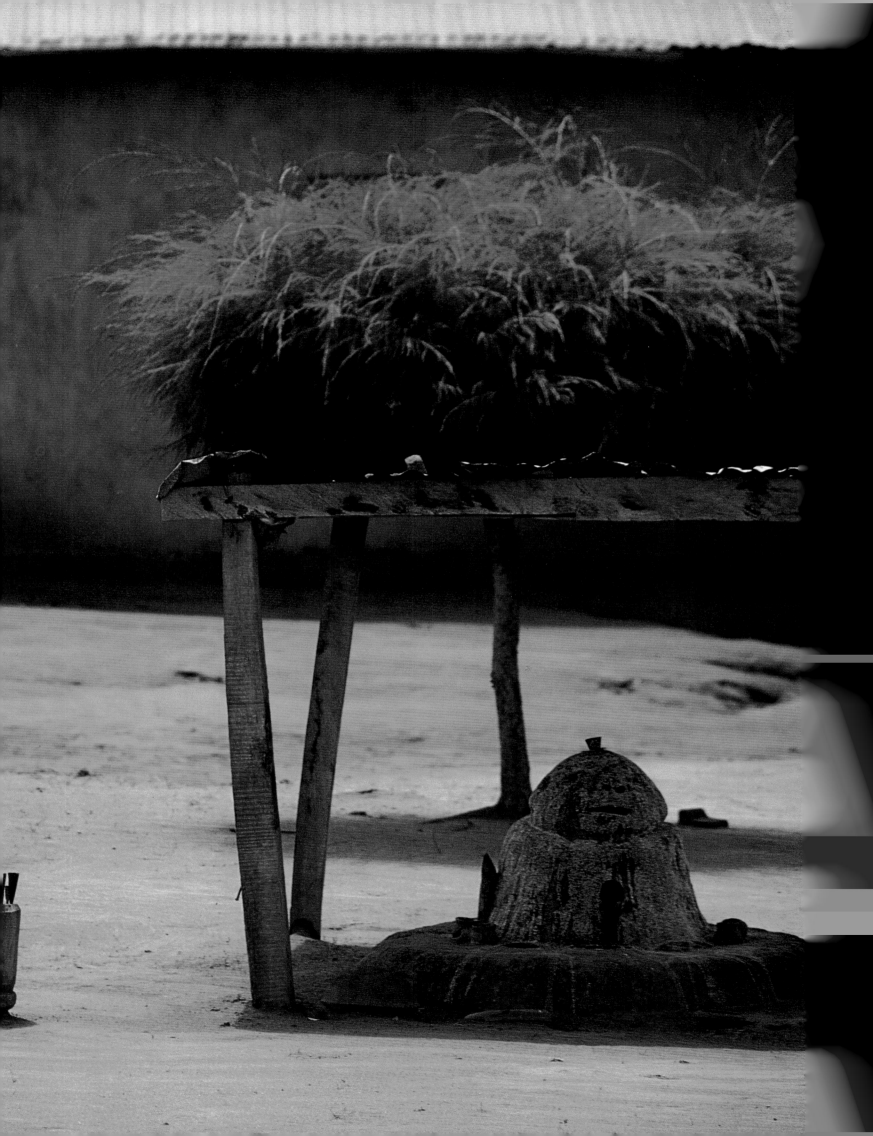

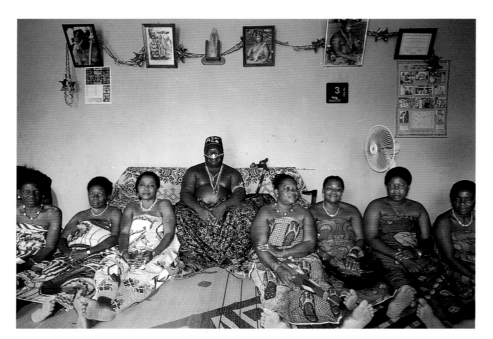

Surrounded by princesses, King Dédjralagni holds court in the audience chamber of his palace in Abomey. His Majesty was in the police service in Cotonou before assuming the throne as the latest incumbent in a long line of ruling kings.

RIGHT:
A silver filter protects the nose of King Dédjralagni from dust. Despite the sceptre, his influence is limited. The descendant of powerful kings who were often bloodthirsty despots today has token duties, such as justice of the peace in family disputes.

The slave trade was slow to get started. Ouidah belonged to a tiny kingdom called Savi, whose rulers had neither enough subjects to be able to sell them nor enough power to subjugate neighbouring kingdoms. On the contrary, in 1727 Savi itself was wiped out when Ouidah was taken by the amazon army of King Agaja of Abomey.

This king's forebears, the "Children of the Panther", founded the kingdom of Dahomey on the Abomey plateau in the sixteenth century. The kingdom exists to this day – its ruler, King Dédjralagni, lives in a red sandstone palace. The former Cotonou police official admittedly has only token duties, mediating in domestic quarrels and acting as a lay magistrate in disputes between neighbours in the Abomey region.

Agaja, the new ruler of Ouidah, was a powerful and cruel king. Earlier kings of Dahomey had already extended their territory in bloody campaigns in which villages were razed and their inhabitants slaughtered or enslaved. Conquest of the coastal region brought Agaja in contact with white slave-traders. He commanded huge quantities of the "wares" they sought. The terrible slave trade began to boom.

Each year throughout the eighteenth century, tens of thousands walked "Slaves' Way", the three-kilometre red sand road linking Ouidah with the shore off which the slave-ships anchored. Today the commemorative stones line the long road as a reminder of their martyrdom. Men had to walk round a "tree of forgetting" nine times, women and children seven times. They had to leave everything behind them: their homeland, their religion, every hope.

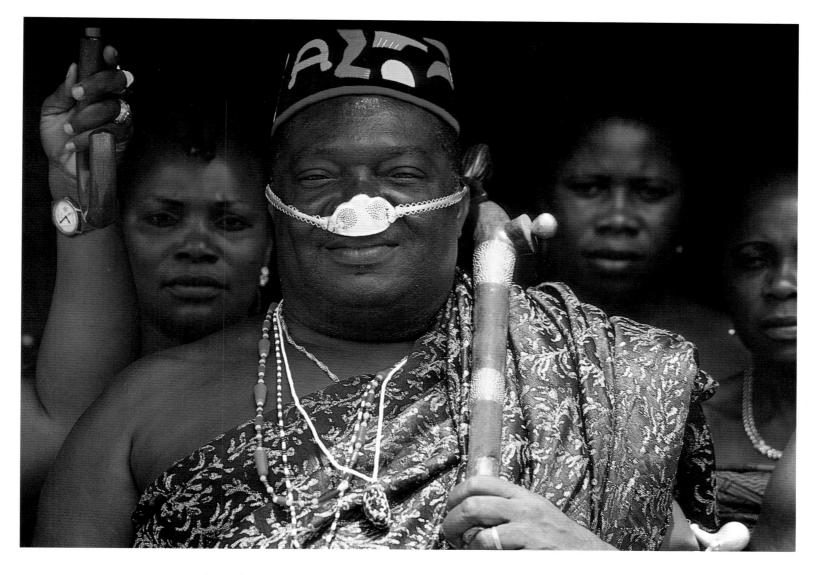

Then the slaves were selected. The weak and the sick were killed and thrown into a mass grave, often being buried alive for the sake of convenience. The remainder were all crammed together in the "House of Zomai" for days on end, with all windows and doors barricaded so that total darkness would intimidate and disorientate them.

Eyewitness accounts testify that before every transport dozens of people chose a voluntary death by jumping into the sea. To avert a mass suicide of their stock in trade, the slave-traders erected a "tree of return", which prospective slaves had to walk round three times. This promised their only consolation: that at least the souls of any who died in a strange country would be shown the way back to their homeland. Finally the slaves were forced on board ship under the curses and whiplashes of the white slave-drivers and their black henchmen.

The slave-traders made sure that no voodoo priests ever came on board in Africa. The people, chained together like cattle for the voyage to the New World lasting up to ninety days, were denied the solace of even a "heathen" religion. The plantation owners also

FOLLOWING PAGES:
On Lake Nokoué, north of Cotonou, a fisherman of the Tofinu tribe hauls in his net. Using nets, bushes and branches, the Tofinu construct feeding-grounds called *akajas*, where they fatten fish for a period of six months.

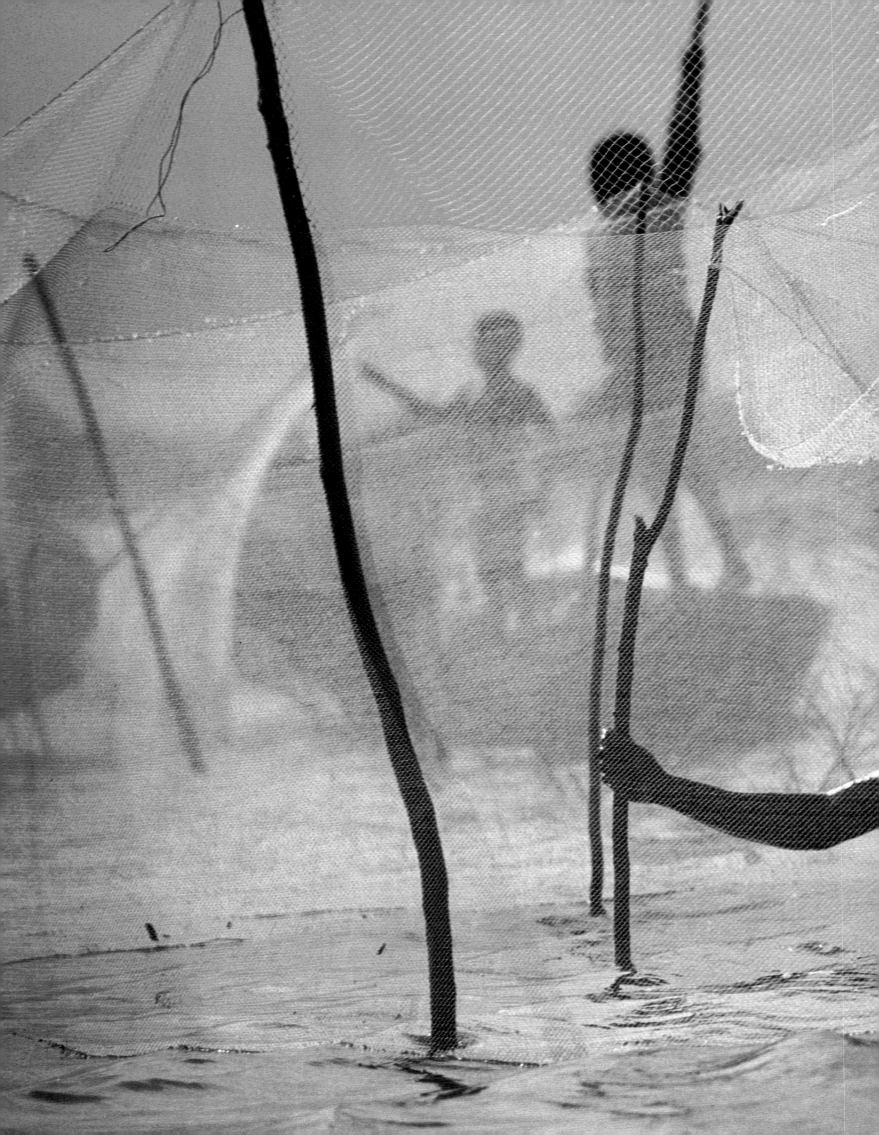

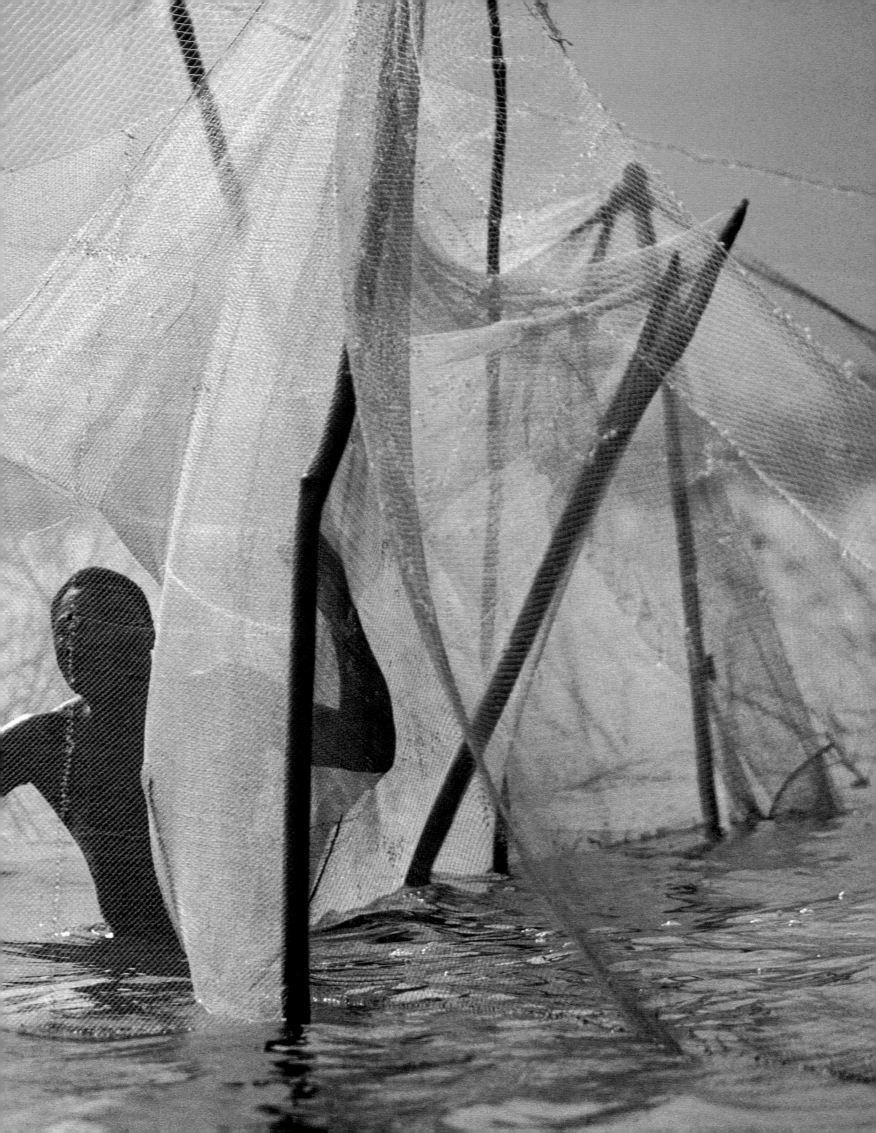

hunted down suspected priests, who they feared would become the nucleus of a revived sense of identity among the slaves.

But the voodoo religion was not to be stamped out. From the sugar-cane fields of Haiti to the tobacco plantations of Bahia in Brazil small groups of people gathered in secret places under the shelter of night to pray to the old gods. This was difficult, however, and not only due to oppression. For voodoo has no bible. The cult is handed down orally even today – in seminaries hidden from the outside world, in which novices of both sexes are taught voodoo language, dance and ritual. The first voodoo communities, lacking instruction from priests, or *hounon*, had to piece together the fundamentals of the cult out of remembered fragments.

Another factor was the Babylonian mixture of languages spoken on the plantations. Dozens of peoples live in the densely populated West African region, each with its own language and its own traditions. In the south of the present Republic of Benin alone, an area the size of the Netherlands contains about fifty different tribes. It is not surprising that in the diaspora new forms of the voodoo cult sprang up. These soon began to incorporate Christian symbols. Although compulsorily baptized by their masters and by Christian

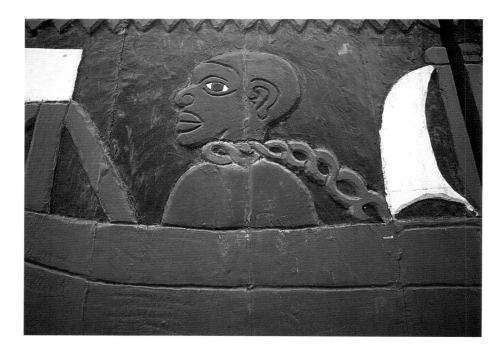

This carving in the Museum of Ouidah is a reminder of the cruel fate suffered by hundreds of thousands of people who were carried off on slave-ships from their West African homelands to the New World.

missionaries, many slaves clung to their old beliefs; on the upper part of an altar they placed images of the Catholic saints, but below, hidden from the view of strangers, they secretly kept the fetishes of the familiar African gods.

In the last two hundred years voodoo cults have become powerful movements in many areas of the New World. Catholic Brazil numbers millions of adherents of Umbanda and Candomblé. Under the name of Vodou in Haiti, Santéria in Cuba, Obeah in Jamaica, Hoodoo

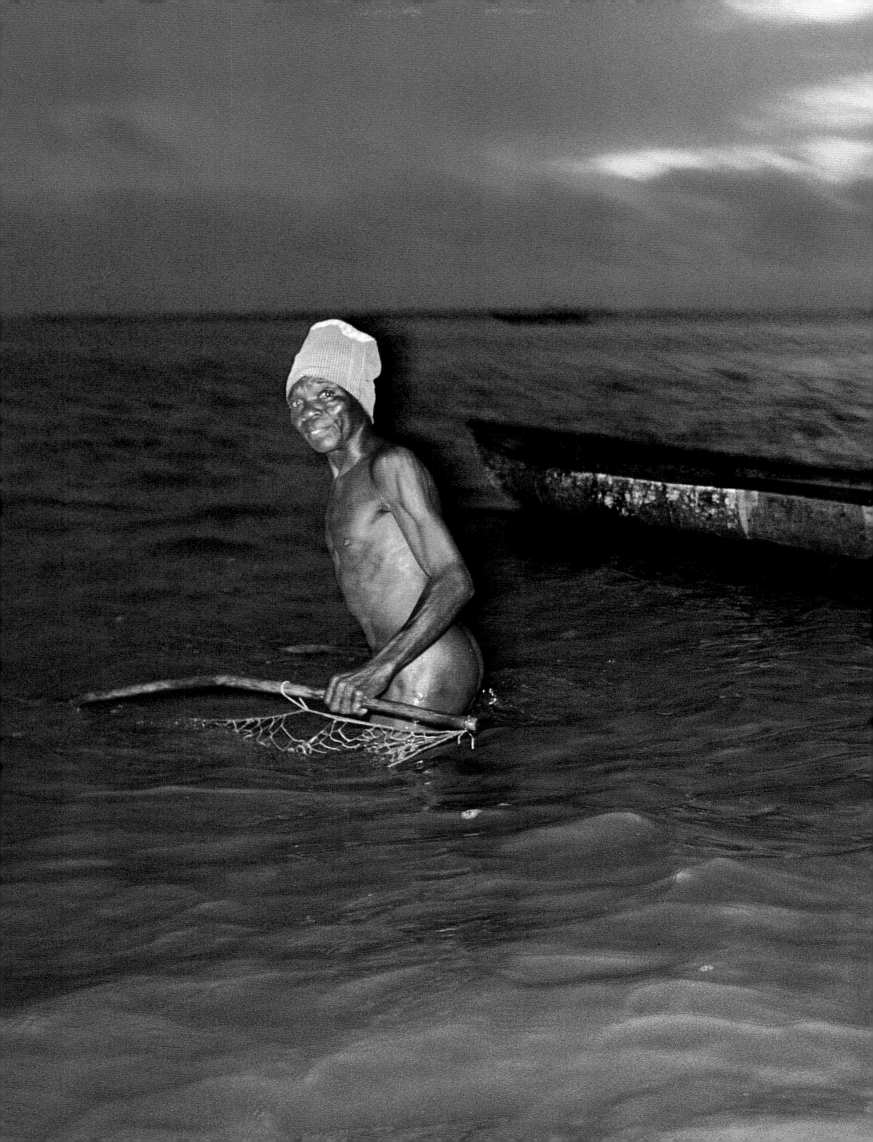

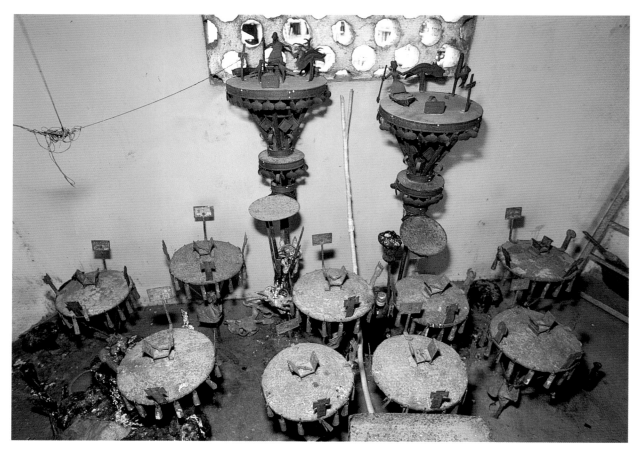

in the Southern U.S. – the black neighbourhoods of New York, Miami and Los Angeles – voodoo flourishes today well beyond the confines of West Africa. Although certain features of the new cults were brought back by freed slaves, then by Africans returning to their roots, the cradle of voodoo remains in Benin.

According to a Fon legend it was King Agaja of Dahomey who brought the voodoo gods to his country. The times were chaotic, and natural catastrophes struck. "Nothing was as it should be. Pregnant women gave birth to billy-goats, goats gave birth to humans." From a market woman who had come to Abomey from a neighbouring tribe, King Agaja learned what should be done to restore the natural order: "In our country we have voodoo, but you do not worship these gods." So King Agaja ordered the voodoo gods be brought to Dahomey and worshipped there – and women and goats once again bore their own kind. Archaeological finds on the west coast of Africa suggest that voodoo cults have been practised there for at least four thousand years. European traders and travellers of the sixteenth century describe ceremonies and temples that have survived almost unaltered to this day, for example the Temple of Dangbe in Ouidah.

This temple is situated within view of the Catholic cathedral. It contains striking wall-paintings of pythons: the shrine is consecrated to Dan, the Great Snake, often also represented in the form of a rainbow. Dan, cosmic energy, creates a bridge between heaven and earth.

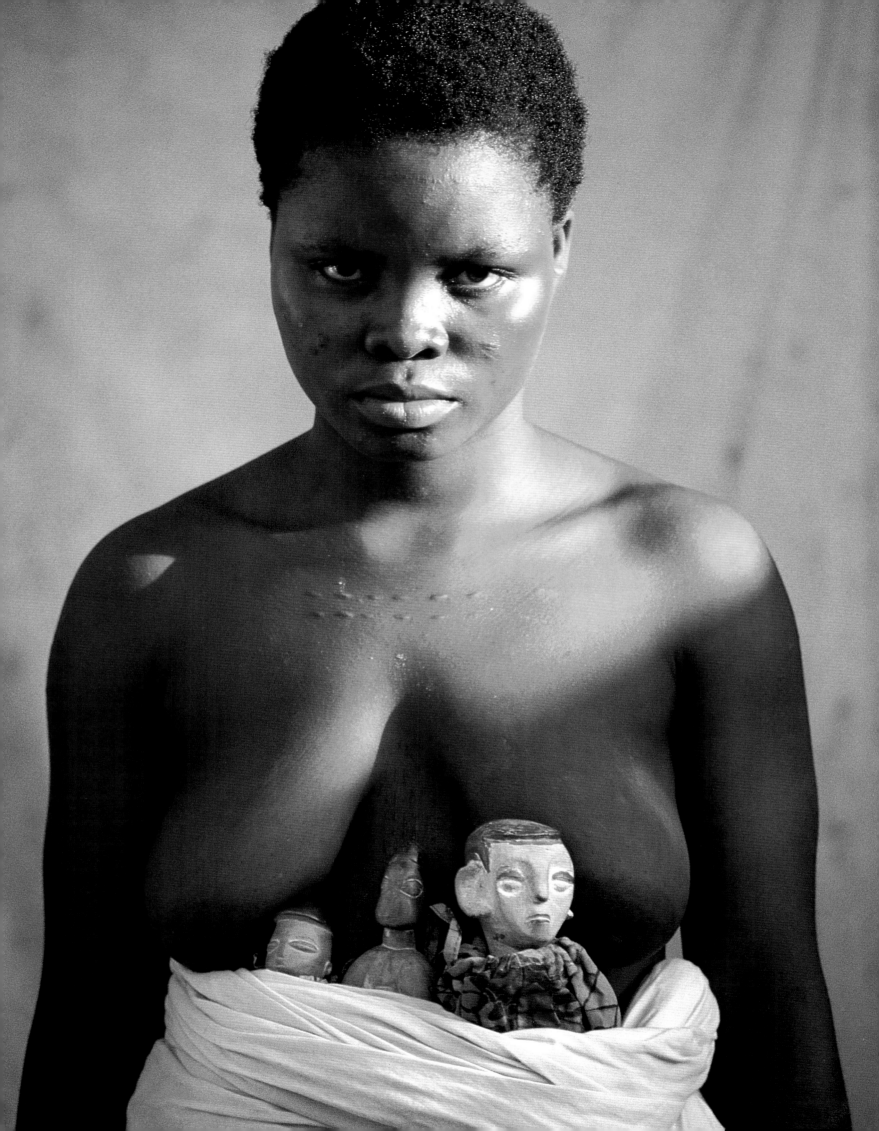

"Min do xun do ba wé, gbê jen kan nan vó" – "If you want to plumb the secrets of voodoo, you'll have to wait for the end of the world", one voodoo song tells. And ethnologists and religious specialists can only agree. Since the 1930s, when the French colonial official Bernard Maupoil studied the culture and intellectual world of the Fon in southern Benin, they have constantly been seeking to understand voodoo theology and ritual. It is a labour of Sisyphus. For there is no voodoo "bible", and voodoo priests do not write books explaining or discussing their religion.

Researchers gain what knowledge they can mostly by interviewing voodoo dignitaries, often through interpreters. That this leads to error and misunderstanding is hardly surprising. For even a didactically skilled voodoo priest would find it quite impossible to

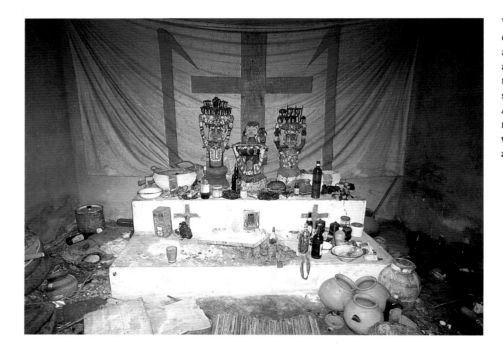

Voodoo priests have a good deal of scope in the design and furnishing of their altars and temples, sometimes even using Christian symbols, including the cross. A similar iconographical mix may be observed among voodoo cults in Brazil, Haiti and Cuba.

give a white person of Western intellectual background any adequate idea of the enormously complex world of voodoo. "You can spend a lifetime with voodoo," says the voodooist, "in your own country or abroad, and you will know and understand as much as you can see between two blinkings of an eyelid." Nevertheless, research has produced something in the nature of a prevailing notion. Imagining voodoo theology as a pyramid, its summit is occupied by Gbédoto, the divine origin of the universe. The universe, divine power, created itself and perpetually recreates itself anew. This process takes place with the aid of a creative energy called Acé.

The voodoo gods are the descendants of this creative energy prin-ciple Acé. There are hundreds of them, and for this reason Christian missionaries long considered it legitimate to damn voodoo as an "idolatrous" cult. In recent times, however, the Catholic Church in Benin has begun to reconsider, recognizing that

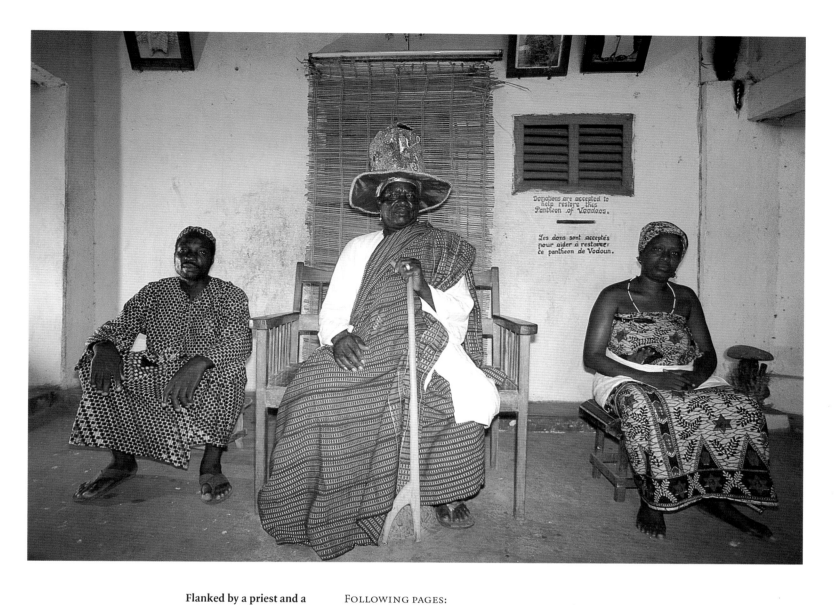

Flanked by a priest and a
priestess, Daagbo Hounon
Huna receives visitors in his
temple in Ouidah. Daagbo is
a voodoo high priest and
consequently one of the
most powerful men in
Benin. He used to be a
famous football player.
Today not only Benin clubs
but European teams are said
to benefit from his magical
support.

FOLLOWING PAGES:
In the Temple of Dangbe in
Ouidah, Dan, the Great
Snake, is venerated. Repre-
senting the principle of
cosmic energy in voodoo
mythology, Dan creates a
bridge between heaven and
earth.

even voodoo knows only one god of creation – made manifest in the gods Mawu and Lissa, who represent among other things the female and the male principles. Tradition goes that Mawu and Lissa had fourteen children, each of whom was endowed with superhuman powers, and these divine children in turn begot descendants. A mighty voodoo pantheon resulted, reminiscent of the Ancient Greek Olympus. There is Shango, god of thunder, Nana Buluku, goddess of the earth and wisdom of the night, and Sakpata, who takes care of social justice but is also responsible for the spread of smallpox. Besides the major gods there are numerous minor divinities, over 260 of whom have been identified by researchers in Benin.

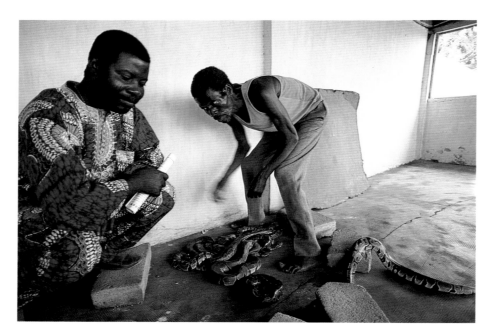

An Ouidah priest tends live pythons, symbolic of the god Dan. Elsewhere Dan is depicted in paintings, as in this voodoo seminary in Doutou, whose walls also display a mural of Sakpata, the god of plagues (RIGHT).

Ultimately, however, these minor divinities are simply personifications of the bisexual god of creation, whom they serve as intermediaries, sending divine messages to humankind and bearing human wishes and prayers to God.

Ancestor spirits also serve as intermediaries, and they are venerated in rituals of their own. "In voodoo there is no strict distinction between life and death, between the visible and the invisible worlds," says Mèdéwalé-Jacob Agossou, a Roman Catholic professor of religious anthropology and theology in Cotonou.

In the cosmology of voodoo the universe resembles a giant calabash, with heaven and earth forming its two halves. In this closed system there is no above or below, no separation between life and death, human and superhuman. Nothing that exists or ever existed disappears. "Gods and spirits are therefore everywhere," Professor Agossou tells us, "and intervene directly in human affairs."

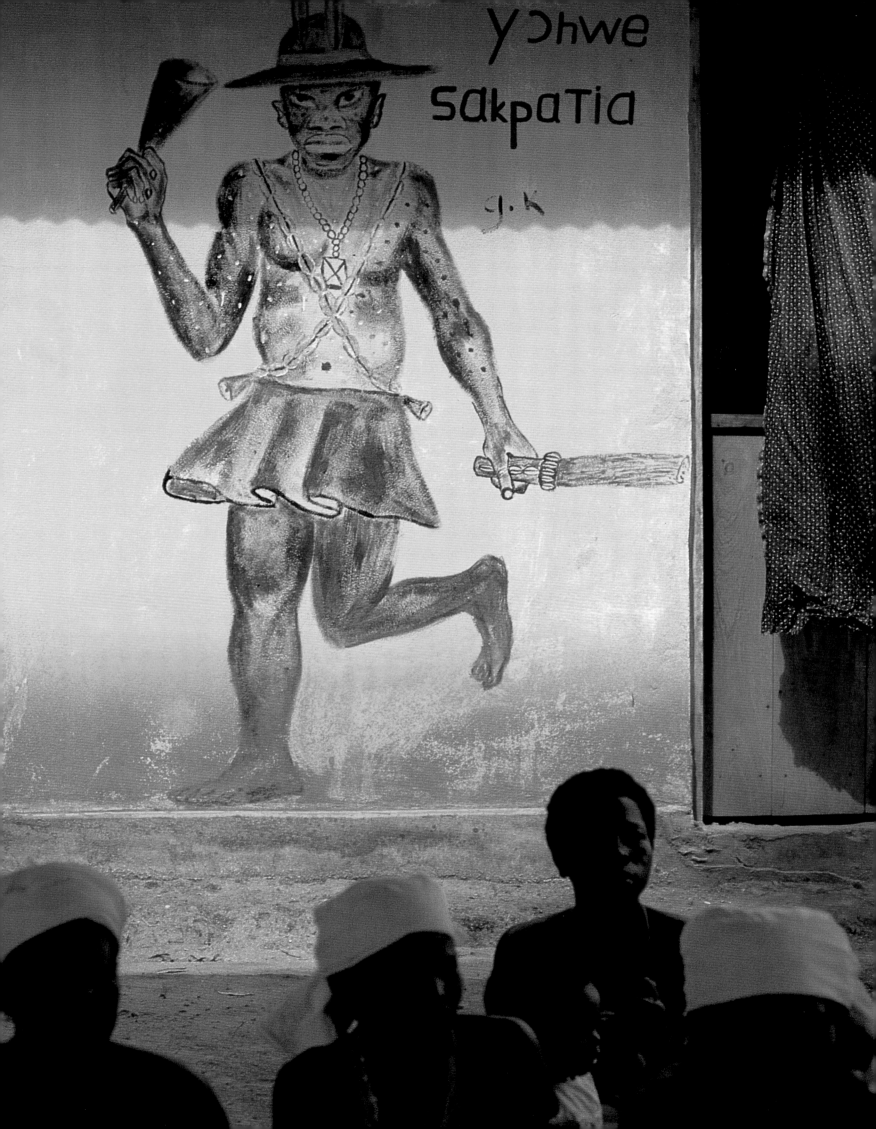

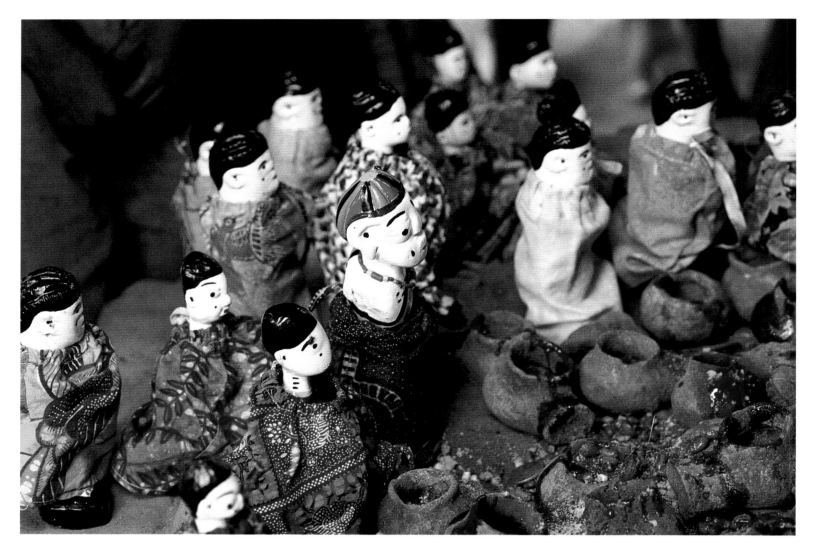

In voodoo there is no forgiving deity like the Christian God. Voodoo does not promise believers life after death in paradise, but equally does not frighten them with visions of hell. A person is immediately responsible before the voodoo gods for everything he or she does. That can have both good and bad consequences. For the gods have thoroughly human characteristics; they can be joyful and generous, but also moody and angry. The gods therefore not only help, but they also punish – for example, when they are not paid the necessary respect, or when religious or moral laws of voodoo are transgressed.

Then the gods see that humankind is visited with sickness and drought. But their anger is never final; it can be averted, and with it misfortune too. If they are to placate angry gods, humans must first get into contact with them. This is done in voodoo ceremonies with the aid of a priest.

Ancestors are represented by small figures which are often lovingly painted in bright colours and adorned with necklaces. Every voodoo ceremony invokes not only divinities but also ancestors, to whom sacrificial gifts are offered in tiny vessels. To worshippers, ancestors are intermediaries between gods and humans.

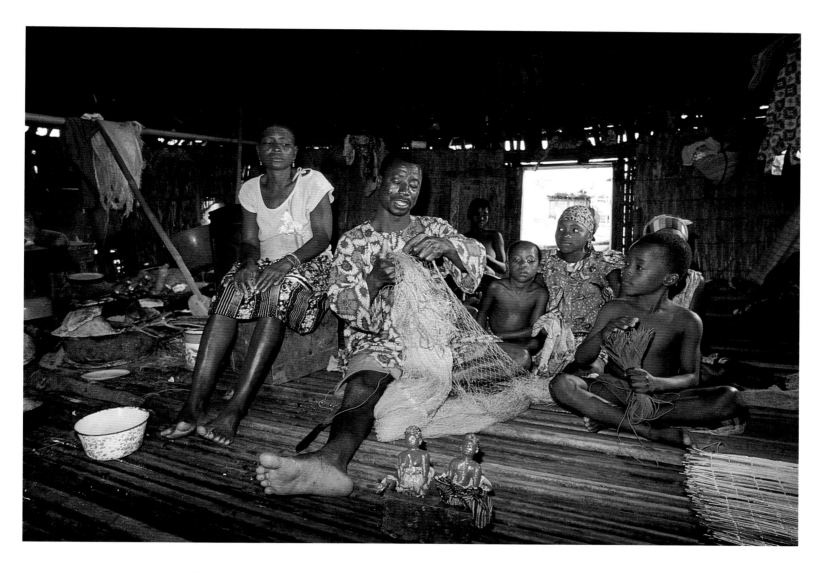

A fisherman's family on
Lake Nokoué. The two red-
painted figures in front of
them in a wooden casket,
their "bed", symbolize dead
twins. They are fed, washed
and put to bed as if the
twins were still alive.

FOLLOWING PAGES:
In the villages of Benin one
often sees women carrying
their dead children in the
form of dolls.

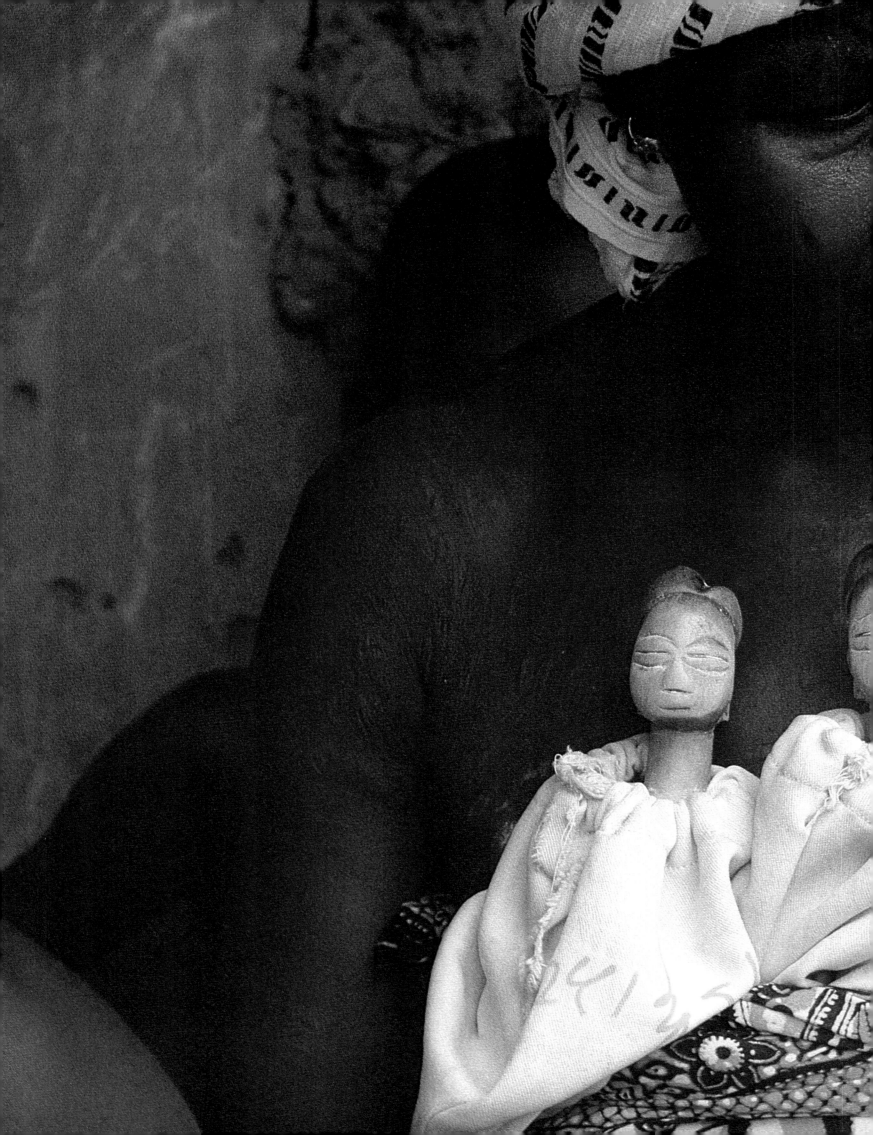

Monsieur Zorro's *grisgris* lay on my bedside table when I woke up next morning. The sun was shining, but deep puddles still stood in the streets of Cotonou. We drove north-west along the Route Nationale. Having eventually turned off onto a sludgy sand road, as our Peugeot struggled on at a snail's pace, I once more had the feeling of going backwards with each metre of the way. At crossings we regularly passed clay fetishes, each displaying an erect penis. Legba, the messenger of the gods, was directing us to the voodoo world.

At the end of a narrow track almost completely overgrown with grasses and bushes lay Akpihoué. The view of the village that met our eyes from a small rise was overwhelming – and at the same time shockingly archaic. Before us lay the village square, with mud huts lining both long sides; above their straw and corrugated-iron roofs fluttered the white flags of voodoo.

A few metres below us was a tree in the shadow of which drummers were beating the ecstatic rhythm of the god Djagli, calling upon him to protect their village from bad magic. A group of men and

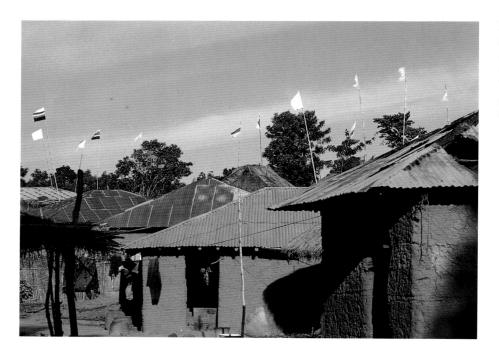

Flags flutter over the corrugated-iron roofs of Akpihoué, many of them white, the voodoo colour. Voodoo ceremonies are both religious events and special social occasions.

women swayed in rhythm. "Yehoé miato siexu méti o kpé miéwu", they sang: "Our voodoo is very strong. Nobody can conquer us."

The far side of the square was formed by a shrine, inside which stood a large fetish representing Legba. In front of it danced a dozen men and women dressed in frayed cloth skirts, their heads and naked upper bodies smeared with a yellow paste.

Sweat was pouring off them, but they were unconcerned. They continued to hop and leap around the village square in a choreography that reminded me of bird movements – and New York Hip-Hop dancers.

34

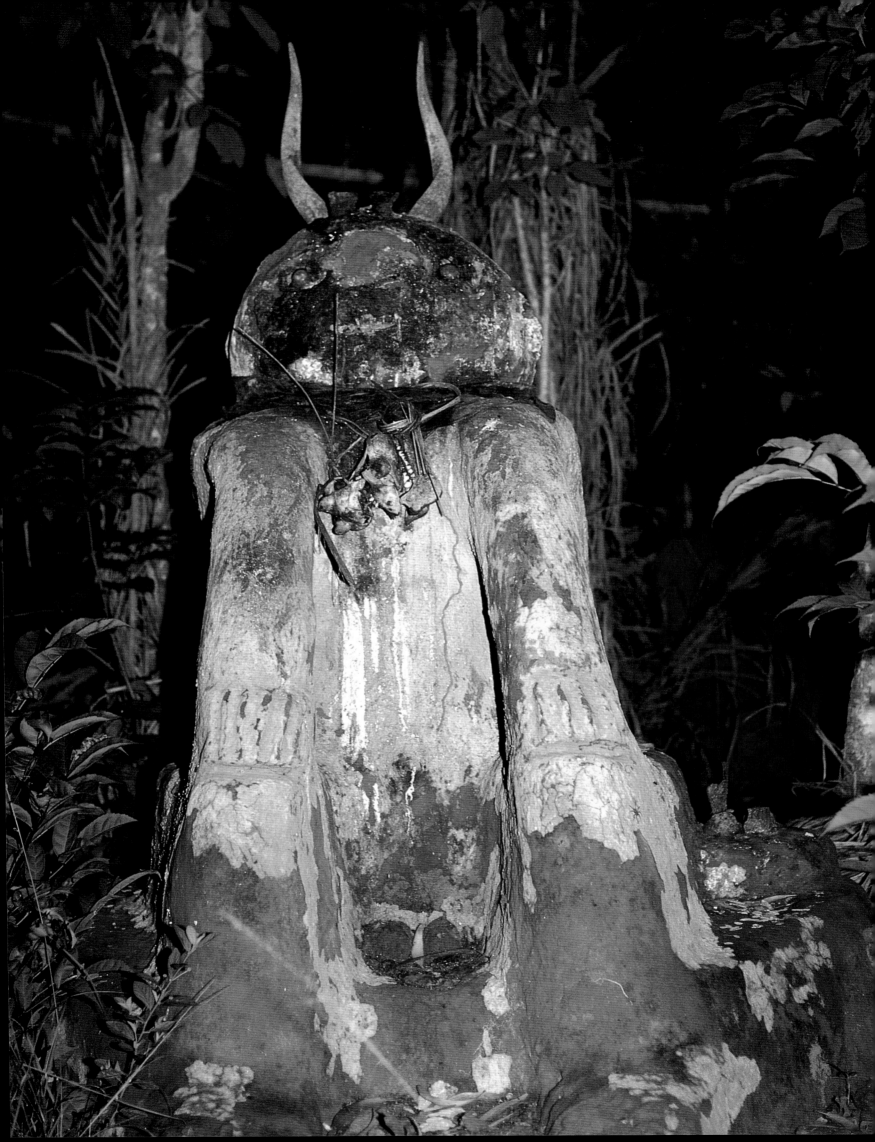

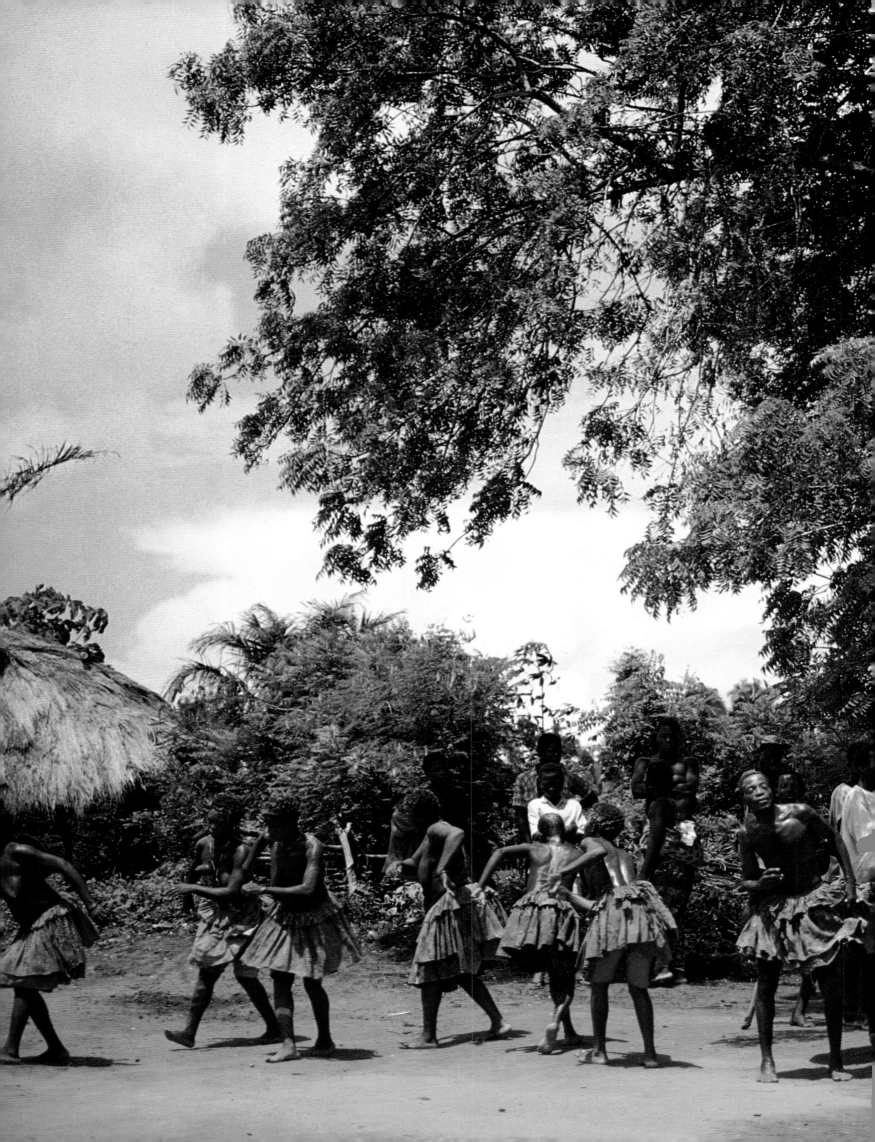

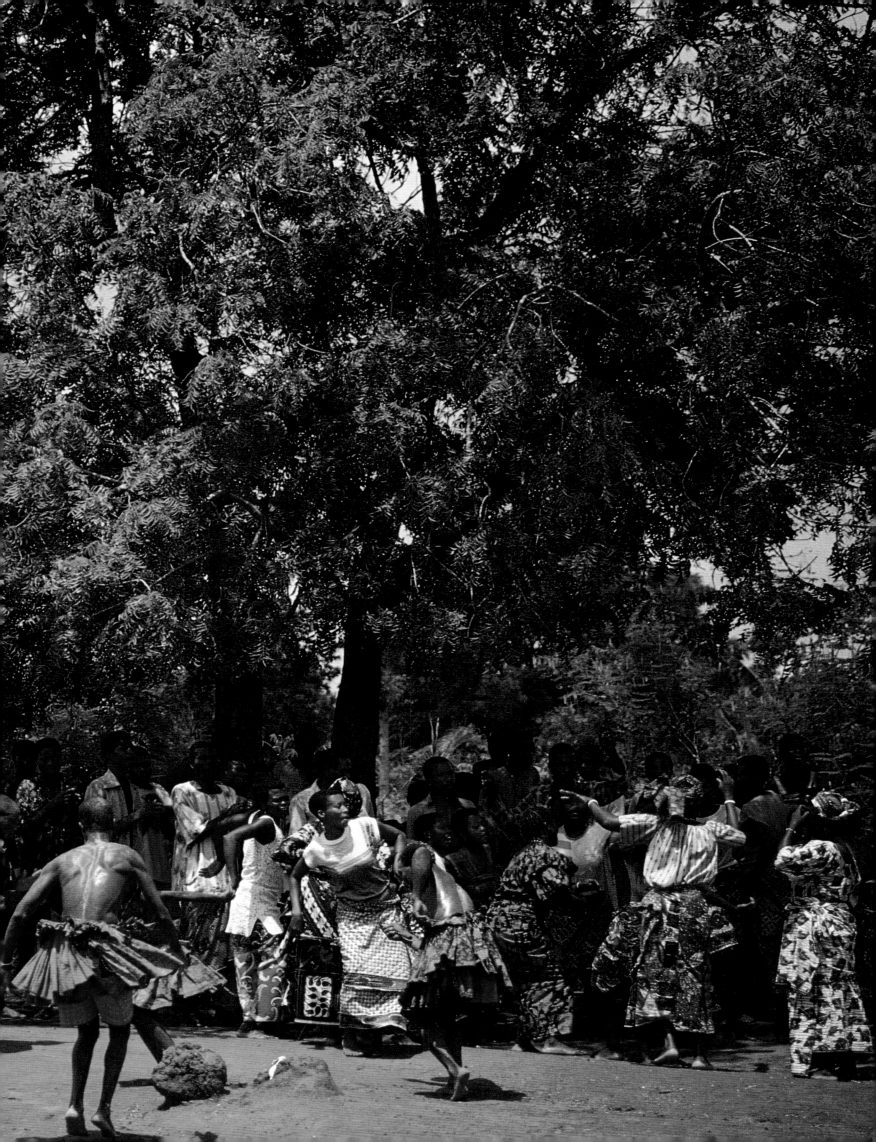

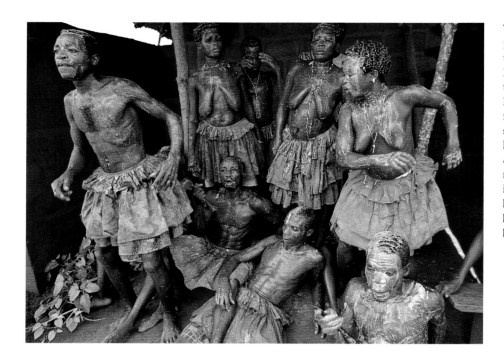

The voodooists of Akpihoué perform a prolonged dance to the glory of the god Djagli, whom they call upon to protect their village. Dancers of both sexes wear flounced cloth skirts, and some have voodoo necklaces. The yellow paste *djassi*, made from ground maize, oil and magic herbs, is thought to strengthen both spirit and body for the hours-long ceremony in the blazing sun.

The group was led by a sharp-featured, muscular man with a shaven head. He was the first to fall into trance. He abruptly ceased to dance, let out a cry of "Bovia!" and, with wildly flailing arms, fell to the ground, where he lay writhing and twitching. Then he got to his feet and eventually dragged himself to the fetish. His eyes rolled upwards so that only the whites showed, and he stammered and mumbled as he embraced the fetish. Djagli had taken possession of him.

In trance, according to voodooists, a god or the spirit of an early ancestor enters a person's body. Some gods conduct themselves very inconsiderately in the process, mercilessly "riding" those whom they possess until, after hours of ecstatic dancing, they collapse in exhaustion. At other times they cause their medium to hack his or her body with a knife until the many wounds pour with blood.

Nevertheless, it is considered great good fortune if you fall into trance during a voodoo ceremony. For a person in trance is considered to resemble the gods and, while in this totally new region of consciousness, to be able to experience, without drugs, one of the most vivid and powerful states of feeling of which human beings are capable.

The villagers looked on calmly while the spirit of Djagli entered four more dancers. This was plainly an everyday occurrence to them. A few metres away from me a woman stood with her baby secured on her back with a cloth. She was chatting with a neighbour; suddenly she gave a shrill cry. Then she scratched her head as if she were mad, yelled, tore her hair, began to reel and would have fallen on her baby if the neighbour hadn't snatched him just in time from his mother's back. A few minutes later a boy who looked about ten years old also fell into trance. He had just come out of school and still had his schoolbag under his arm.

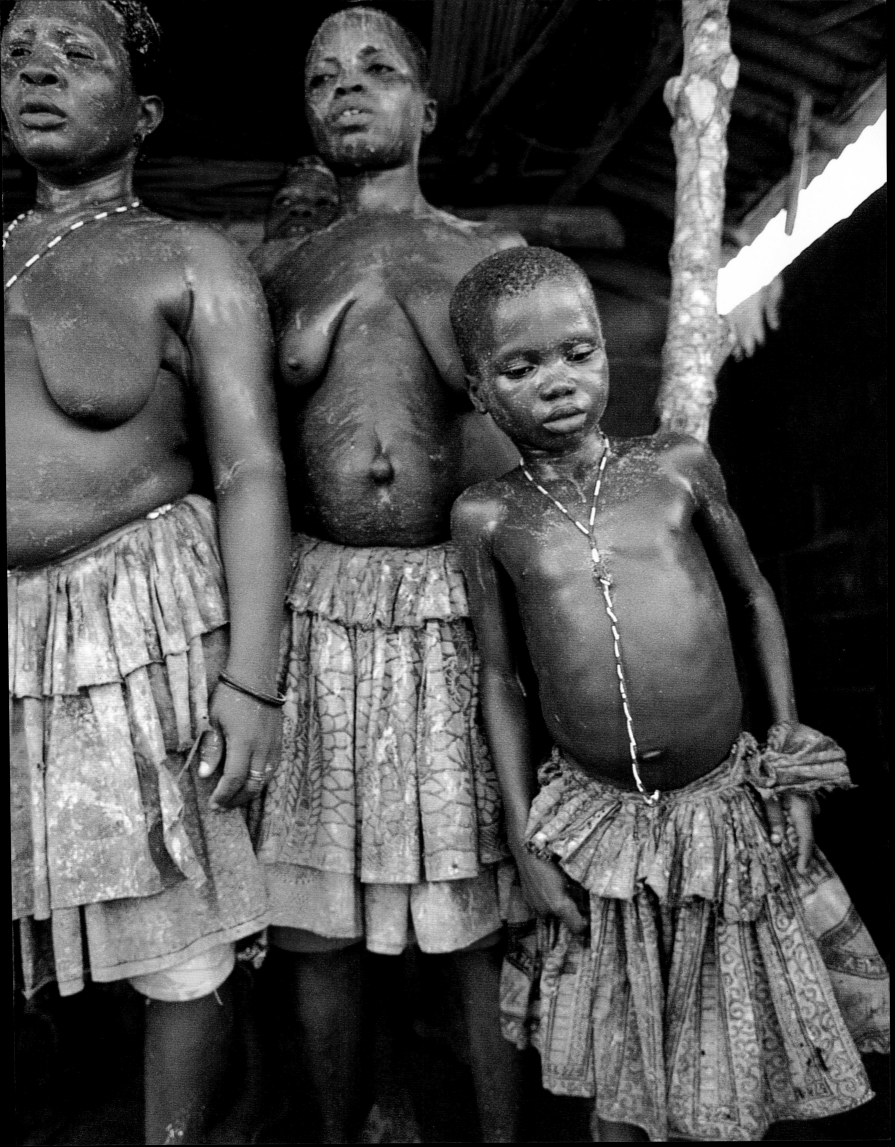

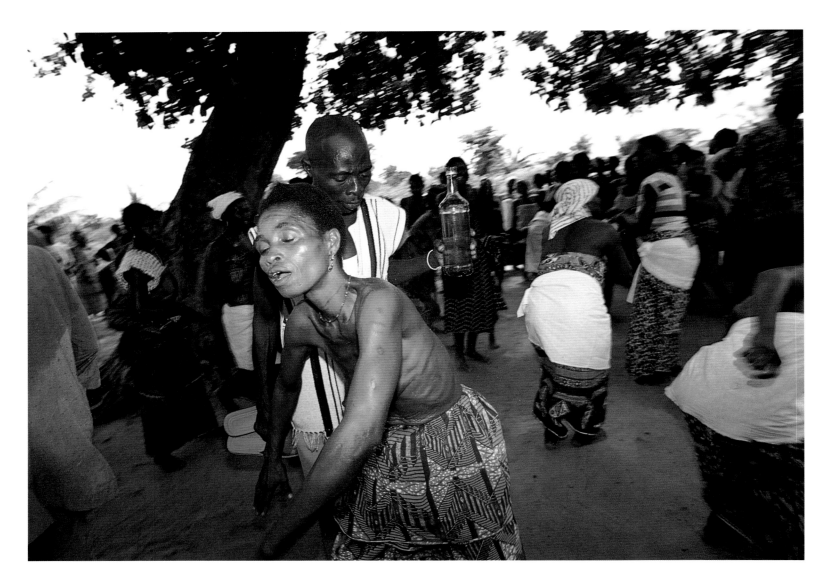

In theory, we were told, even non-voodooists can be quite spontaneously possessed by the gods – although this is not desirable. For trance in a state of possession requires experience and special training if the danger of severe injury is to be avoided. During their initiation into voodoo, novices learn how they should conduct themselves when in trance, so that their movements are completely relaxed and follow the rhythms of the drumming and songs appropriate to the god being venerated.

In older voodooists and priests trance is often imperceptible. They slip effortlessly into this special state of being, which gives them a deep and strikingly impersonal calm. When they open their eyes and stare with unseeing gaze, the transformation is complete: gods look out of human eyes.

In a state of trance, voodooists believe a god or the spirit of a forebear passes into the body. This woman is possessed by the spirit of the water goddess Mami Wata. Her companion watches to see that she does not injure herself while in trance.

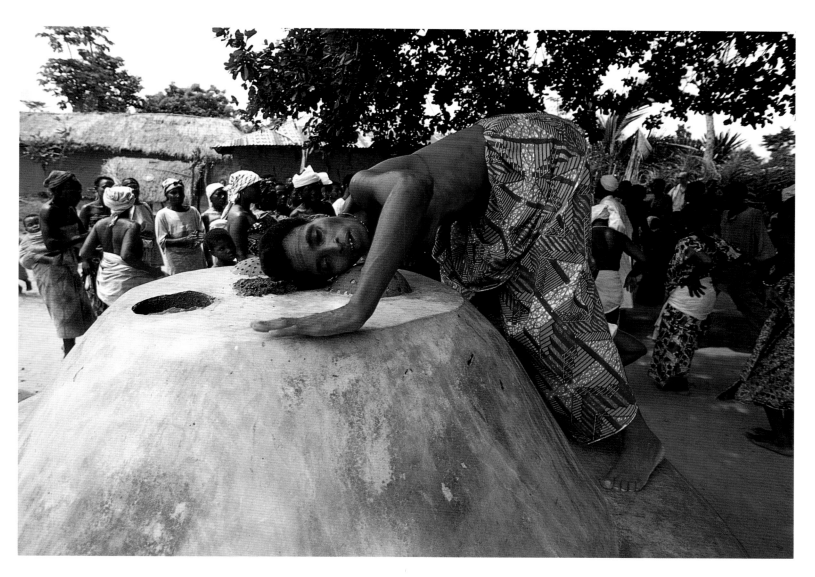

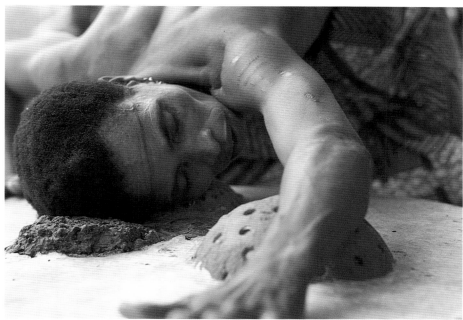

Still in trance, the woman embraces one of the fetishes that guard her village against evil spirits. Priests preside over the making of fetishes. Besides representational forms, often made of wood, there are abstract fetishes such as this pudding-shaped stone at Akpihoué.

FOLLOWING PAGES:
Dialogue with the goddess Mami Wata: a medium in trance receives messages from the divinity. The behaviour of the voodoo gods when they take possession of someone can be unfeeling, as when they "ride" the medium until he or she is gripped by uncontrollable convulsions.

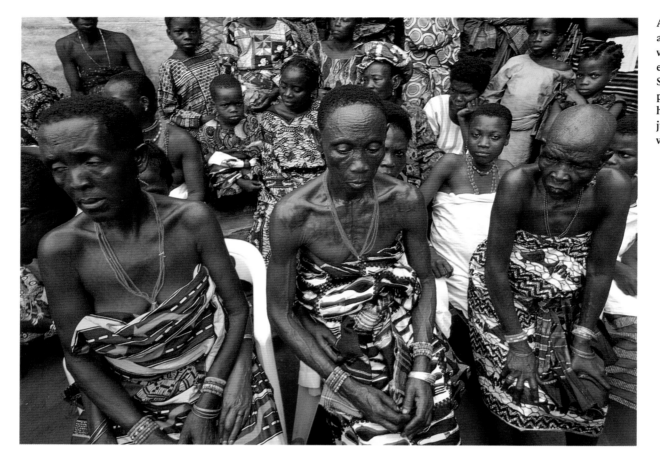

African tradition respects and honours old people, and voodoo communities are no exception. At a ceremony in Sakété these three elderly priestesses have a place of honour, their word and judgement carrying great weight.

The ceremony continued for three hours before reaching its climax, the offering to the god Djagli. Once again it was chicken's blood which dripped onto the fetish and in which the dancers rubbed their faces. Whether animals or fruit are offered, millet gruel, tobacco or drink, depends on the particular preference of the god or gods being called upon and the occasion of the ceremony. A ceremonial offering is not so much an attempted bribe as a giving and taking – for help received, a person must give something back to the gods. The exchange, besides, renews and strengthens the bond between humans and the divine powers.

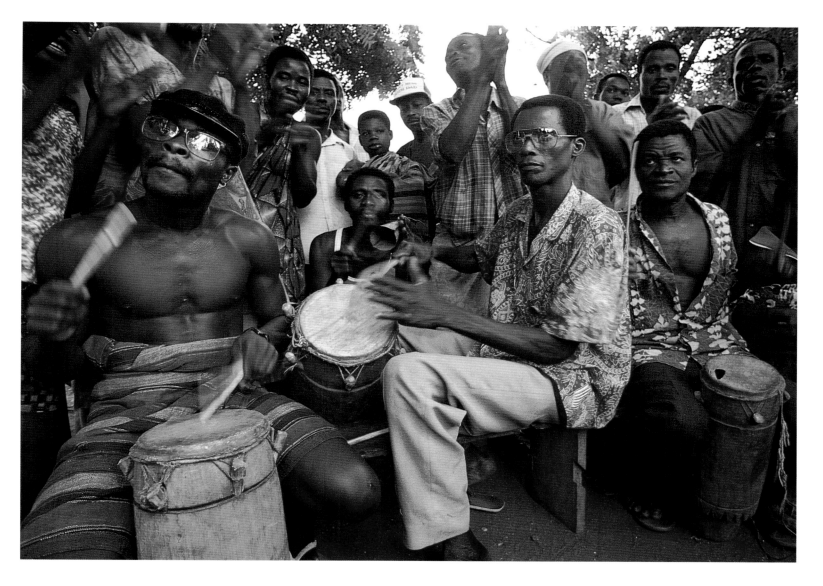

In a ritual washing in palm wine and herbs, an old voodoo woman finally recalled the dancers from the sphere of the divine to earthly reality. With blissful faces they walked unsteadily back to their huts. The villagers who had simply watched were happy, too: Djagli would protect Akpihoué from witches and sorcerers in future.

For it is witches and sorcerers, rather than angry gods, that bring evil, the diabolical, into the world. They can turn themselves into birds and fly, but mostly they appear in normal human form. As long as they remain unidentified, they will go about their mischief at night, causing people to fall sick suddenly or even die, making women barren and men impotent, stealing the souls of young children, poisoning cattle or spoiling the harvest.

Music is essential to voodoo ceremony. The villagers of Gongohoué play and sing in honour of the god of plagues, Sakpata. Each divinity has special melodies and rhythms, played on drums, bells and maracas.

FORTUNATELY there are people like Nago who can expose witches and sorcerers and their dark machinations. Nago is a *bokonon*, a voodoo fortune-teller. We paid him a visit in the small hamlet where he lived, not far from the village of Akpihoué.

In voodoo cosmology fate is embodied by the asexual divinity Fa, also known by the names of Ifa or Afa. Fa has the form of a sphere or oil-palm nut. By means of the shells of such nuts the *bokonon* can communicate with fate. He uses two pieces of string, to each of which eight nutshell halves are fixed. The *bokonon* drops these on the ground, and the oracle is read from the fall of the nutshells, open or closed side up. The sixteen primary symbols, which may also represent individual voodoo gods, give 256 symbols in combination. So the Fa oracle, the origins of which lie in the prehistory of mankind, is one of the most complex of all divination systems (the Chinese I Ching, for example, has only eight primary symbols giving sixty-four combinations).

The Fa oracle has a similar status to that possessed in other cultures by the Bible, the Torah, the Koran and the I Ching. It is the codified ethical system of voodoo religion and culture, passed on by oral tradition alone. Each symbol has its own oracular saying as well as various explanatory myths and stories. A *bokonon* needs many years of training, a good memory and keen intuition before being in a position to predict a client's future.

Nago, a *bokonon*, or voodoo fortune-teller, consults the Fa oracle. Fa is an asexual divinity who, together with the god Legba, is responsible for linking the human world with the divine and for facilitating communication between them. Fa is ubiquitous, and is consulted not only in religious connections but also in matters of everyday life. The divinity is embodied in the oil-palm whose fruit Legba taught humans to use as an oracle. Eight nutshells (or cowrie shells) are fixed to each of two strings. Uttering prayers, the *bokonon* lets them fall.

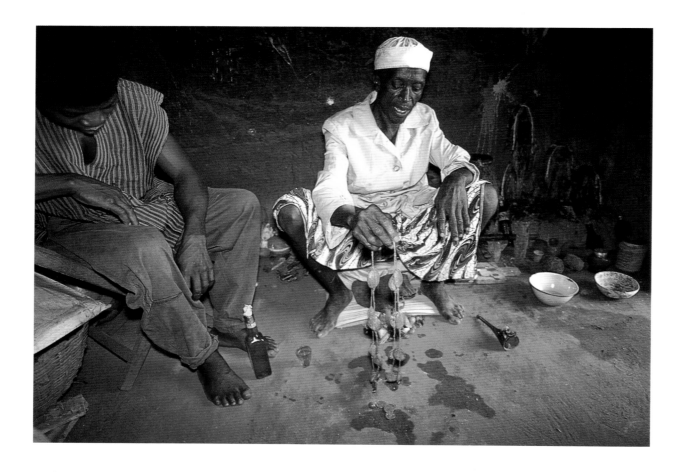

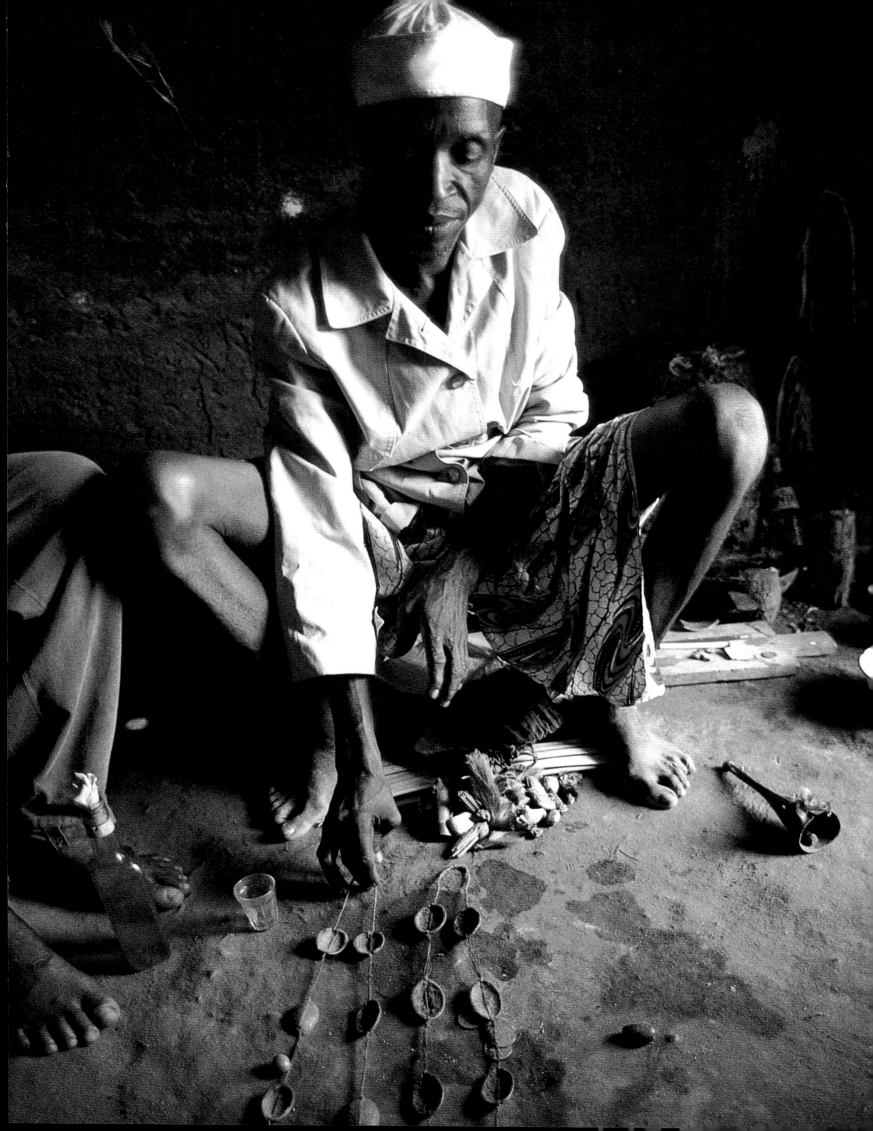

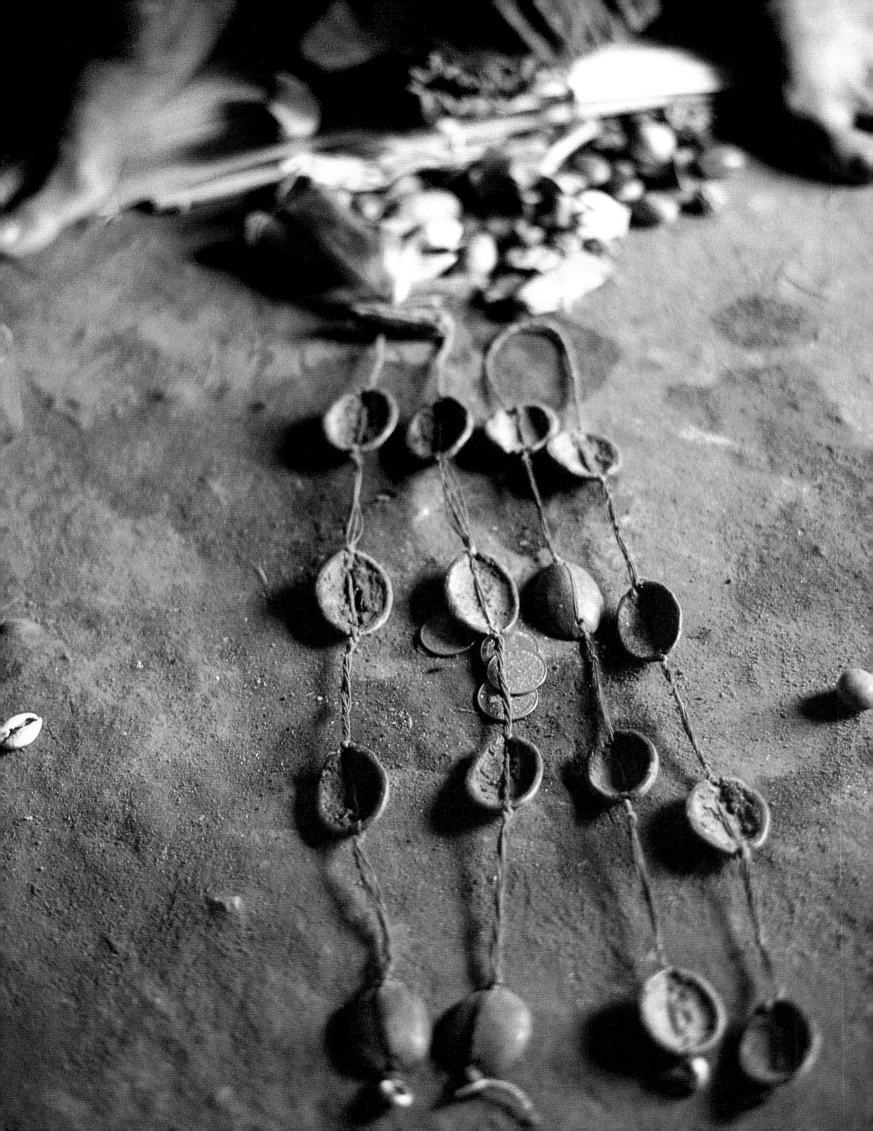

LEFT:
The oracle depends on the pattern of nutshells – some open side up, some closed side up. Fa has sixteen main symbols, giving a total of 256 in combination. It is among the most complex of all divination systems. Few initiates are capable of interpreting the oracle's manifold pronouncements, and then only after years of instruction from oracle priests, who orally pass on vast numbers of sayings, myths and interpretations.

RIGHT:
The *bokonon* Nago has interpreted the oracle. His client, a farmer, having sprinkled a few drops of gin over the two fetish figures as an offering to the oracle god Fa, takes a sip herself. Meanwhile Nago prepares a *grisgris*, a good-luck amulet, using a powder, some herbs and a white cloth, which Fa has advised the woman always to carry in future.

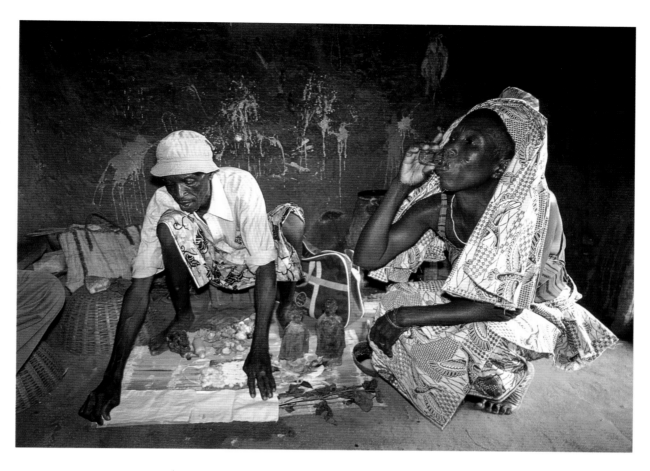

Not wishing to hear our fates, we only asked the fortune-teller whether our research on voodoo was likely to have a successful outcome. Nago took our 500 African francs (just under 2 U.S. dollars), scooped water with his hand out of a big vessel behind him, and began to moisten the numerous fetish figures standing around. He rang a bell, sprinkled some gin over the fetishes, and himself took a sip. We did likewise. Then the *bokonon* tossed the oracular strings one after the other.

The symbol Sa Meji came up. Nago interpreted: We would be successful in the end. We should not let ourselves be deterred by setbacks, but should trust the voodoo gods and be persistent, in accordance with the old saying: "If your house burns down, no-one will help you. You must do the work yourself."

We bought a white dove. Nago plucked a few of its feathers and buried them in his garden. Taking a piece of white fabric, some down, talcum powder and drops of scent, he made two tiny packages. I added mine to Monsieur Zorro's *grisgris*. As we parted the *bokonon* promised he would pray to the voodoo gods for us.

PERHAPS HE PRAYED to Mami Wata. We imagined so from the scent and the white colour of the offerings, both characteristic of the white-faced water spirit, often represented in murals in voodoo temples as a mermaid. Mami Wata is supposed to make her followers powerful, wealthy and influential – reason enough for her to be honoured at regular ceremonies.

Djalé, known as Tchodo, the *hounon* or priest of the village of Hountohué, had gone to his temple early that morning. Here he kept not only statues of Mami Wata but also fetish-figures of many other voodoo gods. He fed them, taking great care that each was given the appropriate food. Mami Wata, for example, abhors alcohol; she drinks perfume or lemonade. Gu, god of fire and iron, mustn't touch alcohol either; it would make him violent. And each god received his or her own gifts. Tchodo wished to avoid any risk that a jealous god would disrupt that day's Mami Wata ceremony.

It began with a joyful procession. To the galvanizing rhythm of the drums, the villagers danced through Hountohué, led by their priest. White flags fluttered over the roofs of the mud huts, red and white pennants were suspended between trees.

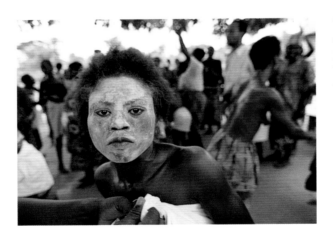

This young woman has daubed her face with talcum powder for the opening of the Mami Wata ceremony, and wears a white wrap; both are typical voodoo features.

Hounon Tchodo wore gymshoes, a white robe, a white turban, and an array of white and blue necklaces. In his right hand he held a kind of sceptre symbolizing the unity of voodoo; it was in the form of a wooden fist with pointing index finger – five fingers united in one. The other followers of Mami Wata, all of them women, were also dressed in white. Many had faces rubbed with talcum powder. The procession stopped more and more frequently as, with loud cries, contorted limbs and rolling eyes, the "Mamissi" fell one after another into trance.

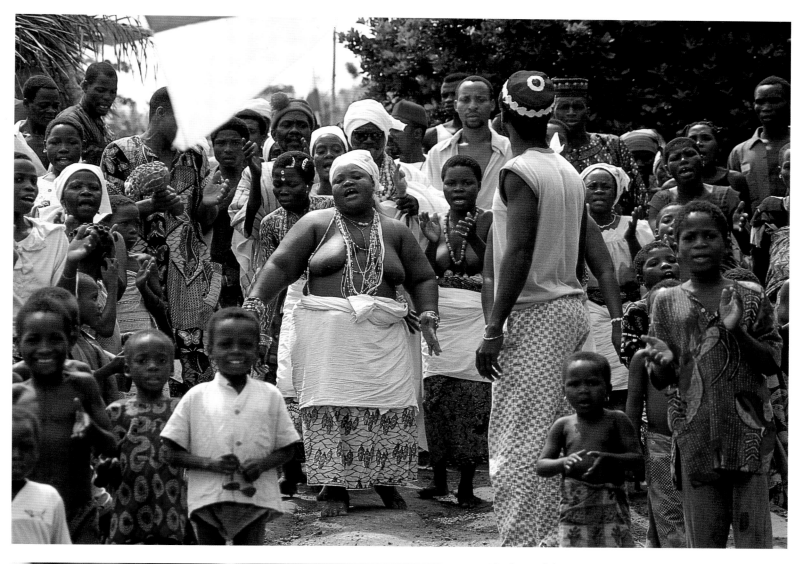

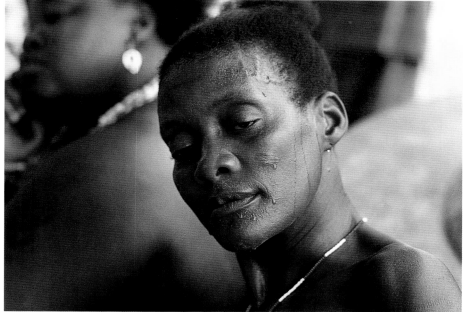

Singing and dancing, the
people of Hountohué parade
through their village. They
are led by the imposing
figure of a Mami Wata
priestess, with the voodoo
priest Tchodo in a white
turban behind her. Rapidly
the worshippers fall into
trance, which sometimes
lasts for several hours
punctuated by ecstatic cries
(SEE FOLLOWING PAGES).

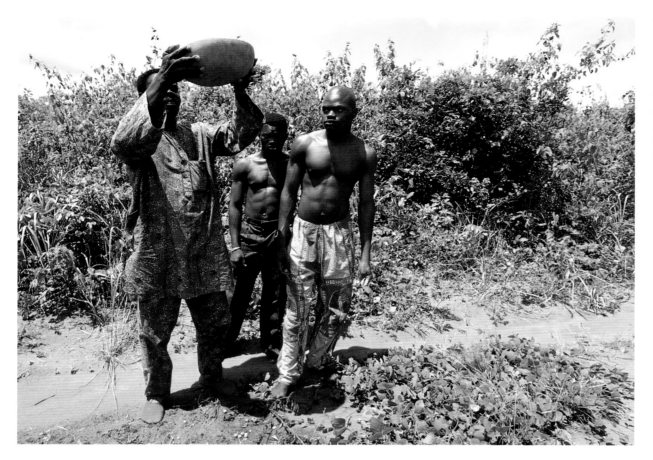

Stammering, they threw themselves upon the Legba fetishes placed around the clearing. Then they jumped up, hopped about or performed stilted movements, frequently uttering squeaking and cackling noises; a short, round Mami Wata priestess shook with convulsive laughter. She held a conversation in a strange language with her assistant, who was also in trance. Their faces jerked and their arms made movements reminiscent of pantomime.

The other villagers watched, amused and fascinated, as if witnessing some absurd piece of theatre. When the priestess let out another peal of resounding laughter, the children laughed too, and the adults smiled; everyone knew that Mami Wata not only loved perfume and other beautiful things but was also fond of fun.

Later young and old gathered around their priest, sitting on a bench in the inner courtyard of his house. A farmer aged about forty was led before him. He appeared very tense. A little over three weeks previously, this man had come to Hountohué more dead than alive. He'd heard, he said falteringly, that *Hounon* Tchodo was not only a priest but also an *azongbeto*, a great voodoo healer, and he begged Tchodo to help him. His soul had been stolen by witchcraft, the man stammered. He had severe pains all over his body. He had quarrelled with members of his family over the division of his father's estate, a farm. A curse had been put on him – he was bewitched. He had been repeatedly hospitalized but the doctors had been unable to do anything for him.

Tchodo, a *hounon* and *azongbeto*, was only too familiar with histories like this man's. After resting the patient for several hours in a special temple, he started treatment. He put him on a herbal course for three weeks and made him take a consecrated water-soluble powder twice or three times a day. The patient was allowed to wash only with soap that Tchodo had made himself.

The man assured the villagers that he felt much better now. *Hounon* Tchodo smiled and adjusted his sunglasses – the right lens was cracked. The last part of the treatment, which he had planned for the day of the Mami Wata ceremony, would produce a complete recovery.

Tchodo made the man kneel, hold his head over a clay jug and inhale the smoke rising from burning herbs. Uttering prayers, the priest shook talcum powder and the *agnagna* herb over the patient's head, upon which his assistants then placed a stone, symbol of the heavy burden he had to bear. Blood poured from a slit chicken's throat over his body, forming red rivulets.

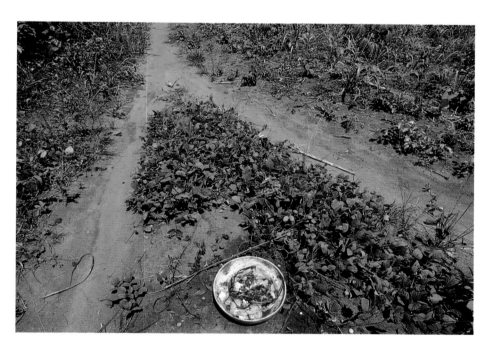

The bowl containing the magic brew is left at a fork in a path. Voodooists believe that spirits, witches or the souls of the dead frequent such spots. Similar ideas are found in folk traditions all over the world.

FOLLOWING PAGES:
In the sacred wood at Sakété an *azongbeto* treats a female patient. After drinking a herbal tonic, she has washed herself with a herbal concoction. Now the healer blows consecrated talcum powder over her back from an oracular board.

Finally, the priest gave the man a special washing, using a herbal concoction that he had consecrated to the goddess Mami Wata and a bottle of lemonade. The stone was removed from his head, completing the process of cleansing from evil spells.

A kind of immunization process followed. One of the priest's assistants made seven incisions in the man's chest, back and limbs with a razor-blade, and rubbed his skin with a powder prepared from the ashes of a crow. Voodooists believe that witches use these birds as means of transport – the ashes of one would serve as a "serum" protecting the patient against future witches' attacks.

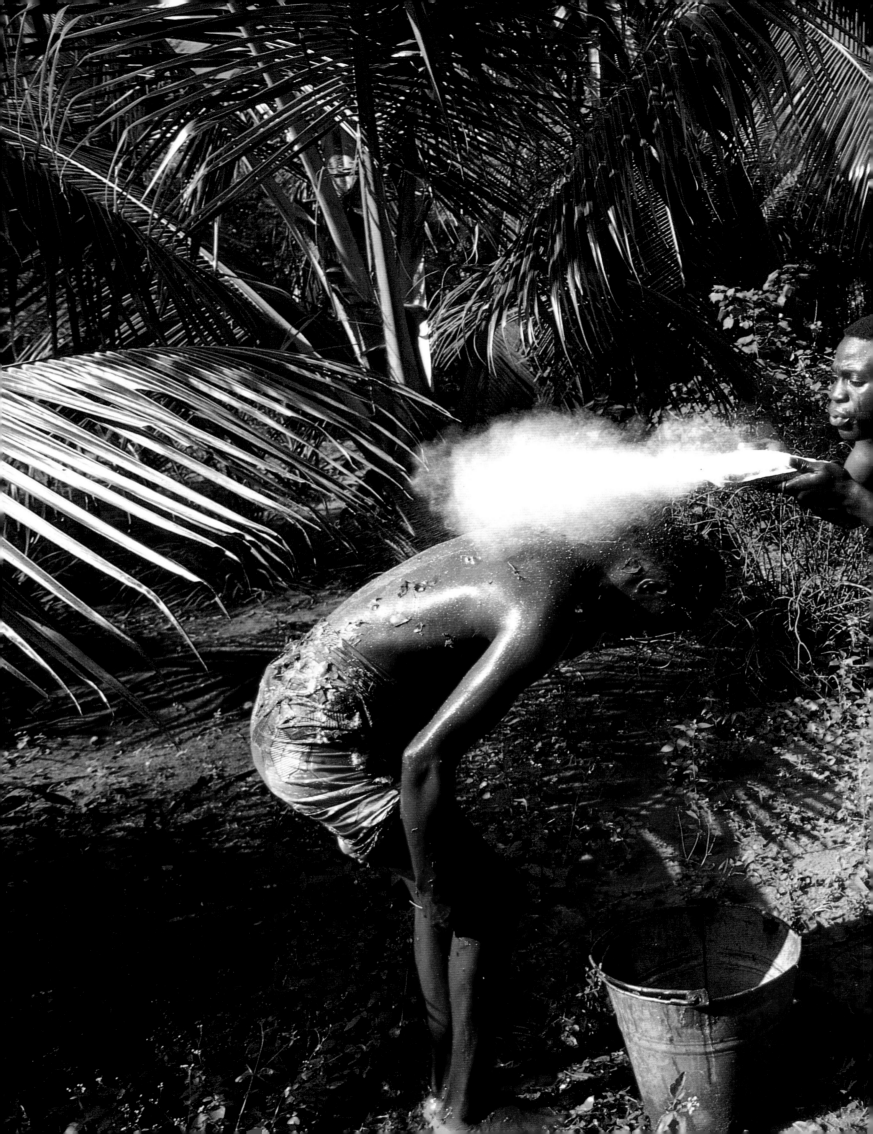

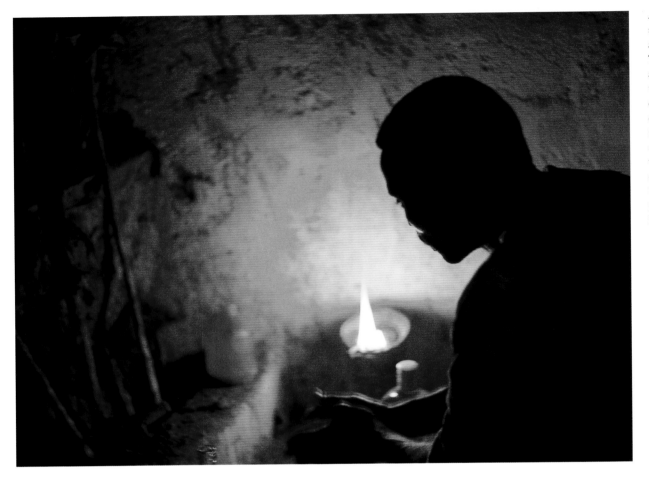

A priest of the *egungun* secret society prepares for a sacrifice in the *egungun* Temple of Sakété. *Egungun* are spirits of dead ancestors that leave the realm of the dead for a short time in order to transmit messages from the gods to humans at special ceremonies, during which they enter the bodies of members of the society. Usually outsiders are strictly prohibited from setting foot inside the temple.

The man was firmly convinced of this when he shook *Hounon Tchodo*'s hand in gratitude. His wife fetched him in the evening, paying the priest and healer for his services with several chickens and bottles of lemonade.

Had it been witchcraft or the panic fear of it that had made the man sick? The Western way of thinking immediately chooses the latter explanation, taking witchcraft to be medieval superstition. But things are seen differently in Benin, where belief in witchcraft, as everywhere in Africa, is strong. Not only farmers in their remote villages but also university professors in Cotonou and government officials in Porto Novo believe that sorcerers exist. And they are right. Sorcerers really do exist in real life; or, more precisely, people who describe themselves as sorcerers.

In an outer suburb of Cotonou, with a population of 600,000 Benin's largest city, lived Germain Bamenou. A muddy path led to his small stone house with corrugated-iron roof. Children played on rubbish heaps or in puddles. A cackling black cockerel took flight in front of the *yovó* journalists' car. Germain Bamenou was about forty. On either side of his bared chest he bore a tattoo the size of a silver dollar. His official occupation was that of a carver of "Airport Art", his own original description of the kitsch figures he sold naive tourists at airports as "traditional African art". Actually, informants had told us, Bamenou was a great sorcerer.

The key figure at an *egungun* ceremony is the *juju* man or magician. In Porto Novo he has a gorilla paw as a personal fetish, which along with various kinds of necklace symbolizes his magic powers. Those seeking the *juju* man's services must speak their wishes into the gorilla paw.

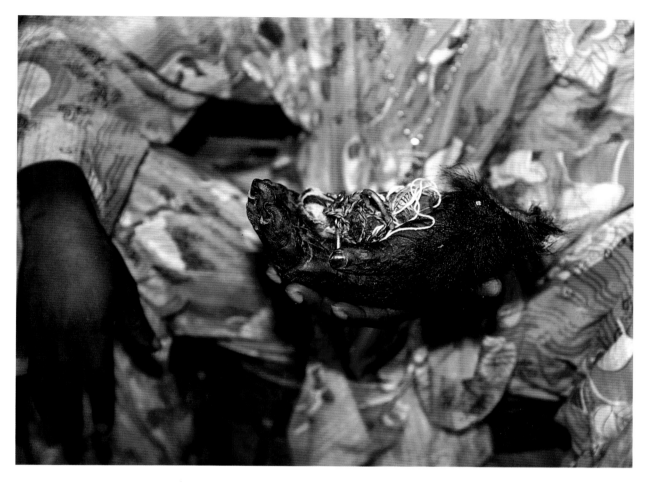

A client was already sitting in the sparsely furnished office room, a profusely sweating African who introduced himself with an embarrassed grin as a "businessman". He said that another businessman had owed him money for some months but was refusing to pay it back, and now something had to be done about it. The sorcerer nodded, his face immobile. From an untanned leather bag he drew some herbs of indeterminate kind, placed them in his client's mouth and told him to wash them down with "Super Schnapps". Then he consulted the oracle: Yes, he could indeed perform sorcery, and it would be successful.

He took a dog's skull from a box and wound some grass round it. Then he filled two nutshells with herbs, wound grass round these too, and put them in a bottle. Uttering incantations, the sorcerer went into the next room, evidently his bedroom. It contained an ancient bed with a sheet stiff with dirt and a fetish in one corner, which was covered in a thick layer of yellow paste and dried blood; the stink of decomposition mingled in the air with the bitter smell of male sweat.

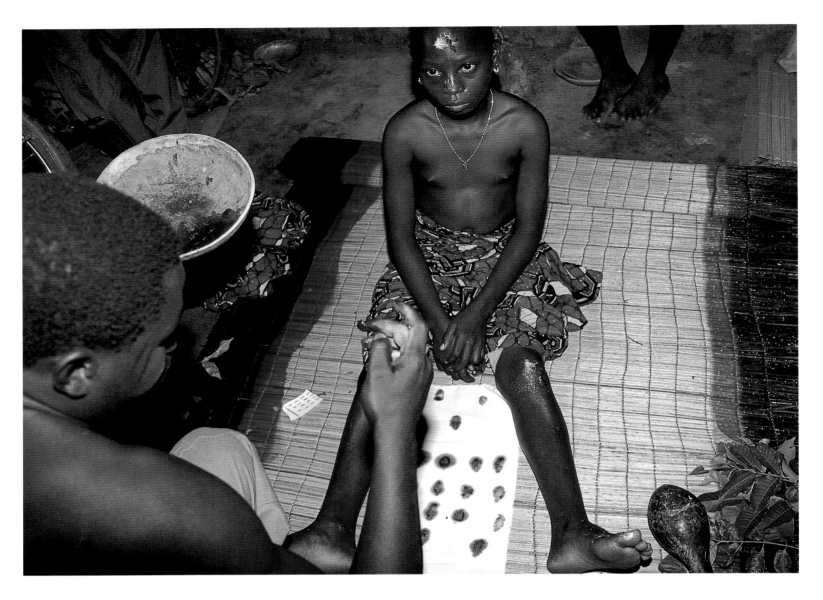

A young girl, whose sup-
posed bewitchment has
caused her mother to
remain barren, has been
brought to an *azongbeto*.
The voodoo healer has con-
sulted the Fa oracle, and
paints the signs on a white
cloth with blood.

RIGHT:
Offerings are shaken onto
the cloth bearing the
oracular signs. It will be
folded into a tiny packet,
which the girl must carry
next to her skin day and
night for some days. Then,
according to the *azongbeto*,
her mother will be freed
from the curse of
barrenness.

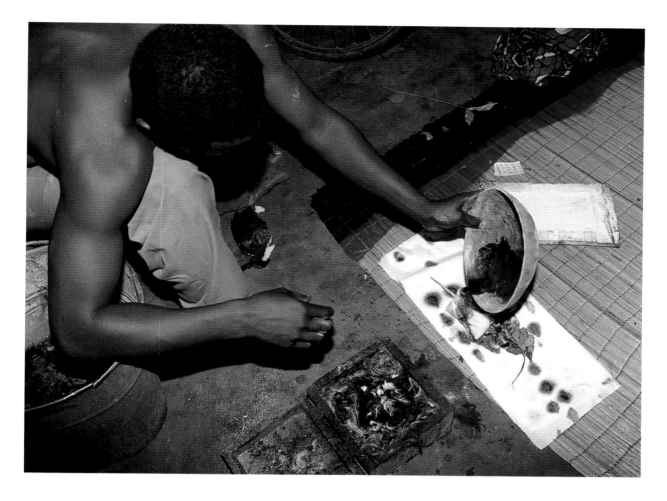

As usual gin was poured over the fetish, then the bottle and the nutshells were buried in the garden. Next came the animal sacrifice. Over the dog's skull two chickens breathed their last, and a goat jerked to its end after receiving a knife-thrust in the throat. All the sorcerer's fetishes were fed with the blood, and his client had to drink it too. With his fingertips the nauseated businessman held a blood-encrusted calabash to his lips and sipped from it.

He asked what would now happen to his debtor. The sorcerer, who had throughout performed his duties with a calm unconcern which he presumably also brought to carving "Airport Art", screwed his face into a grimace. The debtor would be hunted in his dreams by wild black dogs. The herbs in the buried bottle would swell up and cause him bowel pains. He would constantly be forced to think of his creditor and his debt – and he would pay in the end.

Sweat pouring down his face, the businessman asked what he owed the sorcerer. The sacrificial gifts had to be paid for, replied Bamenou. And he was to receive 10 percent of the amount of the debt when it was paid back. And if it was not paid? "It will be paid," said the sorcerer. "And you will pay too. Promptly."

IN THE CAR on the way back we tried to collect our thoughts. Had we simply witnessed a trickster's hocus-pocus? Germain Bamenou lived with his wife and children in the humblest circumstances, and it didn't seem likely that his witchcraft could do either much good or much harm. Our guide was shaking his head. He was a practising Catholic, but he still believed in witchcraft. And he was afraid of it. Even someone in his family, he told us, had been bewitched ... but he didn't want to talk about it.

Belief in witchcraft and its medical consequences is a subject not readily talked about even in Western-educated circles in Benin. It is admitted that fear of witchcraft is a serious problem, that it can cause mental disturbance, which in turn can lead to serious physical ailment. Professor Henry-Valère Kiniffo of the University of Benin in Cotonou, however, speaks of "completely mysterious occurrences". In his surgical practice he continually encounters cases he finds inexplicable. X-rays show needles inside patients' arms; rusty nails, pieces of cotton waste and glass, or parts of scissors, have to be extracted from stomachs. Could people have introduced these objects into their bodies in trance during a state of possession? Professor Kiniffo will have nothing of such a logical and plausible explanation. Although a scientist, in cases like these he cannot help speaking of a "miracle" – not excluding witchcraft.

RIGHT:
A calabash containing blood, from which everyone who has sought the services of the voodoo sorcerer Germain Bamenou, must drink.

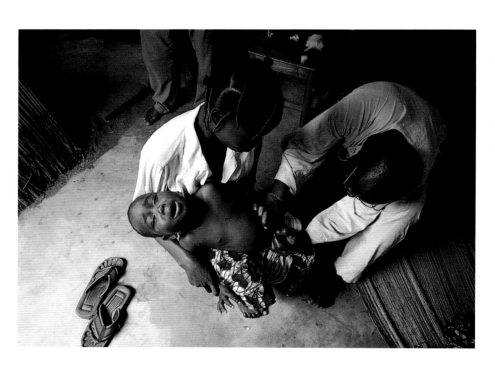

Inoculation against witchcraft: a small boy cries as a voodoo healer shakes magic powder into a shallow razor incision. Since the *azongbeto* has previously inoculated both the boy's parents, the curse is now lifted from the entire family.

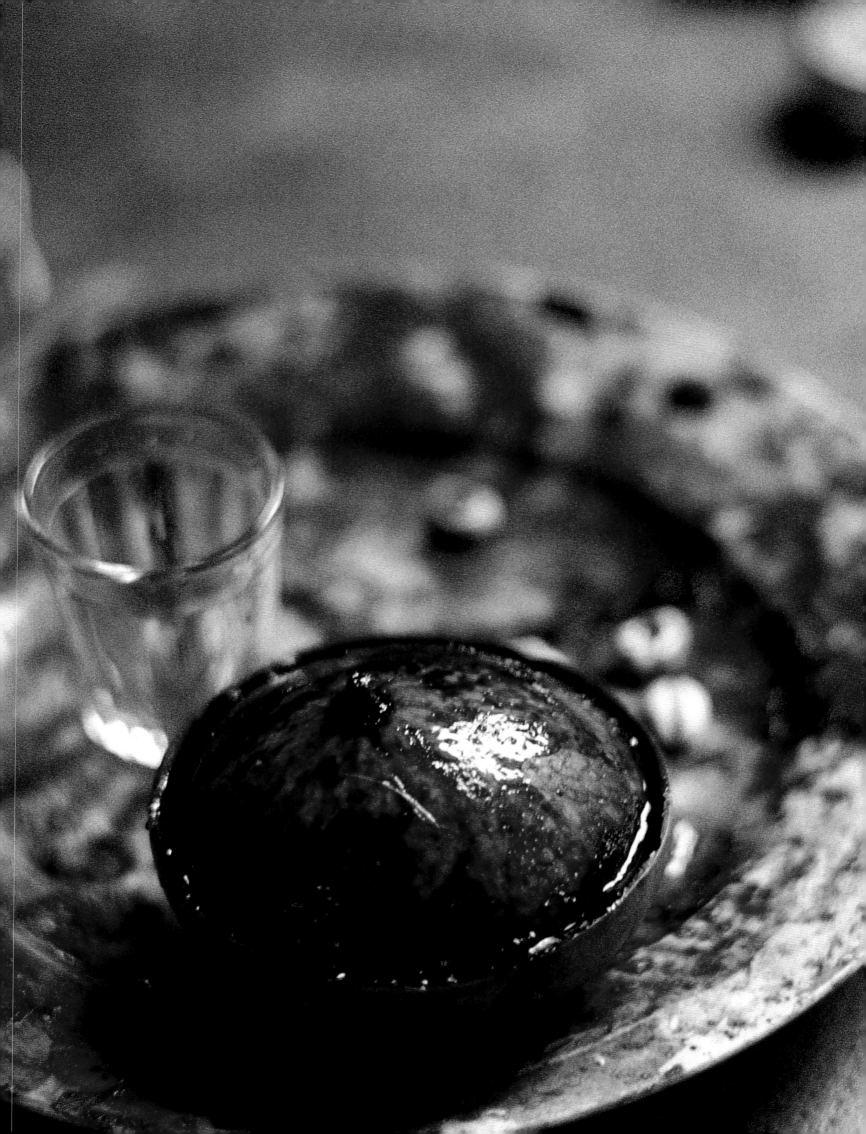

Nowhere in the world has there been any proof of witchcraft. Attempts have been made for many years, for instance, to solve the mystery of zombies. The undead not only haunt horror movies and Michael Jackson's video *Thriller*, but have been reported for centuries on Haiti. It is thought that *houngan*, practitioners of voodoo witchcraft, using secret toxins and techniques, can poison a person so that seventy-two hours after burial the "corpse" can be brought back to life. Will-less, as in a trance, the zombie then obeys the command of his or her master and will behave as his slave.

In his book *Passage of Darkness*, the American ethnobiologist Wade Davis describes his attempts to explain the mystery of "zombification". Davis does not think that stories of zombies are mere fantasy or superstition. He suspects that *houngan*, of whom he was able to observe several at work, may possess some very powerful neurotoxins, such as that produced by the blowfish Fugu (*Fugu rupripes rupripes*), tetrodotoxin, lethal in the smallest doses. When strongly diluted, it puts the victim in a condition of apparent death: the body is totally incapacitated, the pulse is indetectable – and yet the victim retains full consciousness.

Do *houngan* know of substances that have escaped the attention of modern science? To someone living in Africa this would not seem so improbable as to someone living, say, in an air-conditioned house in Los Angeles. Every Los Angeleno knows that his or her house can be reduced to rubble in an instant: scientists predict further devastating earthquakes in the near future. Faith in the technological achievements of Western civilization, however, helps us repress such anxieties.

In Africa this is not so easy. Anyone who has cowered in a thatch-roofed mud hut in pitch-dark, beset by lightning, thunder and torrential rain, has physically experienced that the forces of nature are not theoretical and abstract quantities. The danger of being struck by lightning is very real ... wasn't it only yesterday that neighbours told us of someone killed by lightning in his hut?

Affixed to the roofs of many huts and houses in Benin are calabash halves, bristling with thin wooden or metal rods. Spiritual lightning-conductors, they ward off the attentions of witches and sorcerers.

Even in our culture, rumours have a powerful effect, as politicians who feel slandered well know. We too have our own modern legends and fairy-stories, and the tabloids supply us with new ones every day. But rumours acquire the power of fact only if they appear generally plausible. If anyone told us that the American president or the British prime minister had been bewitched, no-one would believe it, not even the ostensible victim.

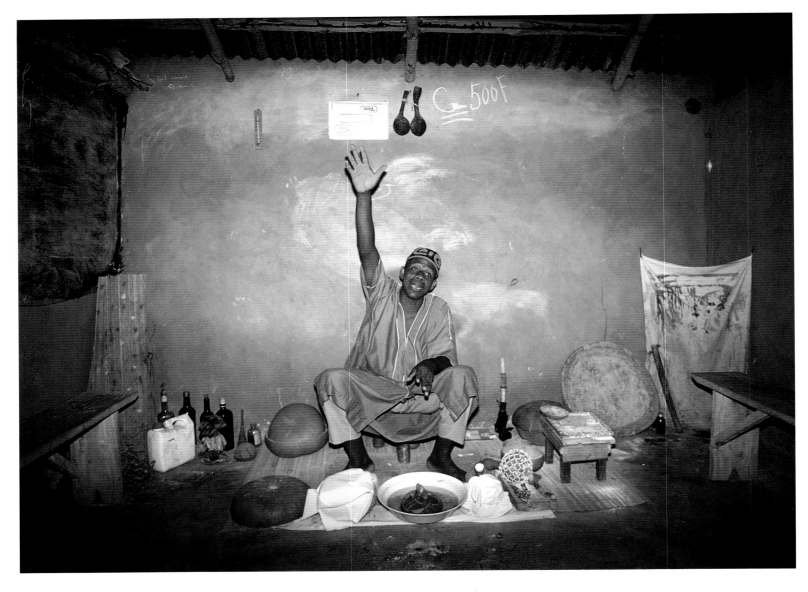

In Benin millions of people take such rumours for fact. After the bloodless overthrow of the Marxist-Leninist régime, the former president of the World Bank, Nicéphore Soglo, took over as head of state in 1991. Like almost the entire intellectual élite of the country, Soglo is a Roman Catholic. Shortly before he officially took office a deadly curse, the *tchakatou*, is said to have been laid on him for opposing the religious supremacy of the voodoo priesthood. The means of his bewitchment during the election campaign of 1991 is said to have been the "African pistol", a lethal cocktail of rusty nails and poisonous substances. Soglo did in fact fall severely ill and had to go to Paris for treatment. People in Benin attribute his recovery to a single reason: their president had become reconciled with the voodoo community.

A voodoo healer in his office. His fee is written on the wall: 500 African francs (rather less than U.S. $2). He diagnoses his patients' complaints with the aid of the water bowl at his feet.

66

VOODOO PRIESTS and healers have a precise knowledge of the psychology of people who come to them. (Voodoo critics say that this is because they themselves encourage their clients' anxieties.) Besides psychotherapy, voodoo healers, *azongbetos*, have a mastery of herbal medicine. For centuries they were the only doctors, and even today many people, especially in villages, would sooner go to them than to a Western-trained doctor.

Of course, there are charlatans among voodoo doctors. But confidence in traditional medicine is very often completely justified. European doctors practising in Benin admit that their voodoo colleagues often know much more than they do about the effects of herbs, and report successful cures, especially in cases where orthodox Western medicine has failed.

In Porto Novo, the capital of Benin, we had the opportunity of observing an *azongbeto* at his daily work. He was treating a young

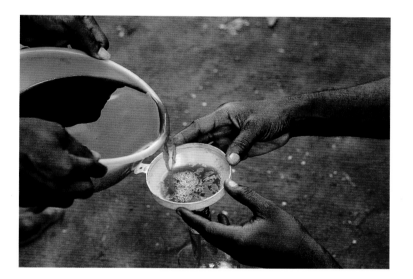 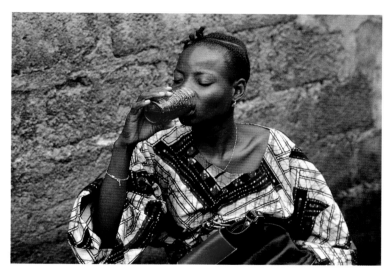

boy's broken arm, not in a surgery or operating theatre but on the public pavement. Carefully he took the boy's arm, which seemed to have a clean break, and set it. The boy had tears in his eyes, but uttered not a whimper. The *azongbeto* applied a bandage lined with herbal paste and put on a splint with three sticks. In two or three weeks, he promised, the arm would be better again.

Dr Isaak Saayi treats more complex cases than broken arms. The President of the Association of Traditional Healers of Benin received us at his home in Cotonou. An operatic aria rang out from the record-player as Dr Saayi opened a bottle of French red wine. The most eminent healer in Benin had studied pharmacy in Paris at the Sorbonne. He told us that he tried to combine the experience of modern Western medicine with that of traditional African practice, "in the struggle against the two scourges from which the people of Benin are now suffering – malaria and, increasingly, Aids".

A young woman drinks a tonic mixture of animal blood and herbs to strengthen her resistance to disease. Many Africans place greater trust in traditional healers than in Western-trained doctors.

In his laboratory, next to pots, crucibles and various chemical substances, between a jumble of international professional literature and bags of herbs, stood a number of fetishes. Sakpata, the pock-marked god of pestilence, was enlisted in the campaign against Aids.

In the village of Gongohoué, not far from Lake Ahemé, we had already witnessed a Sakpata ceremony. To the beating of drums and the laughter of onlookers four young voodooists had made their appearance. They wore bright-coloured women's skirts, scarves and caps. The men danced together, took a few acrobatic turns and teased each other. Suddenly, two of them lay down on the ground. From their movements, panting and groaning the delighted spectators immediately recognized what was being represented.

Then a fifth performer leaped into the circle. He too wore a coloured skirt; but he brandished a wooden rifle. His wild dance raised clouds of dust, just as the god Sakpata had strewn germs to

Dr Isaak Saayi's dispensary: next to bottles of medicine, bags of herbs and gourds containing powder is a fetish.

the winds with his giant broom, enraged when the gods' messenger Legba had mocked him for his lameness. The pair of lovers grew still. They both began to groan again, but now in pain: the pleasures and the costs of the age of Aids was the theme of the performance, and the laughter of the audience began to sound forced.

In this annual sacrificial ceremony, the people of Gongohoué begged Sakpata's intervention to spare the village from epidemics. The dancers were reminding the villagers that they themselves were responsible for their lives and well-being; it wasn't the voodoo gods that caused illnesses, but human beings whose lustful desires and wicked behaviour had aroused the anger of the gods, who were now bent on just punishment.

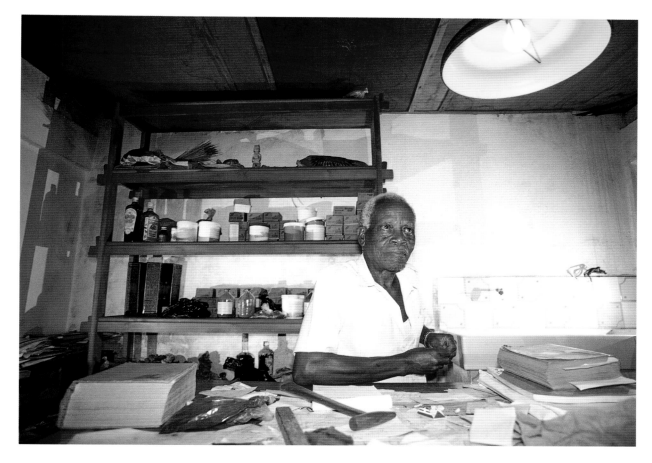

In Dr Saayi's laboratory creative chaos reigns. A pharmacist who studied at the Sorbonne, Saayi seeks to combine the experience of modern Western medicine with the arts of traditional African healing – especially in the campaign against Aids.

FOLLOWING PAGES:
A Sakpata ceremony in the village of Gongohoué. By means of role-playing, voodooists inform the villagers how the Aids virus is spread. A young performer takes the role of a soldier.

The powerful voodoo secret society known as the Gelede, whose members have long watched over moral order in village communities in West Africa, has now joined the campaign to spread public knowledge about Aids. For such purposes dancers often perform with "two faces". They wear characteristic wooden masks, skilfully carved and brightly painted, that tell symbolic stories or convey commentary on political or social issues. We were told that in some places new motifs have been added to the traditional ones, including a gigantic condom.

And since one careless man cannot be allowed to bring harm to a whole family, initiates of the Gelede Society at once tell the audience what is likely to happen to anyone who transgresses their law – a voodoo trial.

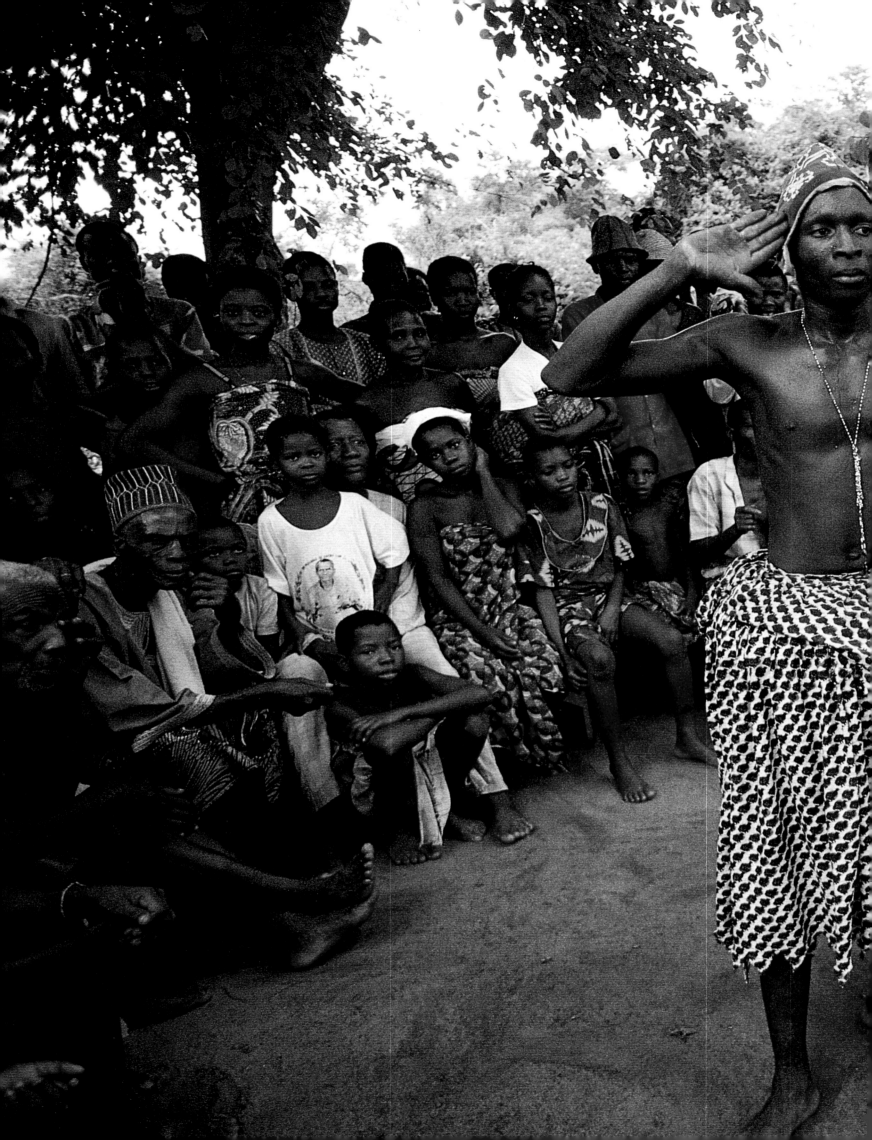

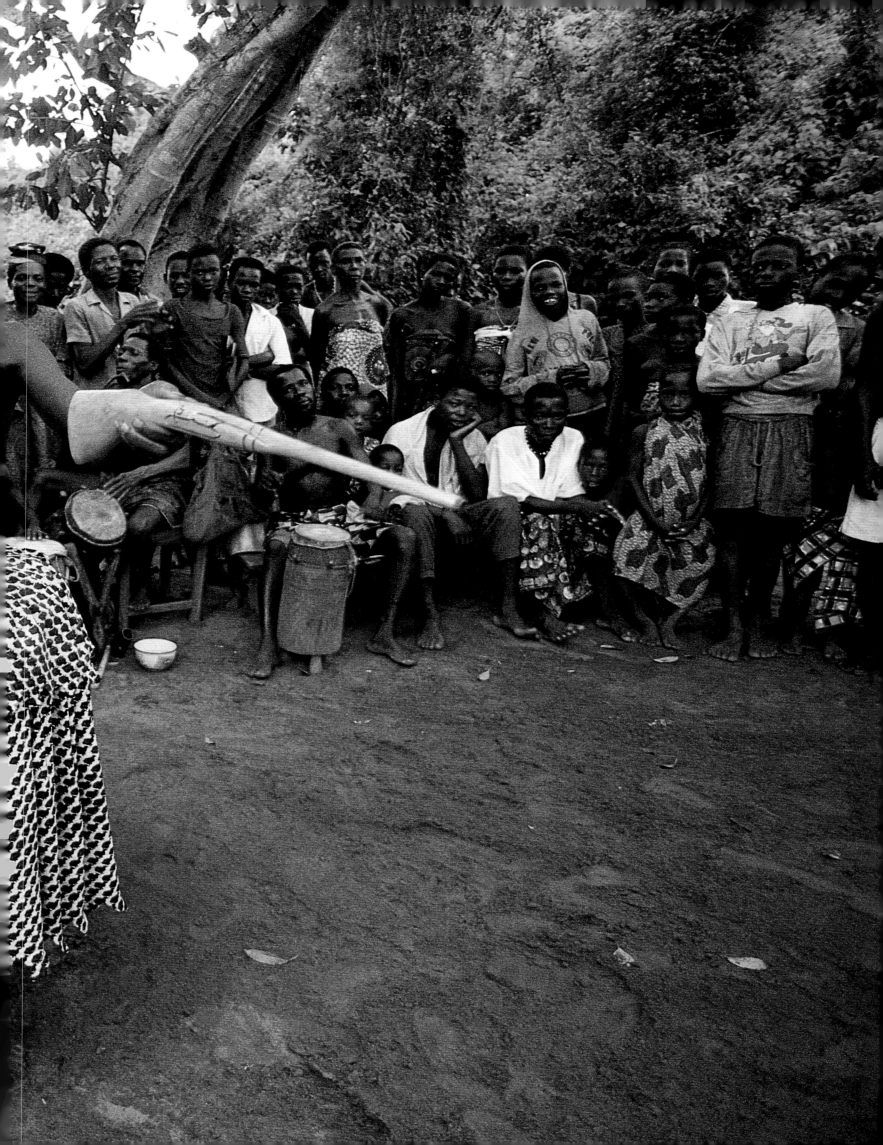

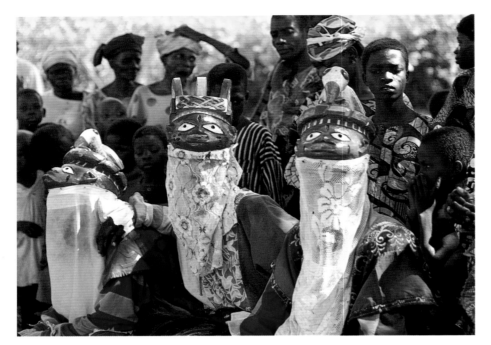

Characteristic of Gelede voodoo are carved masks worn by dancers on their heads as a "second face". Members of the Gelede Society have been the guardians of moral order in local communities from time immemorial – in the tradition of the "Great Ancestral Mother", as sons and daughters of whom Gelede initiates see themselves. At Sakété the brightly painted wooden masks, whose traditional motifs are constantly supplemented by modern ones, are kept in a sacred wood.

FOLLOWING PAGES: During a ceremony at Sakété, dancers comment informatively or satirically on everyday matters, and also on political and social problems such as Aids. The village's oldest inhabitant shows a Gelede dancer his wholehearted approval.

We witnessed the operation of a voodoo court in Hountohué during the Mami Wata celebrations. The priestess there, aided by an assistant, held a public hearing. Both women were still in trance, but now the goddess Mami Wata was far from jovially inclined. The women's faces were grave as a young woman was led before them by her husband.

The husband accused his wife of cooking a meal for another man. In the strict moral code of voodoo this can be judged tantamount to adultery. In defence, however, the wife said that she really hadn't done more than cook, and it had been on one occasion only. After a short period of consideration, Mami Wata spoke to the villagers through the mouth of the priestess: the young woman was guilty of a marital offence, but in minor degree.

In penance she must have her head shaved by her husband and submit to a symbolic whipping with a tree-branch. The couple then walked home somewhat downcast but wholly reconciled. But not before the woman had received a final stark warning from Mami Wata via the priestess: if at the end of the year she should still love the other man, she would die.

The hair on the back of my neck rose at the absoluteness of this prophesy. To the villagers, however, it seemed the most natural thing in the world. Anyone who transgressed the laws of voodoo would be punished – now, not in the afterlife.

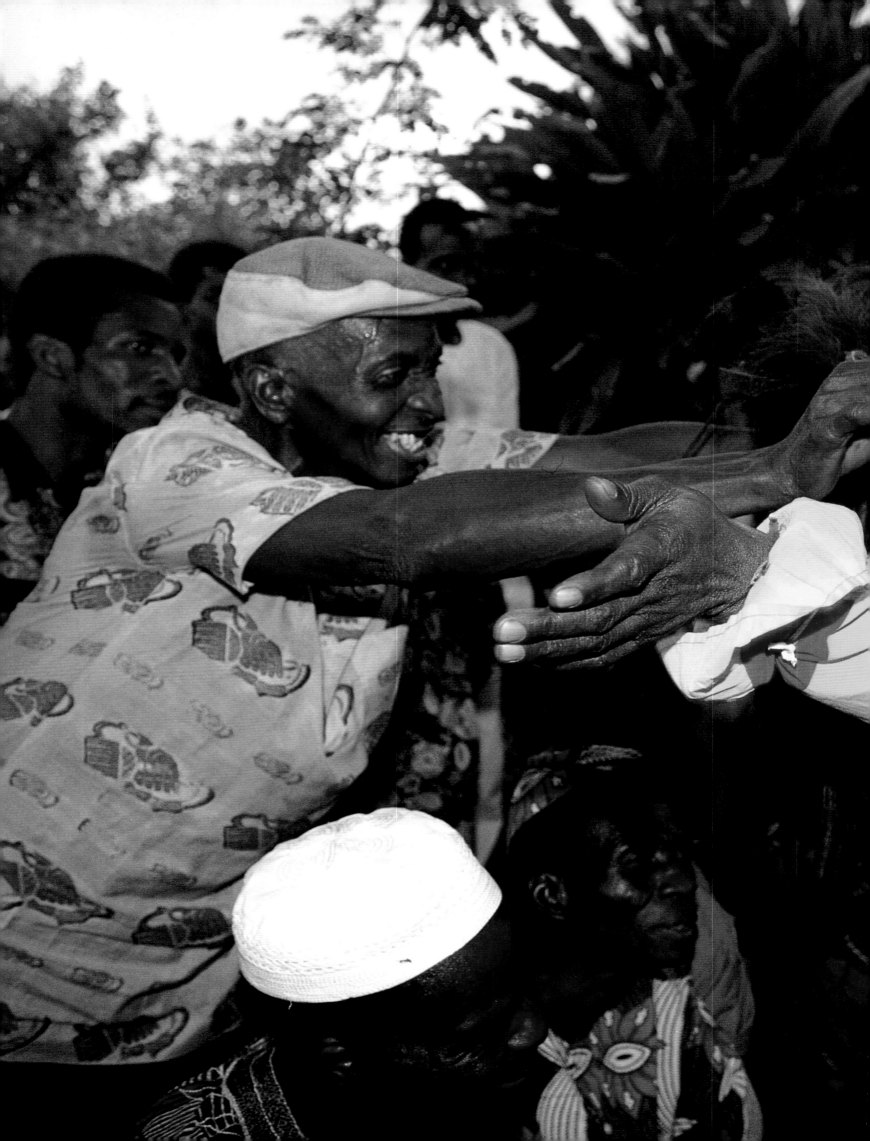

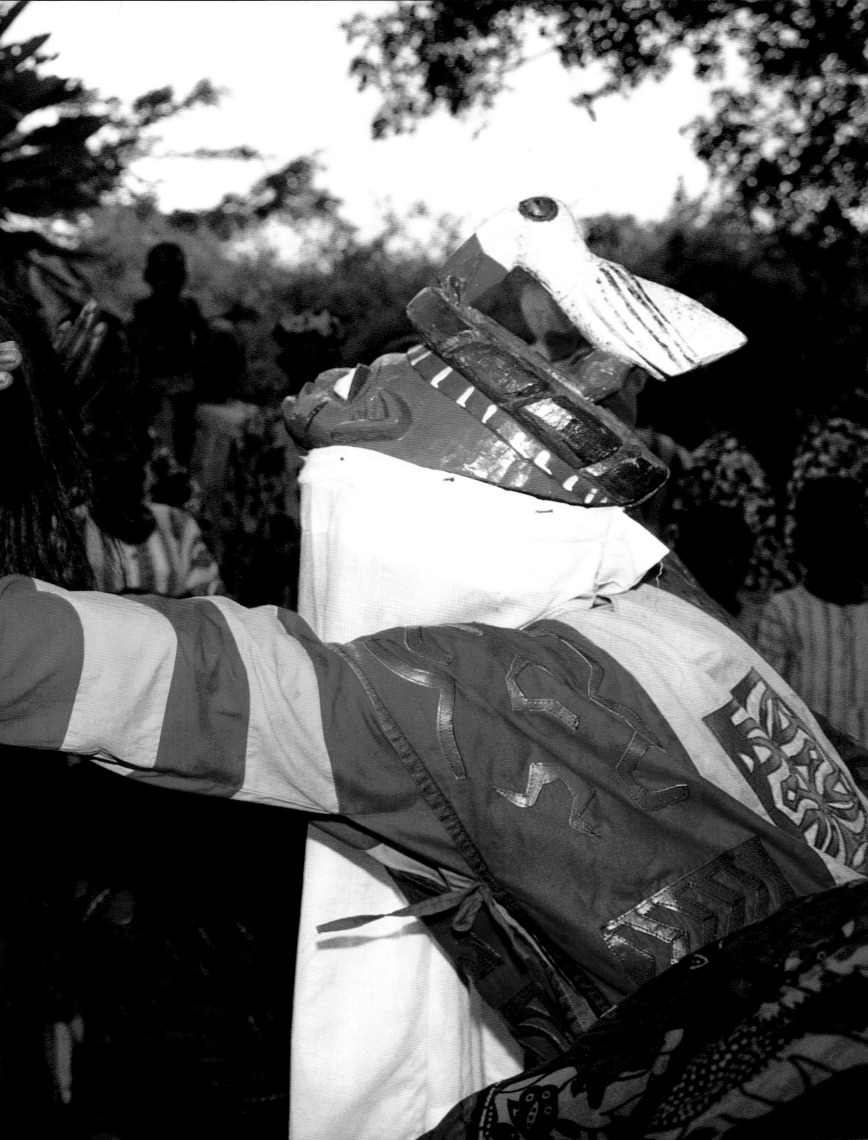

IT IS NOT ONLY THE GODS who can prescribe punishment, but also the spirits of ancestors. For voodoo believers the dead are no longer flesh and blood, but neither are they dead in the rationalistic Western sense. The living can communicate with ancestors just as they can with gods. And indeed, a number of "dead" members of a family may themselves have become voodoo gods, of a kind known as *ajina*, who are responsible for a family's well-being jointly with its living members.

It is usually the priest of the Fa oracle who passes on advice or commands from the realm of the dead, Kutome, to the living. In the *egungun* cult of the dead among the Yoruba tribe, however, the spirits of ancestors enter the bodies of masked dancers – a most unsettling phenomenon.

On a dusty square in the Akpagnon Kodji quarter of Cotonou two or three hundred people had gathered, almost all of them men. The nervousness and irritability that hung in the air could have been cut with a knife. Playing children were severely reprimanded by fathers or grandfathers, who measured the *yovó* journalists with hostile eyes. Drum rolls sounded, hard and aggressive. A whispering ran through the crowd, and beings from another world tramped into the square. They were accompanied by powerfully built men who made room for them with blows of their sticks, which was completely unnecessary since the crowd moved back anyway. They knew that anyone who so much as touched one of the head-to-foot masks, covered with beads and spangles, could fall ill or even die. And severe punishment threatened anyone who dared to cast a glance at the faces of the masqueraders concealed behind fabric or cowrie shells.

The masqueraders were members of the *egungun* secret society. As children of Oya, goddess of whirlwinds, they had the task of keeping the ancestors up to date with the present world. Like most of the major voodoo dance ceremonies, this one lasted approximately one month in all. It included secret meetings in which only *egungun* took part, and ceremonies for the present families of ancestors that took place in a "sacred wood".

The dance that now began on the Akpagnon Kodji square was, so to speak, the official finale of the whole ceremony. Since *egungun* is a cult reserved for men, female spectators were unwelcome. Again and again, the whirling dancers abruptly stopped, and rushed up to the rows of onlookers. The dancer in the mask of Akaba used a rusty, scimitar-like weapon to draw towards him a man who hung his head in fear and humility. Of course the man knew that the voice from the grave was speaking to him through a human being. But this human being was in trance, possessed by an ancestral spirit – and so was a voodoo spirit.

An *ajina* priest in Ouidah calls upon ancestors with his bell. His headdress of red parrot feathers, and the pot in front of him decorated with the same feathers, are insignia of his office. *Ajinas* are embodiments of outstanding personalities among ancestors who have become voodoo gods.

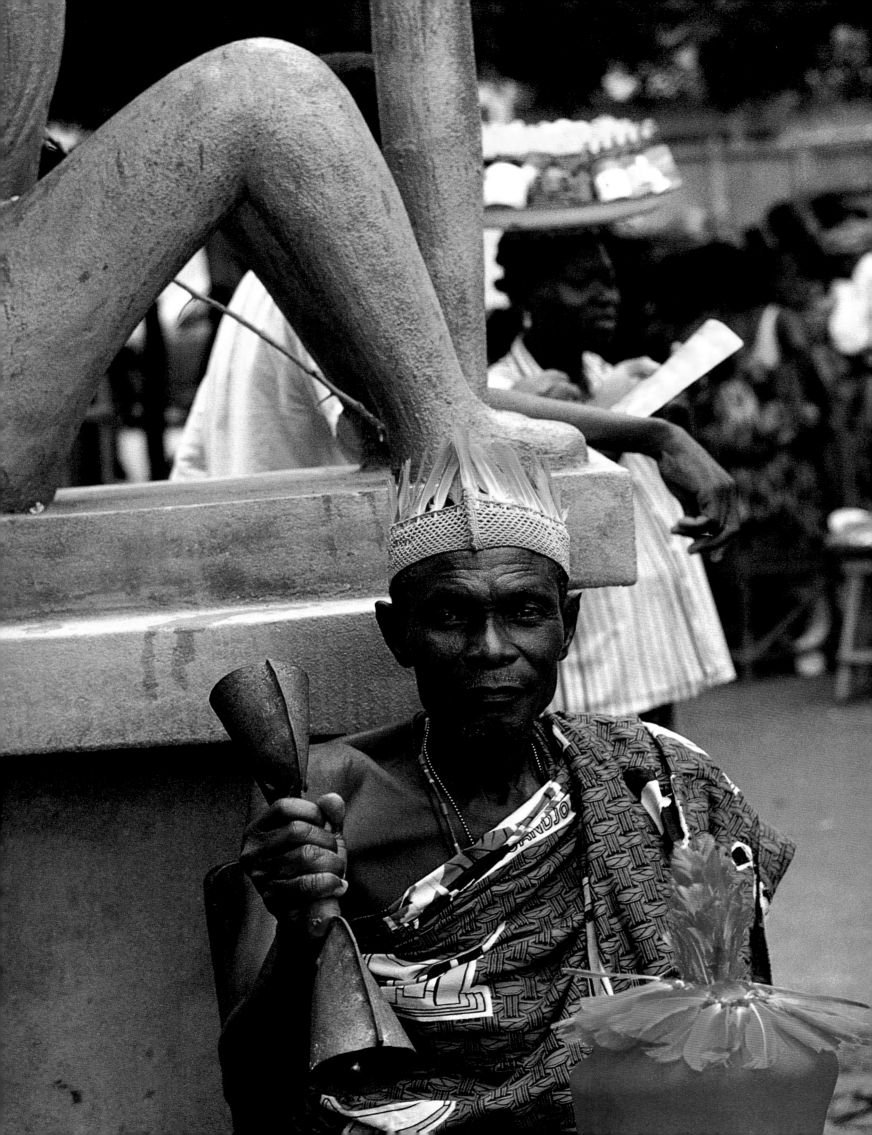

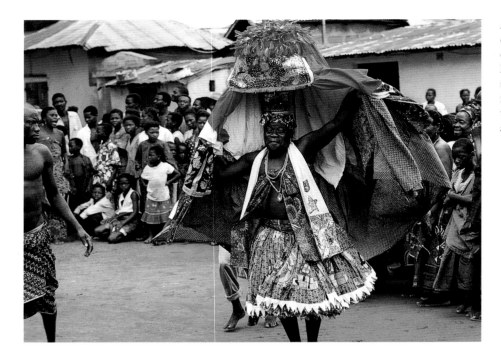

A man dances in veneration of the ancestors during a ceremony in Ouidah. Balanced on his head is a shaped, feather-trimmed fabric bale, which contains the secret essence of an ancestral god.

The Akaba dancer spoke very insistently to the man and seemed to touch his conscience. Finally, the man nodded in resignation, drew some banknotes from his pocket and handed them to Akaba's assistant as he swung his stick. The *egungun* "trial" continued for over an hour. After the ancestors had issued a ritual series of instructions and commands to an old man who looked like the head of a large clan or even of a whole town quarter, they retired. Passing by billboards, hooted at by drivers and stared at by street traders, they were led back to the nearby *egungun* temple by their assistants. From there they began their journey back to the realm of the dead.

Another organ of voodoo justice is the Zangbeto secret society. The "Night Watchmen", also known as "dancing haystacks" from their all-over masks made of palm-straw, patrol the streets mostly after dark, and the police then discreetly withdraw. A district superintendent in Porto Novo told us: "If you disobey a regulation, say throw away rubbish somewhere unauthorized, the Zangbeto come up to your house and call your name out loud in a terrifying voice. They list all your offences and give you a time-limit for reparation, and the neighbours can hear everything. If you don't obey the Zangbeto, they will make you pay, and if you committed a serious crime, they can kill you."

VOODOO is certainly a great power in Benin. And its most powerful priest is the "Grand Commandeur", Sossa Guédéhoungué. He is a rich man. He owns a Mercedes and a Volvo, has several houses, innumerable children and seventeen wives, as our driver Alban pointed out to us, not without a trace of envy. In front of his property in his home village of Doutou stands a larger-than-life-size statue of the Grand Master himself.

Sossa Guédéhoungué was equally impressive in person. He must have been over sixty years old, yet radiated strength. He knew how to combine cordiality with patriarchal authority, and seemed to me a man to whom people would naturally turn for advice and support when in trouble. He invited us to accompany him to the Gligbangbé ceremony. Two white bullocks were going to be sacrificed – as protection against evil spirits and also in order to strengthen still further the close contact that the Grand Commandeur enjoyed with many voodoo gods.

Wearing a plain white robe and a white cap, Guédéhoungué took his place in a sumptuous raised chair. He was surrounded by a number of his very many sons, and about twenty white-clad women squatted at his feet – not his wives but initiates from the village. Two large groups of musicians beat drums and bells or shook calabashes trimmed with glass beads. A choir sang, women danced, it was impressive.

The Grand Master had an assistant carry out the sacrifice of the bullocks, and the same assistant took a bowl filled with blood to the nearby "sacred grove" to feed the numerous fetishes kept there. Finally, Guédéhoungué walked over some white sheets spread on the ground to the altar. The fetishes were scarcely recognizable as such: constant streams of sacrificial millet gruel and animal blood had transformed them over the years into amorphous lumps. Now they shone blood-red. Once again, the overpowering smell of death and decomposition. Guédéhoungué sprinkled gin, and the ceremony was over.

Outside the temple the initiates sang: "Voodoo does good for man." At least the Voodoo Grand Master did, for every participant in the ceremony was handsomely paid – in cash. Sossa Guédéhoungué was in a good mood. Now he was even protected against bullets, he said. He invited me to put this to the test and shoot at him. I had no pistol on me: did the Grand Master really think that I would have carried out this voodoo test if I had had one?

FOLLOWING PAGES: Members of the Zangbeto secret society in a village at Grand Popo. The Zangbetos are known as "dancing haystacks" on account of their all-over masks of straw. Their traditional role is that of "voodoo police".

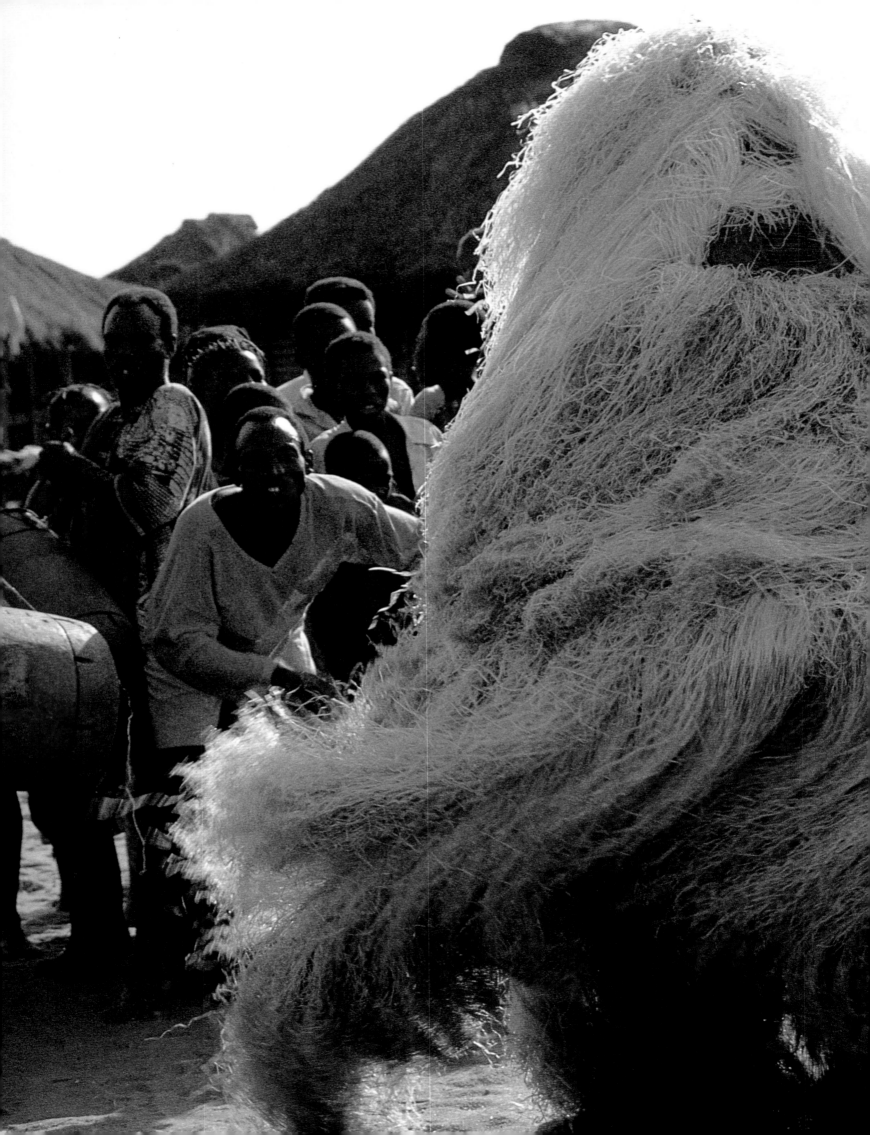

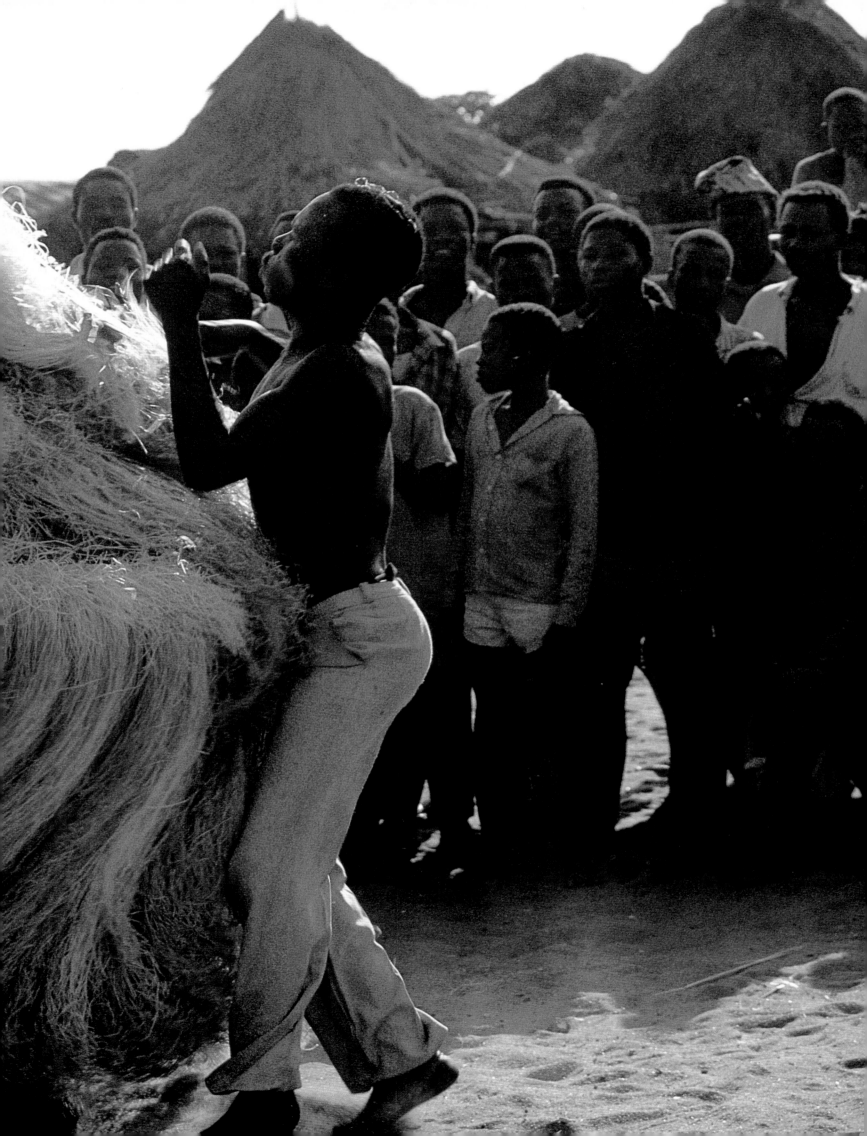

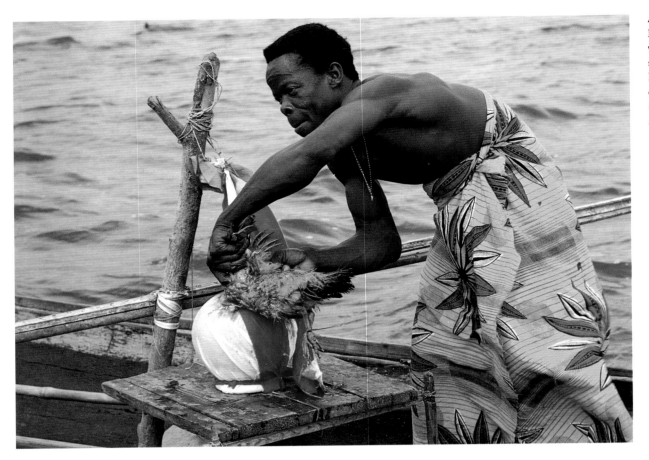

On an earlier visit to Benin, Henning Christoph had photographed a voodoo cult, Kokou, that transforms its adepts into true supermen. It is practised among the Tofinu, a fishing tribe of about 45,000 that live in pile-dwellings on the dirty, brackish waters of Lake Nokoué, the large lagoon that lies between Cotonou and Porto Novo.

In many ways Kokou resembles Djagli voodoo. Like Gligbangbé, these are cults of ancient war gods and embody the fighting principle, their rituals symbolizing the fighting strength of voodoo. In Kokou voodoo blood flows copiously, this time human blood. When its practitioners, exclusively men, have fallen into deep trance and danced ecstatically for hours, constantly smearing themselves with the yellow *djassi* paste of ground maize and palm-oil, they take to their knives.

Here the spectator needs strong nerves. The men slash themselves in the upper arm and draw blades over their own often densely scarred chests. They ram their heads against stone fetishes, not stopping when blood flows. Evidently they feel no pain, thanks to the strength of the god Kokou, which has flowed into their bodies and now gives them the capability of tracking down evil spirits wherever they might be concealed.

Father René Grosseau has been with the Tofinu as a Catholic missionary for many years. His station is located in the middle of a pile settlement. Through the cracks in the floorboards stagnant water can be smelled, seen and heard. When the drums of Kokou sound at night, Father Grosseau pours himself a double whisky. He knows that missionary zeal alone is not enough to save a single soul from the clutches of Kokou.

So he runs a small hospital, and has sunk several wells, so that the Tofinu need no longer drink infected water. Seven thousand Tofinu have become *katoliki*, he told us. "Most would probably like to overcome the fear through which voodoo rules their lives," he supposes. Evidently he himself is not completely proof against this fear.

Were Father Grosseau to campaign openly against voodoo, he probably wouldn't receive much help or backing from the Catholic

FOLLOWING PAGES:
Members of the Church of the Celestial Christians, founded by an African, row past pile-dwellings of the Tofinu, singing hymns against voodoo, which they regard as a satanic and idolatrous cult.

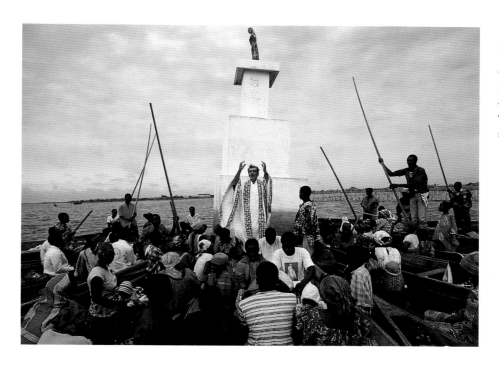

On Lake Nokoué, Father René Grosseau celebrates mass beneath a statue of the Virgin Mary. For many years he has tried to restrain voodoo influence among the Tofinu, with moderate success.

Church of Benin. About 20 percent of Benin's population is Catholic, including almost the entire political and intellectual élite. The Catholic Church has cultivated friendly coexistence with the voodoo cults for a number of years. Writers like the theologian Jacob Agossou and the sociology professor Honorat Aguessy stress that, despite all cultural differences, Catholics and voodooists pray to the same single God. In Benin even Islam, which through its aggressive conversion campaigns has become an all-powerful religion in many West African states, remains well in the background. Twelve percent of the population, mostly in the north, is Muslim. Fanatical Muslims have been known to burn down a voodoo temple, but so far such incidents have remained the exception.

83

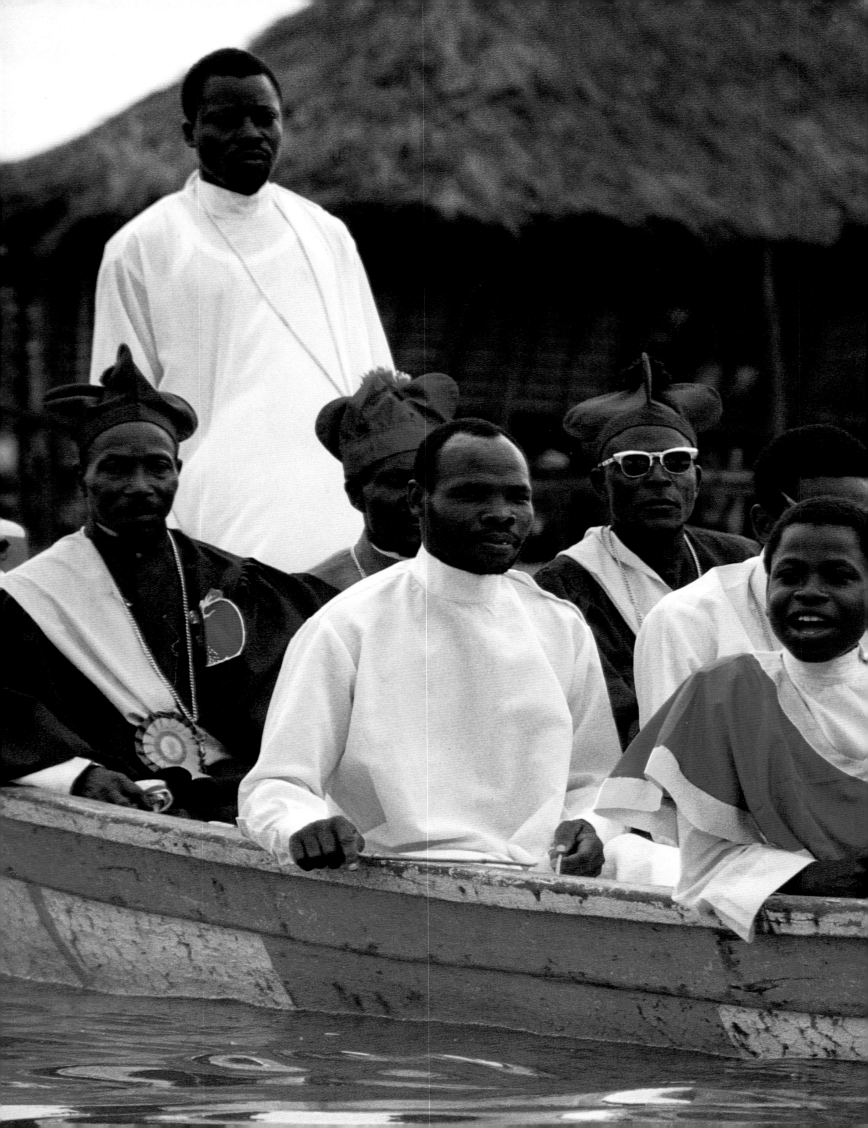

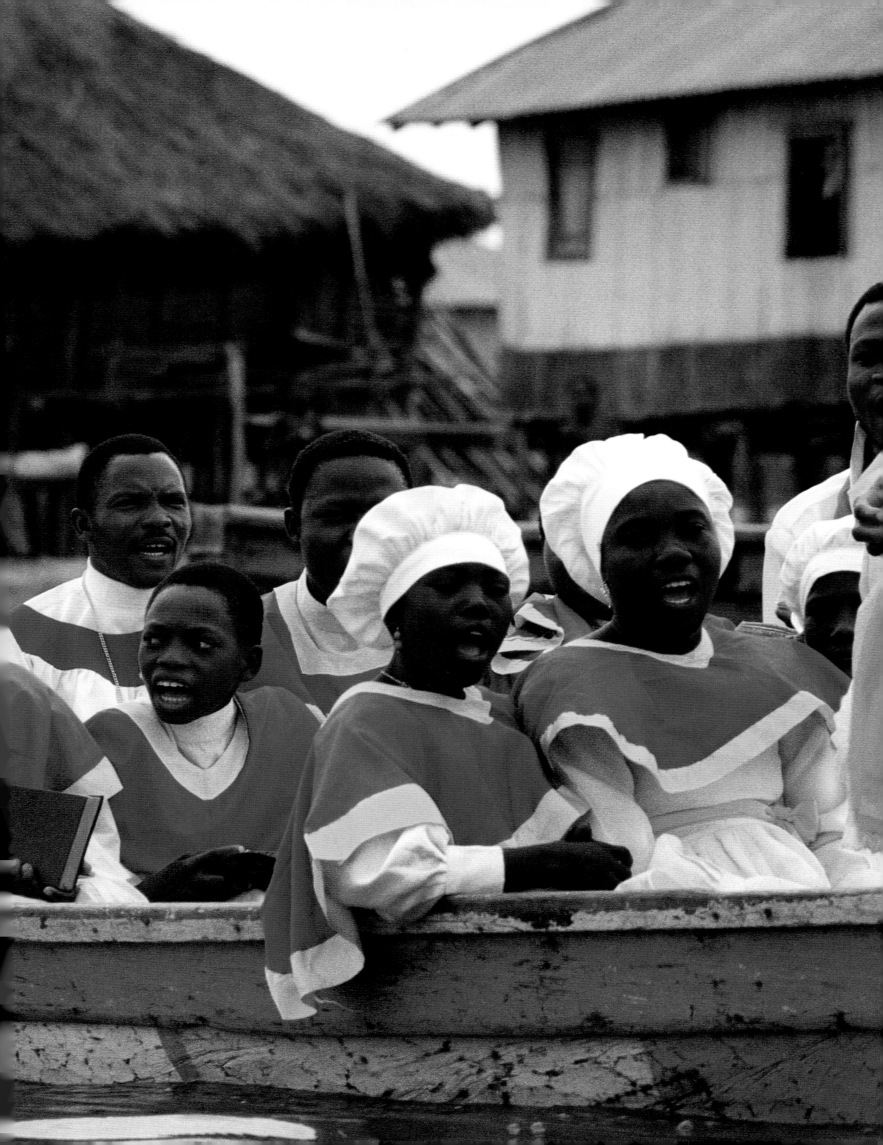

The voodoo community wishes no confrontation with other religions either, maintains the "Grand Commandeur". After a New Year meeting with Pope John Paul II in 1993, Sossa Guédéhoungué told the Holy Father that he, the Pope, was a man of great magical power, one of the most powerful *azeto*, sorcerer-healers, that he had ever met. Sossa Guédéhoungué has no worries about competition between religions. He knows there are many "fifty-fifties" among Christians and Muslims. "During the day they're Christians or Muslims. But at night they go to the voodoo priests."

In Benin voodoo is not only a religious and cultural force but a political one as well. Mathieu Kérékou, who came to power after the military coup of 1972 and made Benin a "People's Republic", very soon had to admit that even Marx and Lenin couldn't drive the voodoo gods out of people's heads. Finally he even hired a holy man from Mali, reputedly a great sorcerer, as adviser and then made him chief of the feared secret police. The holy man Mohammed Cissé also had other African heads of state as clients: Eyadema (Togo), Mobutu (Zaire) and Omar Bongo (Gabon). Eventually the holy man was sent to prison for embezzling the state bank of Benin of an estimated equivalent of 7 million U.S. dollars.

In 1990 Kérékou was forced to resign, his régime finally brought down by the break-up of the Eastern bloc. He left Benin with a ruined economy and huge foreign debts. The democratically elected government of President Nicéphore Soglo set about economic re-organization and the building of democratic structures. The President and the intellectuals of the political debating circle Sillon Noir ("Black Furrow") wanted the voodoo cults and their leaders to take part in these processes.

The current political task in Benin is as difficult as it is desirable. Western democratic ideas, the separation of powers for example, are not easy to communicate in an African country stamped in a mould of traditional tribal structures. Sossa Guédéhoungué, at any rate, sees himself as a contributor to the political decision-making process on the highest level. Soglo was like a son to him, he told me. It was like one big family, with the older members helping the younger ones. No, he wasn't an official adviser. But he was giving the President regular advice.

"VOODOO is Devil's work. Give up the practices of Satan, or you are lost!" When slogans like these are heard in Benin, from a rattling loudspeaker fixed to a car, a man or a woman dressed in flowing white usually sits at the microphone. These are members of the "Celestial Christians", one of the numerous Christian sects that compete for souls in West Africa and especially in Benin.

Whereas Christian movements such as the Methodists, the Baptists and Jehovah's Witnesses were mostly imported to West Africa by white missionaries, it was an African who founded the "Church of the Celestial Christians" in Benin. The "Prophet" Samuel Oshoffa, carpenter and scholar, was directed to do so in 1947 in a heavenly vision.

The Prophet was able to win few followers before he died in 1985, in a car accident. Since that time, however, the number of Celestial Christians has swollen to well over ten million in Ghana,

FOLLOWING PAGES:
The Celestial Christians submit to a strict hierarchy, which is reflected in their costume. Blue sashes denote "visionaries", community members who receive revelations and prophecies directly from God.

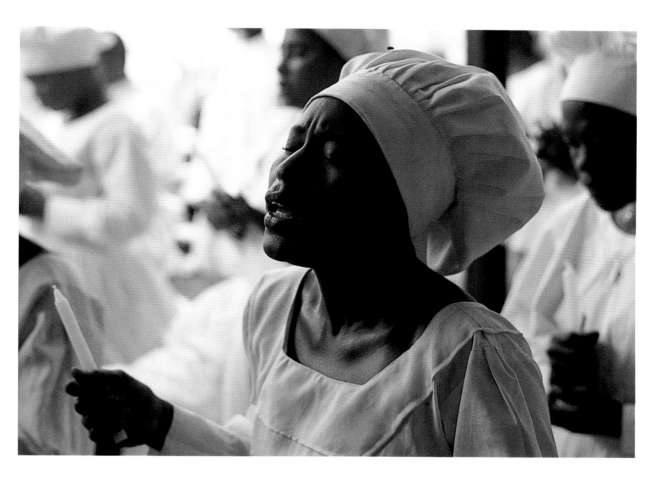

With fervour a young member of the Celestial Christians entreats the blessing of Jesus. More than ten million West Africans belong to the church founded by "the Prophet Oshoffa" in 1947.

Togo, Benin and Nigeria. Their church sees its main task as the struggle against evil in the world; and that means especially the struggle against voodoo.

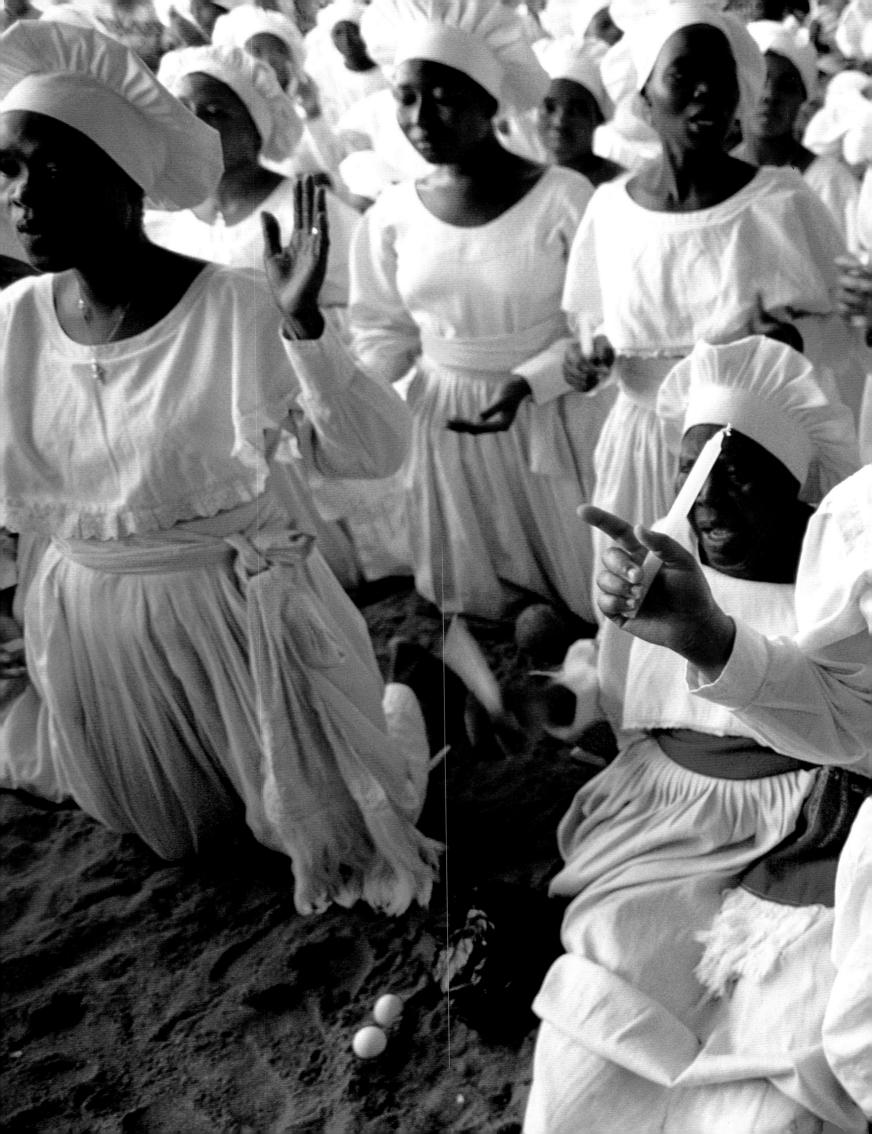

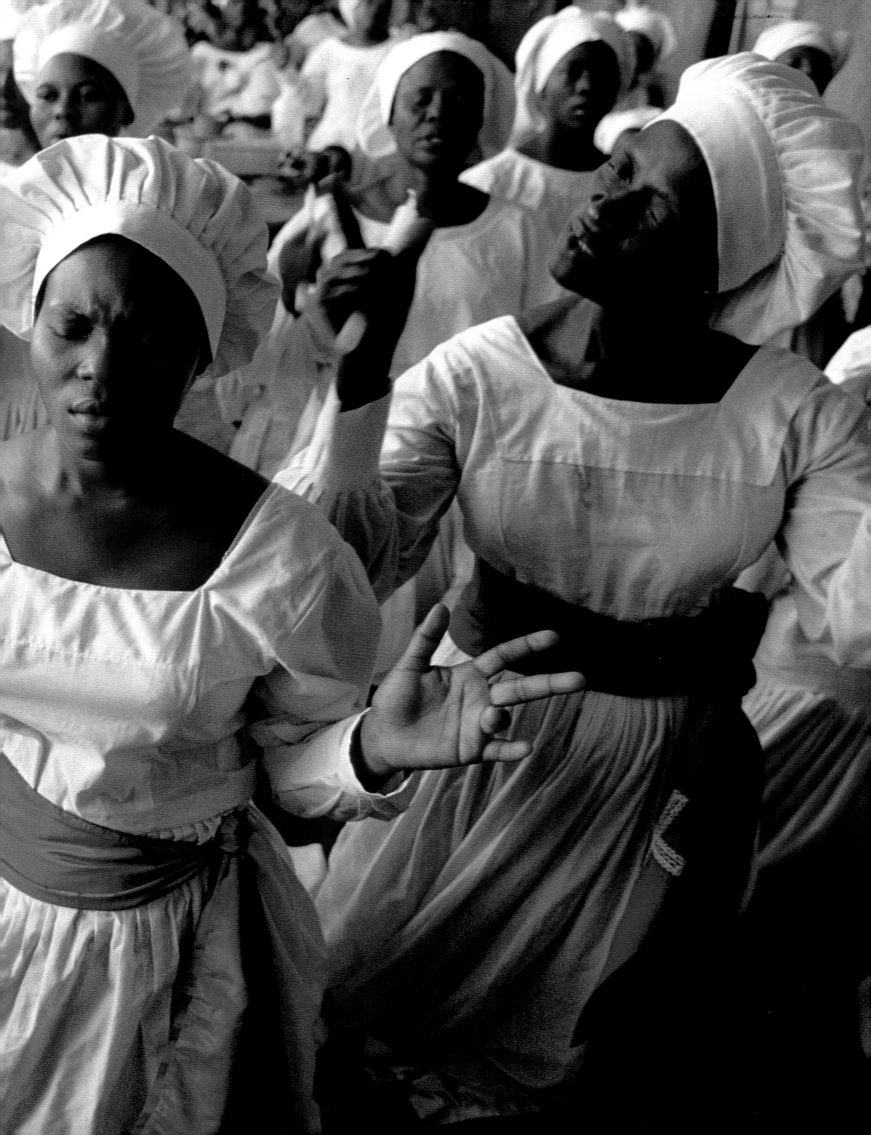

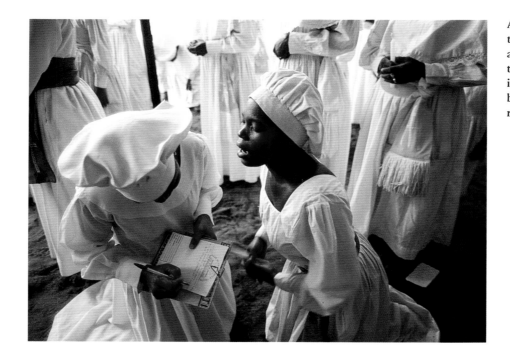

A young woman falls into trance during holy service and begins to speak in tongues. Each of her words is carefully noted down, being regarded as divine revelation.

Arriving at the Celestial Christians' centre in the Sikekodji quarter of Cotonou, we saw an ugly grey concrete building more like a ware-house than a church. Above the sandy courtyard rose a vaulted corru-gated-iron roof; in a recess stood statues of Christ and the Virgin Mary at an altar decorated with artificial flowers.

Although midday mass was not due to begin for three hours, the church and courtyard were already filled to overflowing with white-clad men and women wearing headgear resembling chefs' hats. Many of the Celestial Christians wore a yellow or white sash round the waist, others wore blue. The hierarchy of the church and the allocation of duties within it were precisely laid down, Senior Evangelist Eugene Amoussou explained to us, giving us a brochure containing numerous chapters.

Everything indeed seemed to be laid down – by divine revelation. "Evangelists" are responsible for baptism and Holy Communion; "leaders" preach the church sermons; "visionaries" are responsible for prophecies. There is a list of twelve "Commandments", which among other things strictly prohibit the use of coloured candles in the Church of the Celestial Christians, as also the consumption of alcohol, tobacco and pork.

Also prohibited are participation in idolatrous cults and black magic, adultery, and the wearing of black or red clothes (except for occupational purposes); when members of the church wear a soutane they must go barefoot; men must not sit next to women in church; women must not go to church during menstruation; women are barred from any church office that would place them in a situation where they had to preach a sermon ...

Growing impatient, I laid the brochure aside. In any case, my attention was claimed by the mass now beginning. About a hundred Celestial Christians, mostly women and children, had crowded onto the benches in the courtyard. Young Assistant Evangelists swung huge censers or sprinkled holy water that they had run from a tap into plastic pails. The congregation began to sing a hymn with thoroughly European-sounding melody and rhythm. Prayers and further hymns followed – and then sudden commotion: several women with blue sashes began yelling.

They breathed in gasps: "Jesus, Jesus, Jesus." They groaned, convulsively jerked their whole bodies, stretched their arms into the air. They had fallen into trance and were now beginning to speak in tongues, mostly in mumbled sounds, but occasionally words and isolated phrases came through: "I can see a light ... JESUS! ... The Grace of God!" Assistant Evangelists hurried up and noted down the words they heard.

At last the mass ended with the Lord's Prayer. I couldn't help feeling that the setting was strikingly familiar, déja vu in fact. Celestial Christians dressed in white, voodooists dressed in white. In both settings there were taboos ruling even trivial details, trances in which divine visions were seen. While most of the congregation, happily chatting, pressed towards the exit, I looked round the church building.

Above the altar on the east side hung a large cross made of neon tubes; the interior was otherwise wholly lacking in decoration. On the ground a young man lay sleeping, covered by a white cloth embroidered with three blue crosses. Placed next to his head and at his feet were a bottle of water, some honey, two coconuts and two oranges, and a candle.

The young man was a student who had been bewitched, I was told in a whisper by a Celestial Christian appearing at my side, whose sash marked him as an Assistant Leader. Bewitched? "Yes, and just before his final examinations. It's obviously a jealous fellow student who has done it. Now he can't concentrate on his work." But the devilish voodoo magic had been broken, added the Assistant Leader, with God's help and "through our prayers". When the student awoke from his healing sleep he was to eat the food, which had been consecrated beforehand, and then he would be protected against all witchcraft in future.

FOLLOWING PAGES:
The activities of the Celestial Christians at their centre in the Sikekodji district of Cotonou include caring for the sick. This young student has been placed under a curse by a jealous fellow student. The Celestial Christians have promised to cure him, through the power of their prayers.

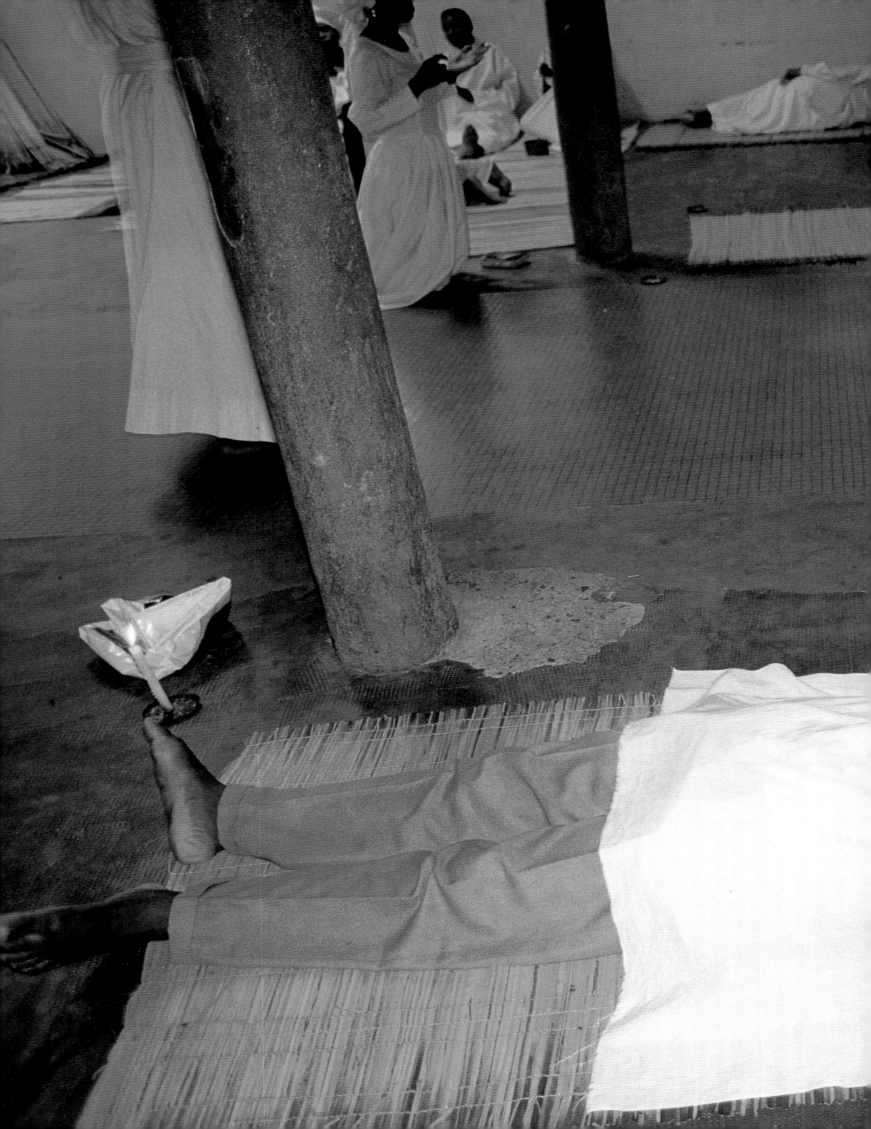

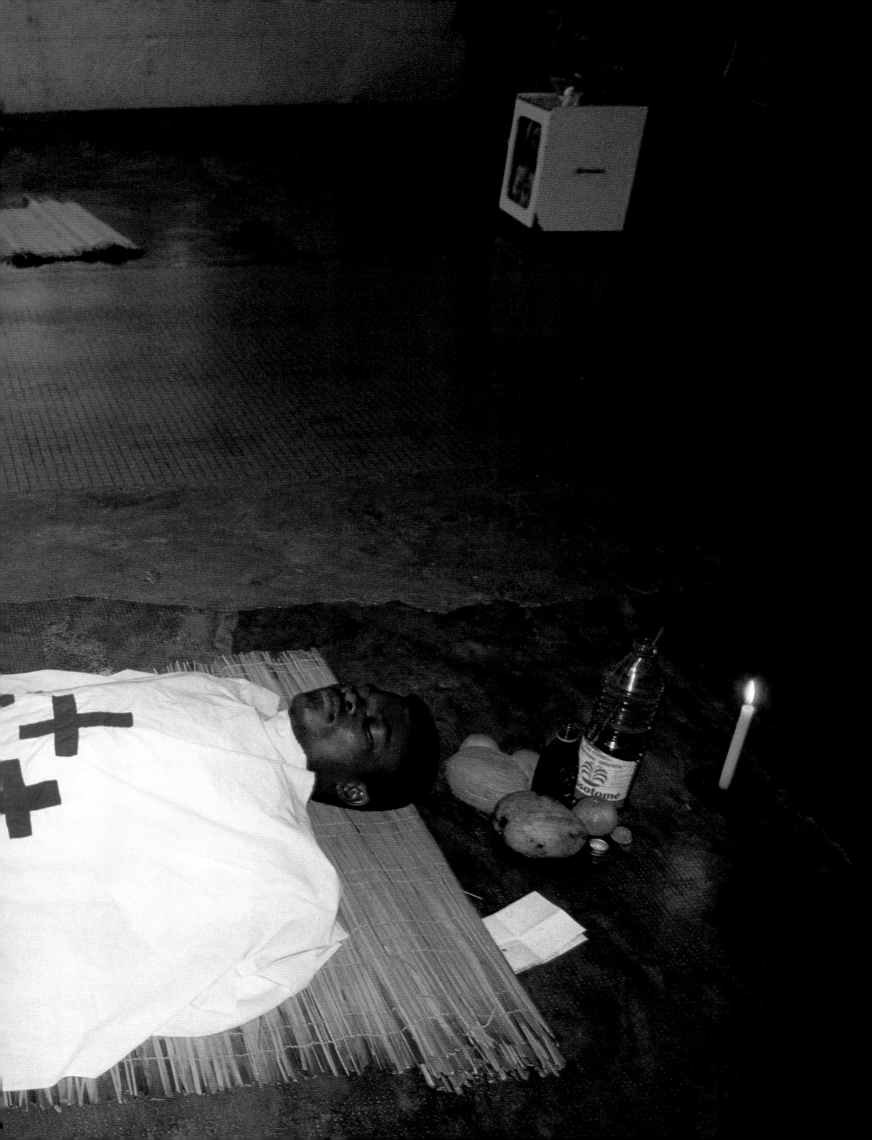

The Celestial Christians use no pharmacy in their healing. All they employ besides prayer is holy water. Nothing more is necessary, the Assistant Leader told us, since people fall ill ultimately through the forces of Satan, which are driven out in the healing ceremonies. Patients are perfectly free, however, to consult a doctor or take medicine as well if they so wish.

Not far from the student a woman lay on the ground, huddled in foetal position. She had been suffering from a lower abdomen disorder and hadn't been able to have children, we gathered from the Assistant Leader while ten members of the congregation walked round the patient in a circle. They began to sing a hymn. Thanks to God's help the woman would soon become pregnant, said the Assistant Leader; this a visionary had learned from God.

The word "vision" made me think of the fat Mami Wata priestess in Hountohué; and I also remembered the offer Senior Evangelist Amoussou had made me – would I like to receive a personal prophecy? Of course, answered the Assistant Leader, I only had to buy a white candle for 50 African francs – a fraction of a U.S. dollar. Soon I was sitting in a bare room surrounded by three women visionaries, their superior, who bore the title of "Wolijah", and his assistant. The candle was lit, and after a short prayer we all knelt.

The visionaries fell into trance – so suddenly that I hardly even noticed. Again unintelligible sounds poured from their mouths, accompanied by convulsive movements. But the trances were over just as quickly as they had begun. And then the visionaries began their prophecies.

I was shocked. These people, who had never seen me before, who knew no more about me than my first name, told me things that they could never have guessed. Some of their statements, it is true, were on a very general level. I should avoid nicotine and alcohol, which would make me ill. But I might quite well have been a non-smoker and non-drinker.

The detailed knowledge these visionaries had of my family and personal circumstances was extremely unsettling. They warned me, for example, against lending money to someone called Thomas – which I had unfortunately done some weeks previously. The Wolijah constantly encouraged me to ask for any further explanation and information I wanted. This I did once, and immediately regretted it. The answer was specific and unpleasant.

Numbed, I listened to the Wolijah explain that mishaps I had experienced were due to the power of evil. Whatever was God's will would come about in the future, and nothing could be done about that. But Satan could probably be driven away – and he still had a lot of mischief and disaster in store for me. I pricked up my ears: so there was some hope?

Soon afterwards I found myself in Dantokpa Market once more. As quickly as I could in the crowd, I bought two bags of sugar, three bags of sweets, two packets of biscuits, one metre of white cloth and a bunch of artificial flowers. I returned to the Celestial Christians, and to a purification and sacrificial ceremony that would have reminded me of voodoo if I had not had something else on my mind.

Three candles were lit. I had to kneel before the Wolijah and three more Celestial Christians, and I was bound by thin palm-leaves. A prayer was said, the Celestial Christians called loudly upon Jesus and the Archangel Michael – and suddenly released my bonds. The Wolijah promised that he would later wind them round the candles and throw the lot into the river: the Devil's power would then be broken. Next I had to wash all over in consecrated tap-water using ordinary bath-soap, and dry myself with the white cloth. In this way all misfortune was removed from my person. The Wolijah prayed for my good luck in the future.

The sweets were shaken out onto a tray, about twenty children formed a circle, and I knelt to make the sacrificial gift. The aim was that the pure spirit of children would pass into me. And it did: the gaiety of the children was catching as they sang a song wishing me luck before falling on the tray.

In my hotel room that night I was once again sleepless. A thousand thoughts were making my head ache, but I withstood the temptation to put Monsieur Zorro's "thunderstone" to the test. In my own body I now felt fear – the "African disease" that voodoo priests themselves are said to help spread. It wasn't voodoo, however, that had brought on this fear – but, by its own account, its own "worst enemy".

"Our voodoo is strong, nobody can conquer us," the villagers of Akpihoué had sung during the Djagli ceremony. Indeed voodoo is strong – when its enemies themselves use the mechanisms that they profess to oppose. Gradually I felt more at ease. I remembered my conversation with Professor Jacob Agossou: God, Allah, Mawu-Lissa – aren't those three names for the same thing?

In the drawer of the bedside table I found a Bible. I placed it on the table. Then I lit a white candle that the Wolijah had given me. I felt for my *grisgris* – it was still there.

The voodoo world

Voodoo is a religion that is deeply rooted in African cultural tradi-
tions, on which it in turn has exercised a powerful influence. Accord-
ing to voodoo theological tradition, entirely orally based, Gbédoto,
the self-created divine first cause, perpetually re-creates itself by
means of Acé, the principle of creative energy. The many hundreds
of voodoo gods are descendants of Acé, but ultimately they are all
manifestations of the creation divinity Mawu-Lissa.

Voodoo is characteristically pragmatic. Gbédoto, Acé and even
Mawu-Lissa are abstract figures difficult to get the mind round, and
cannot readily be called upon for protection or help. Voodoo believ-
ers, "Children of God", therefore customarily address themselves to
personifications of the creation god, as it were to "ministers" of the
chief divinity. In the voodoo scheme these gods have individual re-
sponsibilities (Shango is the god of thunder, Gu the god of fire and
iron, and so on) and thoroughly human character traits.

Voodoo is not based on a dualism that divides the world into
rigid oppositions. Life and death, heaven and earth, mind and mat-
ter are not seen as mutually opposed. In the case of a sphere or a
calabash it is impossible to distinguish "above" from "below". The
voodoo way of thinking finds it just as impossible in the case of the
universe. That means that the gods and the spirits of ancestors have
a direct influence on human life, and equally that humans can com-
municate with both gods and the souls of the dead.

Such communication is effected in ceremonies and rituals, which
form the spiritual centre of the voodoo religion. A substantial part
in this is played by sacrifice, which is the expression of an attitude
that views the association of humans with gods as a process of
giving and taking. The gods give help and protection, in return for
which they can expect veneration and sacrificial gifts, among which
each divinity has his or her own individual preference – for example,
Mami Wata for perfume, Shango for bullocks and Dan for corn.

If human beings disappoint the gods, by ignoring their
commandments for example, then the gods punish them. The
converse is also true: should a voodoo god fail to deliver the help
that his or her followers expect, that god will be abandoned by
them. At worst, the god will fall into oblivion and his or her temples
into ruin. Voodoo believers would not think of this as giving up the
voodoo religion, for they will continue to venerate the composite

A young man dances to the
galvanizing rhythms of the
warrior god Kokou. Ritual
dance and sacrifice form
the spiritual centre of the
voodoo religion, providing
the occasion for human
beings to communicate with
the divine powers.

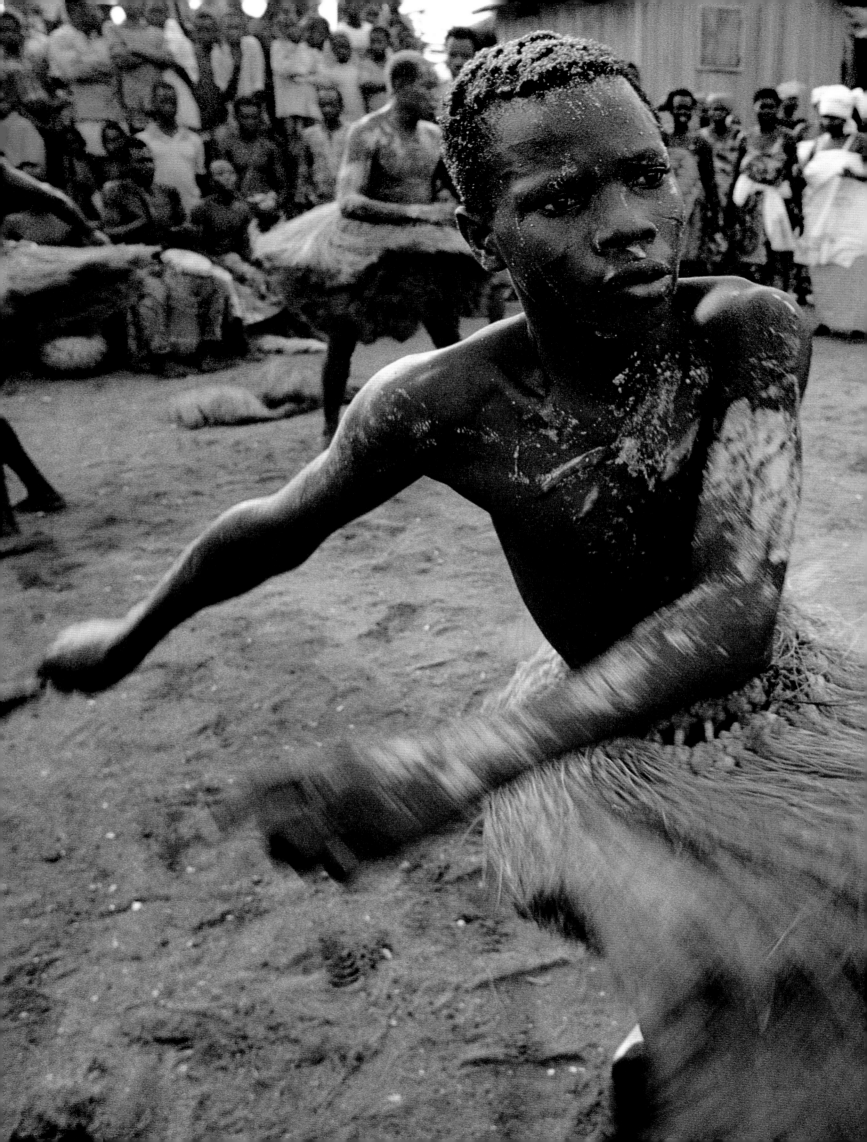

creation divinity Mawu-Lissa; it is just that one of the supreme divinity's "ministers" ceases to be followed.

Sacrificial gifts are presented directly over fetishes, the earthly dwelling-places of the gods, whose power is concentrated in them. Fetish-figures are often made of wood or clay, but may consist of other materials. The voodoo priest decides, usually after a period of trance, what form they will take, which is sometimes abstract.

During trance, gods or spirits of ancestors enter the bodies of possessed persons and speak through their mouths. When a priest provides a temple with cult objects or organizes a ceremony, he is therefore implementing divine inspiration. Not every priest receives the same divine inspiration, so that one and the same voodoo god may take a different form from one region or village to another, or be known by a different name or be venerated by different ritual.

Human beings can enter into direct contact with the voodoo gods only through the agency of a voodoo priest, a *hounon*, or voodoo initiates. Basically, anyone can become a voodoo initiate or even a priest, if it is the divine will; this may be ascertained by consulting the Fa oracle.

Before any action is taken on behalf of any cult, and also in order to determine whether someone is worthy of becoming a "Child of God", or even a priest, Fa, the god of fate, is consulted. Sometimes a *hounon* inherits a cult practice from his father or grandfather. No-one objects to this, as long as the Fa oracle is in agreement. Priests may also be appointed by the Fa oracle from the ranks of voodoo initiates: Daagbo Hounon Houna from Ouidah, now one of the most influential voodoo priests in Benin, is an example. Daagbo was a carpenter and a famous footballer before assuming religious office.

People often become voodoo initiates after receiving help from a priest or healer, perhaps after a serious illness. It used to be common for children to be apprenticed to priests, for to become an initiate enhances a person's social prestige. It still does, though today voodoo seminaries have difficulty finding adequate numbers of trainees.

Thirty years ago it took a novice fully three years of painstaking learning to be initiated into the songs, dances and other rituals of voodoo cults. For trainees isolated from the outside world in voodoo seminaries and for their families, this was a hard time, both emotionally and financially: not only did voodoo novices drop out of the workforce at home, but the equivalent of average annual earnings had to be paid to the seminary as well.

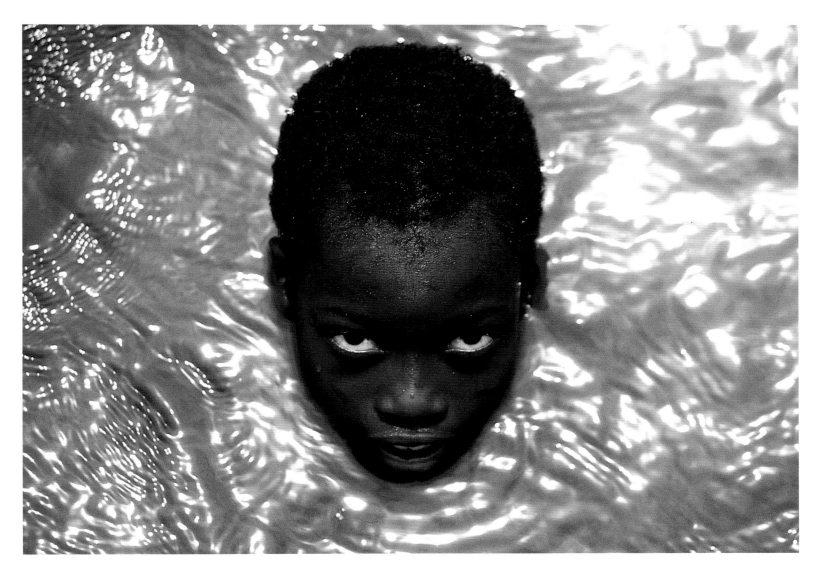

With rapturous gaze, a
young girl adept of the
water goddess Mami Wata
looks into the photogra-
pher's camera during a
bath. Many voodoo initiates
are women and young girls,
men being in a minority
both in this and many other
cults.

In recent years, however, the initiation period has been reduced
to seven months at most, and it is above all women, schoolgirls and
very young girls who join the "Children of God". The number of
voodoo initiates in Benin today stands at around 750,000. The influ-
ence of voodoo extends well beyond this circle: in health organiza-
tions, trade unions, political parties and sports associations, voodoo
is a social and political force.

Even active practitioners of Christianity or Islam regularly call on
the services of voodoo priests or healers. Such people are called
"fifty-fifties" in Benin – Christians or Muslims by day and voodoo-
ists by night.

Visitors from the realm of the dead

EGUNGUN

The voodoo believer sees no sharp distinction between life and death, between heaven and earth. If a person dies in a traffic accident, a voodoo priest will hold a ceremony to "gather up" the victim's soul and show it the way to Kutome, the realm of the dead. Otherwise that soul would find no rest, but haunt the night with terrible cries; and at the place of death further accidents would constantly occur. There is, however, one way back to earth from Kutome – in the shape of *egungun*, the Yoruba word for the souls of dead ancestors, which leave the realm of the dead for a certain time in order to protect the living or give them advice.

Dead ancestors may also serve as messengers between the human world and the bisexual creation divinity Mawu-Lissa. As such they are venerated in special ceremonies in which spirits of ancestors enter the bodies of dancers wearing richly coloured and sumptuously decorated head-to-foot masks. *Egungun* initiates are organized in a secret society, and no-one except its own members may enter an *egungun* temple or so much as touch one of the masks.

An *egungun* ceremony usually lasts for a whole month. Its end is marked by a public spectacle, at which female spectators are not wanted. The masqueraders assemble on the market square of a village or town quarter and begin a whirling dance. In an unusually high or low voice they sing songs in Yoruba and give advice to on-lookers over such matters as inheritance disputes. Since the masqueraders actually become voodoo gods for the duration of their trance, their advice or judgement is binding on those to whom it is given, and failure to observe it can result in punishment, which is executed by the *egungun* masqueraders themselves.

The masks worn for the *egungun* ceremony evoke beings from another world as they move through the Zongo quarter of Benin's capital, Porto Novo. The wearers of these robes, richly ornamented with shells and spangles, embody the spirits of primal ancestors who have come from the realm of the dead, Kutome, to help and advise their present-day descendants.

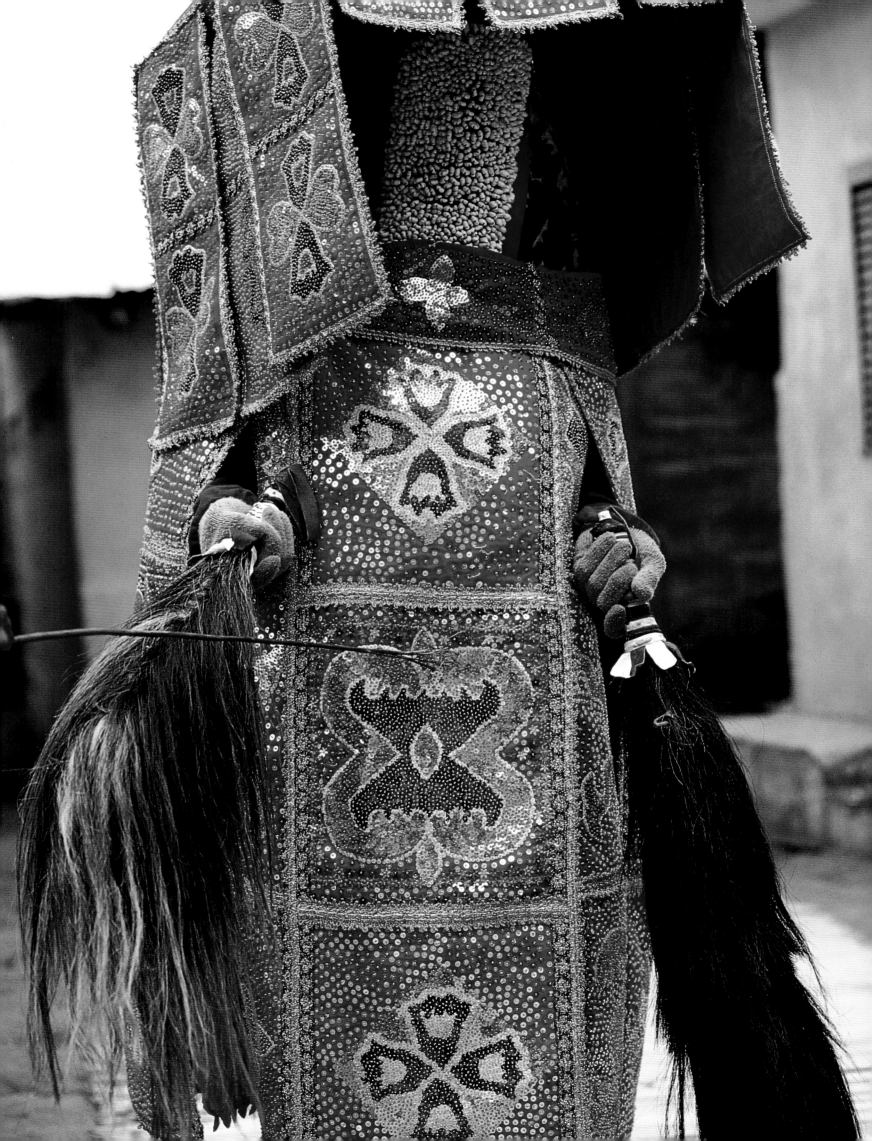

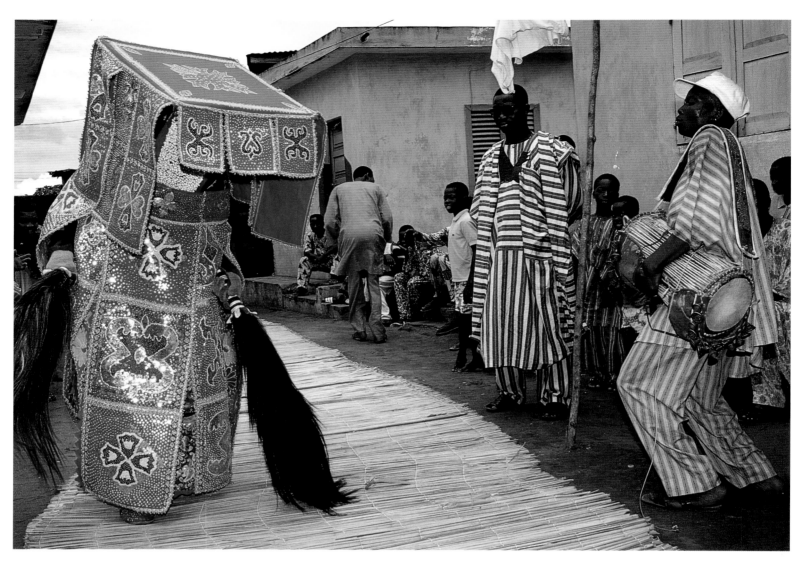

Spurred on by the rhythm of
the drums, an *egungun*
begins to dance. To protect
his precious robes from dirt,
mats are spread on the
ground in advance of the
ceremony. As insignia of his
status, this ancestor carries
long horsetail whisks.

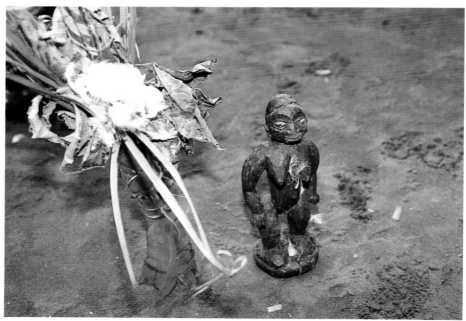

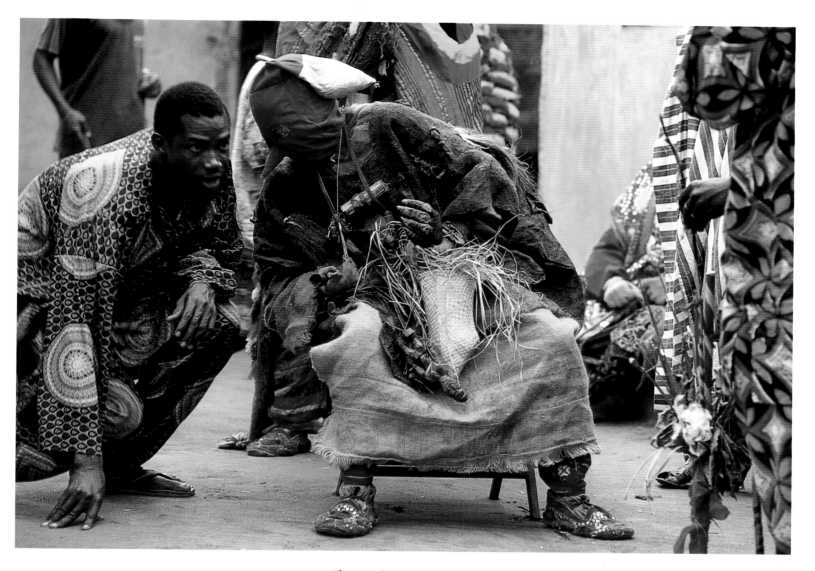

The most important figure
at an *egungun* ceremony is
the *juju* man. Instead of
gorgeously coloured cere-
monial robes he wears a red
mask, reminiscent of a
hangman's headdress, and
coarse sacking; only his
shoes are ornamented with
bangles. The *juju* man is a
magician; his appearances
are rare. Strung round his
neck is a bag containing
numerous fetish objects,
among them a small figure
stained red from countless

blood sacrifices (LEFT,
BELOW). A key utensil is a
severed gorilla's paw –
expressing the magician's
great power and his poten-
tial for doing good. At the
same time the *juju* man car-
ries objects intended to show
that he has equal power to
bring about evil. He super-
vises the ceremony from a
chair, occasionally giving
instructions to his assistant
(SEE ALSO FOLLOWING
PAGE).

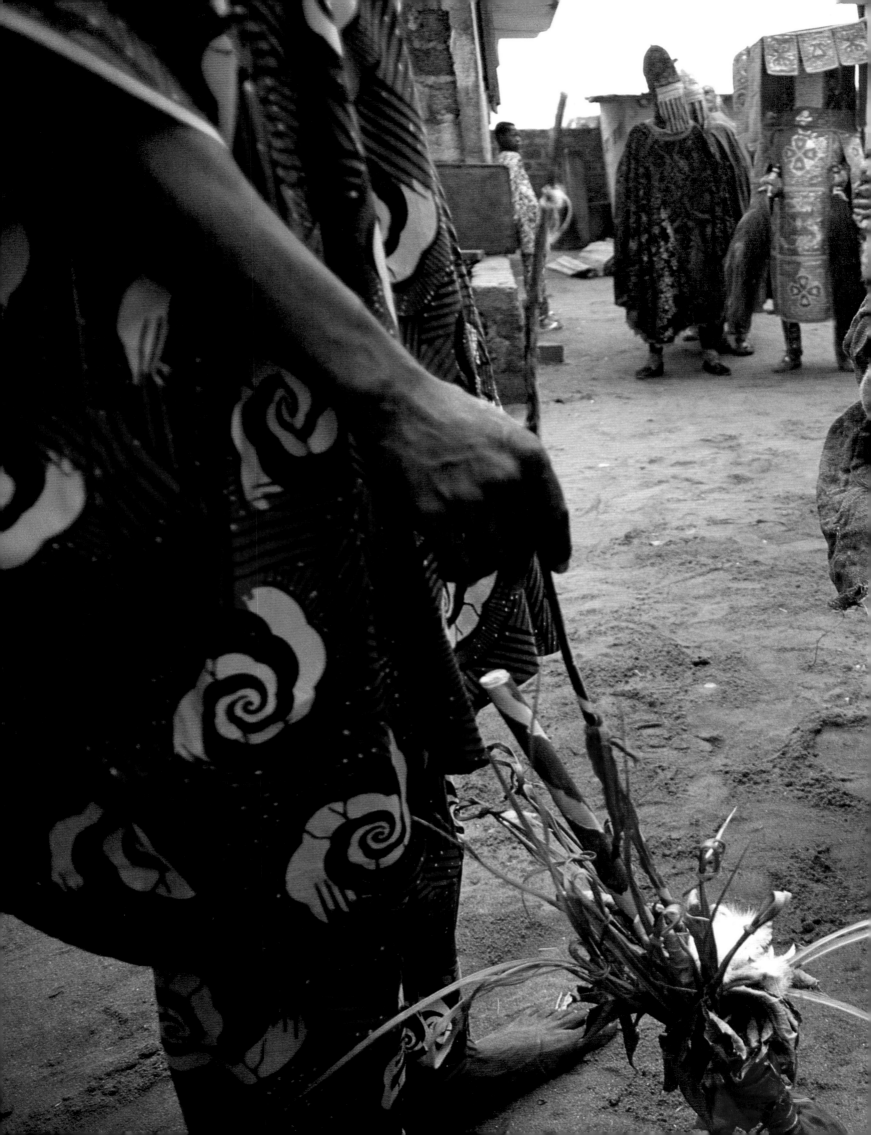

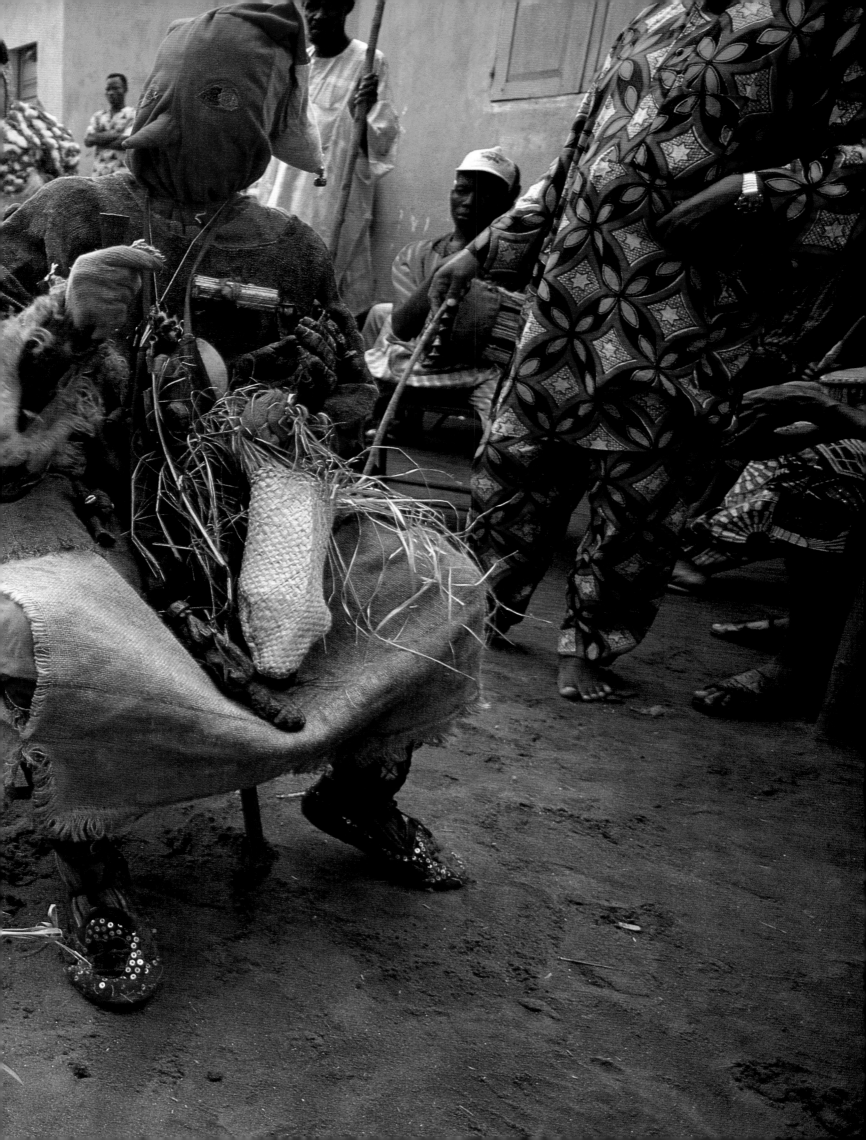

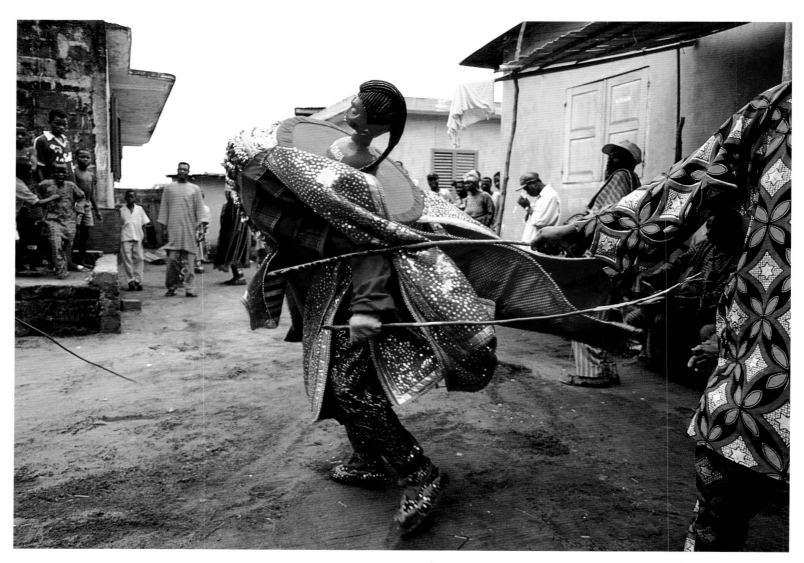

The dance of the *egungun* becomes more and more ecstatic. This mask embodies Eshu o dara, the Yoruba name for the gods' messenger Legba. A woman's head symbolizes the problematic disposition of the god; the colour red indicates that it is dangerous to anger Legba. An *egungun* communicates a message from the other world to an onlooker (RIGHT). The *juju* man plays his part too; his assistant holds out the magician's fetish staff (FAR RIGHT).

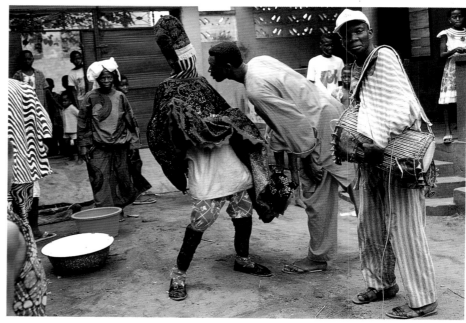

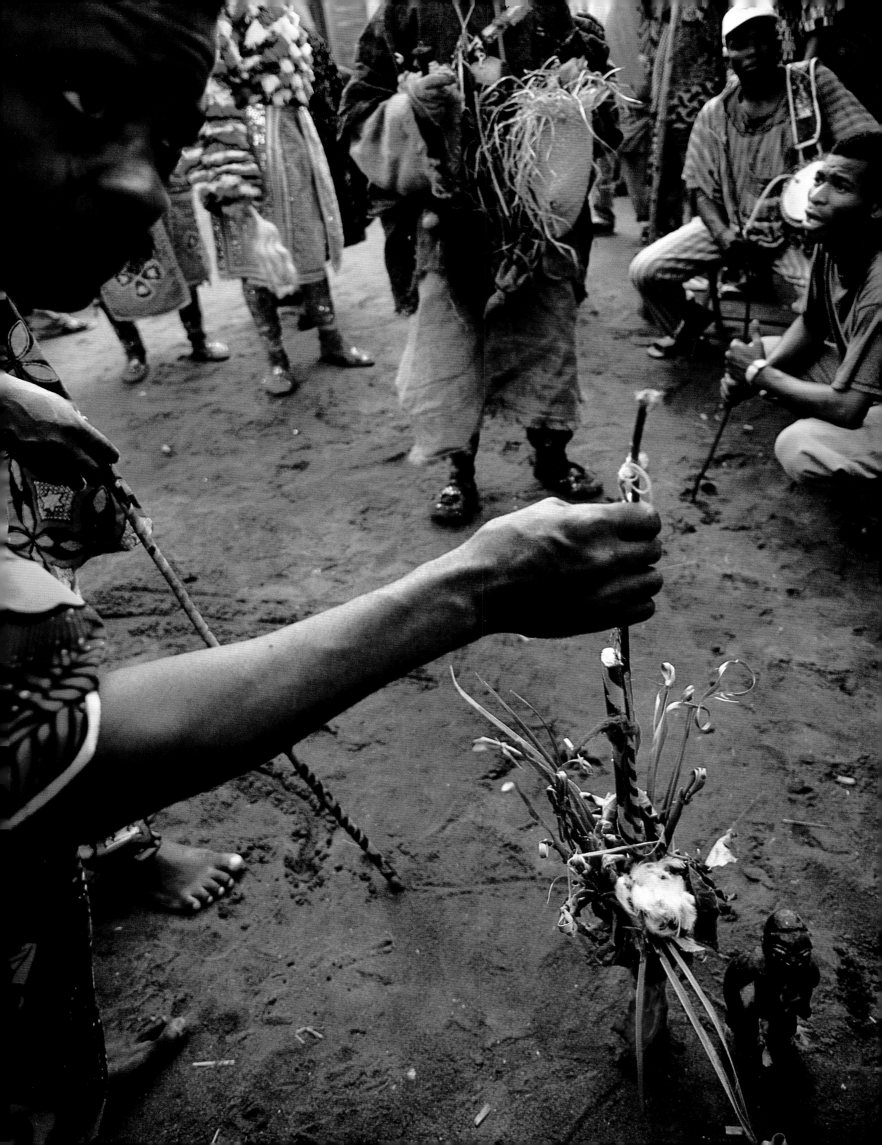

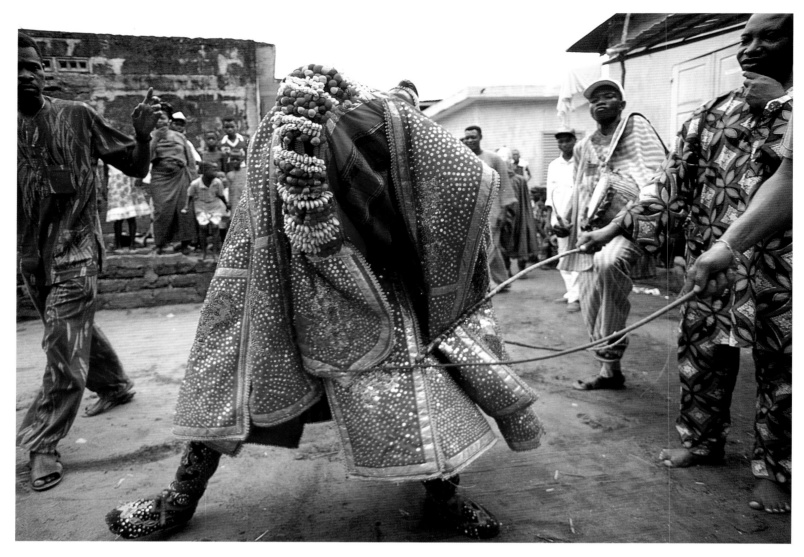

Assistants called *balé* hold back the *egungun* robes with thin canes. Touching the clothes of ancestors is prohibited. The Egungun Society warns that physical contact with the other world can result in death for the uninitiated. The *balé* also collect the money demanded by the *egungun* for their advice. Anyone who fails to pay enough can expect a good kick.

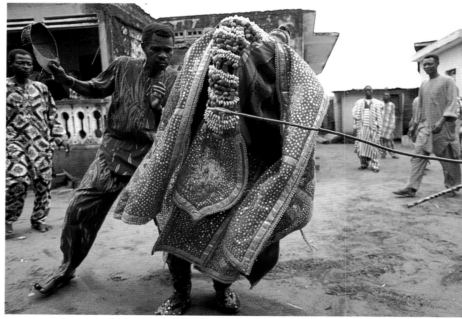

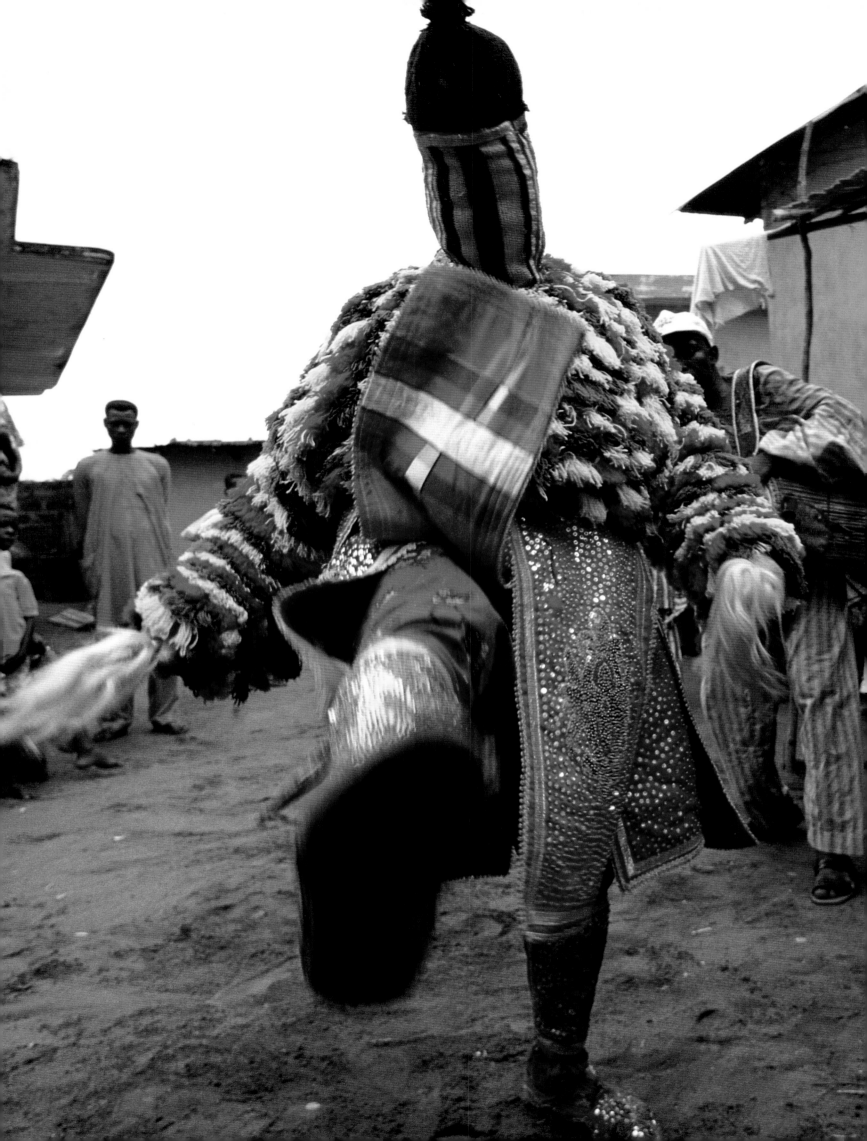

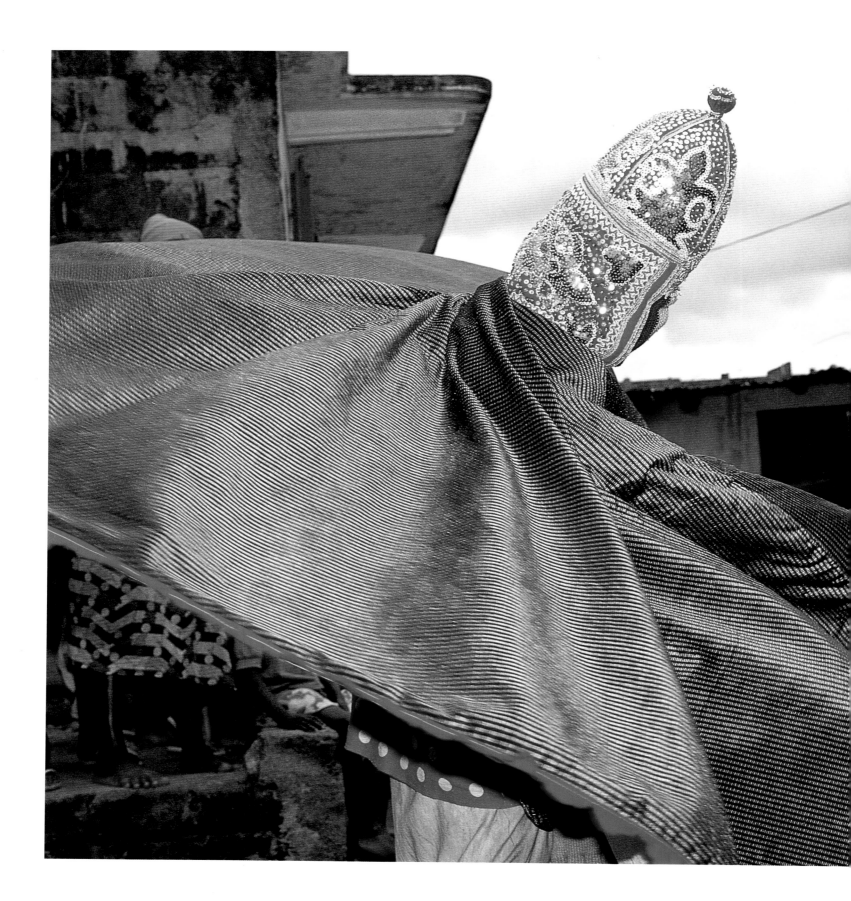

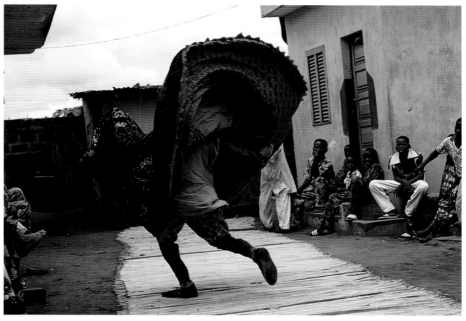

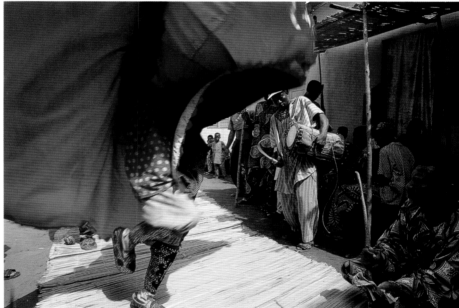

When the *egungun*'s robes fly high in whirling dance, onlookers glimpse the flesh-and-blood man hidden beneath the precious costume-masks that are passed on from generation to generation.

FOLLOWING PAGES:
From the mouths of masqueraders gods and spirits speak. When an *egungun* draws one of the onlookers towards him with his scimitar, interrogates him and admonishes him, this is taken as a serious warning from the beyond.

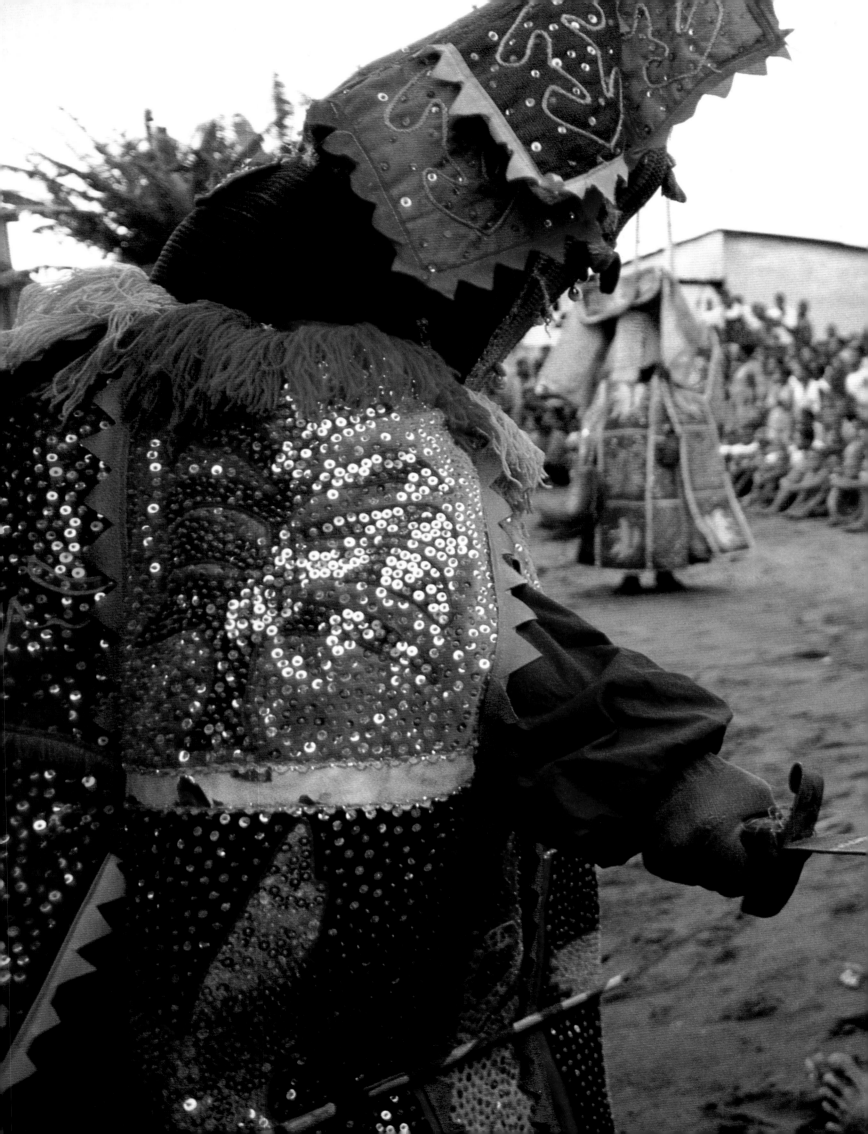

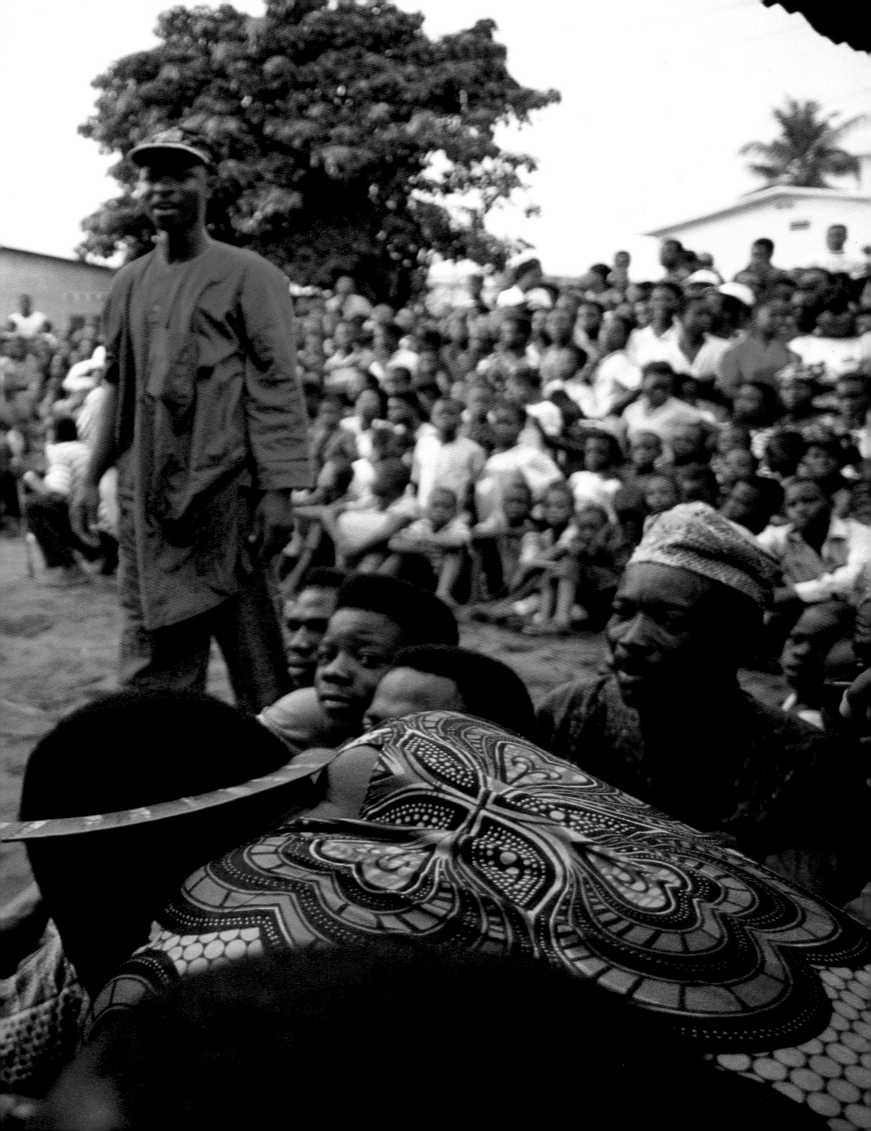

The magic power of the ancient warrior god

K O K O U

Scarcely any other voodoo ritual makes such an alien and alarming impression on outsiders as does the ceremony in veneration of the ancient warrior god Kokou. Besides the power of the god, it also expresses the destructive effect of all power, and the warrior's self-denial that is necessary for fighting. Whereas violence and the shedding of blood are only symbolically indicated in Djagli ritual, both elements are found literally in the Kokou cult.

Initiates dance in deep trance for as long as the aggressive rhythm of the drums drives them on, and this can last for a whole day. As in the Djagli ritual, Kokou initiates use *djassi* paste as a ritual strengthening elixir, and they also wear a skirt made of raffia or straw.

In contrast to the Djagli ceremony, certain parts of the Kokou ritual are performed by men only. For Kokou is not only an excellent warrior, but also extremely violent, as are the dancers possessed by him who, in order to demonstrate their voodoo strength, cut themselves in the arms and chest with glass splinters and knives or beat their heads against stones until blood flows. In these actions they do not seem to feel pain.

Whereas Kokou ritual formerly gave the warrior protection or even invulnerability in battle, its main purpose today is defence against witchcraft. Kokou gives the dancers, during trance, the capability of tracking down evil spirits or sorcerers wherever they may have concealed themselves, in an anthill, say, or a village hut.

Woe betide any spectator who fails to pay the Kokou ritual proper respect. Then the Kokou priest, it is said, uses his magic power to force that sacrilegious person to enter the temple, where he places a sacred calabash on his or her head. As punishment the hounon can make the vessel become very heavy, but he will lessen the weight as soon as the sinner has repented. Anyone who does wrong, they say, has every reason to fear Kokou, "for his power is infinite".

In a village on Lake Nakoué, young women wearing initiates' necklaces rub *djassi* into their faces and bodies. This paste made of palm-oil, maize flour and other ingredients fortifies them for the strenuous ritual to come.

FOLLOWING PAGES: Voodoo initiates help one of their number who has fallen through a garden trellis while in trance. Since initiates learn how to behave in trance, any serious injuries are rare.

114

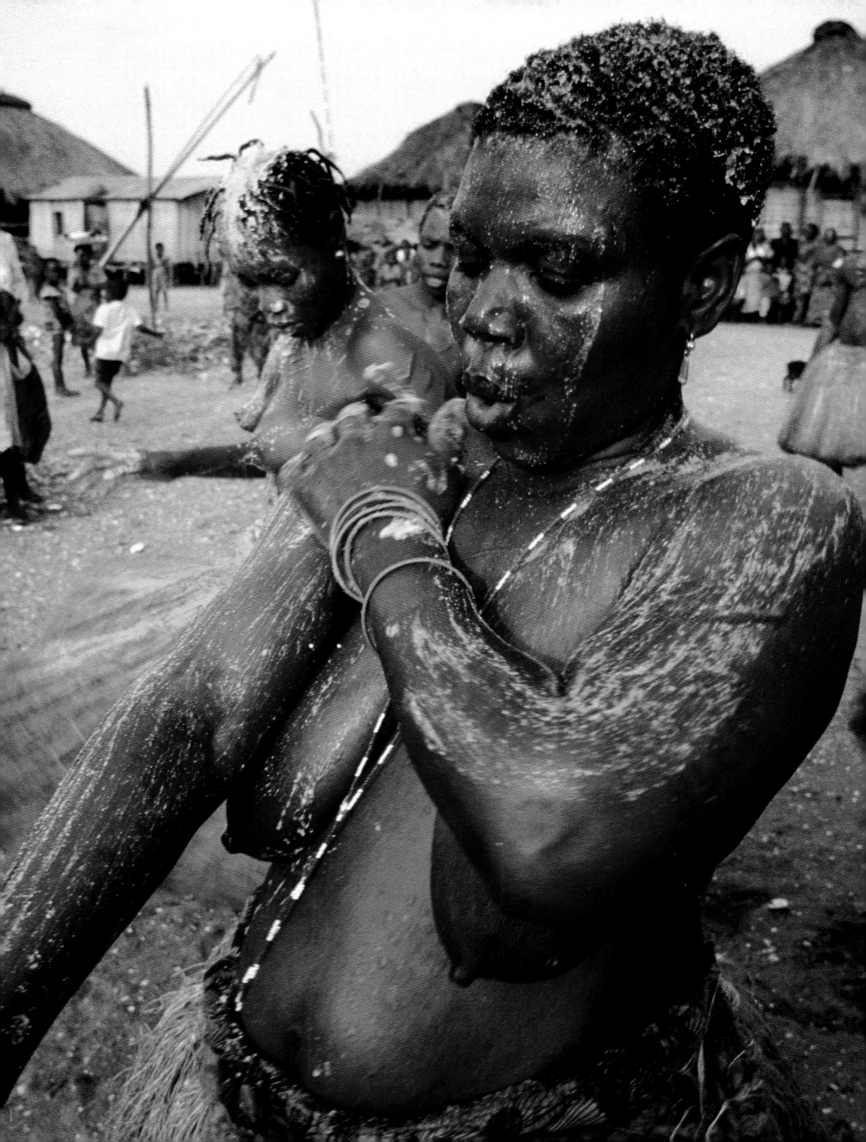

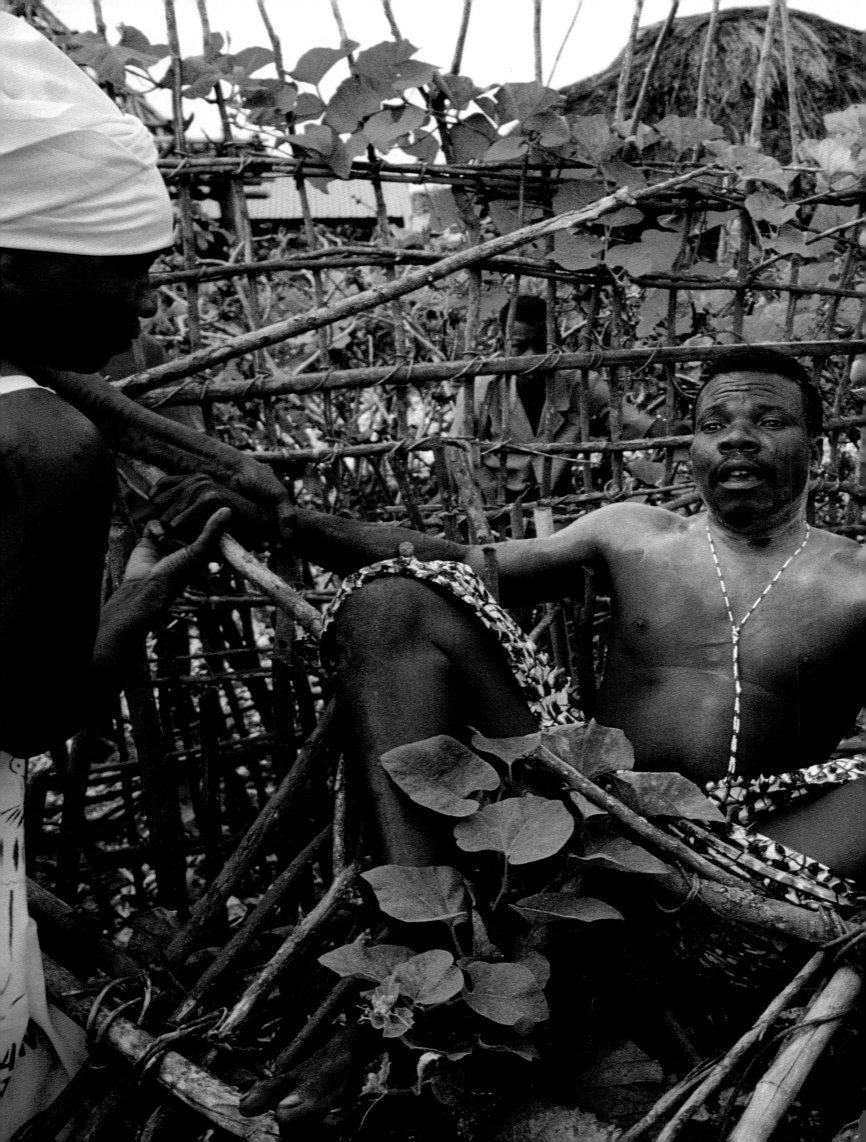

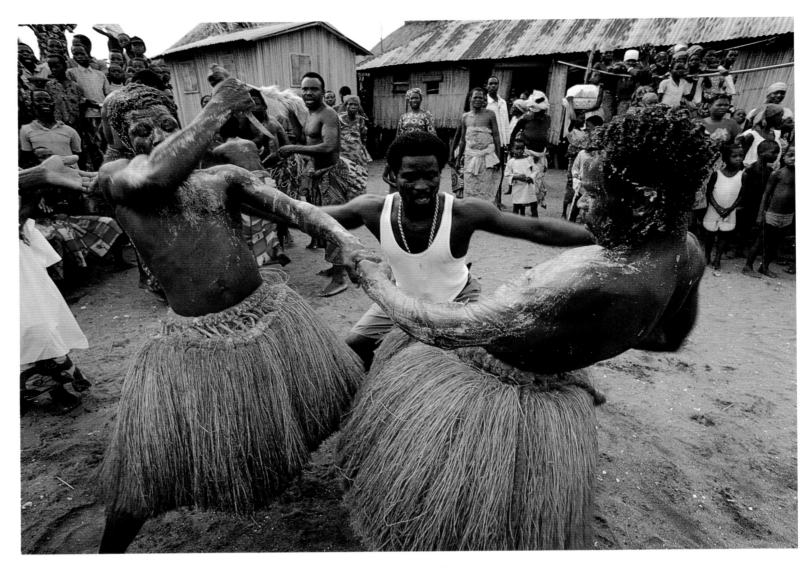

The climax of the Kokou
ceremony is not for weak
stomachs. To demonstrate
the power of the ancient
warrior god, two initiates in
trance slash themselves in
the arms and chest with
knives, as a priest (middle)
officiates.

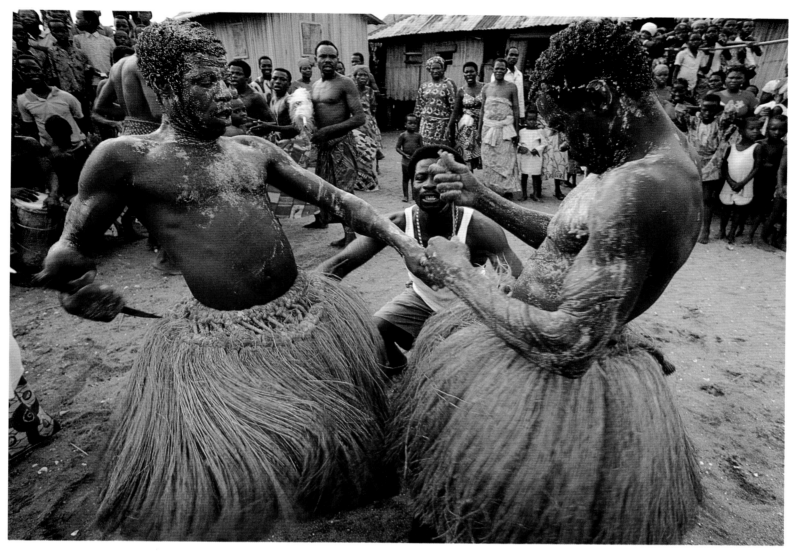

The dancers, wearing raffia skirts, stab and slash themselves repeatedly. Possessed by the god Kokou, they appear insensitive to pain. This violent part of the ceremony is reserved for men; otherwise, women may venerate the voodoo god who once gave soldiers invincibility.

FOLLOWING PAGES: Blood spurting from a head wound does not deter a young voodoo initiate in his ecstatic dancing. He draws strength from embracing the fetish of the divine messenger Legba, who wears a straw skirt like the Kokou dancers.

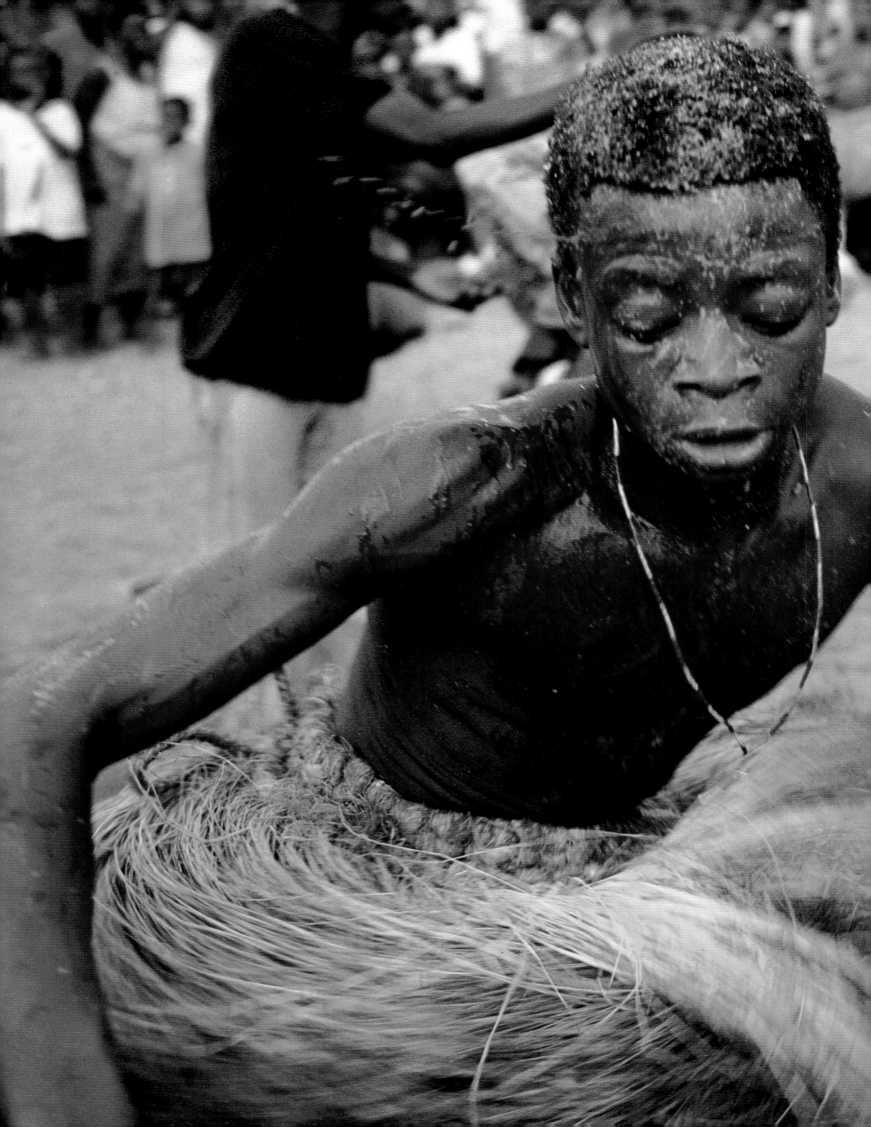

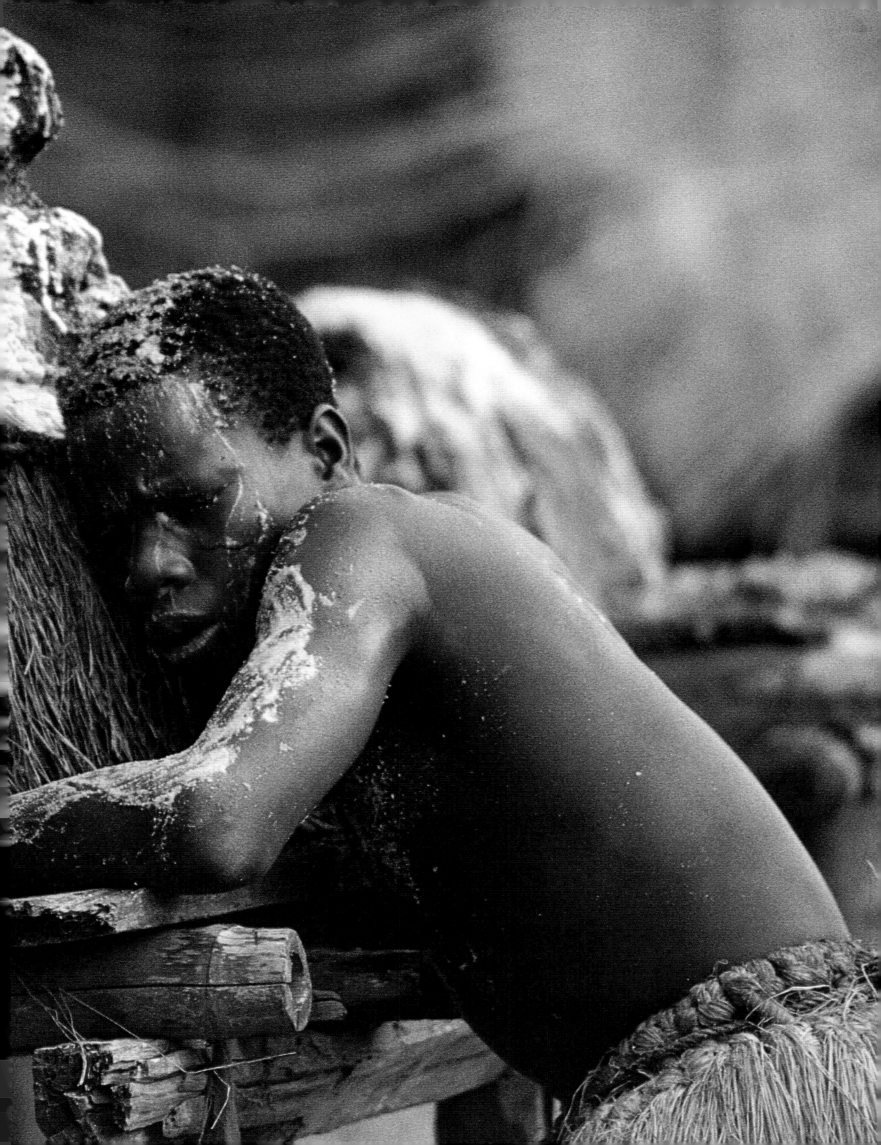

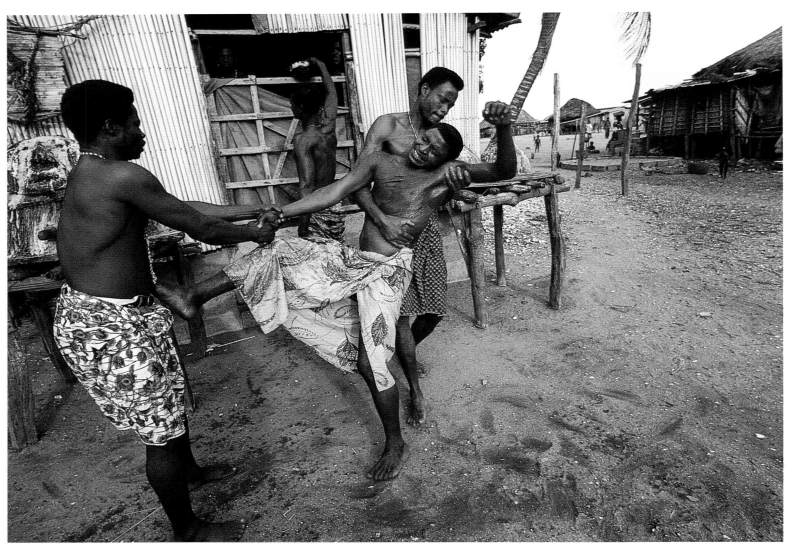

It requires considerable effort and strength on the part of the priest and his assistant to bring this violently resisting initiate into the temple. There they will put the raffia Kokou dancer's skirt on the man, whose scarred chest bears witness to previous ceremonies.

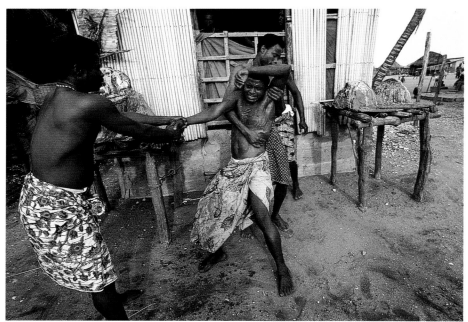

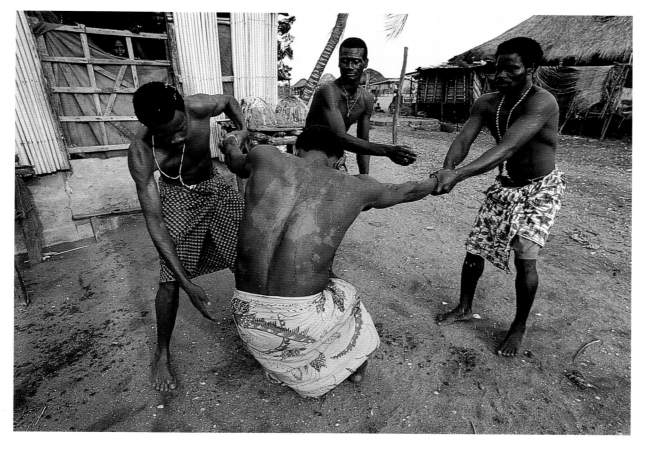

Voodooists believe that during trance a god or ancestor enters a person's body. Although gods like Kokou do not scruple to encourage self-mutilation, it is considered great good fortune to be possessed by a god.

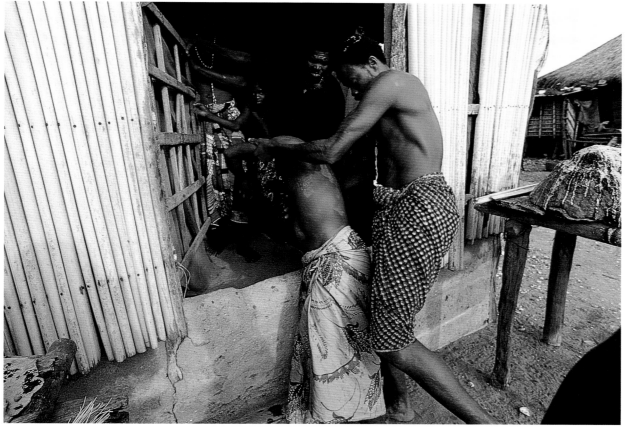

FOLLOWING PAGES:
In the temple of the village of So Tchanhoué the priest brings a ceremony to an end. He places the "sacred calabash" on the powerful Kokou fetish, deeply encrusted with *djassi*, as invokes the god for help and protection. Fetishes, made of various materials but usually of wood, clay or metal, are regarded as the earthly dwelling-places of the gods and foci of their power.

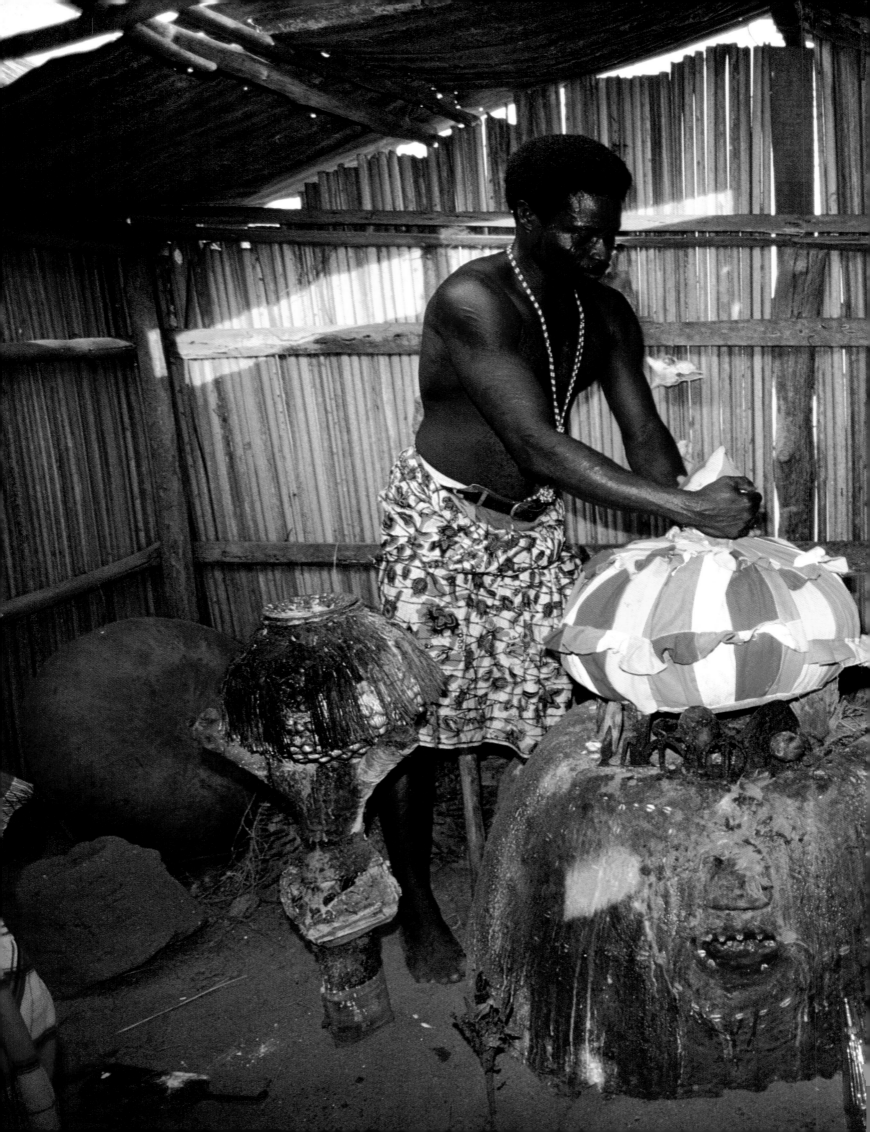

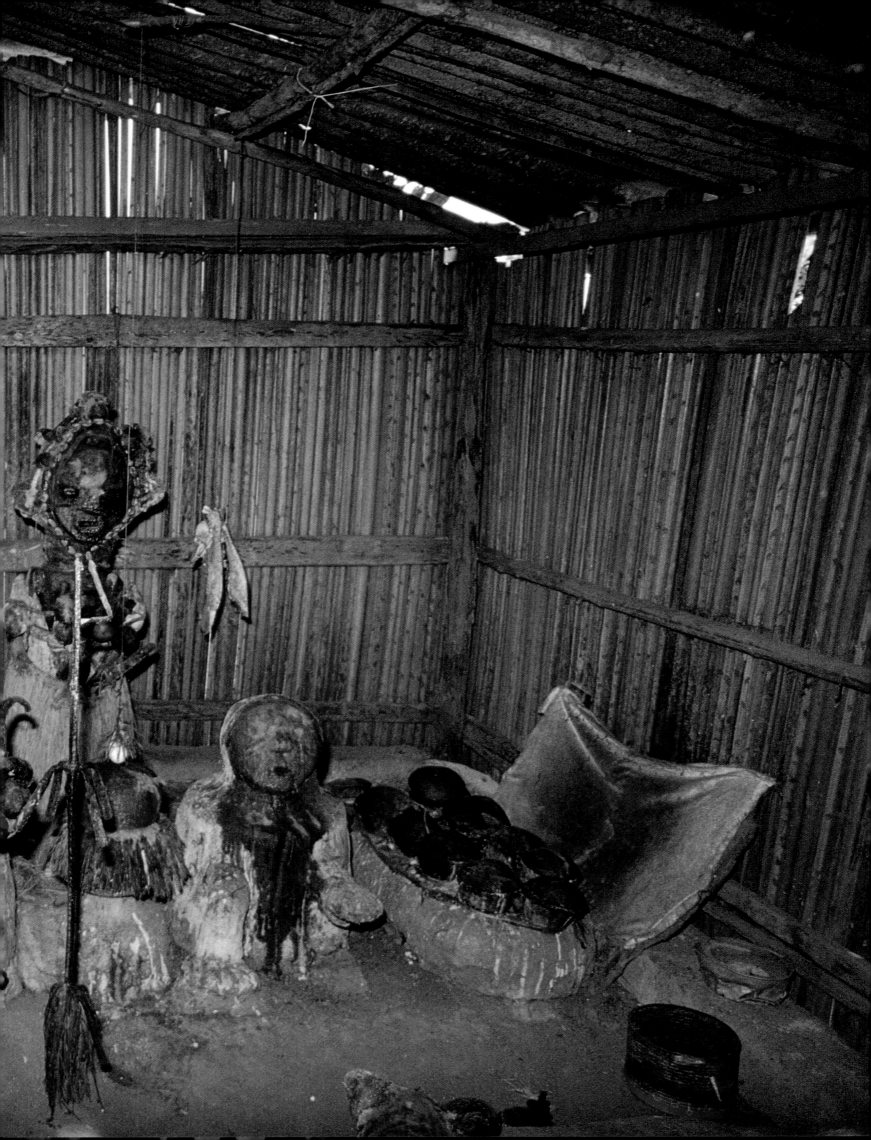

The enemy's bullets are powerless

GLIGBANGBÉ

Gligbangbé is another voodoo warrior god. Although his following is not very extensive today, this divinity has special significance for Sossa Guédéhoungué. The "Grand Commandeur" of all voodoo cults in Benin holds a regular sacrificial ceremony in his home village of Dotou, with a view to consolidating his close contact with the god and achieving spiritual and physical invulnerability.

The animals sacrificed in this cult are cows, cockerels and goats. Their blood is "fed" to the fetishes placed in the temple and the nearby "sacred grove". At the end of the ceremony Guédéhoungué often asks an onlooker to shoot at him with a pistol. The Grand Commandeur insists that he will be in no danger, for thanks to Gligbangbé the bullet will bounce off his body or he will be able to catch it in his hand.

Guédéhoungué's disciples – who are numerous, for he is a wealthy and powerful man – maintain that he has already given repeated proofs of his invulnerability. Adherents come from Benin's neighbour states to the seminary at Dotou to seek Guédéhoungué's help in establishing contact with voodoo gods. Should anyone blaspheme against voodoo, the Grand Commandeur has one of his disciples, with a special messenger's staff, visit the blasphemer and give him or her an unequivocal summons to a kind of voodoo court hearing at his seminary.

Voodoo priests do not, as a rule, restrict themselves to purely religious duties. They also have a social role. As the highest representative of the voodoo cults of Benin, Sossa Guédéhoungué enjoys considerable political influence, which reaches into governmental circles. He is also a very experienced herbal healer, and his patients are said to include Benin's president, Nicéphore Soglo.

Sossa Guédéhoungué, "Grand Commandeur" and President of the voodoo cults of Benin, is a powerful man with the bearing of an African potentate. In his home village of Doutou he holds an annual ceremony in veneration of the warrior god Gligbangbé, surrounded by his numerous wives, children and initiates.

FOLLOWING PAGES:
In the shade of a tree, female initiates begin their singing in praise of the gods and of the supreme priest of the land. On the walls of the houses divinities are depicted, among them the pockmarked god of plagues, Sakpata (left) and the rainbow-snake Dan.

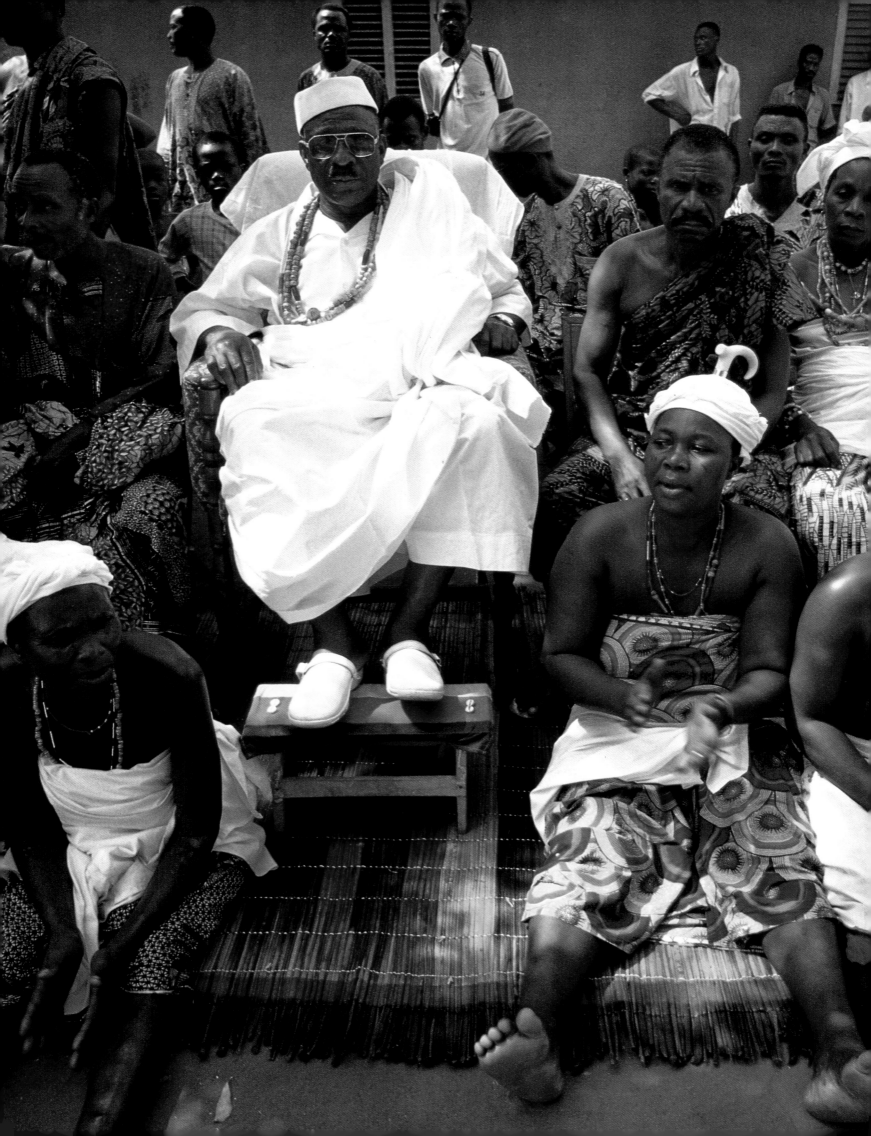

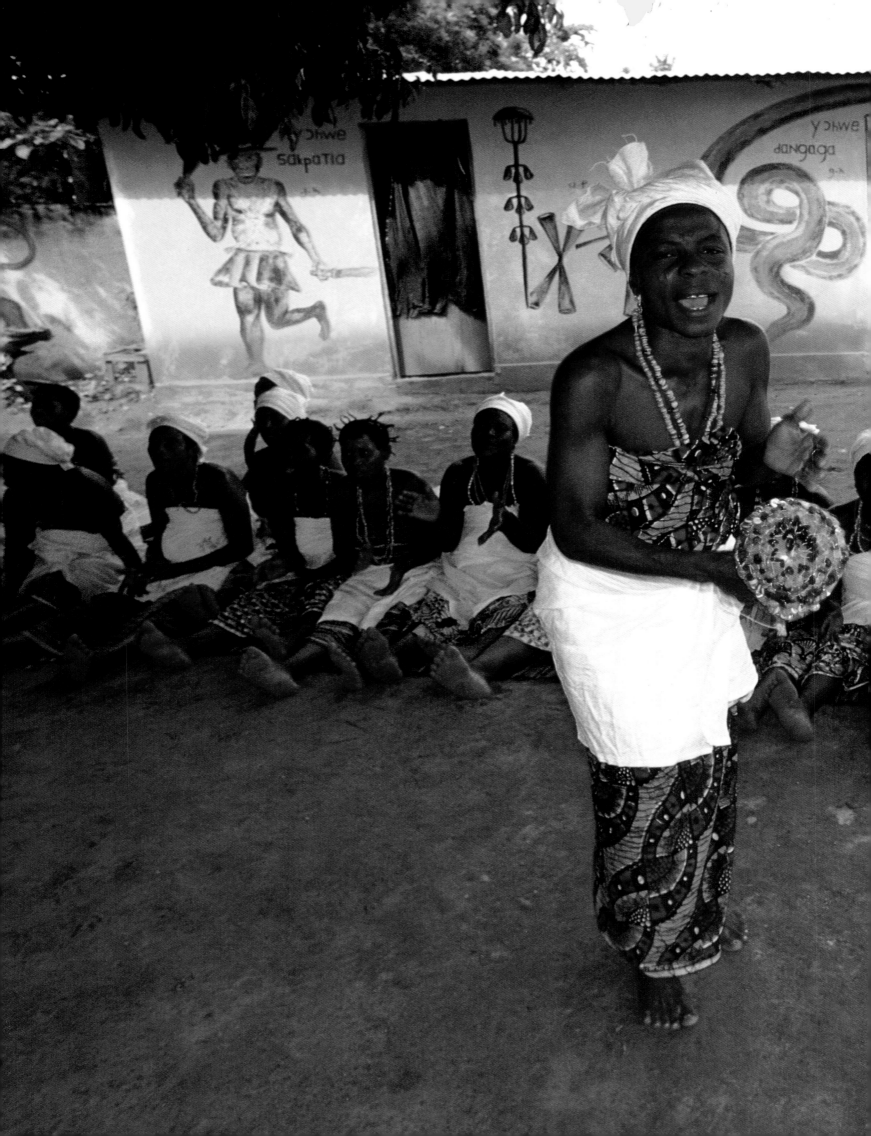

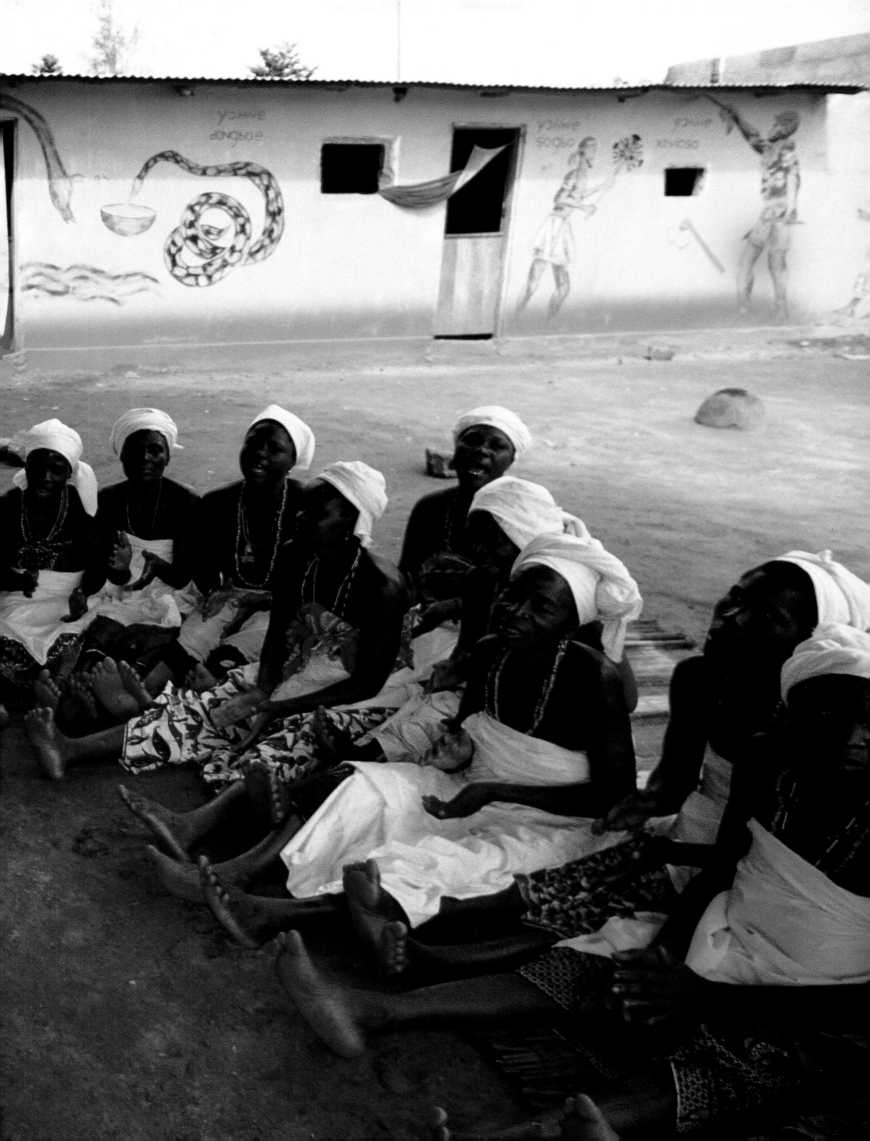

Chickens are slaughtered as a prelude to a sacrificial ceremony. While the villagers crowd round a group of drummers, a white bullock lies stunned on the ground.

Sossa Guédéhoungué walks over white sheets to the temple, followed by his assistants. He is clad all in white – the voodoo colour.

FOLLOWING PAGES:
With one quick incision the stunned bullock's throat is slit. Its blood will be offered to the god Gligbangbé, while its meat will provide Sossa's initiates with a festive roast. Bullocks are the most precious sacrifical animals; Guédéhoungué celebrates his high standing with the gods and in the voodoo world with generous sacrifices.

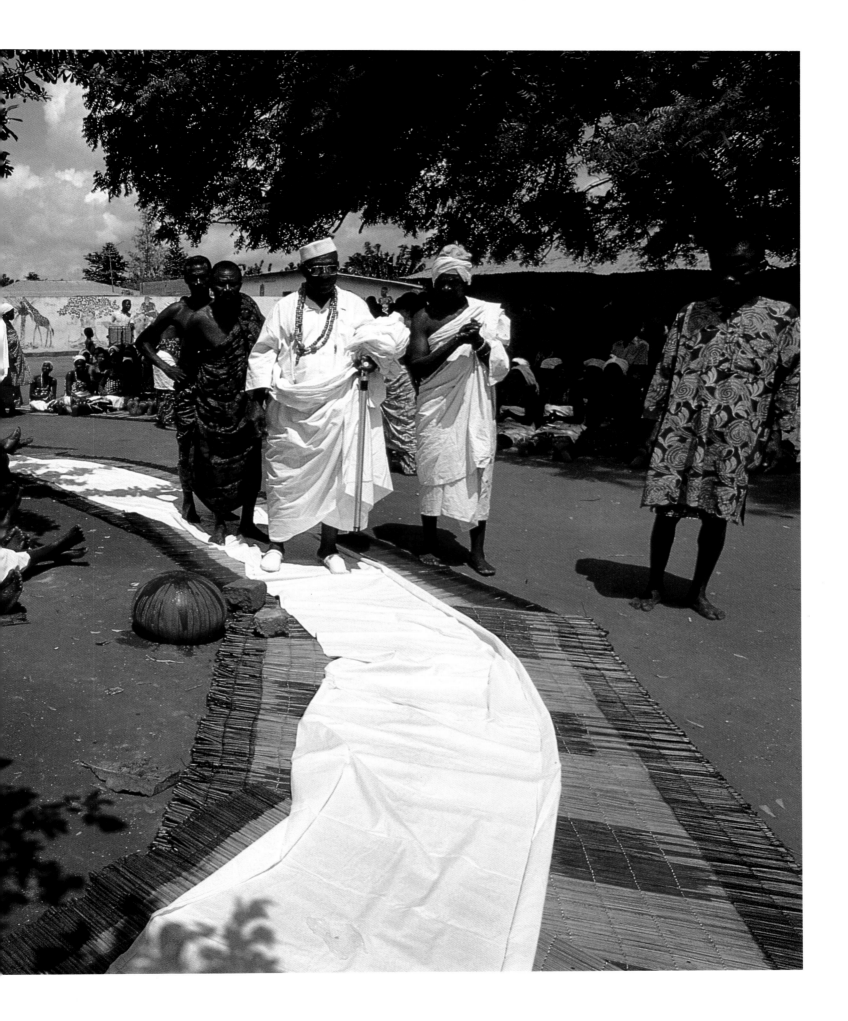

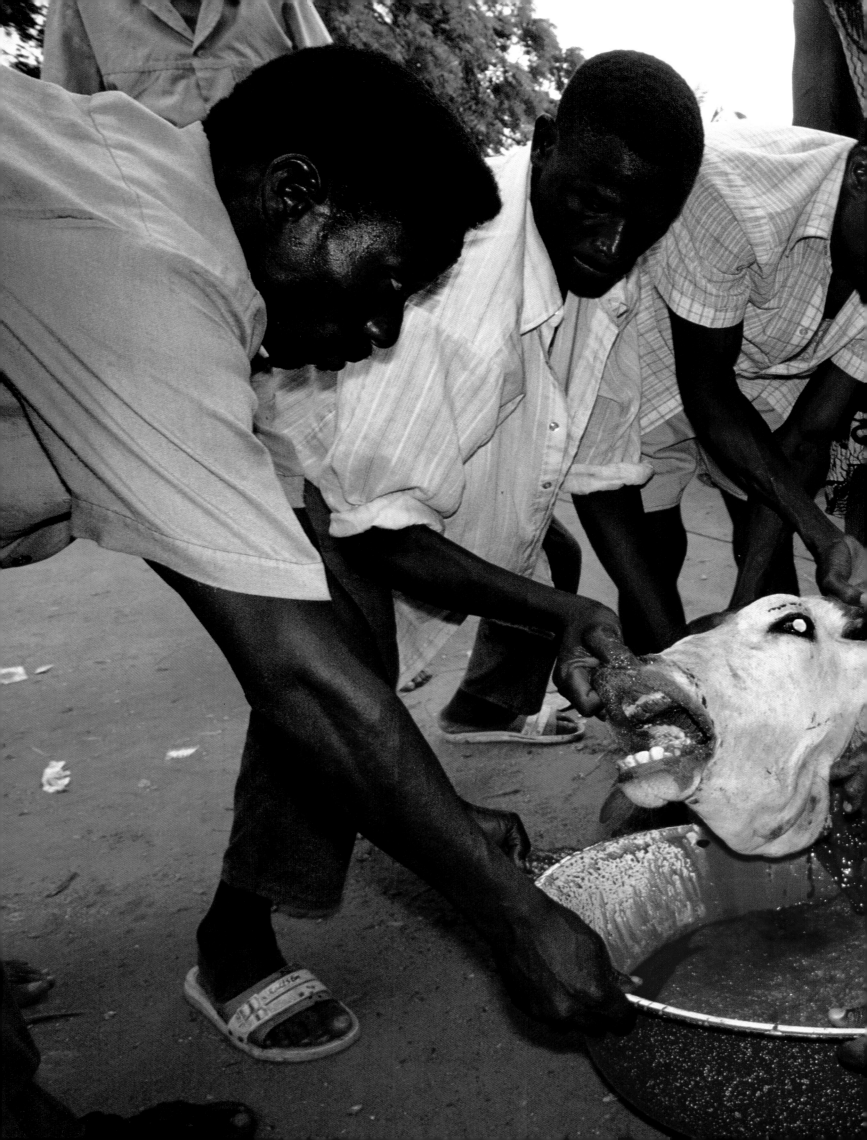

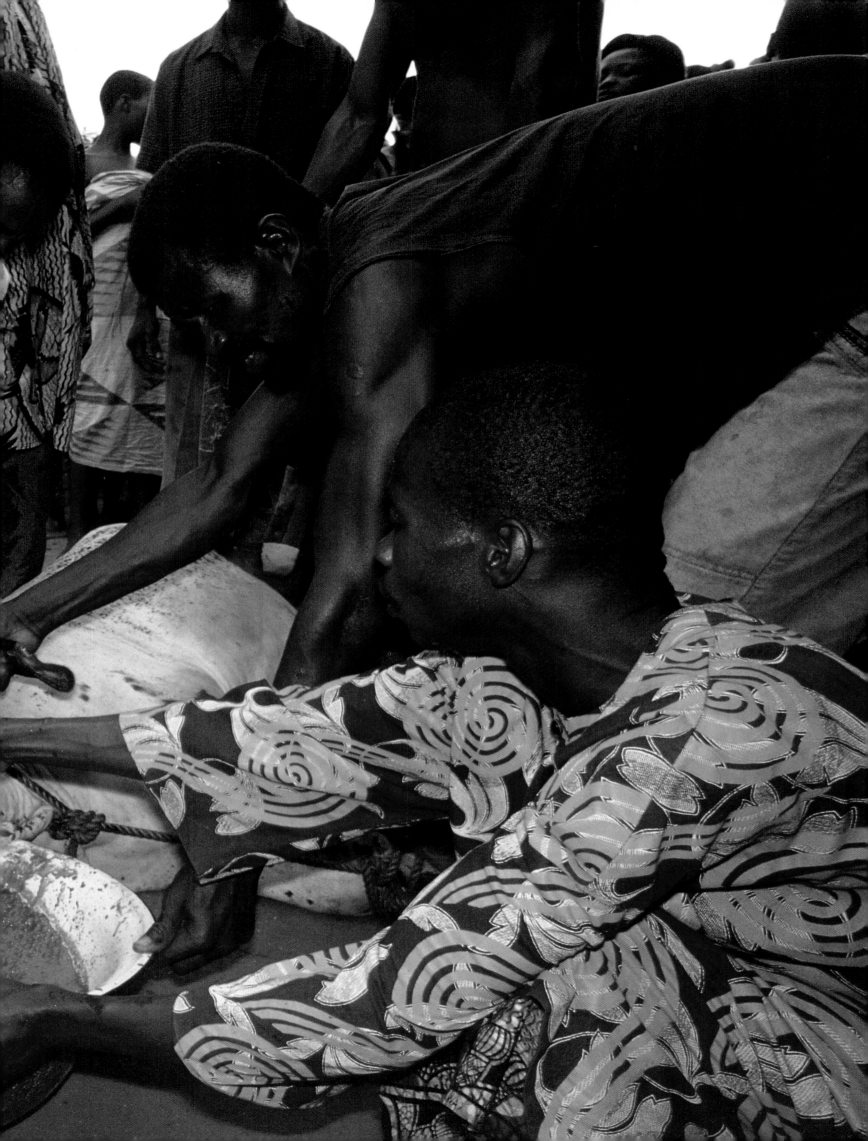

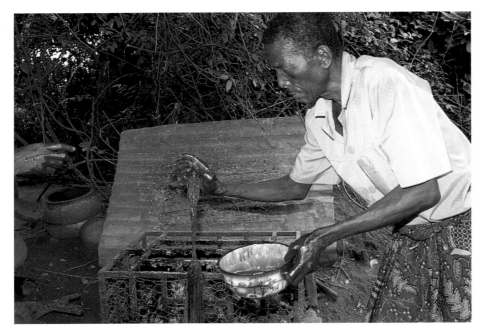

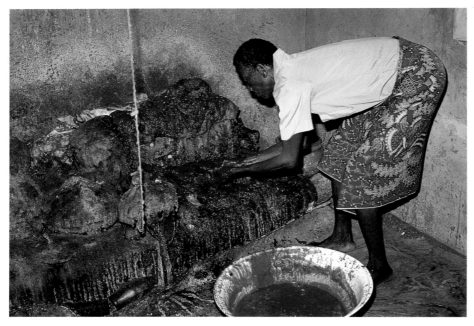

In the sacred grove near the temple after a sacrifice, an assistant "feeds" the fetishes of various voodoo divinities. At the temple, he has already added bullock's blood to the encrustation over the fetish of Gligbangbé.

Guédéhoungué at brief prayer beside the fetish of Gligbangbé, gleaming red with blood. Through ritual sacrifice the priest strengthens his relationship with his god, thanking him for a protection that even, he claims, makes him invulnerable to bullets.

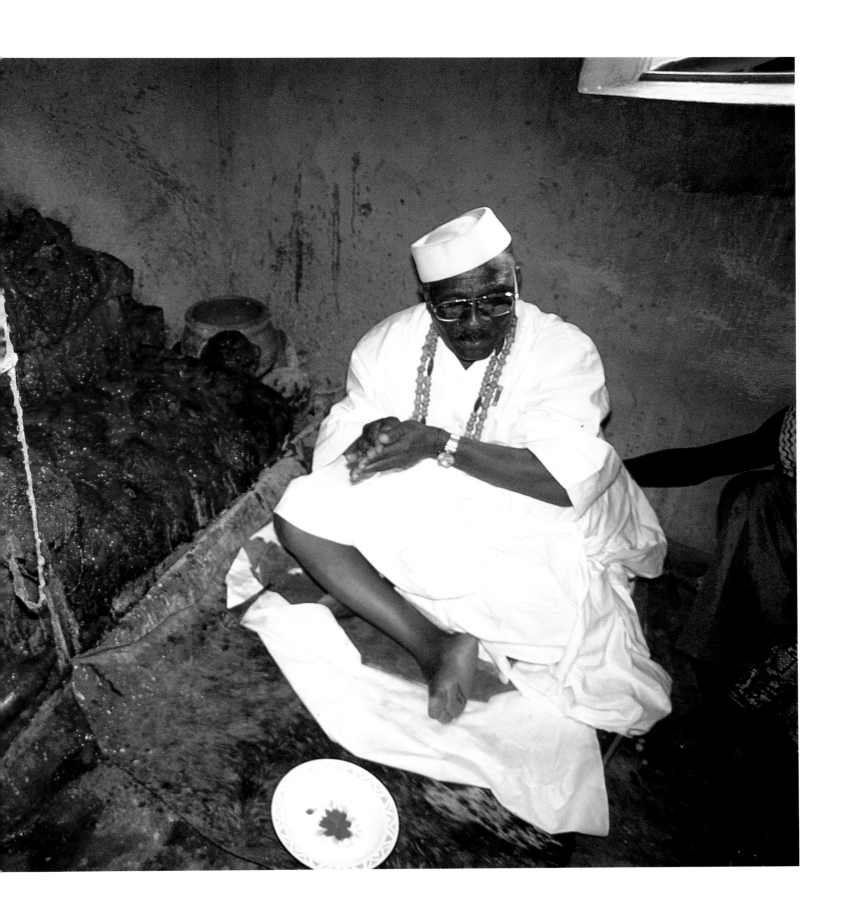

A temple for the family god

The voodoo cosmos has room for many gods. Some of them are venerated by all voodoo believers, some are known in only a single region or village, others within a single family. The voodoo god Abessan belongs exclusively to Benin's capital, Porto Novo. Like many other voodoo gods, Abessan offers his followers protection and spiritual support.

According to legend, a nine-headed serpent once appeared to a hunter and commanded him to build a temple to the god Abessan. This he did, and the hunter's descendants, who belong to the Yoruba tribe, venerate Abessan to this day. Although anyone may ask for Abessan's protection, this god is something of a house divinity for Henri Kiki and his extensive clan.

A former sergeant in the French colonial army, Kiki became a warden of the Temple of Abessan and its only priest. The ardent admirer of Napoleon and Charles de Gaulle has laid out his temple like a barracks: flowers grow in rank and file, everything is kept sparkling clean. Kiki keeps no retinu; women of his family are called on to help at ceremonies in honour of Abessan.

Kiki regards Abessan as his first ancestor, and venerates the god much as deceased members of the family are venerated. As the women crouch respectfully on the ground, call upon Abessan and offer him sacrificial gifts, Kiki supervises the ceremony from his priest's throne.

Abessan's power is concentrated in a great mound composed of blood, palm-oil and maize gruel. A few years ago the fetish was still nearly two metres in height, straight as a candle. But then Abessan fell victim to strife between the Zangbeto voodoo secret society and fundamentalist Muslims who burned down the Temple of Abessan, melting the fetish away. After the two factions made peace, the fetish could grow again. It is now about a metre in height, as thick as a tree-trunk, and stands as straight as a soldier.

Henri Kiki is a priest of Abessan. The focal point of the temple he erected to the divinity in Porto Novo is a huge column of solidified fat, composed of sacrificial gifts that over the years have accumulated into a fetish.

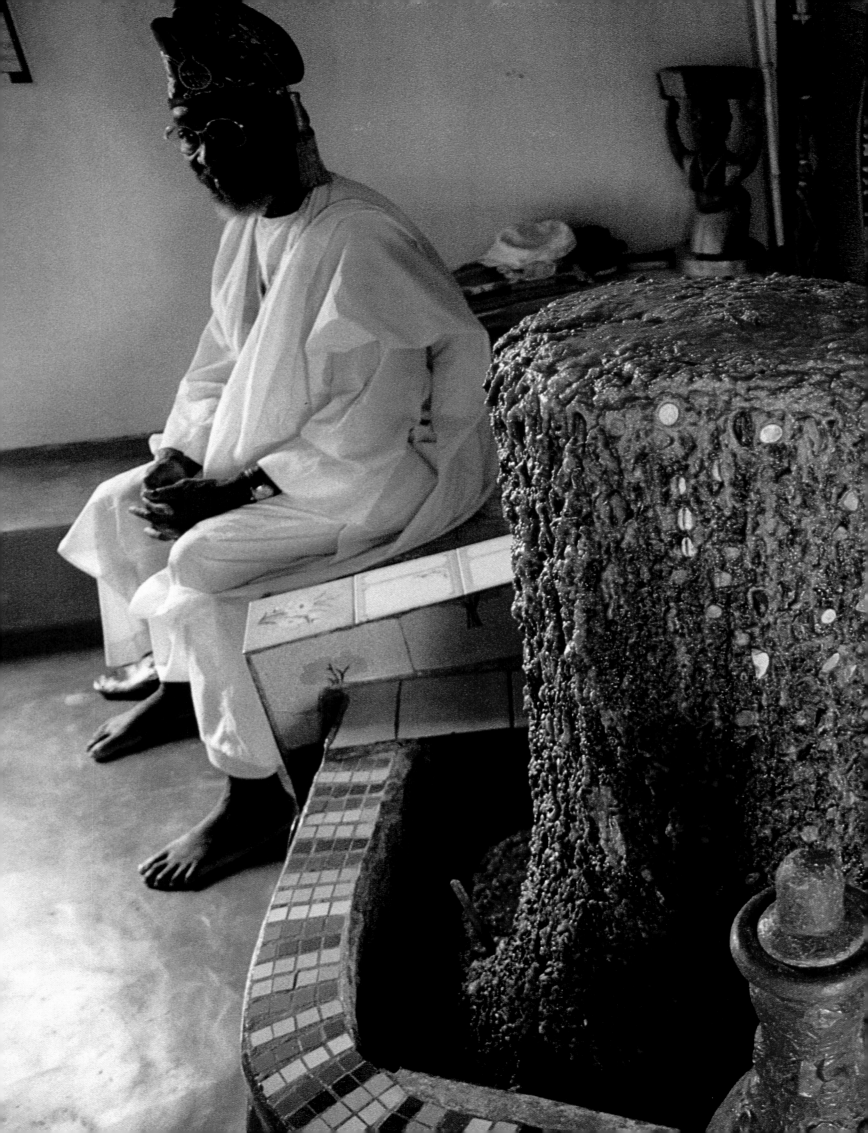

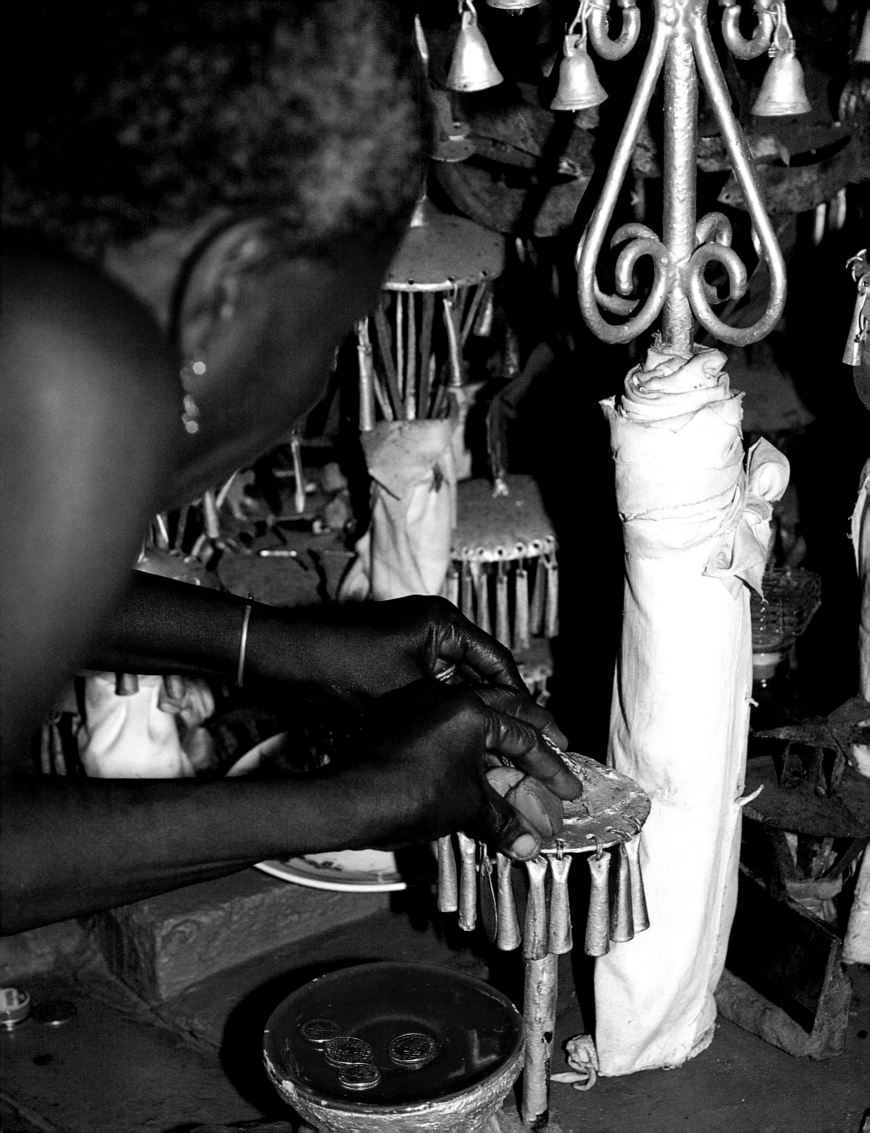

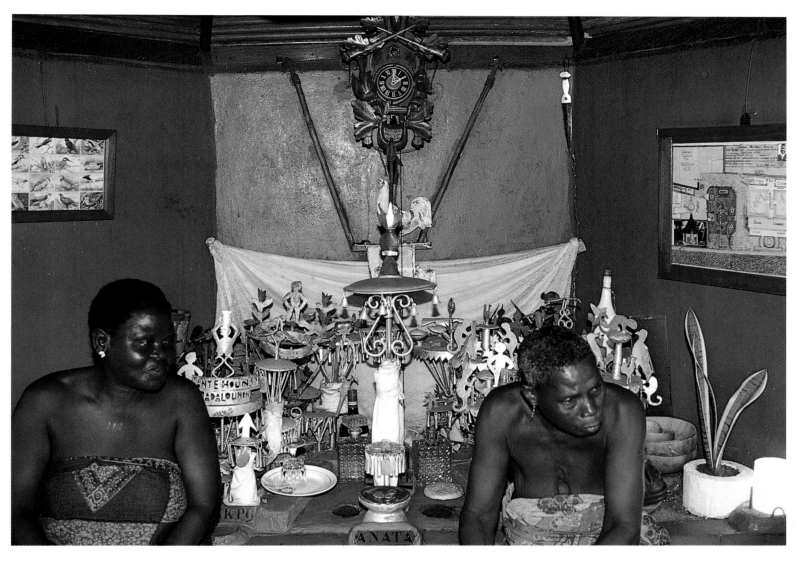

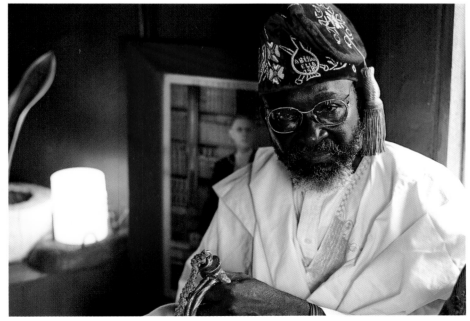

When they seek the protection of Abessan or another ancestor, the women of the extensive Kiki clan place coins, kola nuts or similar gifts on ase, stands for the offering of gifts to the dead. Henri Kiki retired from the French colonial army as a sergeant. His admiration for France and Charles de Gaulle is expressed in the portrait of the former French President hanging on his wall and the cockerel – symbol of Gaul – fixed to an *ase*. The cuckoo-clock above the ancestral shrine has nothing to do with voodoo; Kiki simply thinks it pretty.

Women call upon Abessan, speaking into hands cupped like microphones. From his raised throne Kiki supervises the procedure, in the course of which the women crawl on the floor. Later they will cook a ritual meal and eat in the company of the ancestors; Kiki will offer the left-overs of the meal to the voodoo gods, with prayers and songs ending the ceremony.

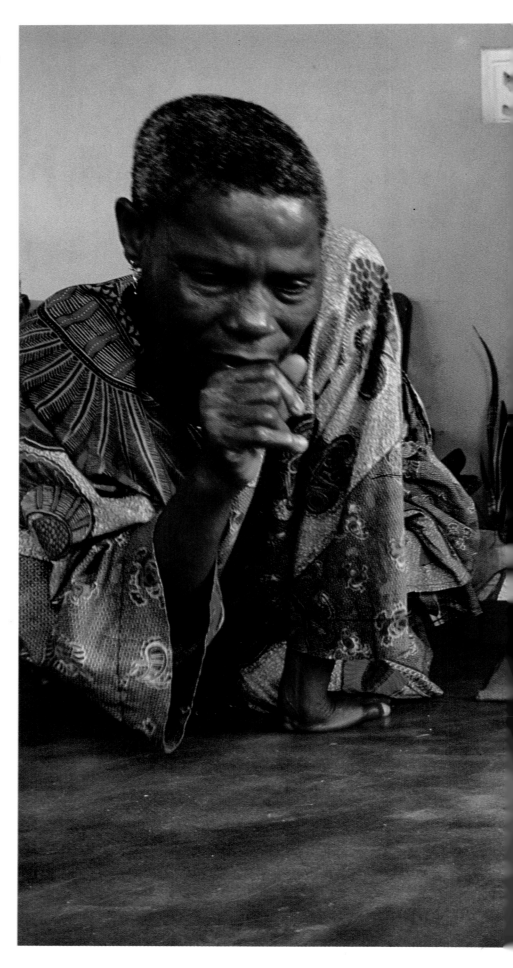

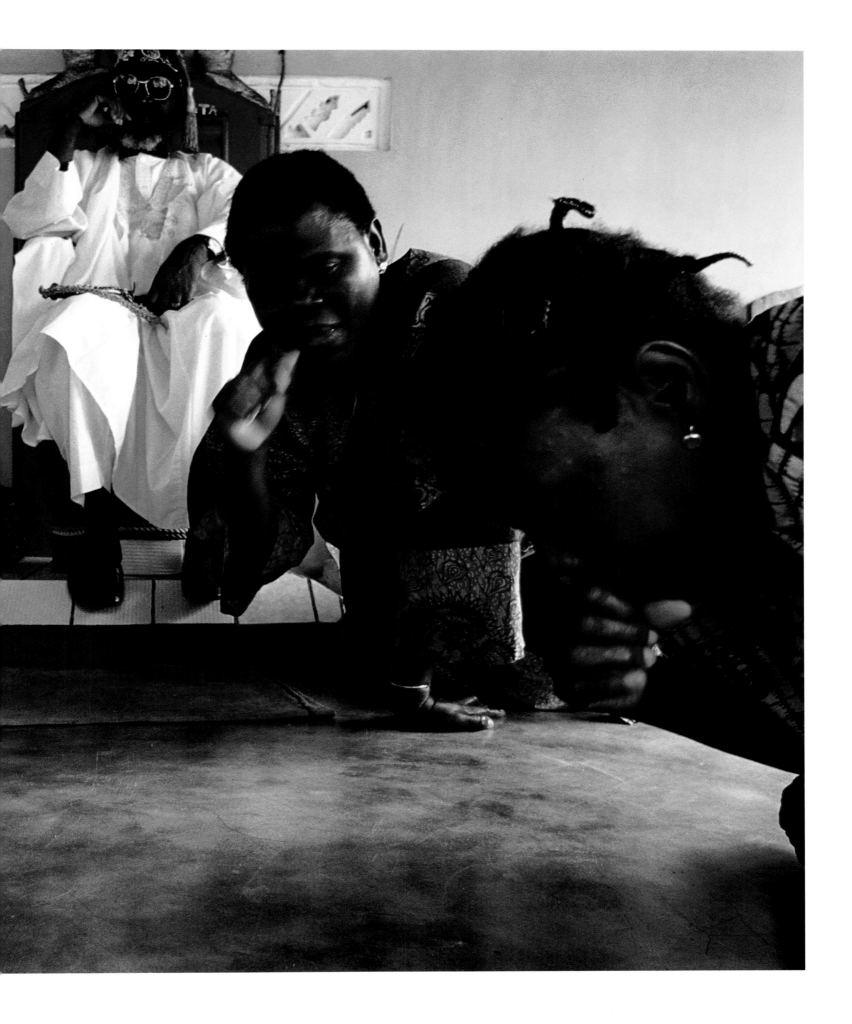

The calls of the faithful grow more and more urgent. Although Abessan is something of a house god for the Kiki clan, any outsider may also seek the divinity's help and protection. Abessan and Kiki have no disciples or initiates. The women of the family assist the priest with his religious duties and see that the temple is always shining clean – the former army sergeant sets great store by this.

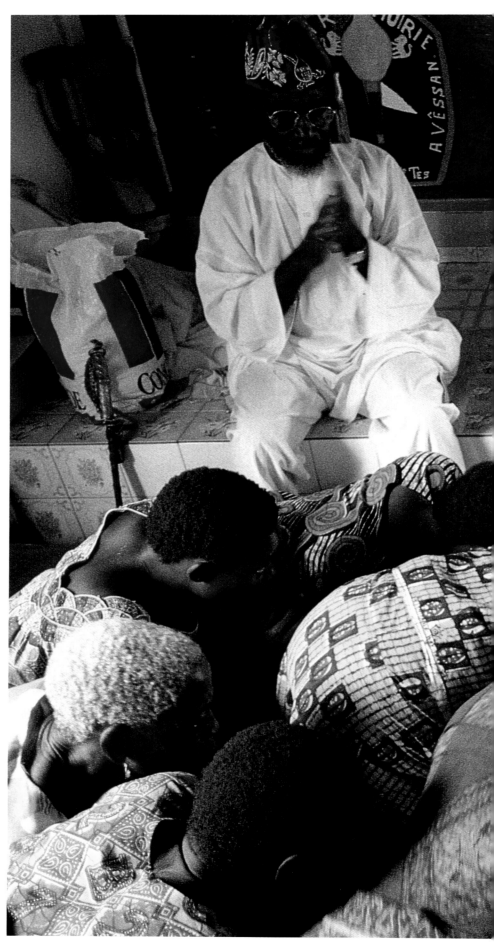

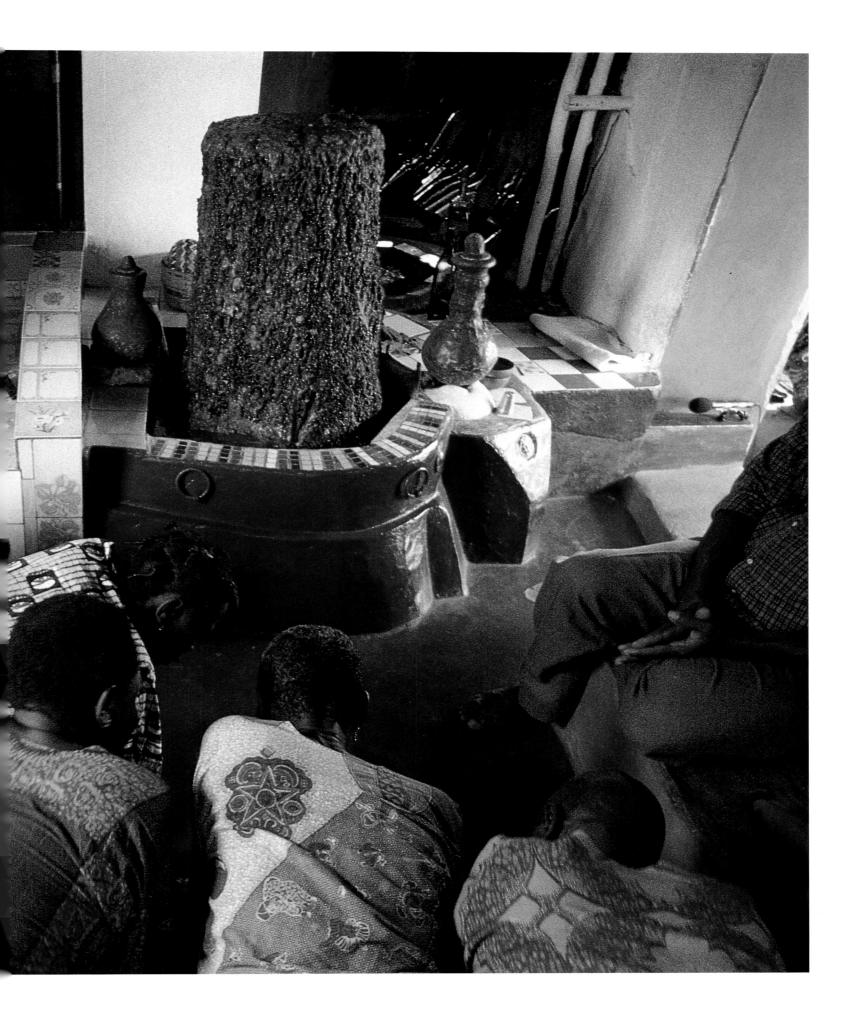

The "Night Watchmen"

Zangbeto is one of a number of voodoo secret societies. It first appeared around 1833 in Porto Novo during the reign of King Toffa and later spread throughout the coastal region of Benin. The "Night Watchmen" maintained law and order in towns and villages, and to this day they function as the voodoo police. At nighttime, and occasionally during the day, the society's members patrol town quarters and villages, keeping a lookout for thieves and settling disputes.

Members of Zangbeto wear palm-straw masks reminiscent of haystacks, completely concealing their bodies, and often surmounted by carved figures and shapes – an elephant symbolizing strength, a calabash the universe. Their vision restricted by a narrow eye-slit, they are led by assistants who sing loudly and beat drums. Their appearance is usually the sign for the regular police to retire discreetly or to confine themselves to traffic control. The Zangbeto Society is undoubtedly a power factor at community level. Its members intervene when people act against the general interests of the community – by dumping rubbish in a forbidden place, for example. Then society members come to the culprit's house, loudly denounce his or her offence and demand a reparatory sum or even pronounce punishment.

The Zangbeto Society keeps its temples and religious ceremonies as secret as the names of its members. Entry into this men's world is prohibited to women on pain of death. In strange contrast to this ritual secrecy is the fact that in many areas the Zangbeto Society has become a folklore show readily displayed to tourists. The "dancing haystacks" offer splendid photo opportunities. Their assistants swallow splinters of glass or press cactuses under their armpits – in both cases without doing themselves harm. In the activities of the Zangbeto Society, the distinction between voodoo cult and pure voodoo spectacle is sometimes blurred.

Members of the Zangbeto Society patrol a Porto Novo street at full moon. They wear masks of raffia bast concealing the whole body, wishing to remain unrecognized when they attend to law and order.

FOLLOWING PAGES:
A very rare picture, for entry into a Zangbeto temple is customarily strictly prohibited to outsiders. The priest "wakes" the masks by sprinkling consecrated water over them.

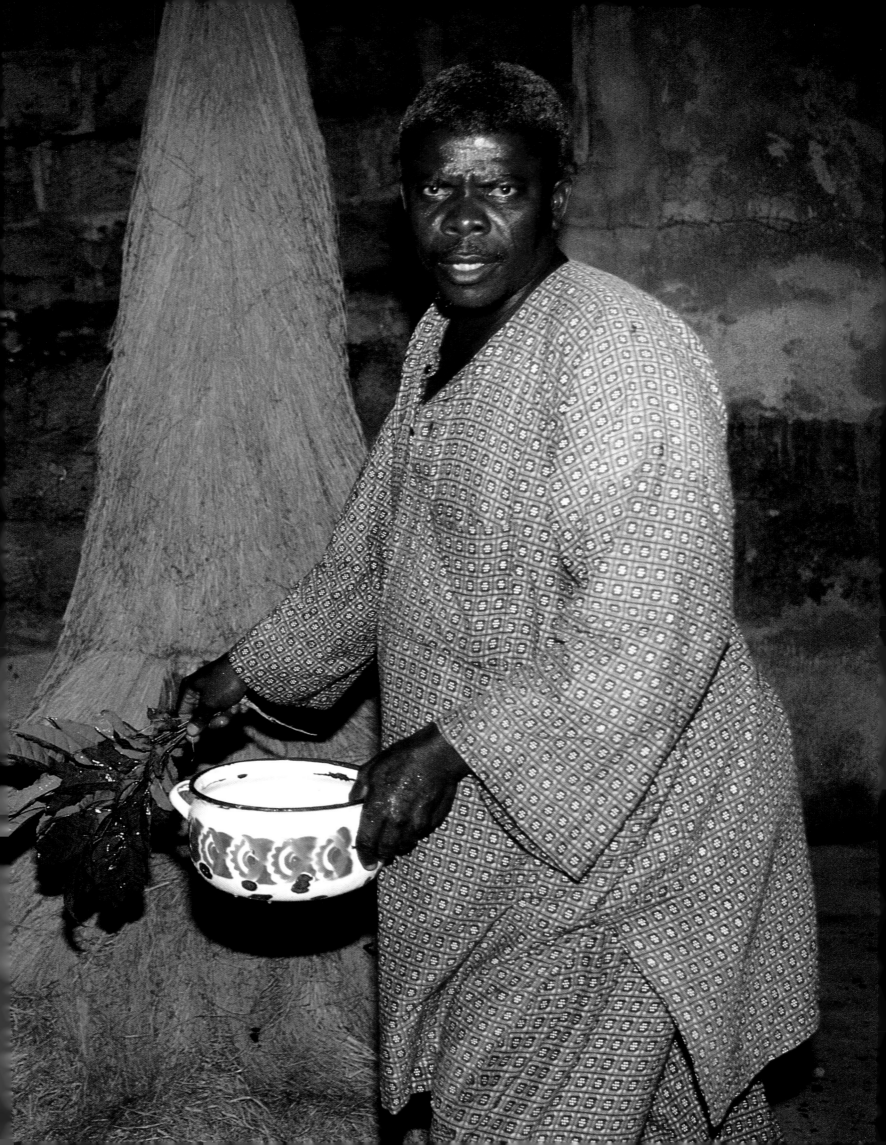

An eye-slit reveals the roguish smile of a masquerader. Every voodoo believer knows very well that Zangbetos are human; but they carry out their function as voodoo police under divine instruction.

The Zangbeto Society is a power factor at communal level. Anyone who compromises the interests of the community or offends against voodoo laws is publicly called to account by the society – and sometimes punished.

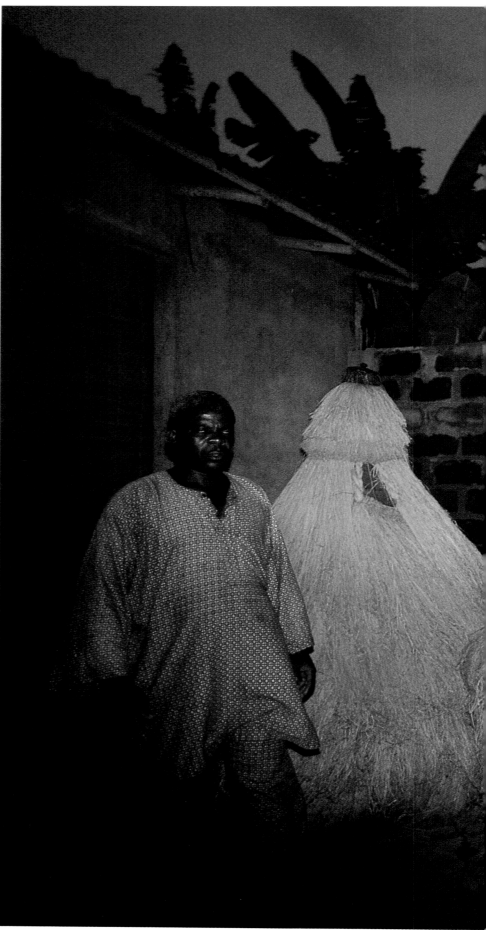

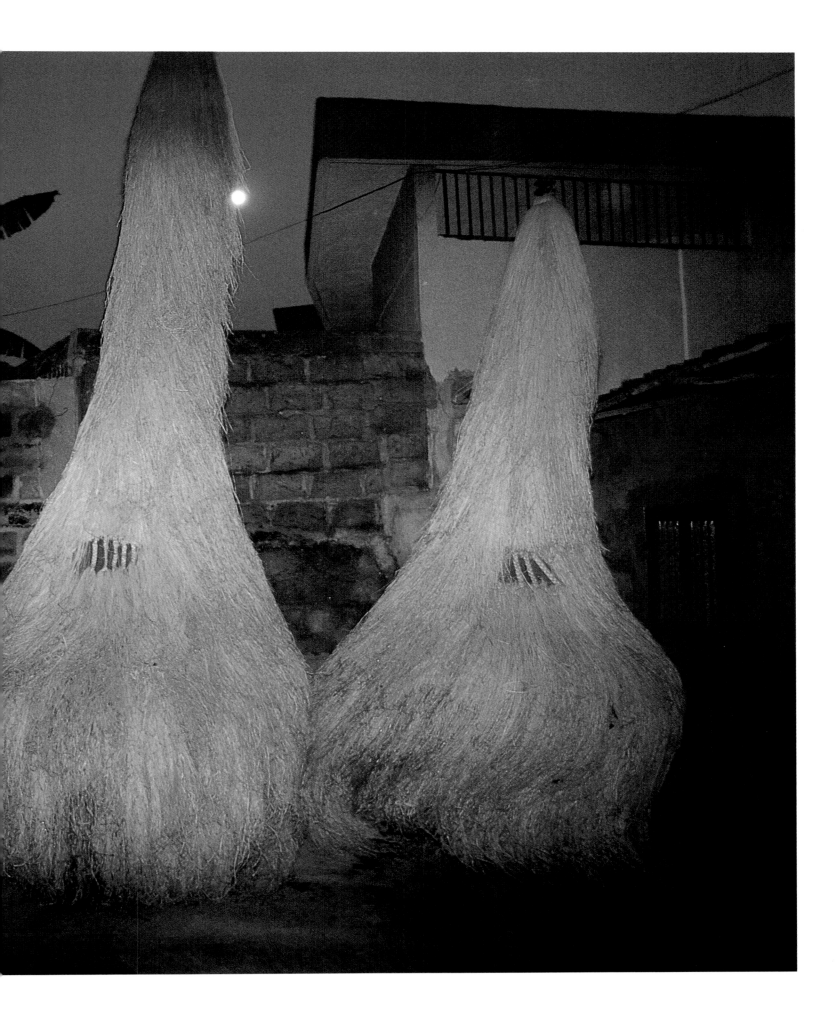

The bird dance wards off evil spirits

DJAGLI

"Bovia, Bovia, Bovia," cry voodoo initiates dancing in deep trance for hours on end in veneration of the god Djagli. The magic word is supposed to renew their strength, making them as strong as Djagli. This divinity was originally a warrior god, like Kokou and Gligbang-bé; all three are venerated by the various Adja tribes in the provinces of Mono and Atlantique in south Benin.

Djagli protects villages and their inhabitants from evil spirits. Because witches like to adopt the forms of birds whenever they approach humans, Djagli initiates do likewise in their ceremonies, winning equality with the powers of evil and the ability to overcome them with the help of Djagli. The dancers repeatedly rub their bare upper bodies with *djassi*, a tonic made of maize, palm-oil and a secret herb mixture. They make movements reminiscent of hopping or flying birds, striking out with their arms as if stabbing witches to death. They wear flounced cloth skirts, which are kept in the temple and put on a dancer as soon as he or she has fallen into trance; this protects against the attacks of witches, who of course try to undermine the success of the ceremonies.

Djagli ritual is supervised by special dignitaries, usually elderly men and women with long experience in the practice of their cult, who also advise the priest and assist at sacrifices in the temple. The priest eventually brings the dancers out of their trance by means of a green liquid and secret incantations. The evil spirits have been succumbed.

A young woman has fallen into trance and is taken to the shrine of Djagli, where she will be dressed in a special skirt. Formerly a warrior god, Djagli is today a protective deity for villages like Akpihoué.

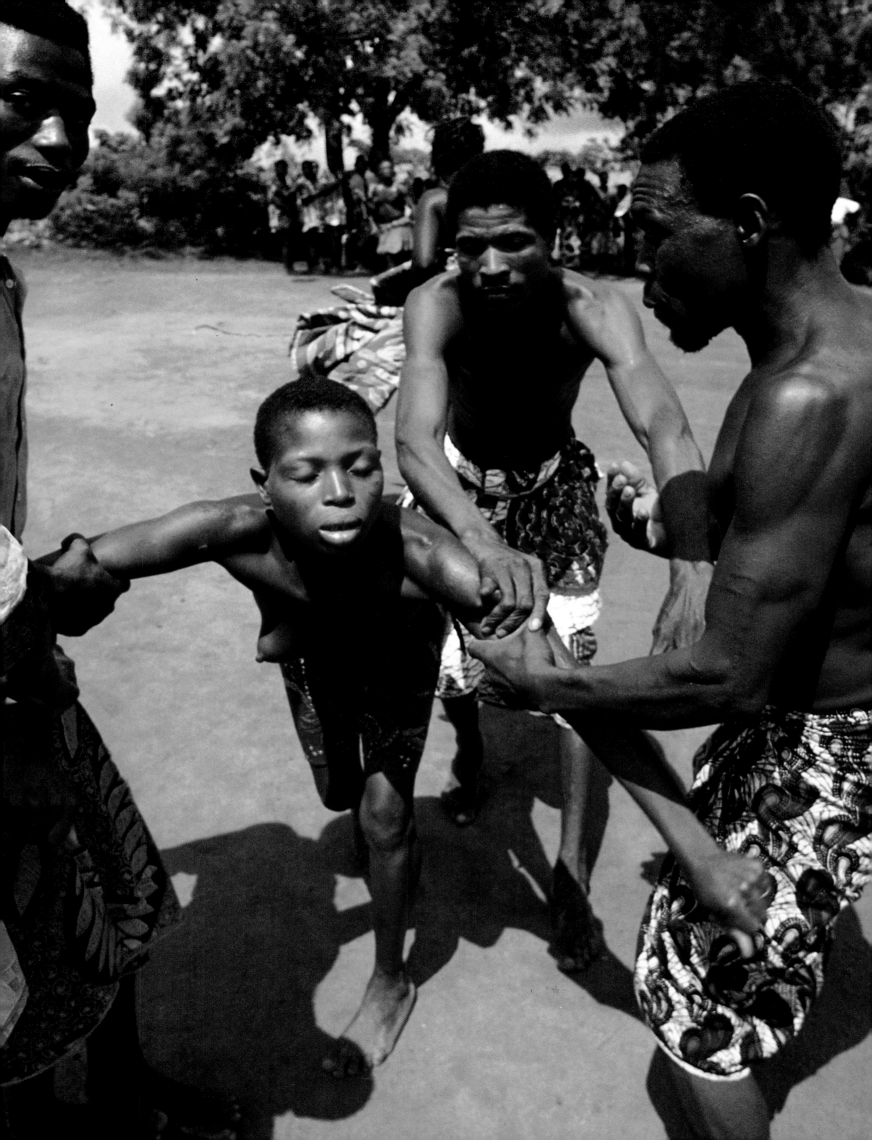

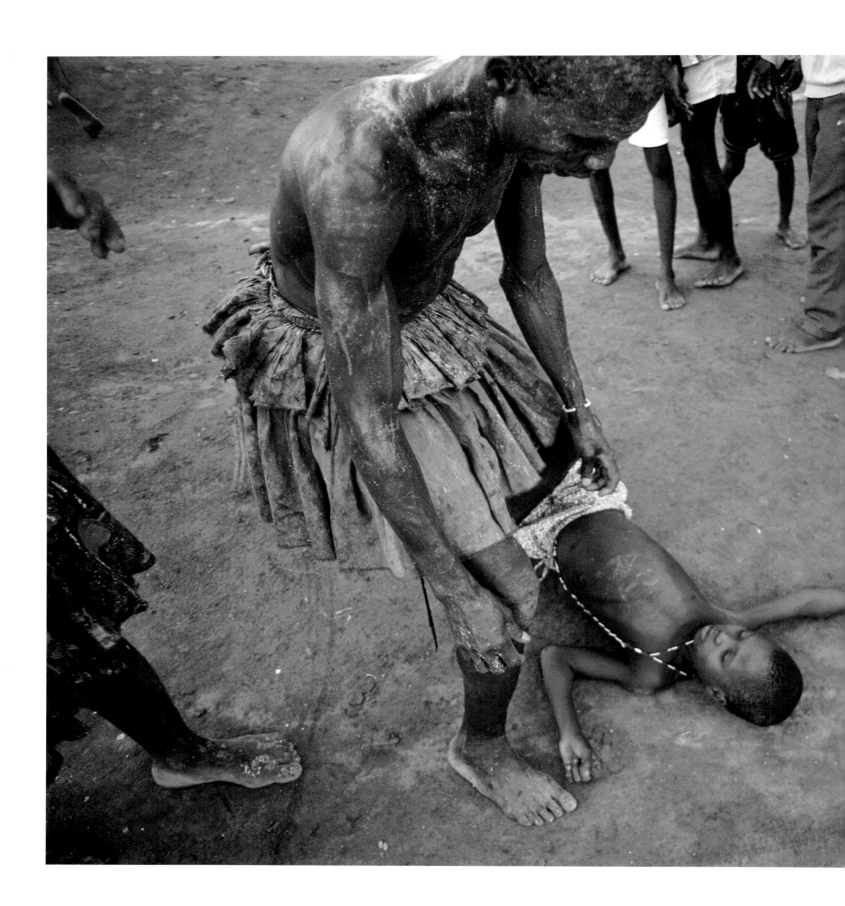

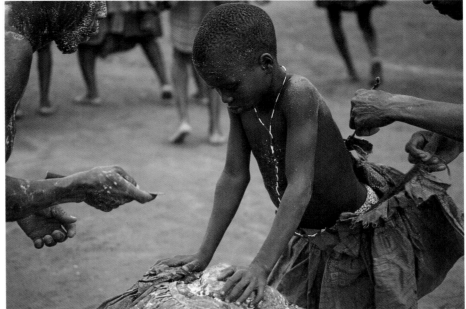

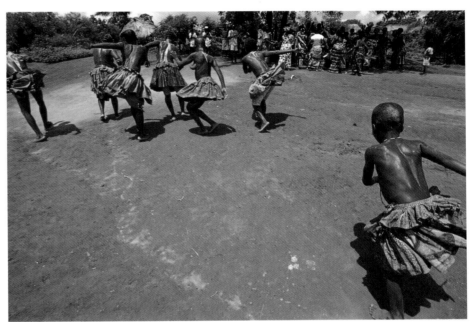

The gods themselves choose their medium. The spirit of Djagli may suddenly enter the body of a young boy. This one has just come home from school – now he lies in the contortions of trance. His necklace indicates that he is an initiate. Like the adults, he too will be dressed in the skirt of Djagli, and dance indefatigably up and down the village square in the scorching sun.

FOLLOWING PAGES:
Since witches like to disguise themselves as birds, voodoo dancers imitate birds' hopping movements. Thus the "Children of God" gain equality with the powers of evil and can overcome them. Djagli's energy is prodigious; dancers possessed by him need scarcely a break for hours on end.

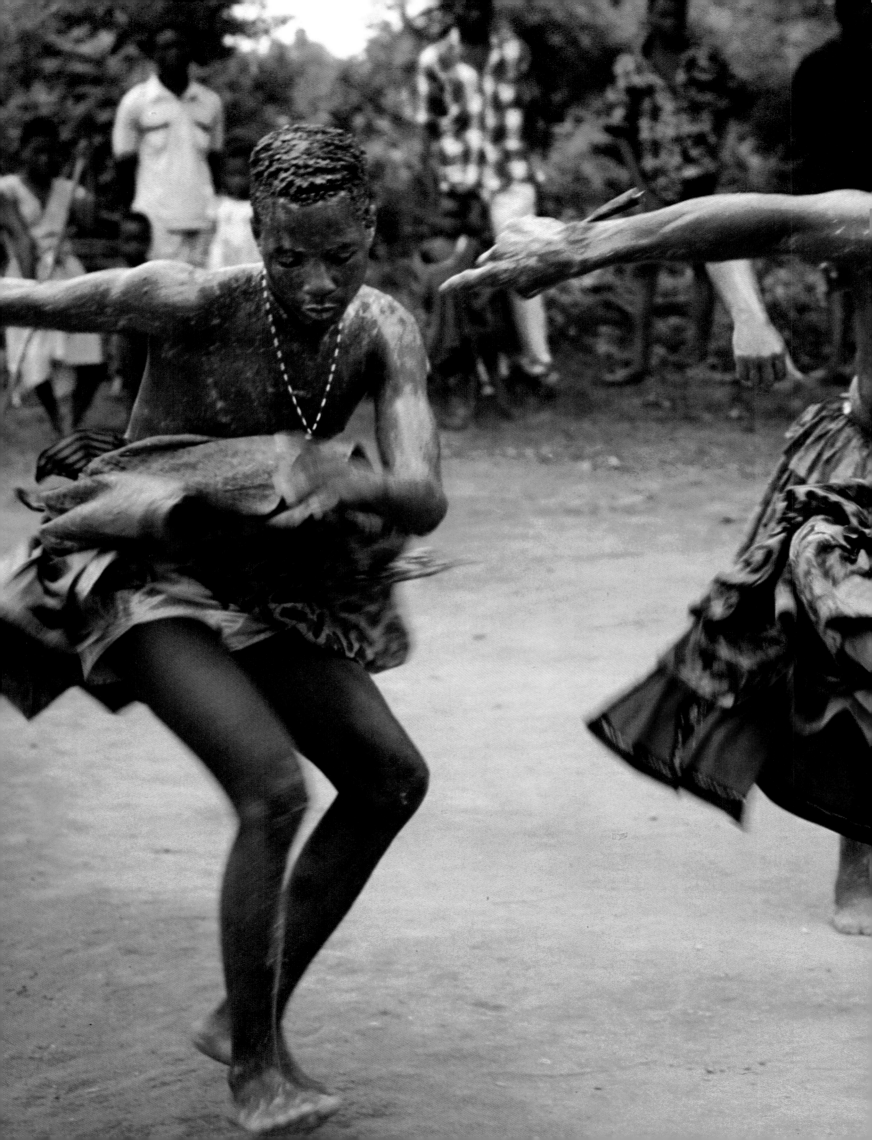

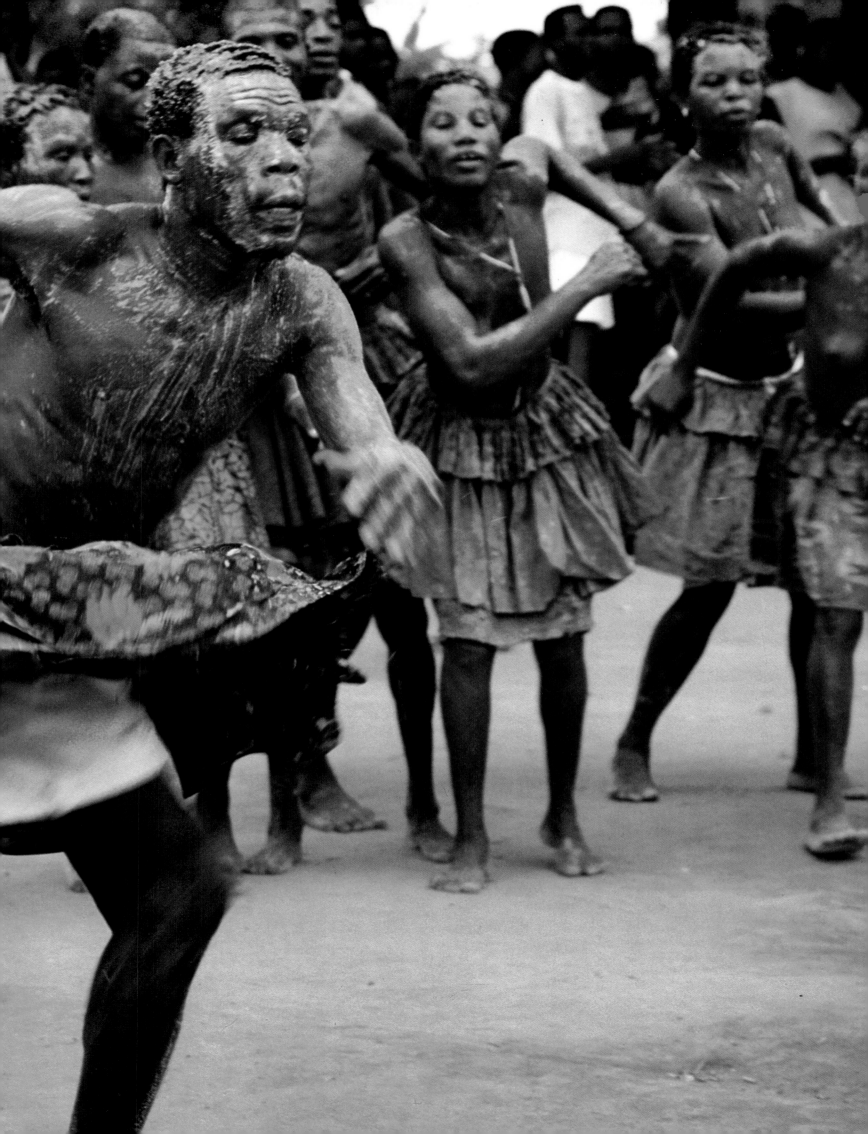

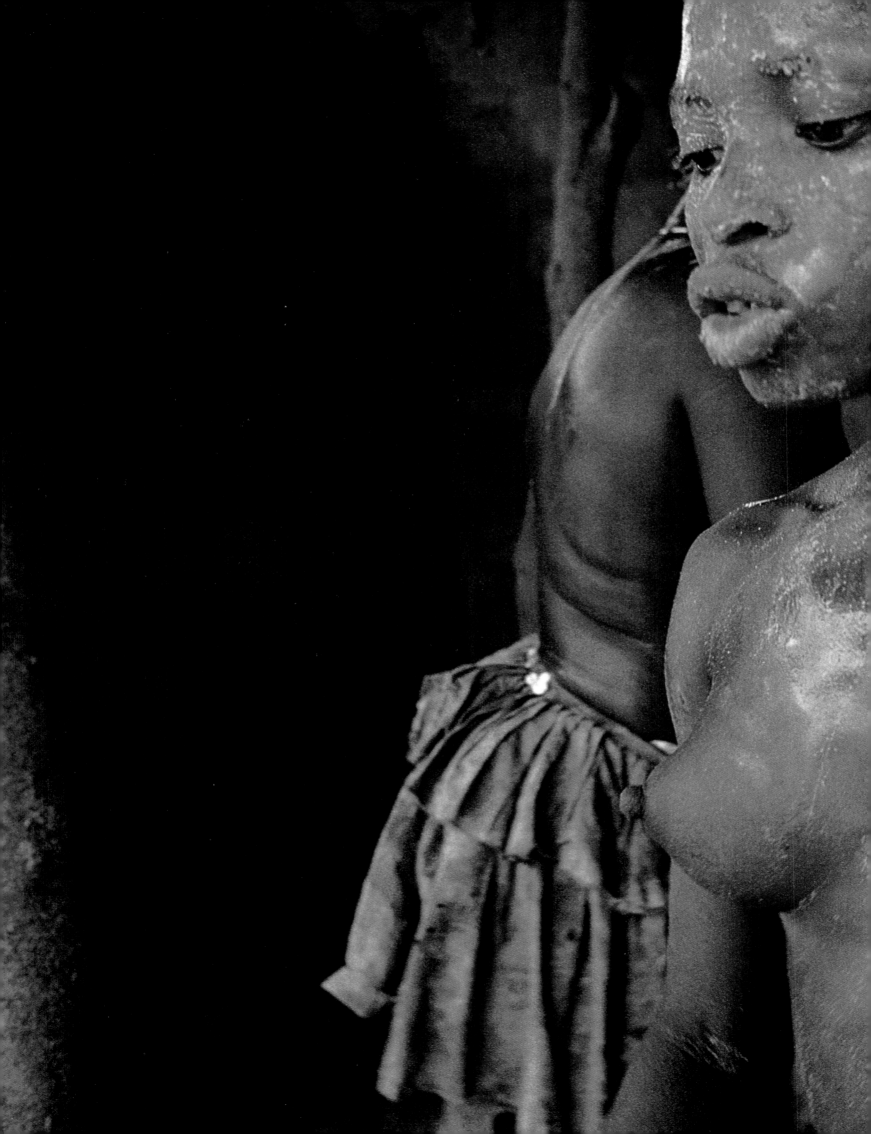

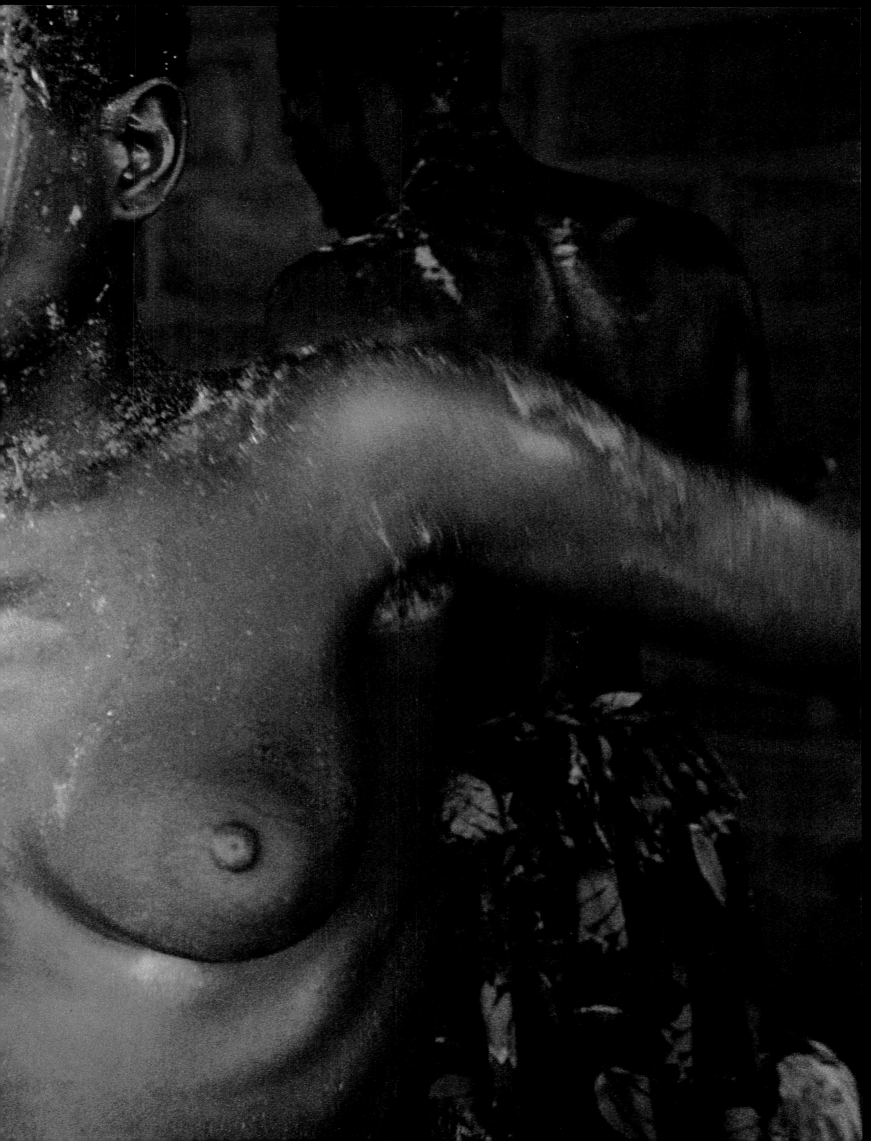

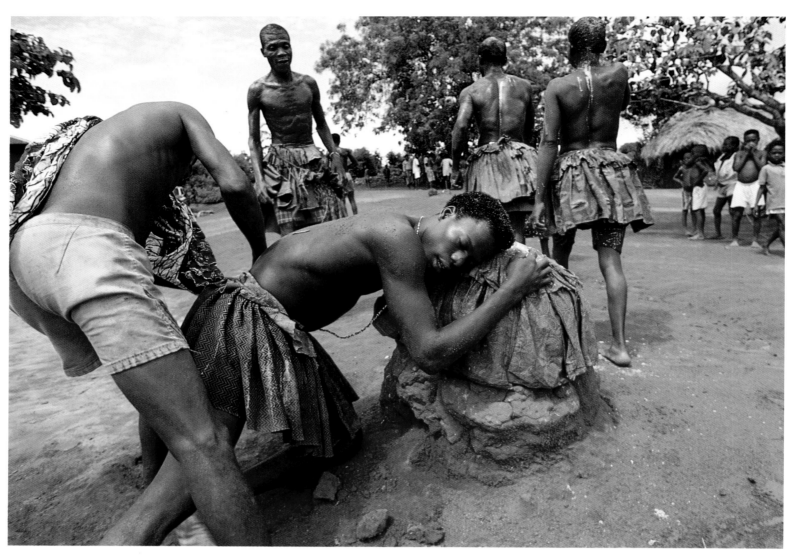

Voodoo initiates repeatedly lay their heads on the Legba fetish, which is covered with a fabric skirt. Through the divine messenger they enter into contact with the god Djagli. *Djassi*, a ritual fortifying elixir made of maize flour, palm-oil and secret herbs, is an indispensable accessory, not only in Djagli ritual but also in that of many other voodoo cults.

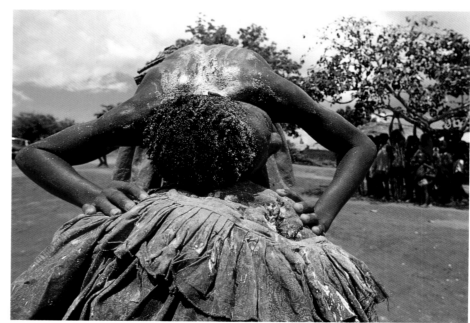

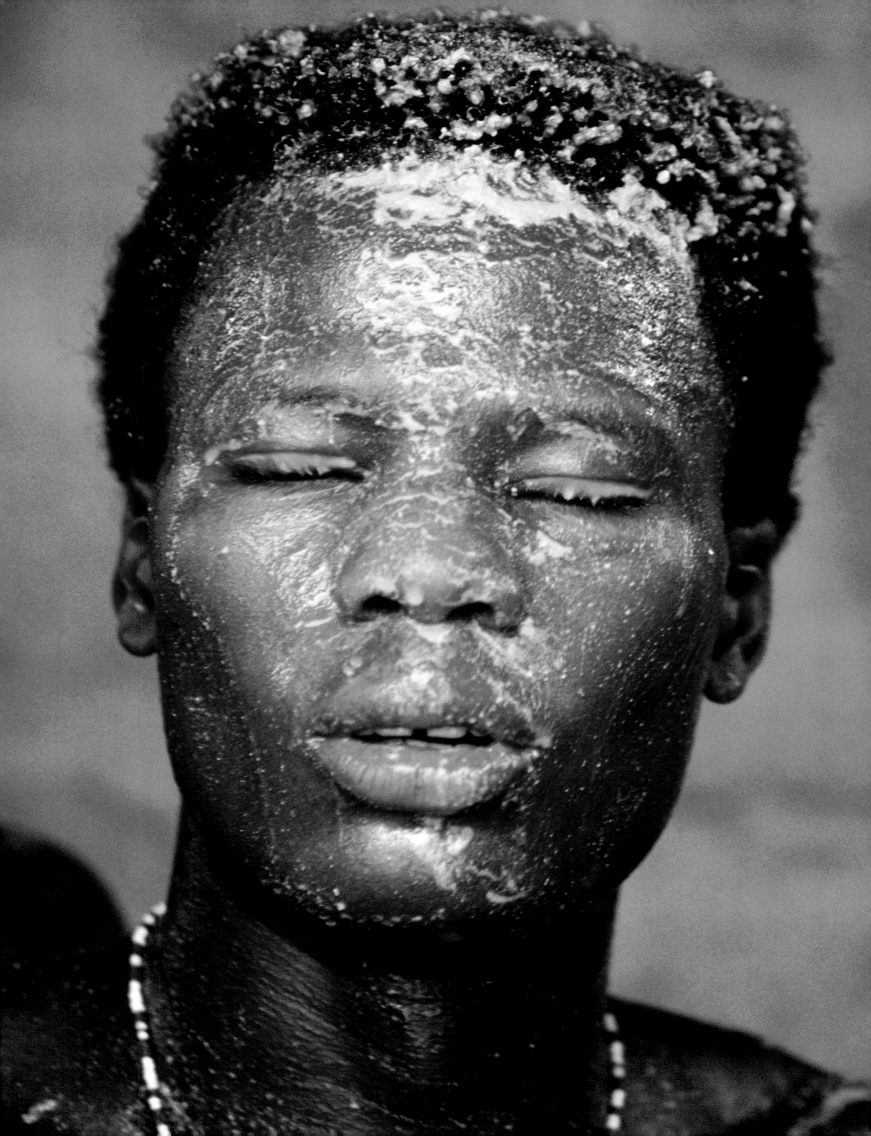

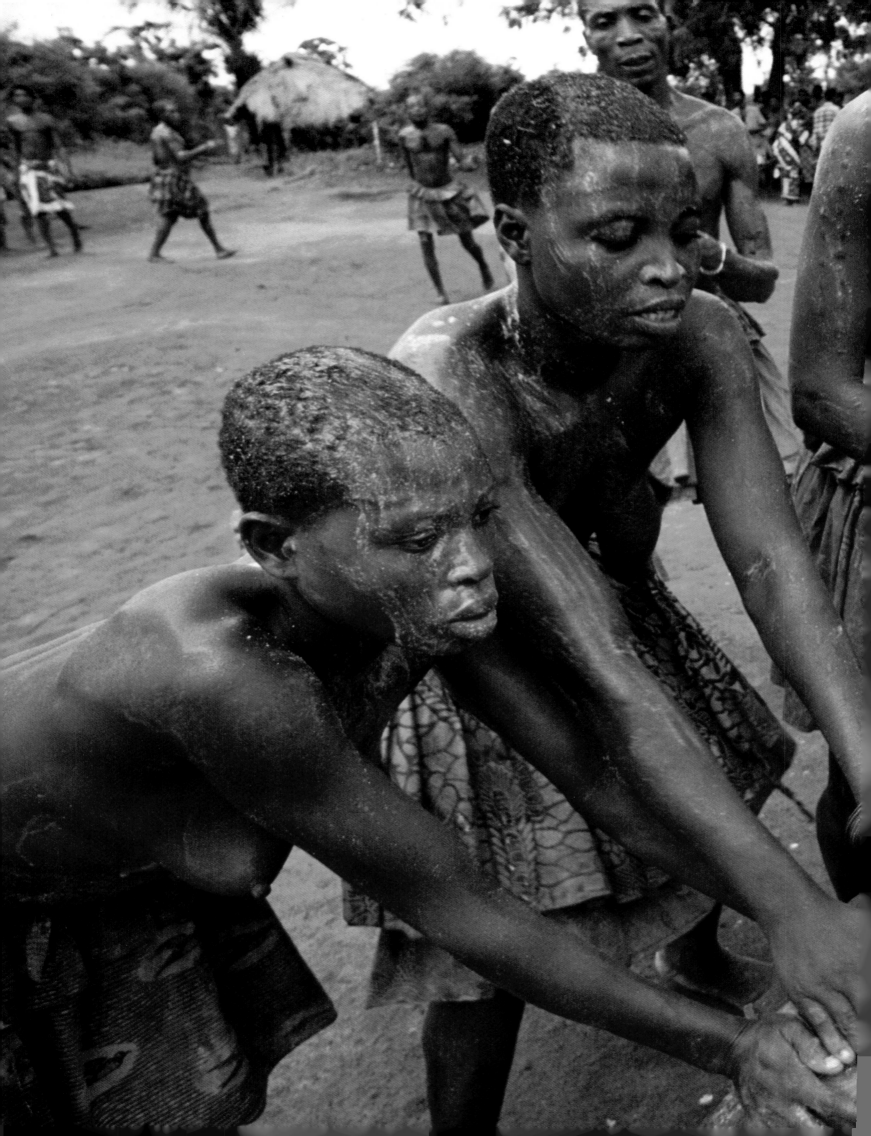

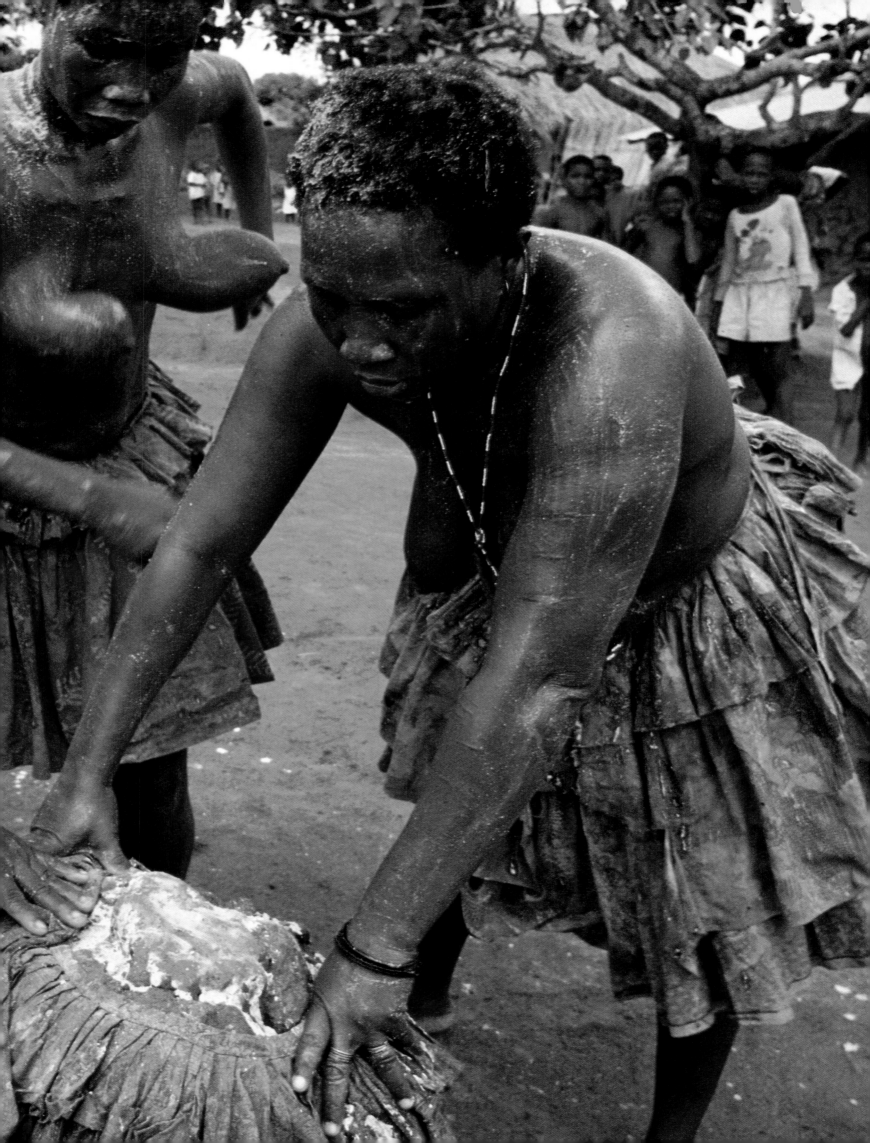

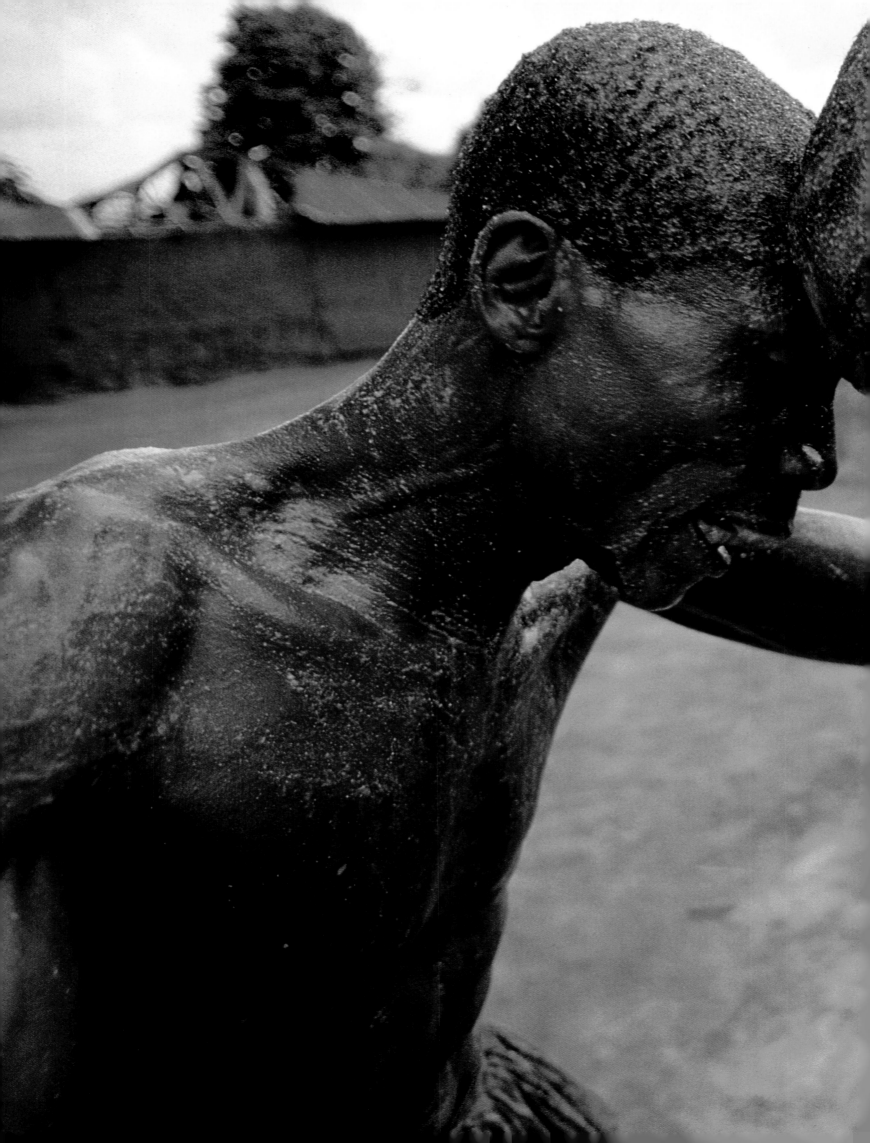

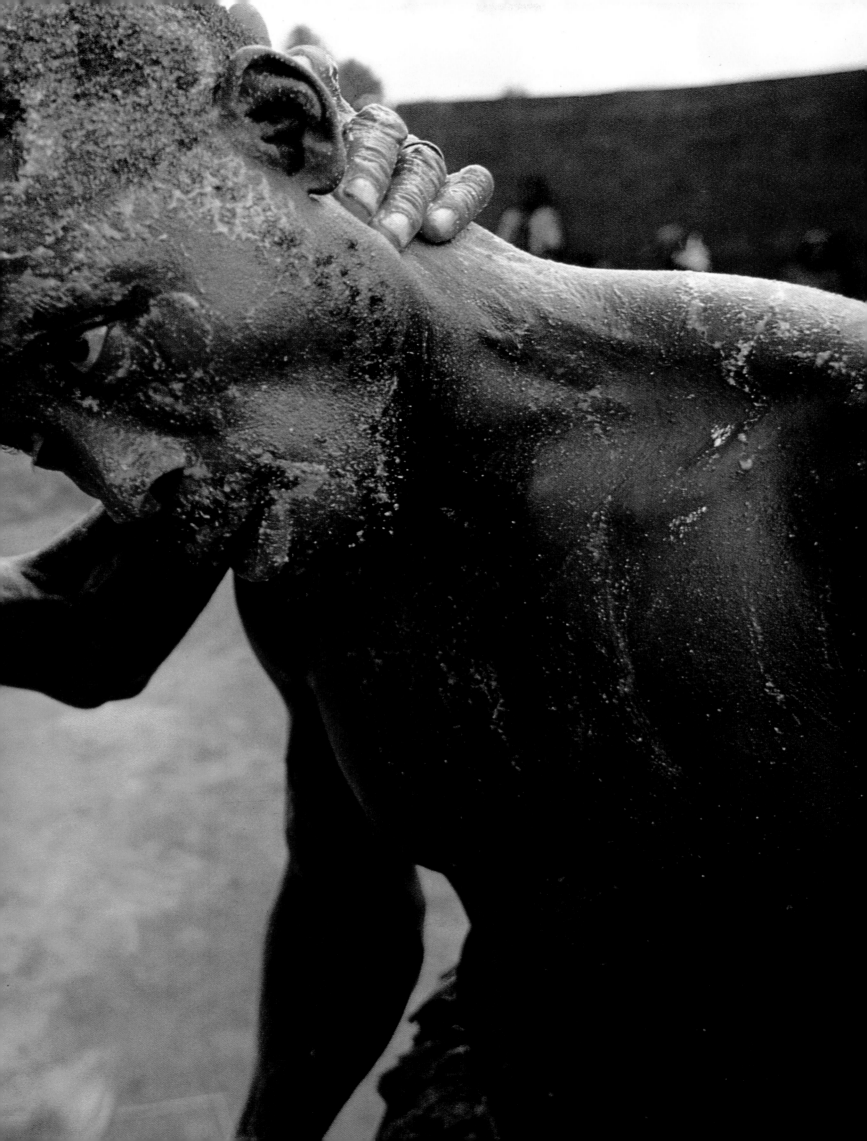

"Bovia, Bovia, Bovia," cry initiates as they dance or rub more *djassi* onto their sweating bodies. This magic word is supposed to renew their strength, making them as powerful as the brave warrior god Djagli.

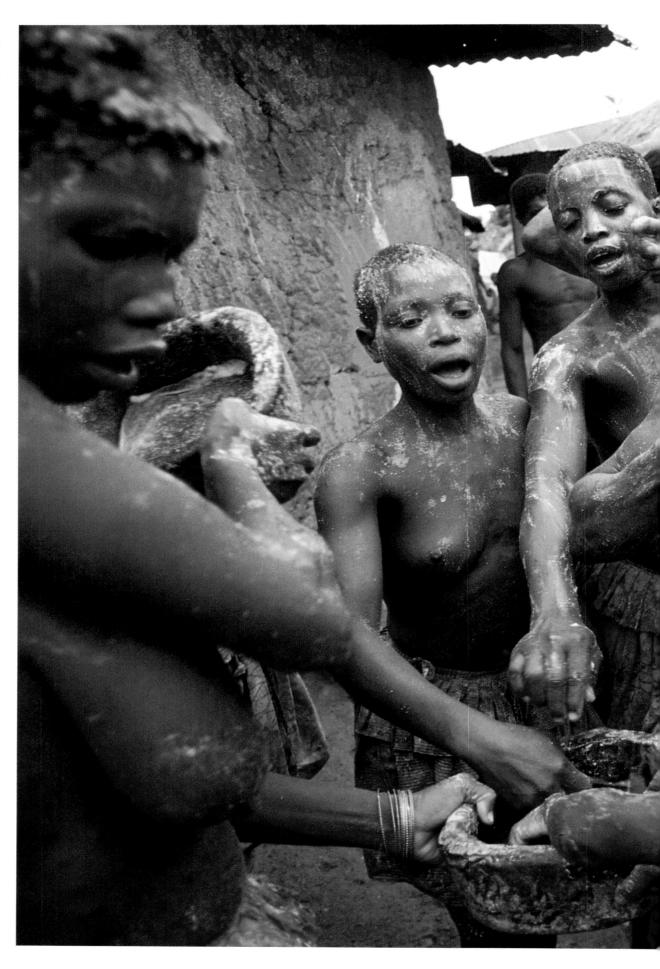

166

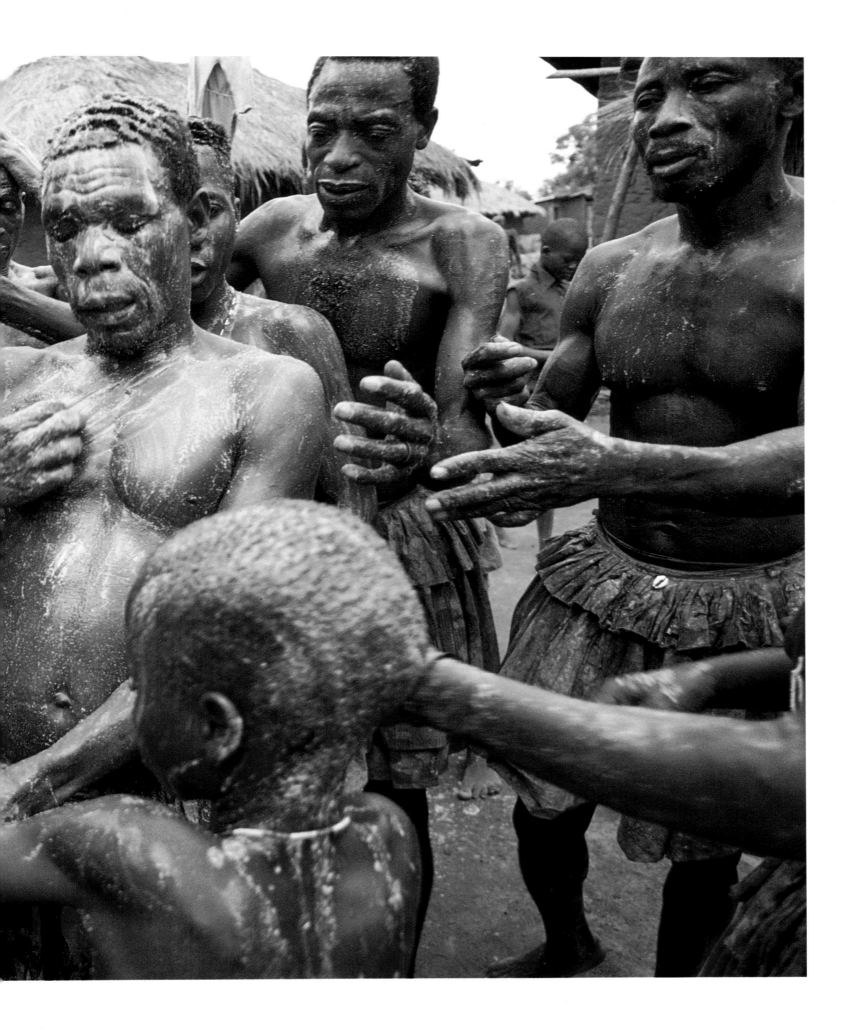

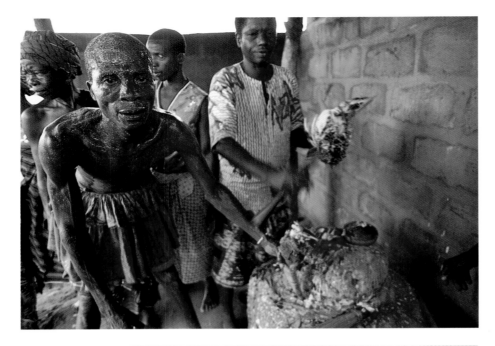

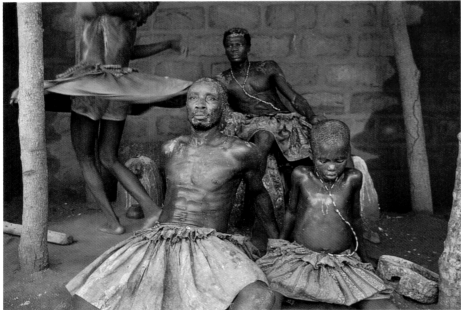

Voodoo initiates dance continuously for many hours, only occasionally taking a brief rest. But at last the ritual nears its end.

FOLLOWING PAGES: An old priestess, experienced in the practice of the Djagli cult, takes a swig of gin and then sprinkles some over initiates. Gradually the dancers emerge from trance, and dip their hands into consecrated water containing a herbal infusion.

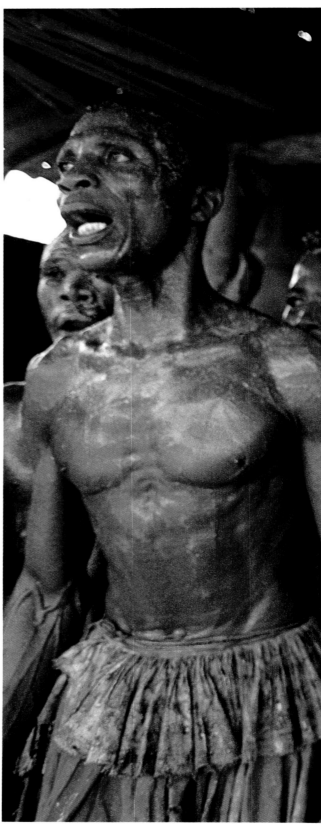

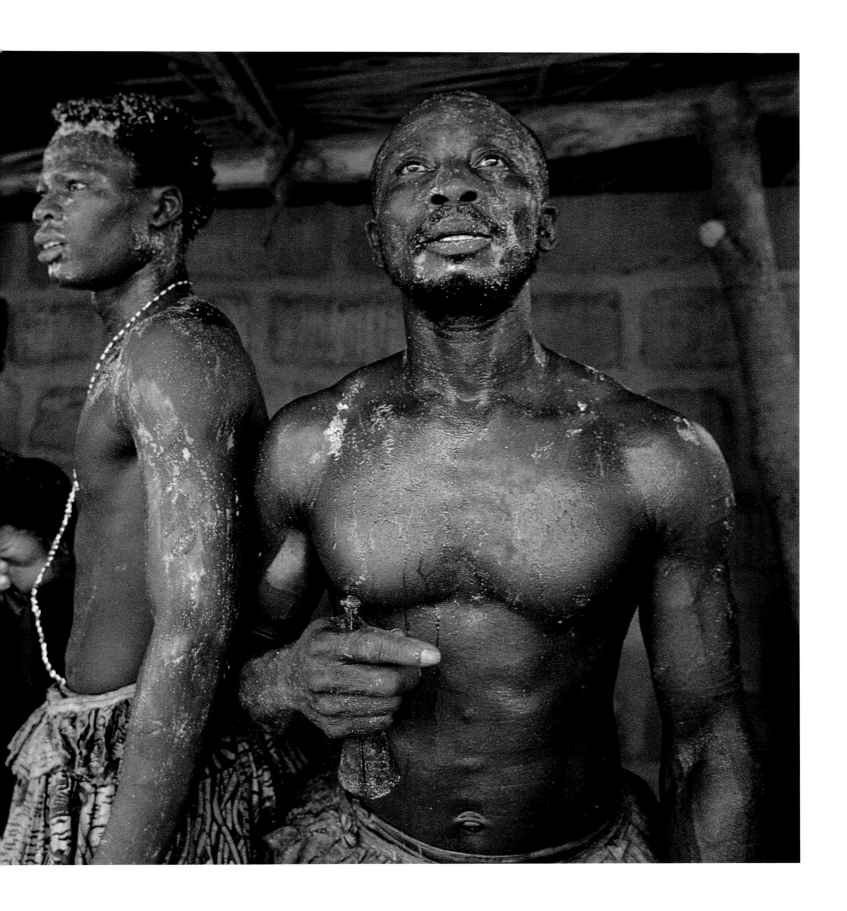

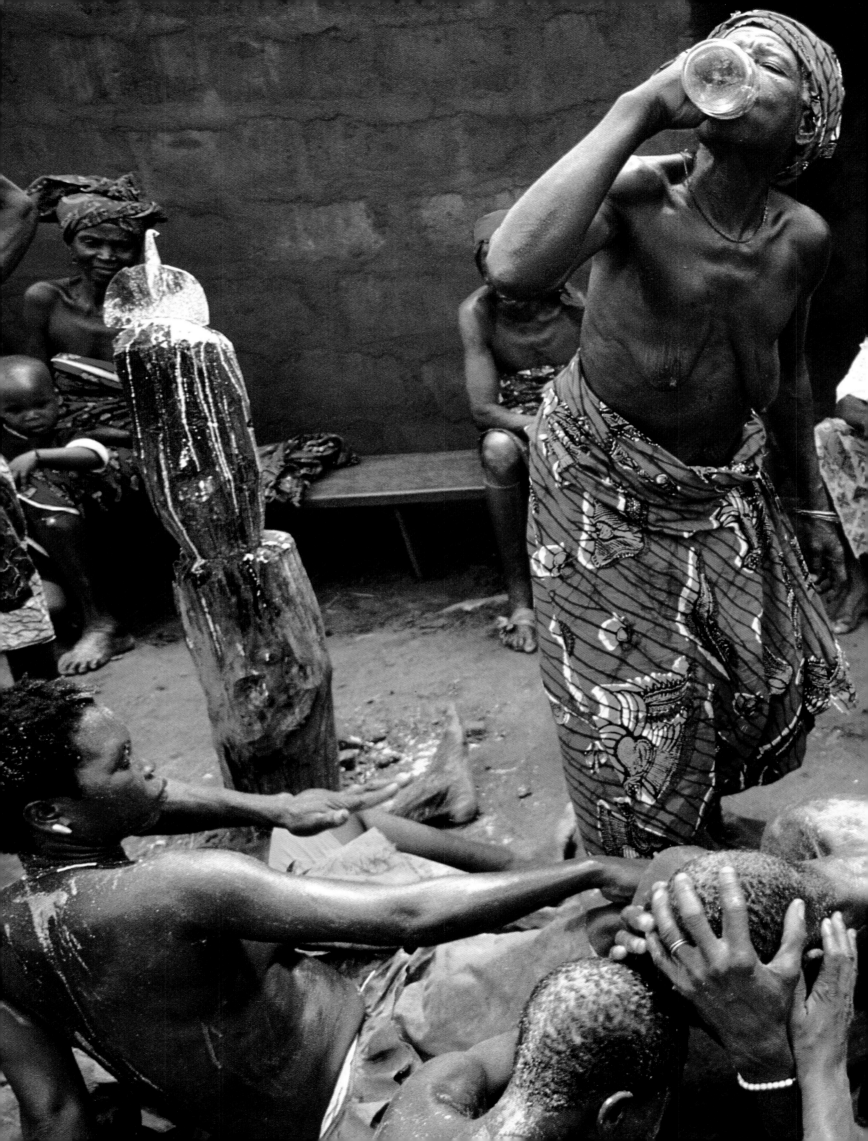

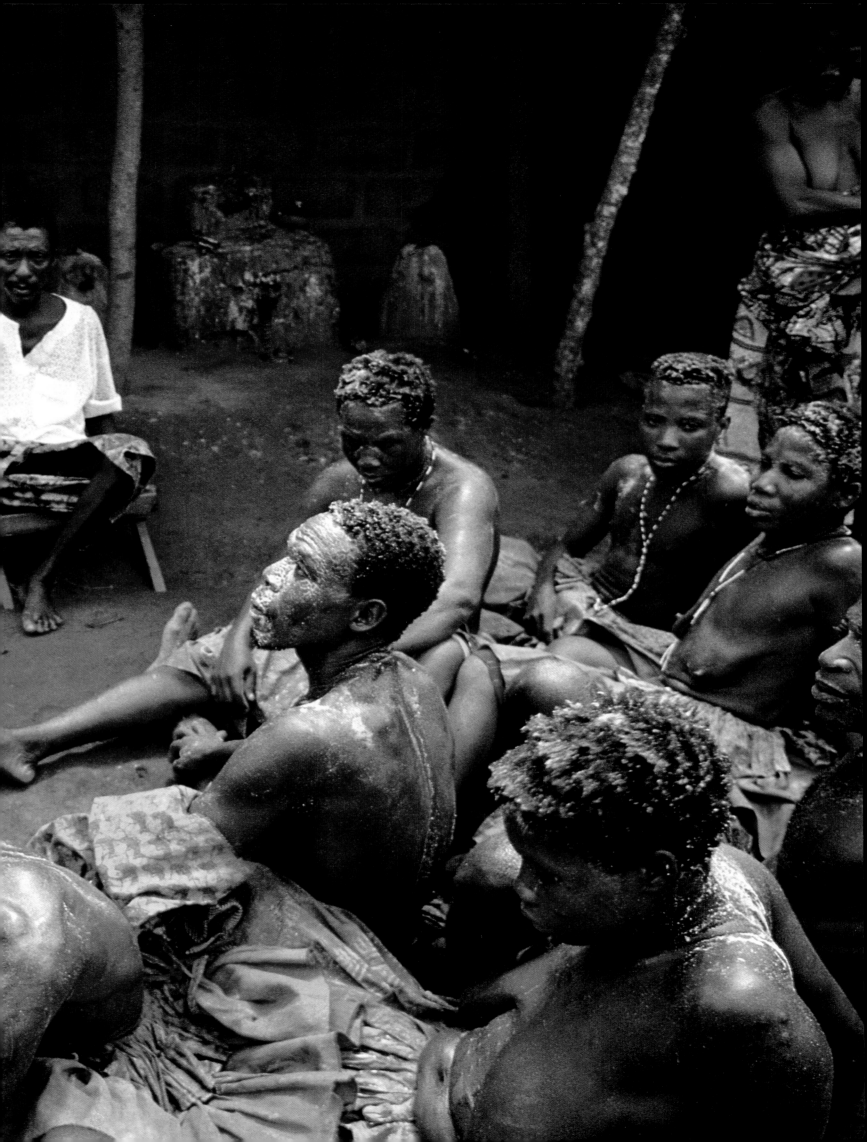

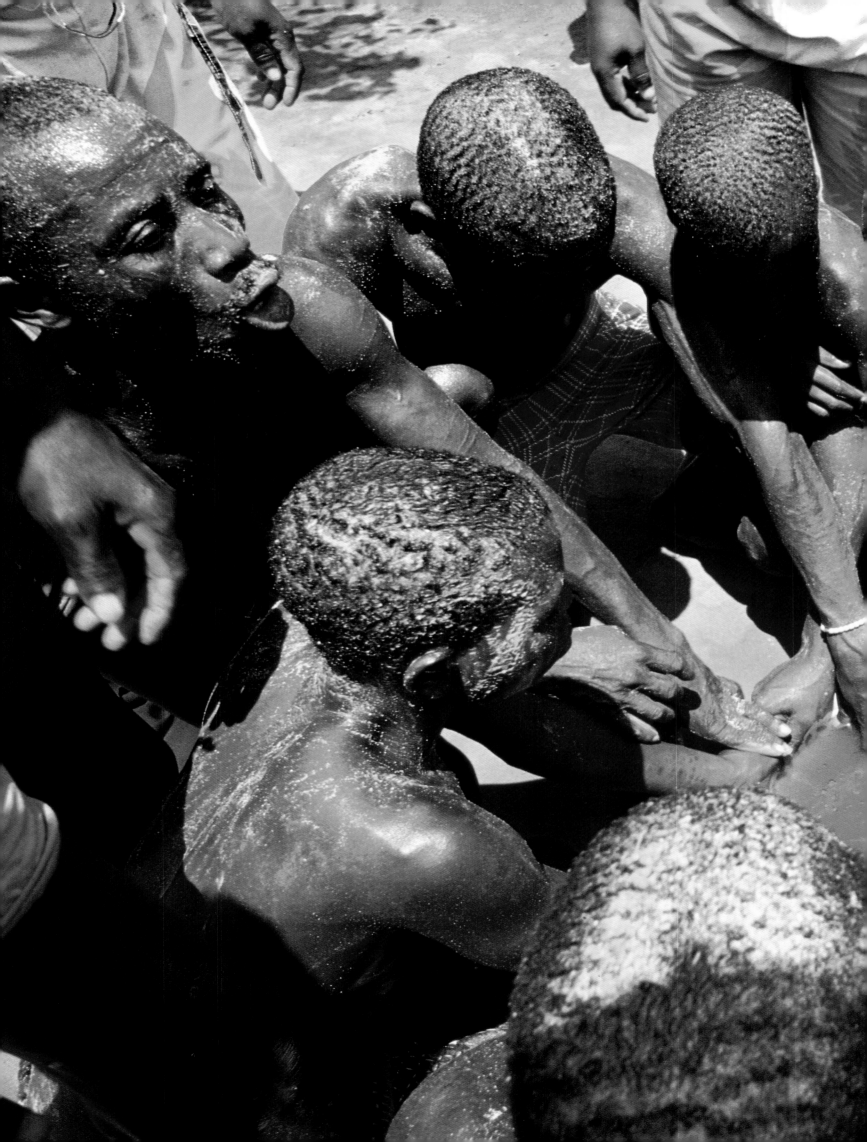

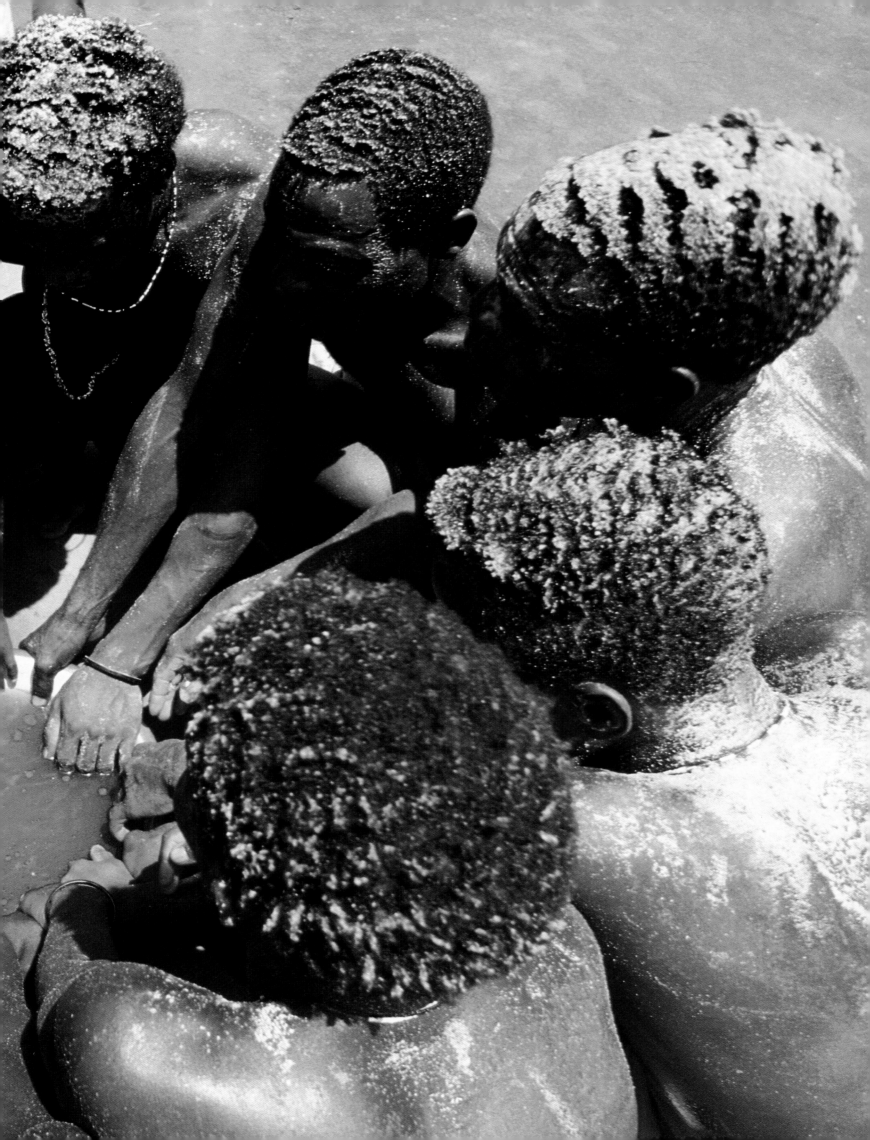

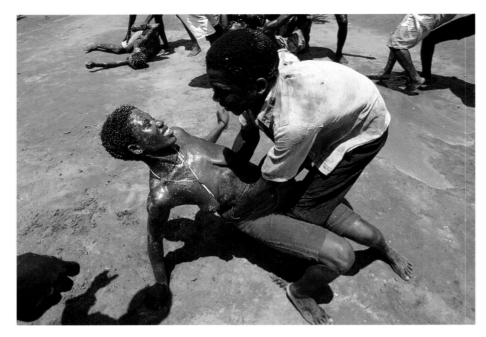

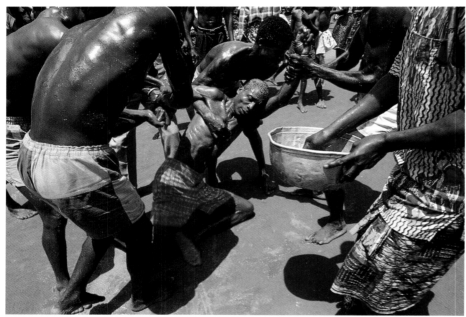

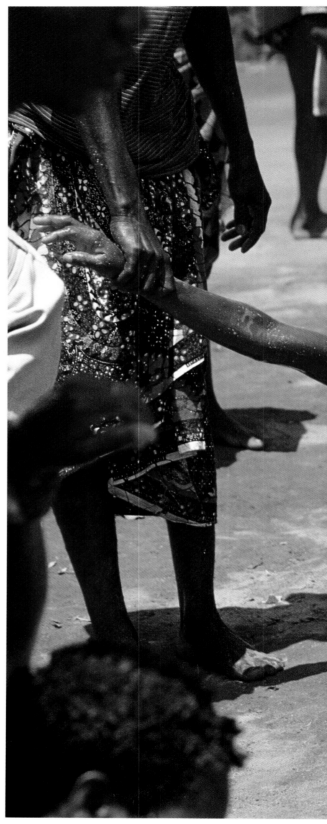

Voodooists often find it difficult to come out of trance, lying apathetically on the ground supported in the arms of others. During the ritual the dancers were on a level with the god Djagli, and consciousness of this, they say, affords one of the most acute sensations of happiness that human beings are capable of. They need no drugs to attain to the divine – only the power of faith.

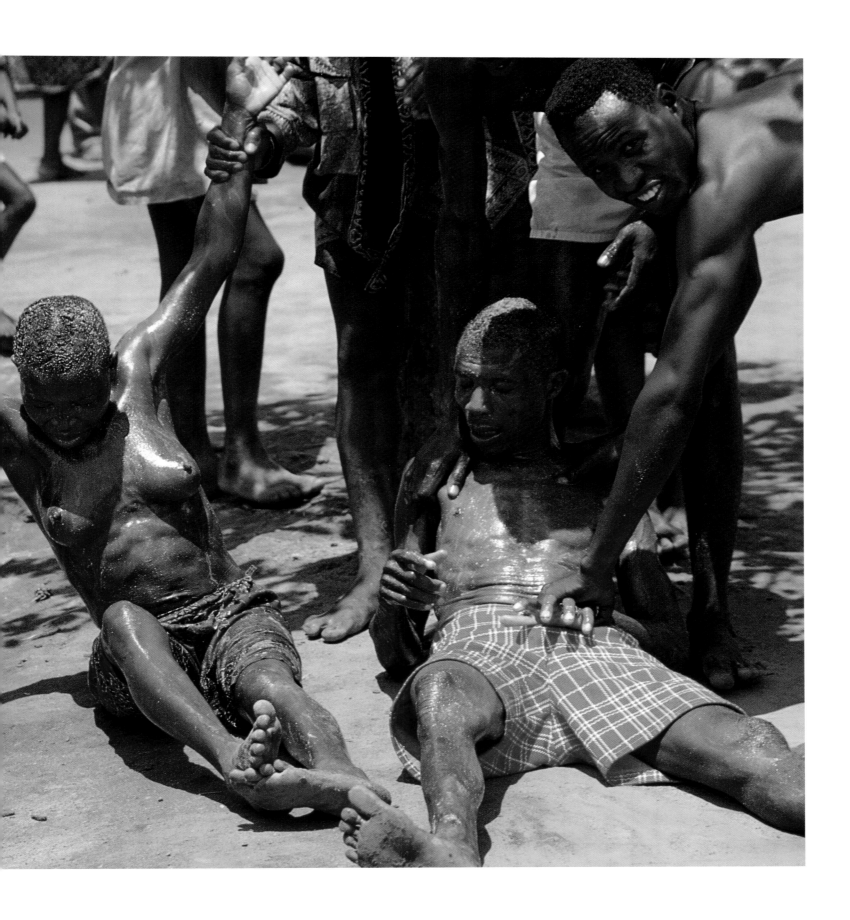

The god of plagues recommends condoms

SAKPATA

Every voodooist knows the ancient legend: one day Legba, the divine messenger, mocked the god Sakpata for having a lame leg, making him very upset and angry. He took an enormous broom and swept up an almighty cloud of dust containing germs and viruses of every variety. A storm blew up and carried the pestilence over all the world.

Until the early twentieth century, the scourge of smallpox claimed more lives among the people living on the Gulf of Benin than the bloody wars of the kings of Dahomey. No form of immunization was known, and village healers had no idea how to deal with the epidemics. In these circumstances the cult of Sakpata sprang up. According to tradition, wise men asked the Fa oracle what measures should be taken against epidemics. The reply: to prevent the spread of smallpox, strict orders and prohibitions must be proclaimed.

In order to give the preventive measures the necessary force, it was announced that each epidemic was a divine act: Sakpata was punishing people for their sins. In temples to Sakpata, statues of the pockmarked god were erected and annual sacrificial ceremonies held before them. Be good to Sakpata and Sakpata will be good to you, went the reasoning. Sakpata not only protected the people's health but also took care of social justice.

The centuries-old ritual is practised to this day. When the harvest is in, people gather in the villages to make sacrificial offerings at the shrines of ancestors and in front of a fetish of the god Sakpata. Today it is no longer smallpox but increasingly the Aids virus that threatens lives in Benin, and in voodoo ceremonies people call on Sakpata to save them from this new plague. Dancers in trance convey divine messages to onlookers, warning of the danger of contagion from the virus, and from time to time even expressly imploring men to use a condom in sexual intercourse.

A priest dances to the glory of Sakpata. According to legend this ancient voodoo god, despite being lame, was a master of dance. When Sakpata was mocked for his lameness by the divine messenger Legba, he swept up a cloud of dust that spread over the entire world, bringing deadly epidemics with it.

FOLLOWING PAGES:
Before a ceremony to entreat the protection of the god of plagues, the inhabitants of Gongohoué make sacrificial offerings to their ancestors, usually represented by statuettes.

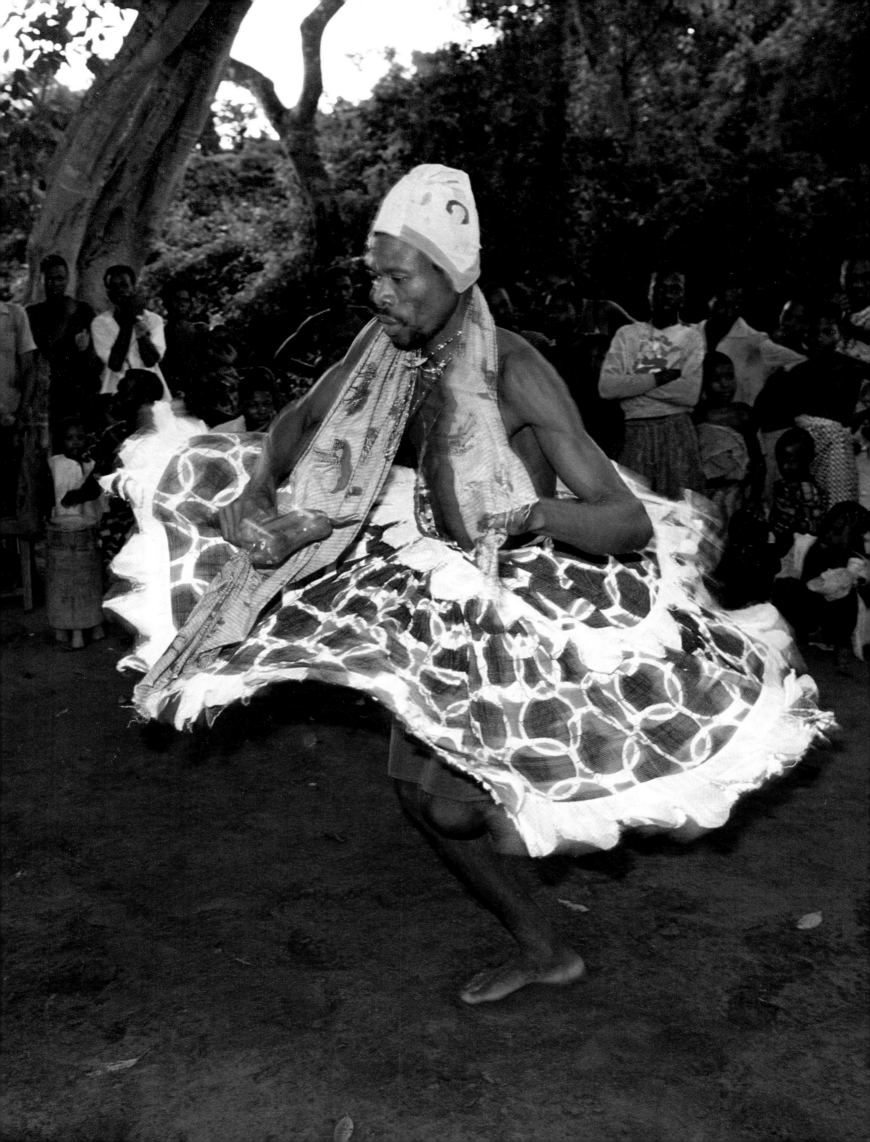

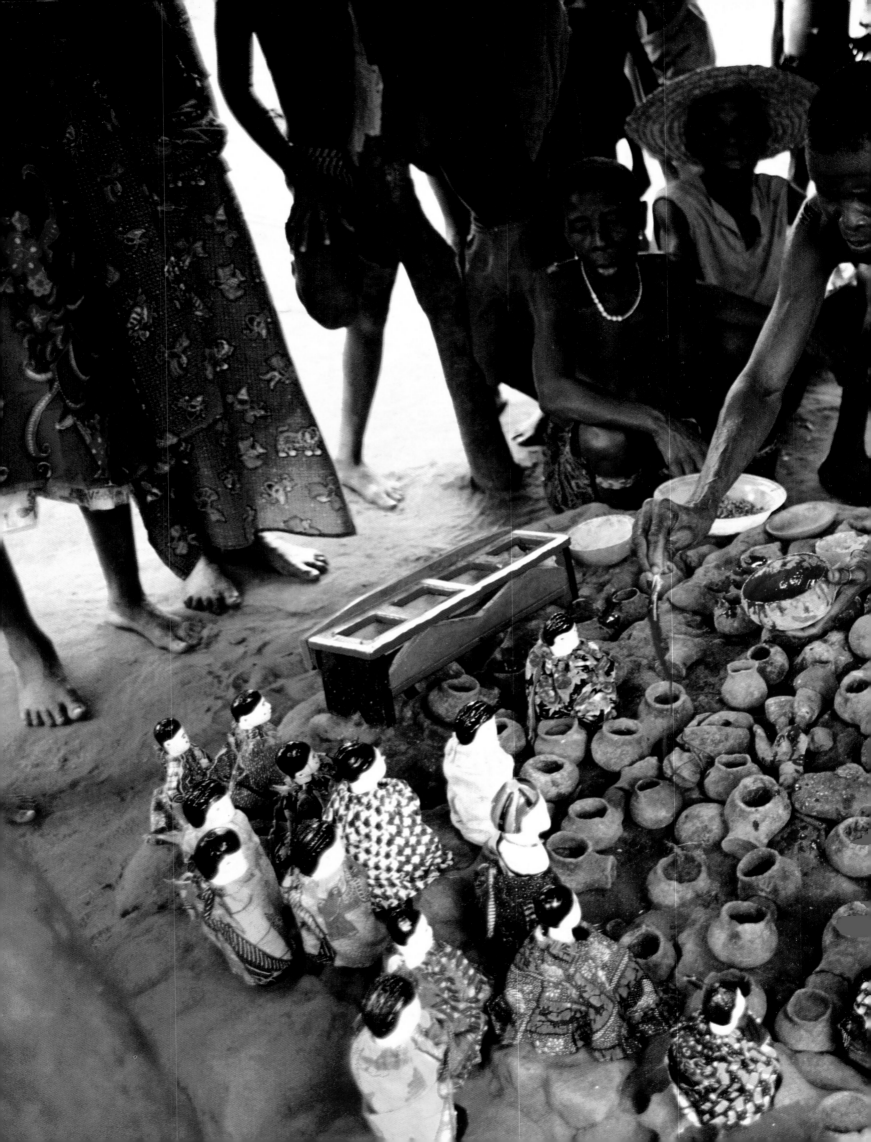

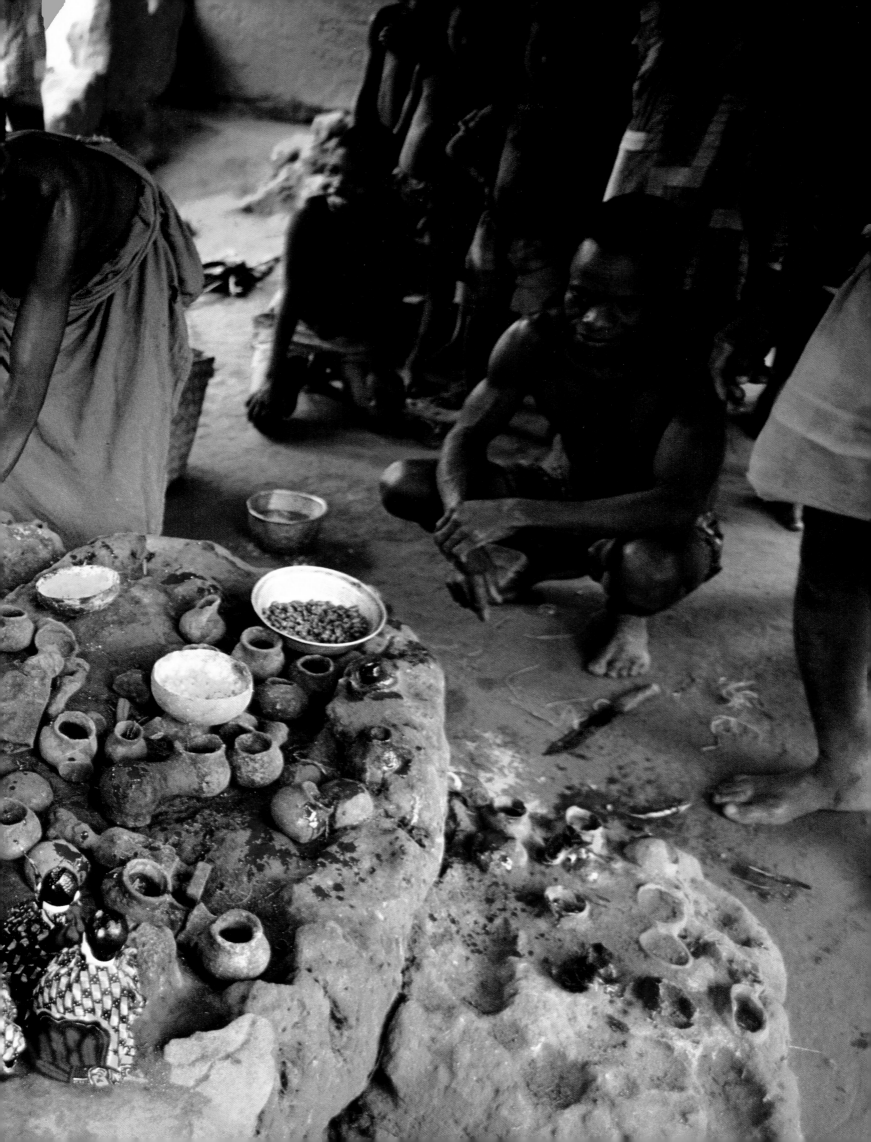

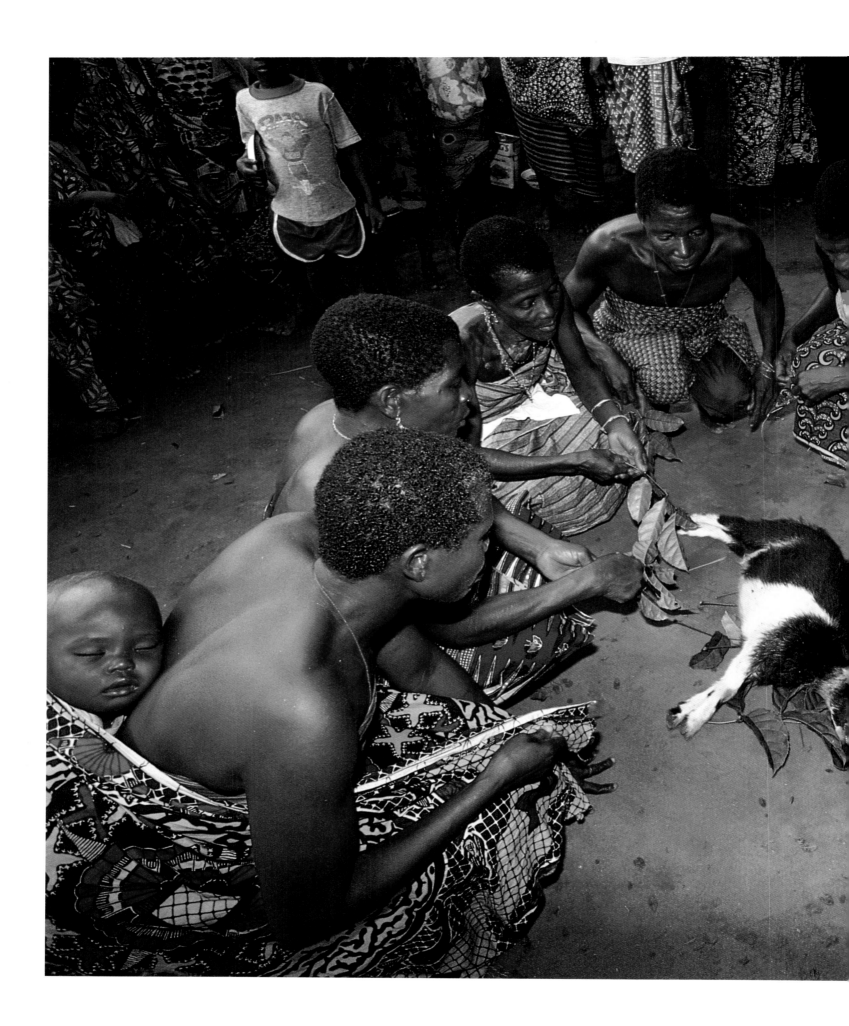

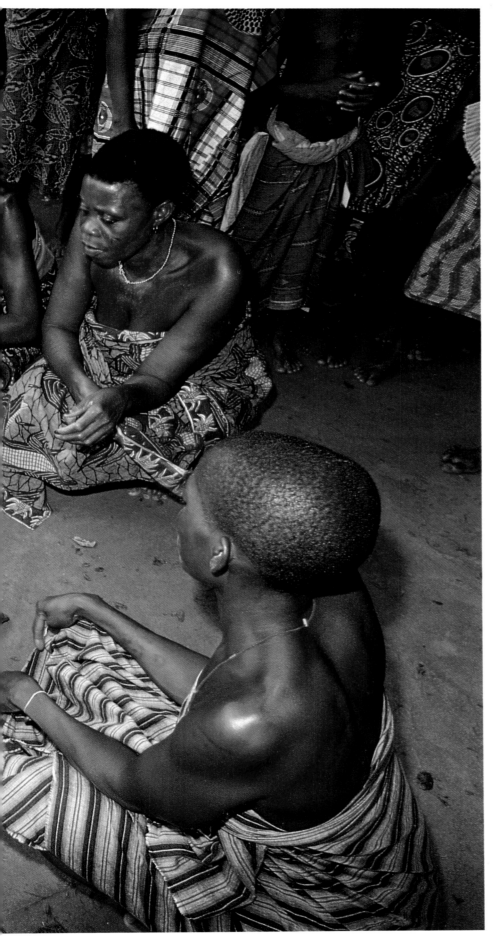

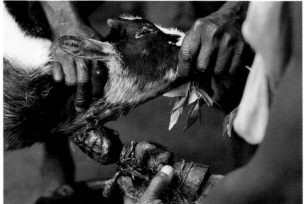

The ceremony begins with
an enactment of "Voodoo
Kills a Goat". An initiate
dressed as a hunter tracks
down a wild beast for sacri-
fice to Sakpata, but this time
returns with a small, very
domesticated one. After rit-
ual slaughter in the temple
over a fetish, it is laid in the
place where the ceremony is
to be held. Women kneel in
a circle round the dead ani-
mal and sing to appease its
spirit. This is an essential
condition for the success of
the sacrifice, and for Gongo-
houé to be spared from
future epidemics.

FOLLOWING PAGES:
The followers of Sakpata
singing and ringing bells on
their way to the temple,
dressed on this occasion in a
medley of colours; usually,
in voodoo cults, white
predominates. Necklaces
and bracelets of beads or
cowrie-shells are worn.

Like Sakpata in the legend,
the priest furiously sweeps
the ceremonial spot –
prelude to a morality play in
which voodoo initiates will
warn the villagers of
Gongohoué about the Aids
virus.

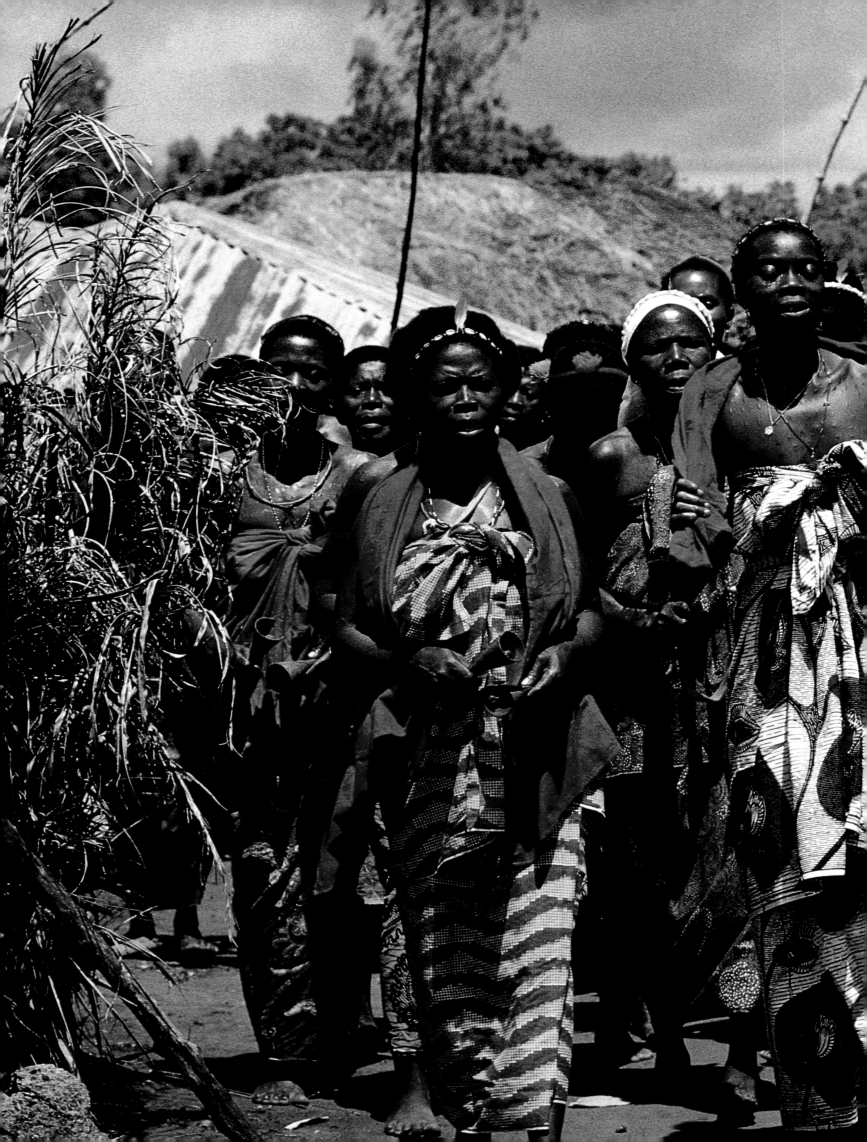

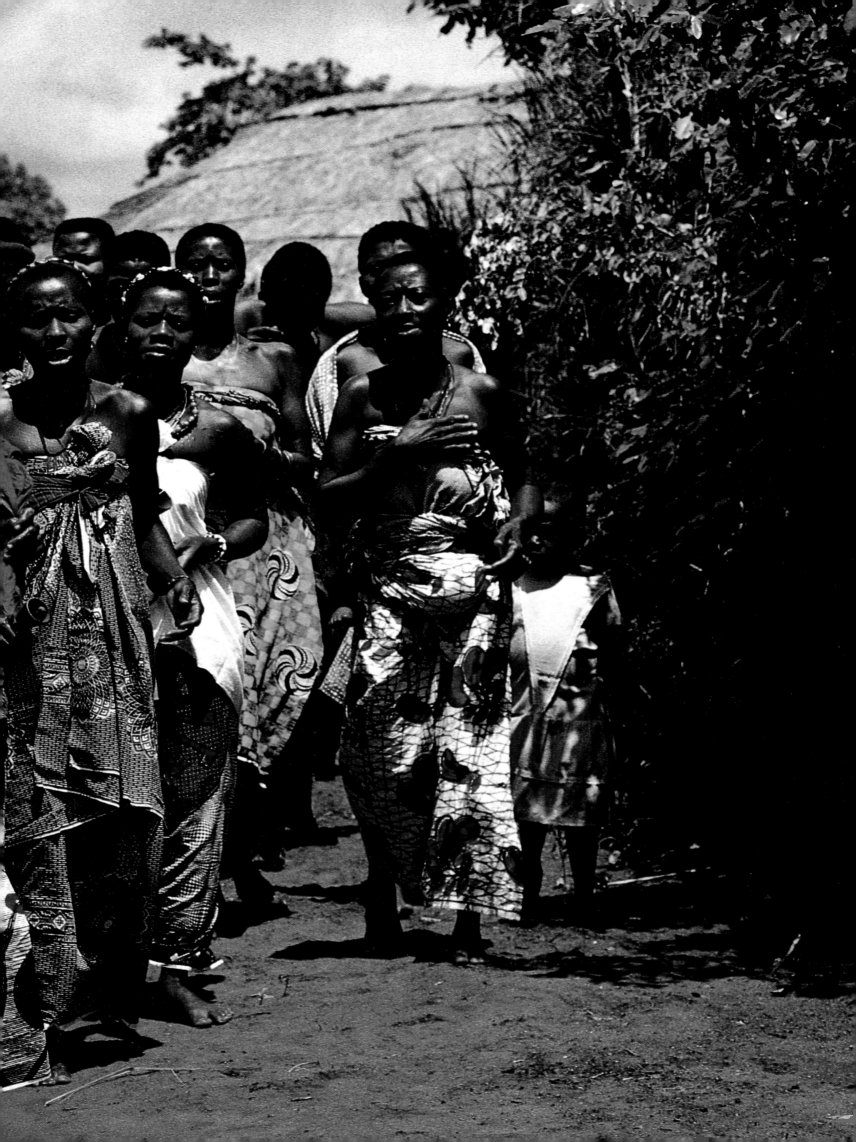

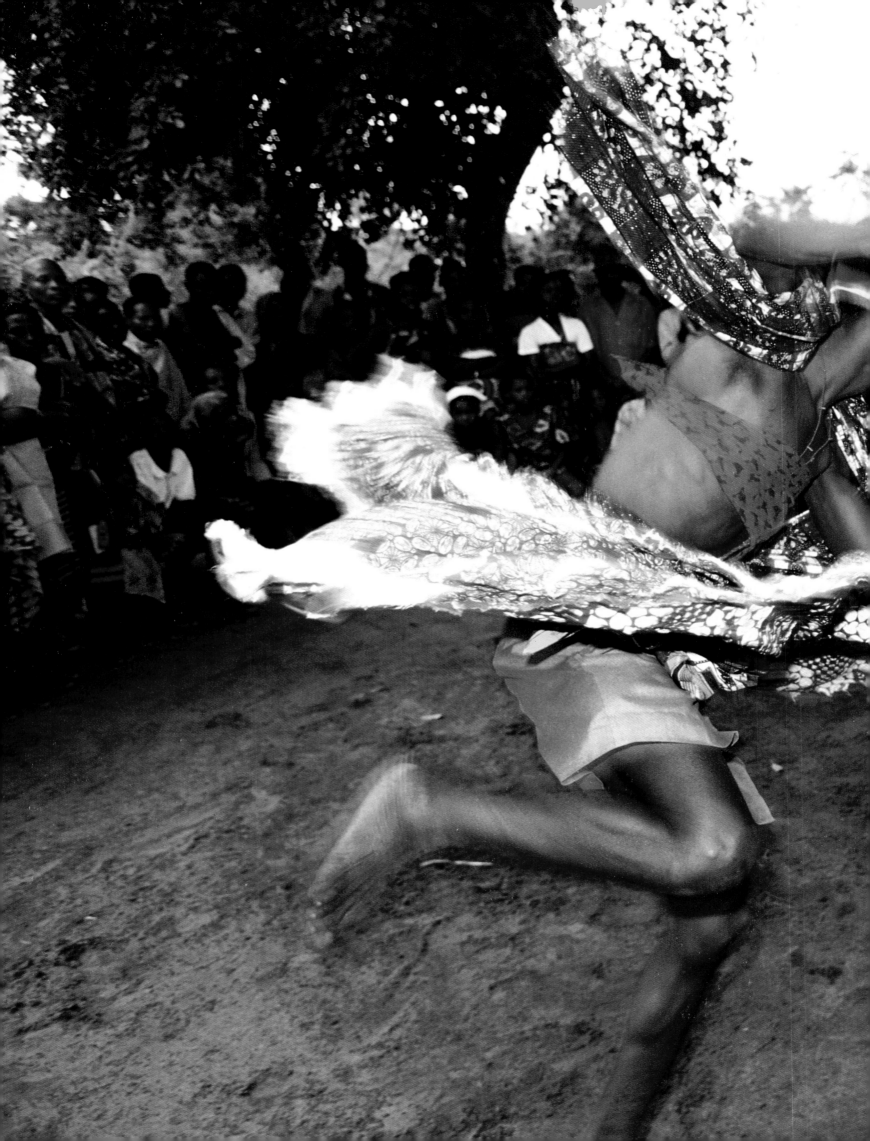

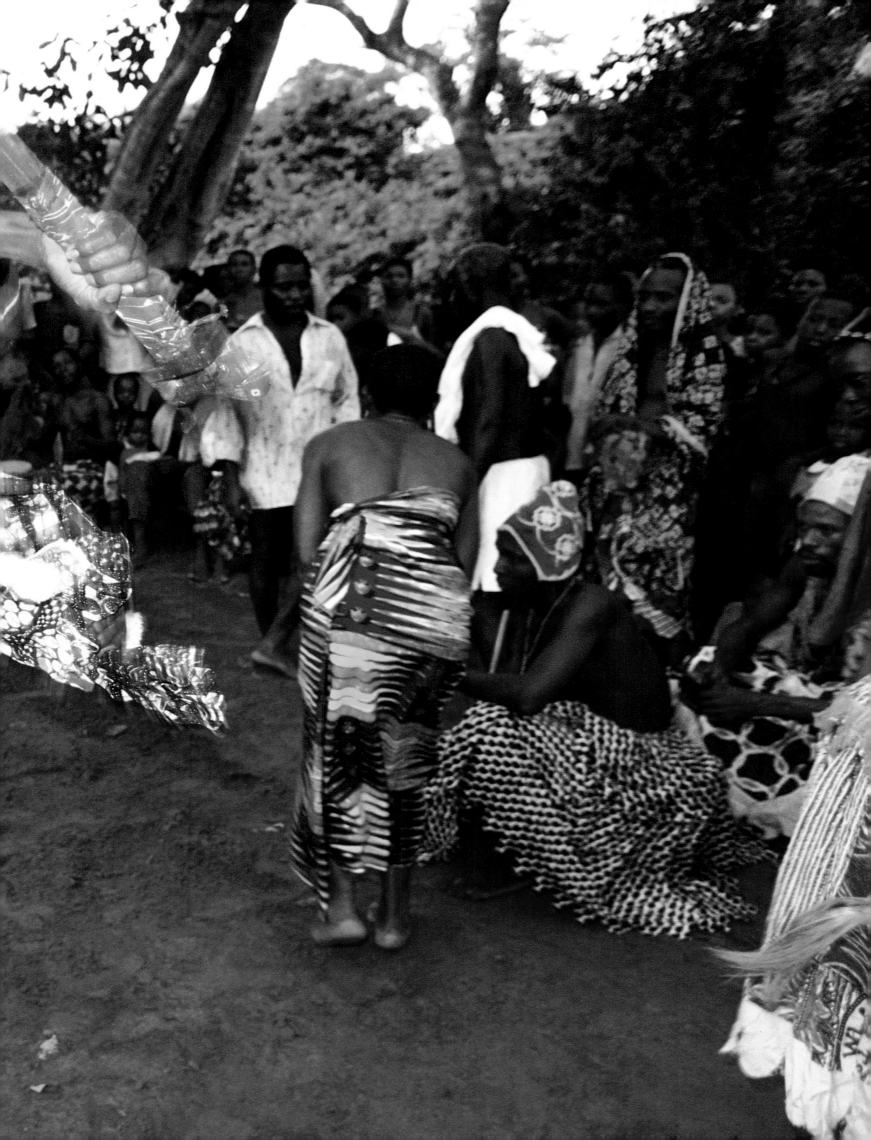

Two Sakpata initiates imitate the act of love – a pleasure fraught with risk in the age of Aids. In Benin over 60,000 people are officially recorded as infected, but the actual number must be many times higher. Sakpata initiates inform the villagers about how the Aids virus is spread. Their message from the god of plagues: "Aids can kill you. Protect yourselves. Use condoms."

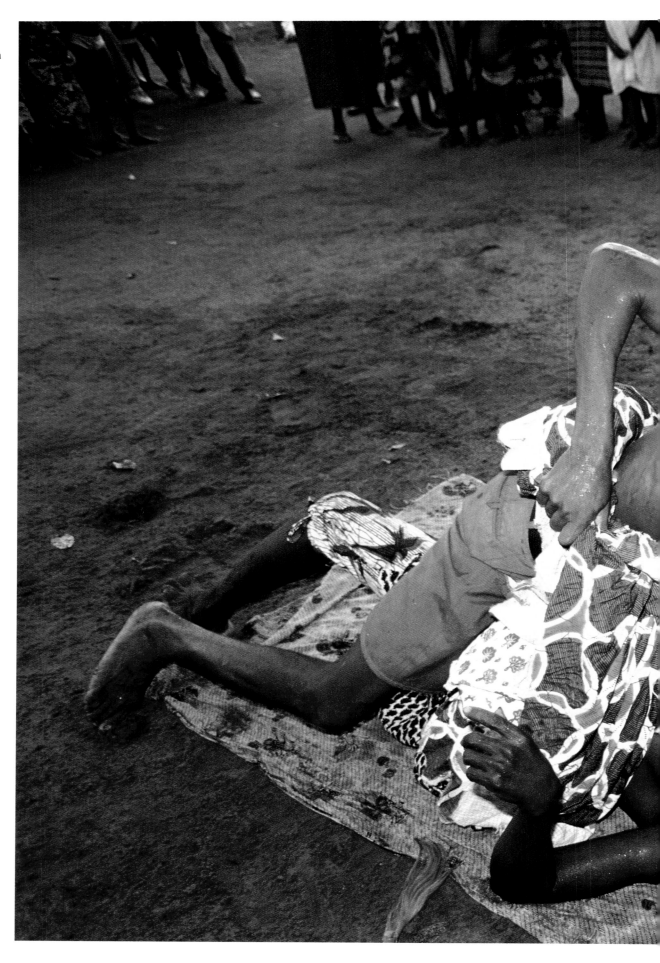

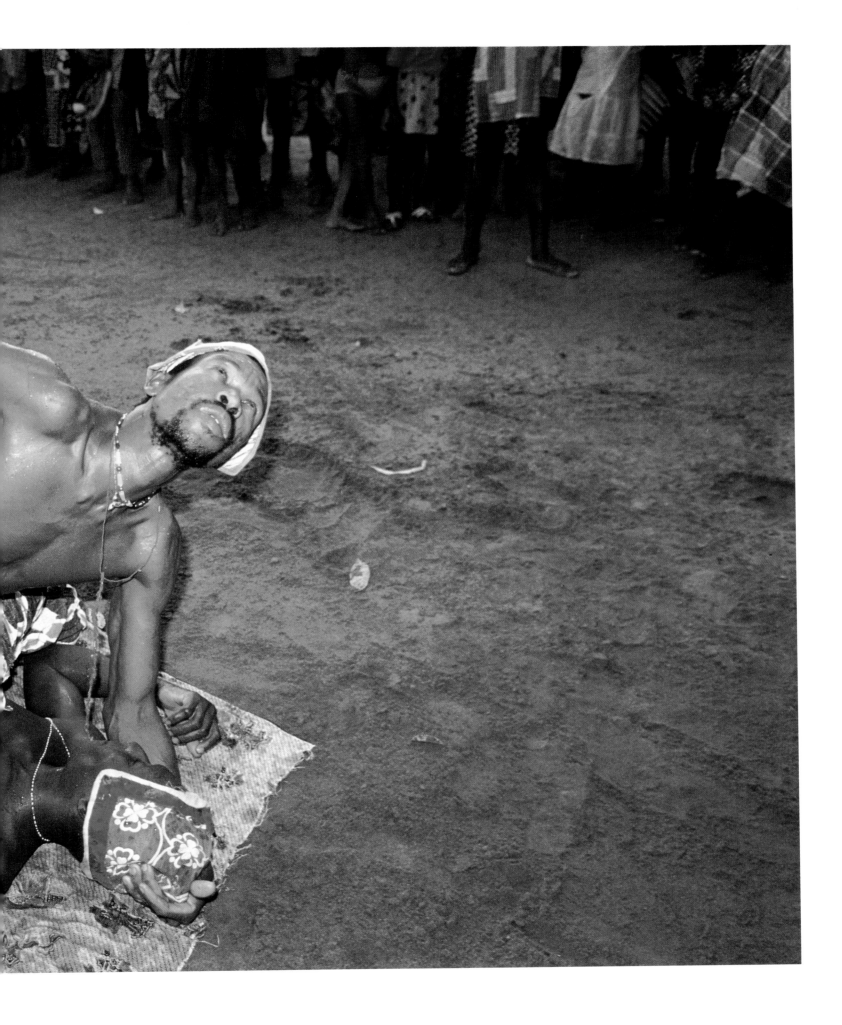

The god of thunder punishes with lightning

SHANGO

Shango, to use his Yoruba name (or Heviosso in the language of the Fon), is a very strict god, who can become violent in the interests of divine justice. The "God of Thunder" is symbolized by a ram. The Shango priests carry a double-headed axe and, like ordinary initiates, wear red and white garments and brightly coloured necklaces of mussel-shells.

Besides giving his followers spiritual protection, Shango directs lightning at anyone who commits a punishable offence. The African voodoo guide Paul Akakpo gives an account of such a case dating from 1992, in Cotonou. A well-to-do woman was robbed of money and jewellery by one of her servants. Because each of the girls denied guilt, their mistress decided to "practise voodoo".

She went to a Shango temple and asked the priest there to get Shango to punish the thief. The priest consulted the Fa oracle and then gave the name of a young servant girl – the thief, according to Akakpo. The woman was told to give the thief one further opportunity of returning the money and jewellery or their equivalent. Should the girl not come forward, Shango's lightning would strike her. The woman did as she had been bidden, and undertook to leave some bottles of lemonade and kola nuts in the Temple of Shango as offerings should she succeed in recovering the stolen goods or having the thief punished.

Two weeks later, during a light shower, the house of the suspect was struck by heavy lightning and she was hurled onto the street. Her clothes were charred; and she was dead. The neighbours took care not to come too near the body so as not to be burnt or poisoned by smoke from Shango's lightning. Only a priest of Shango was allowed to remove the corpse. The spot on which Shango had dispensed justice was ceremonially cleansed, so that innocent passers-by should come to no harm.

In front of the Temple of Shango at Sakete, a small village to the north of Porto Novo, stands a brightly painted concrete statue of the god. In his right hand he holds the double-headed axe which identifies him, and in his left a bowl into which offerings of palm-oil are poured.

FOLLOWING PAGES: Once a week the Shango priestess, wearing a characteristic red apron, leads the faithful to devotions in the temple. She is flanked by her son and white-clad initiates. Red and white are the colours of the god of thunder.

188

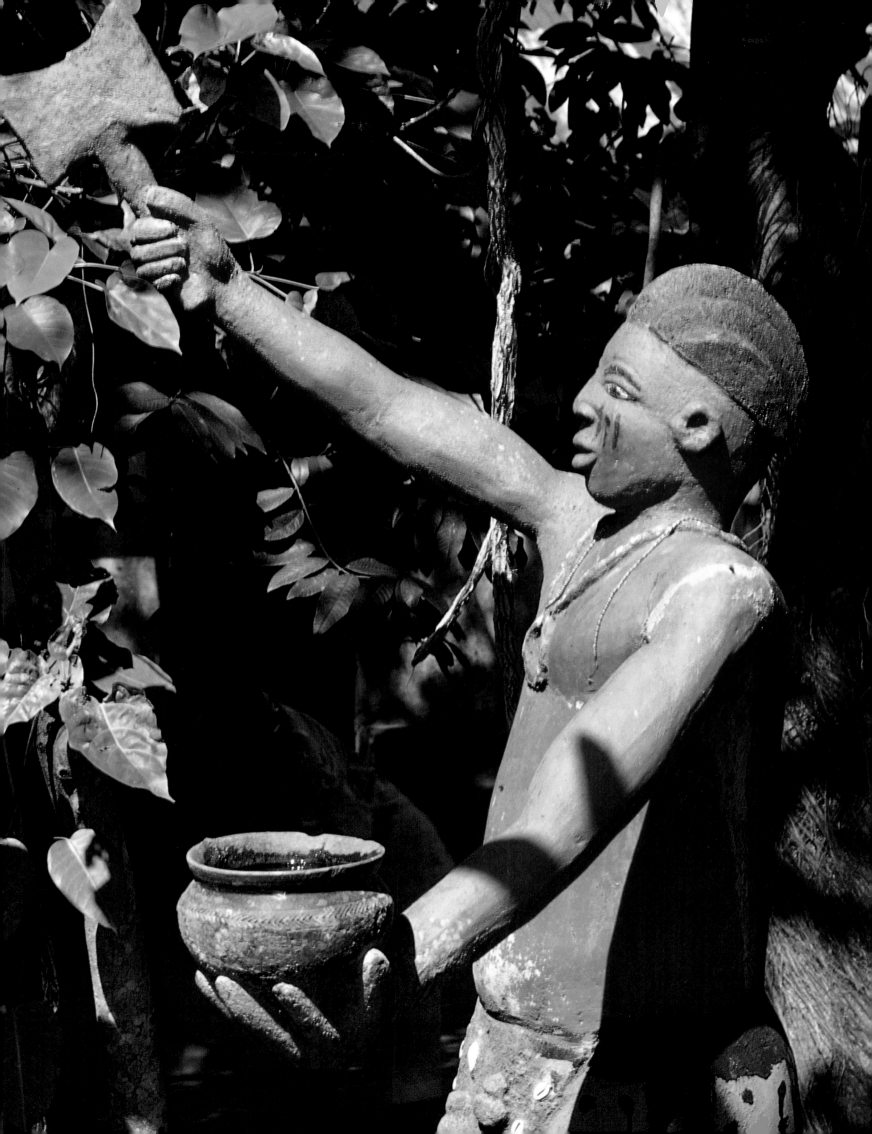

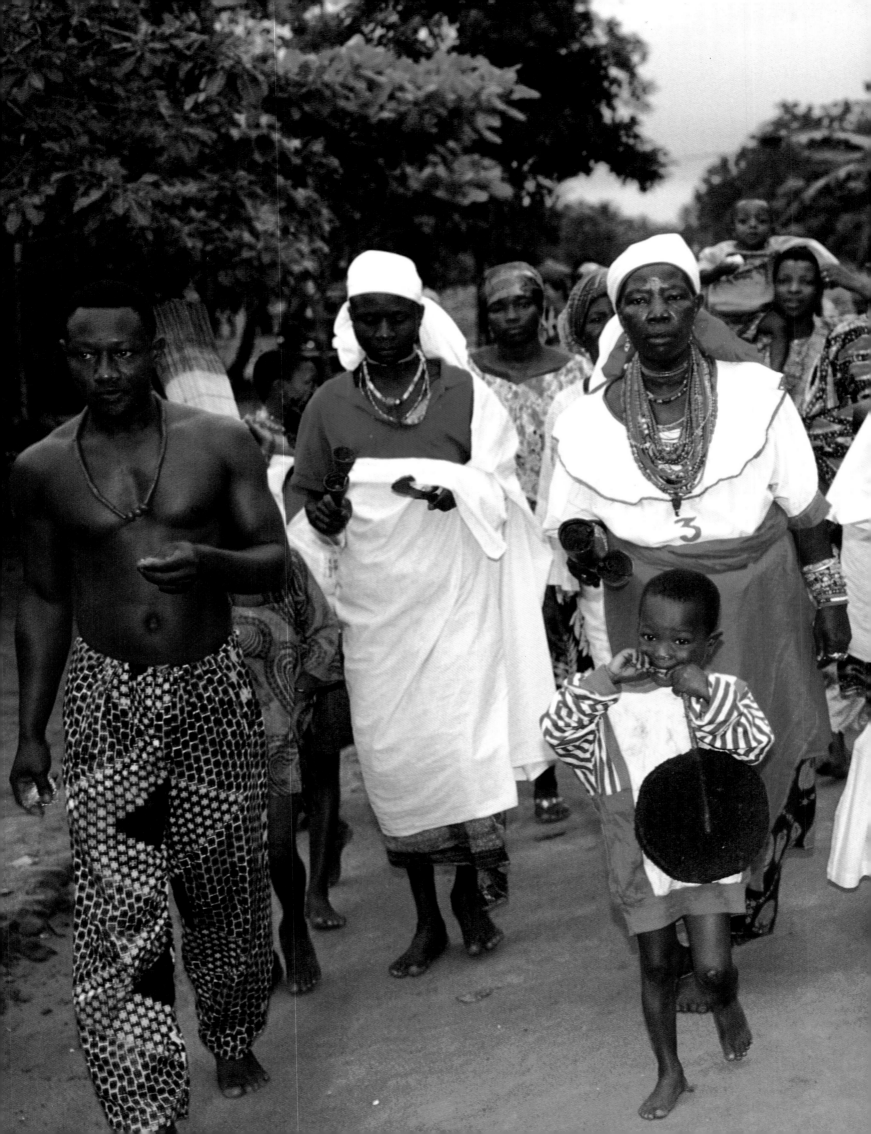

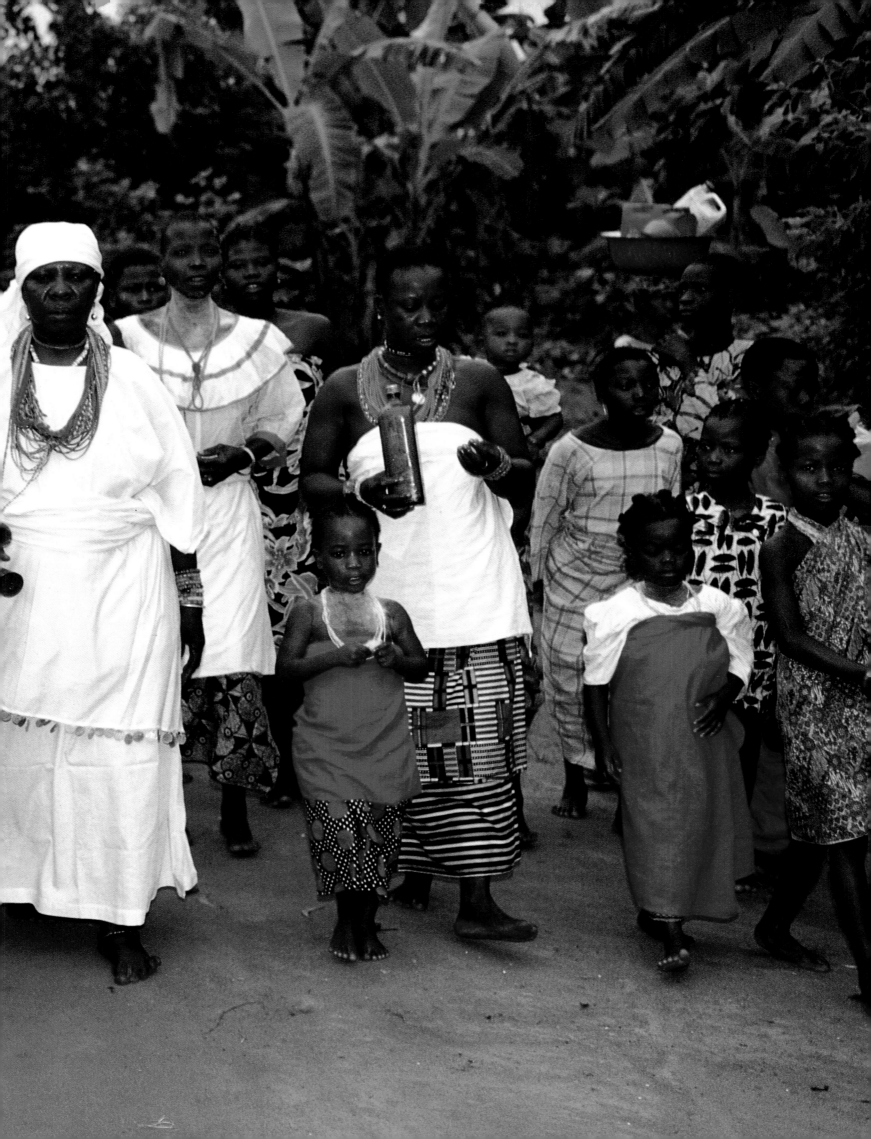

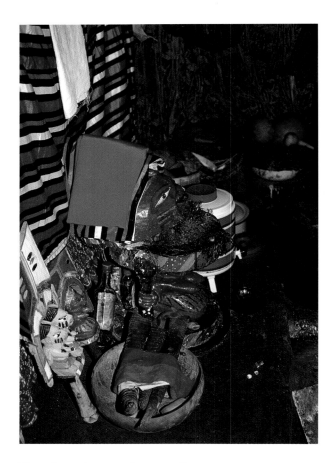

The priestess's son makes an offering of kola nuts to the Shango fetish, as an old woman provides a bowl of holy water from the cold storage vessel to the right of the fetish.

FOLLOWING PAGES: Two small girls, the youngest members of the Shango community, prostrate themselves before the priestess to receive her blessing.

Shango is fond of hard liquor. Even the youngest initiates of his cult, identifiable as such by their red and white necklaces, are given a sip of gin at the close of the ceremony.

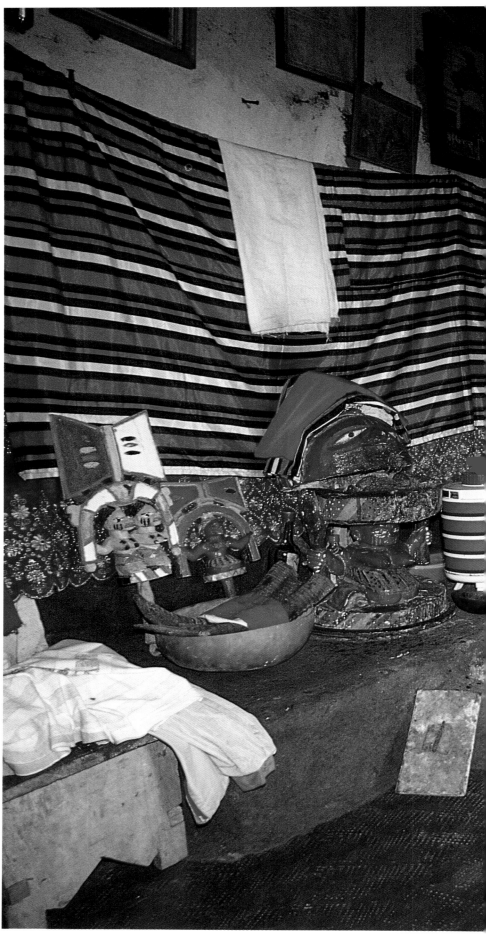

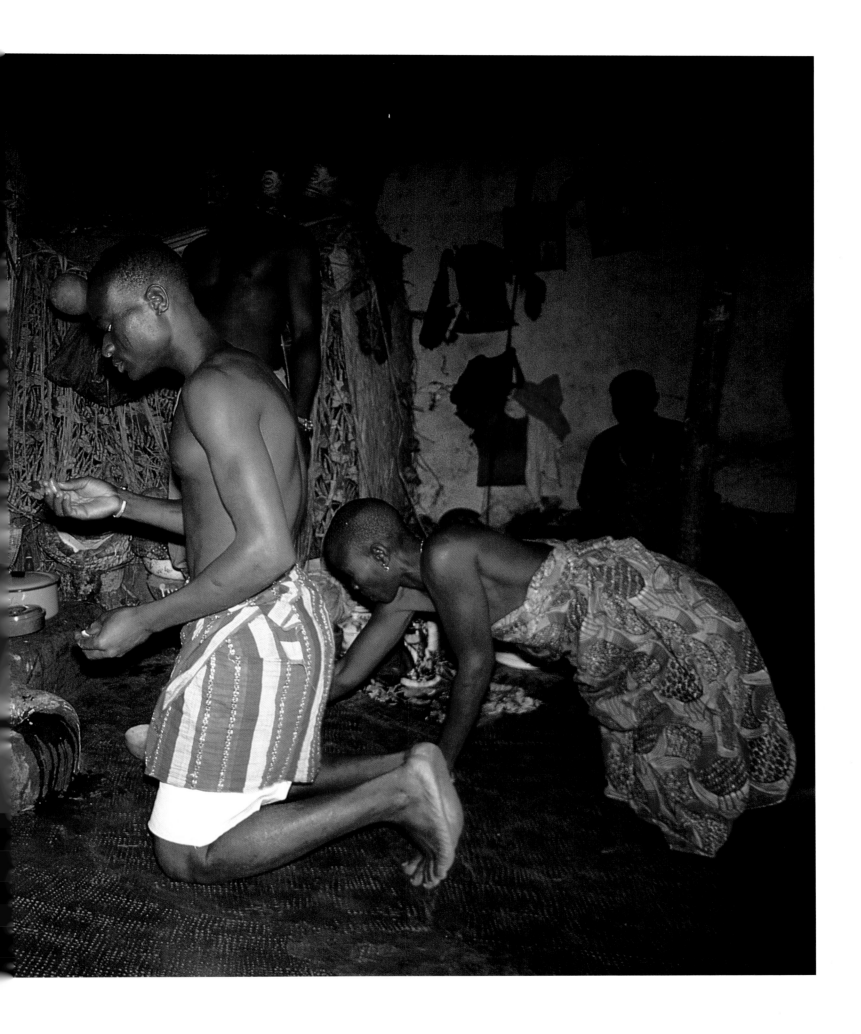

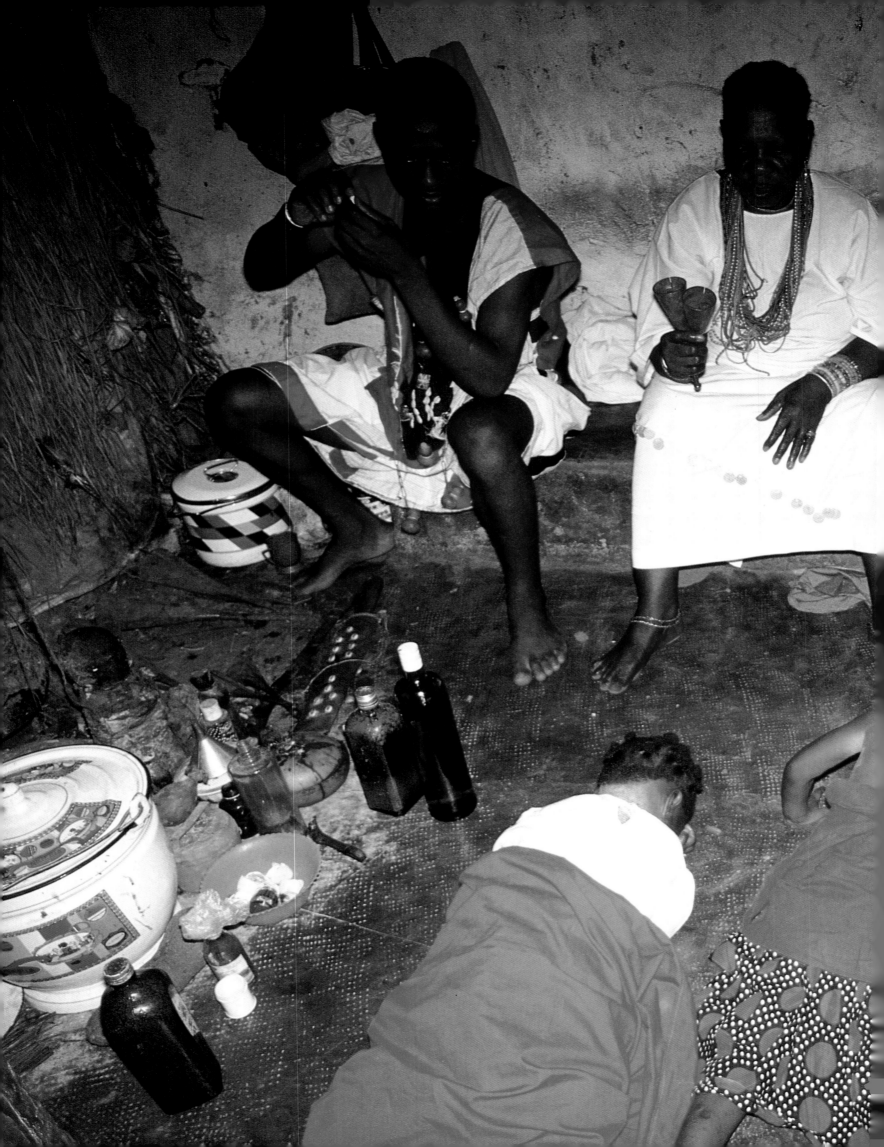

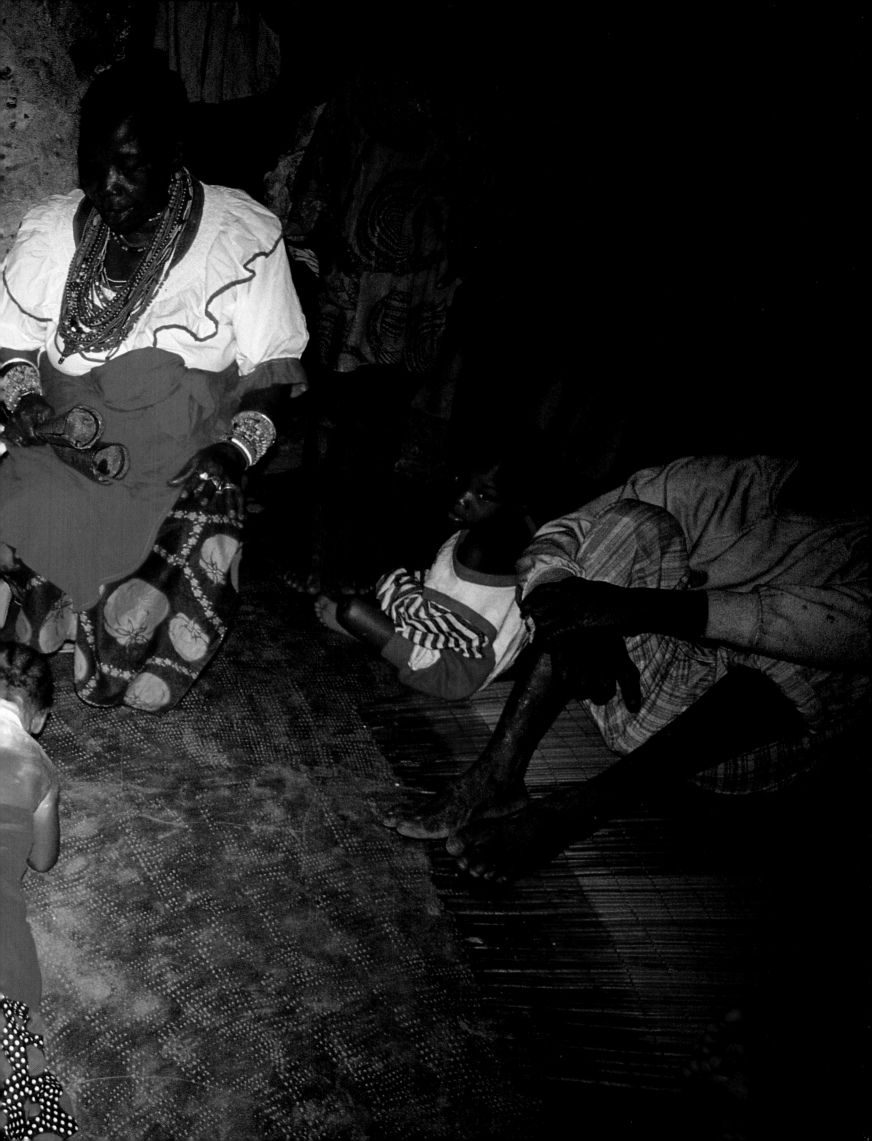

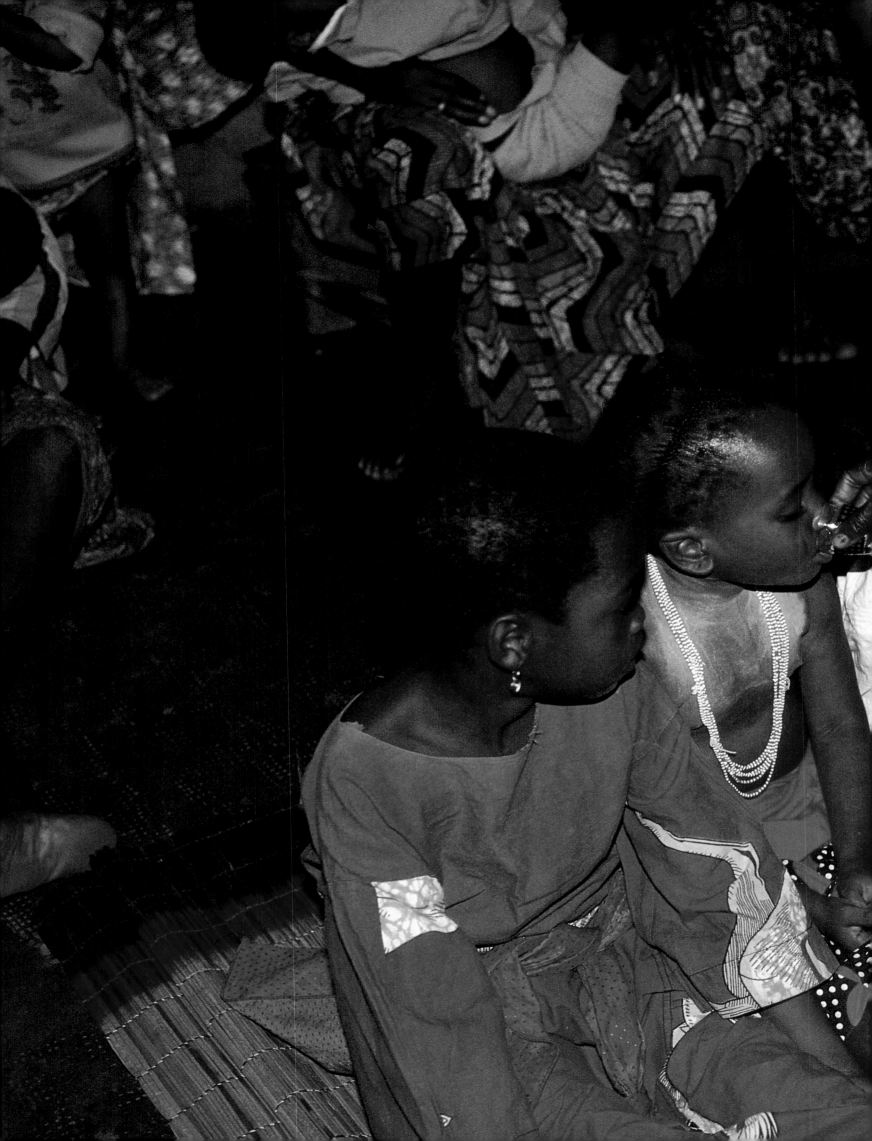

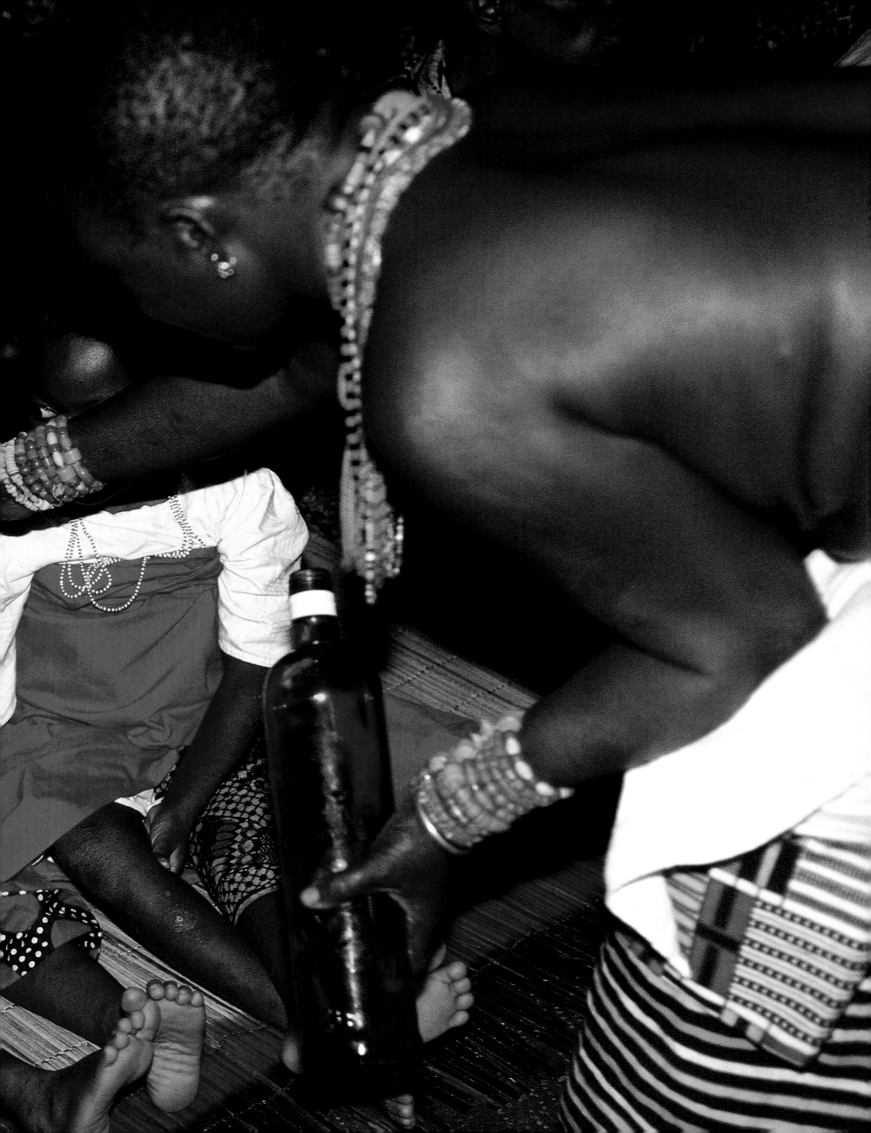

Black and white magic

Belief in sorcery and witchcraft, as we have seen, is widespread in Benin. Many people spend a large proportion of what is often a scant income in protecting themselves against witchcraft. Perhaps as many others call on the services of a sorcerer to bewitch an enemy or attain good luck, love or success by means of white magic.

The most eminent voodoo priest in Benin, Sossa Guédéhoungué, maintains that black magic is in contradiction to voodoo, and that anyone who has another person bewitched is arrogating divine powers to themselves. It is for the gods to decide, he states, whether and how a person should be punished for a transgression. In fact, however, black magic is very widely practised in Benin, and one hears stories of the "African pistol", a lethal concoction the components of which, apart from the nails and razor-blades, are reputedly undetectable in the victim's body. Fortunately, this sort of case seems rare today.

The voodoo sorcerer Germain Bamenou, from Cotonou, protects clients against sorcery as well as treating haemorrhoids and female infertility. If required, Bamenou can even collect debts, directing his magic not against people's lives but rather against their physical well-being.

Many of the items needed by Bamenou in his sorcery are obtainable on the Cotonou "fetish market" – animal skulls, birds' claws, snakes and plants. After he has consulted the Fa oracle and propitiated the gods with sacrificial gifts, Bamenou begins his ceremony, which aims first and foremost at winning power over the spirit, for example, of a debtor. Once that is achieved, Bamenou can make the spirit see to it that the debt is repaid (if it is not, the debtor's body must suffer acute abdominal pain).

In Benin, Bamenou's sorcery is not a criminal offence. That it works, at least in particular cases, almost everyone in Benin believes. Bamenou is accommodating to his clients: payment need only be made when the desired result is achieved.

Chicken's blood is dripped onto a dog's skull bound with string – part of the black magic ritual of the voodoo sorcerer Germain Bamenou, of Cotonou. A businessman has called upon his services to collect money from a tardy debtor.

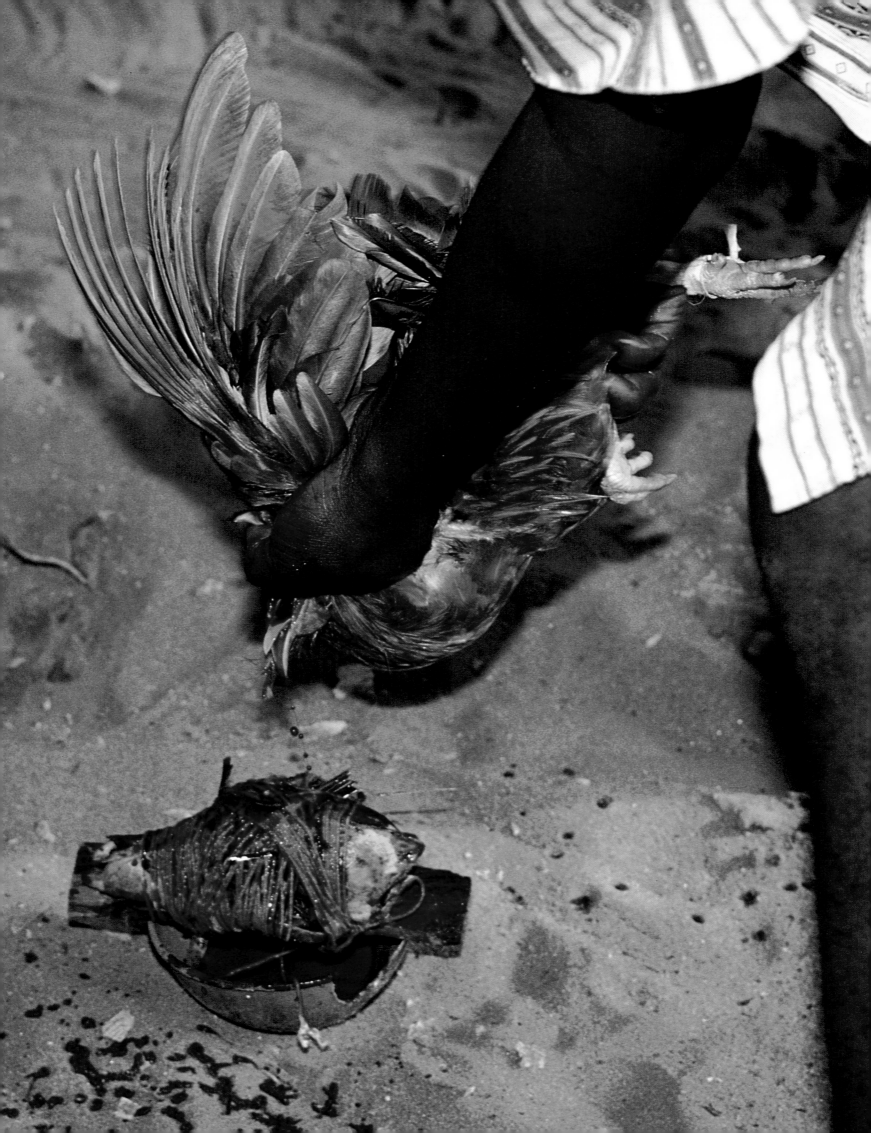

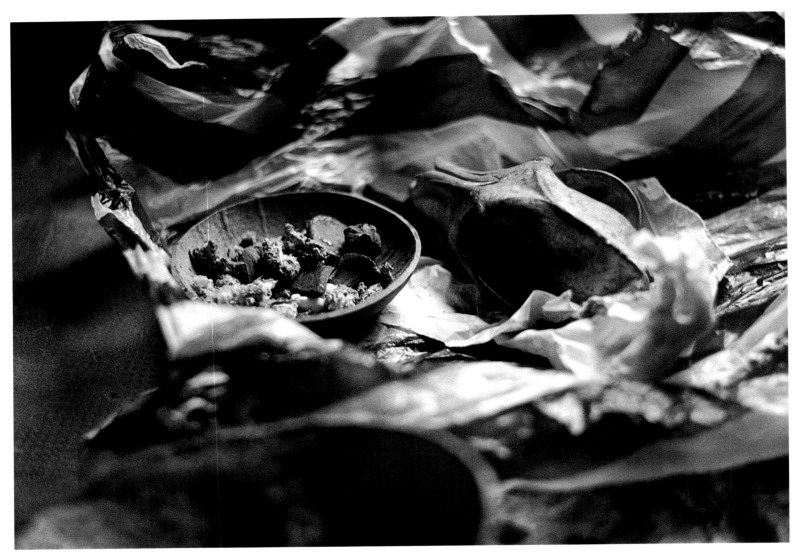

The sorcerer Bamenou has placed his magic ingredients in a calabash: herbs of secret kind, treebark and ground animal bones. All this is stuffed into a dog's skull. Later Bamenou also fills a hollow kola-shell with herbs and puts it in a bottle.

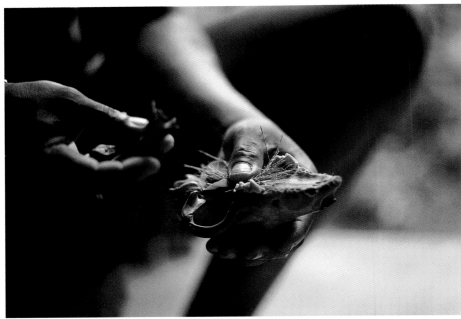

The spell-casting ritual begins. Bamenou utters magic incantations over the dog's skull, breaking off from time to time to wind more string round it. On the sorcerer's chest are two tattooed magic signs. Finally, murmuring incantations, Bamenou places the skull in the open doorway of his house. Since there is no fixed distinction to the voodooist mind between the animate and the inanimate, it is possible to communicate with any spirit – one need only find the right "wavelength". Bamenou tries to track down the soul of the debtor; then he will impose his will on it. The sorcerer secures the help of his fetishes, which he keeps in the corner of the room, with offerings of gin.

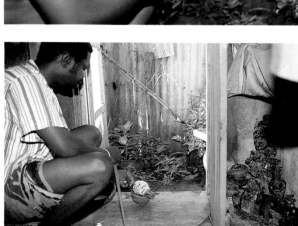
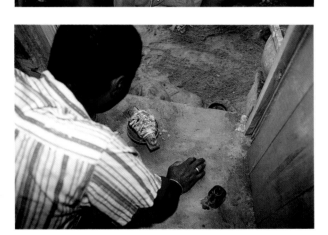
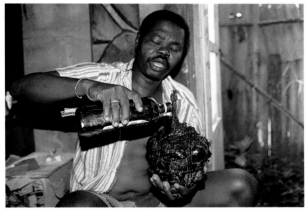

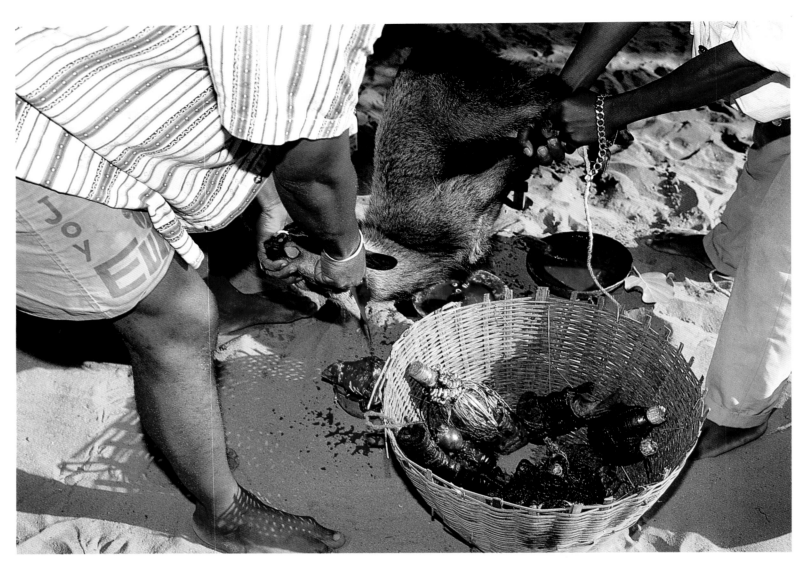

With an assistant's help the sorcerer slaughters a goat over the dog's skull; blood must flow if the black magic is to achieve success. Bamenou keeps his fetishes (*bocios*) in a basket; sacrifices are made to them too, so that they do not become envious and do harm. The bottle containing the kola-shell is buried in the garden.

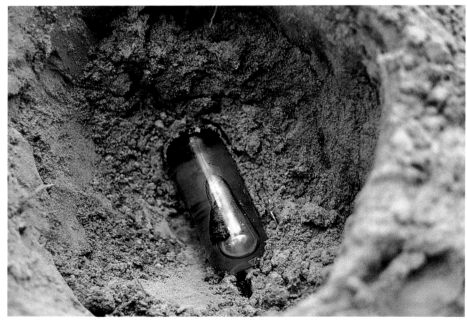

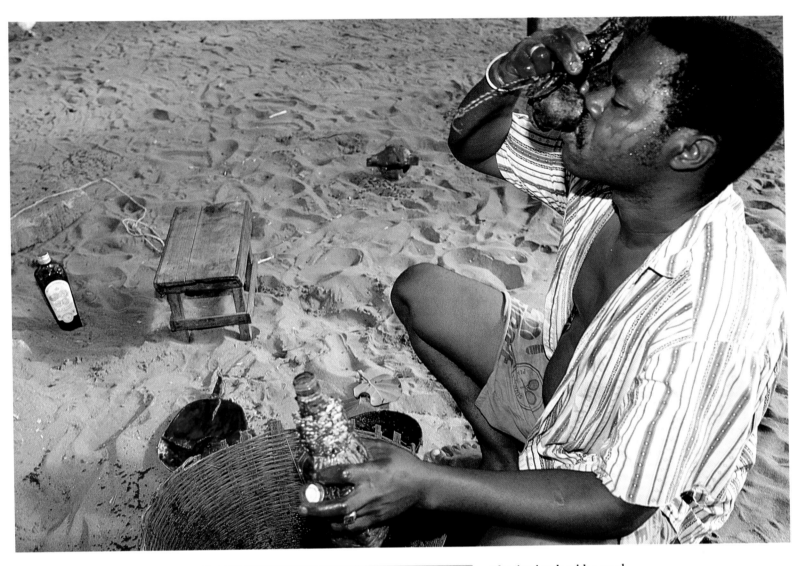

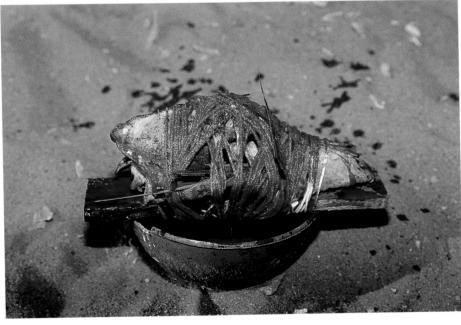

The ritual ends with a good swig of gin from a blood-encrusted calabash. The bewitched dog's skull will guarantee that the debtor suffers nightmares in which he is pursued by wild dogs. The grasses inside the kola-nut in the bottle will swell up and cause the debtor severe abdominal pains. The sorcerer assures his client that his debtor will be forced to think constantly of his creditor – and in the end will pay.

Inoculation against anxiety

THE VOODOO HEALER

An often obsessive fear of evil spirits, sorcerers and witches is so widespread in Africa that it is known as "the African disease". Western-trained doctors are frequently at a loss when confronted with patients doubled up in pain who claim that they have been bewitched, and for whose complaints thorough examination reveals no cause.

Hospital doctors sometimes end up advising patients to turn to an *azeto* – a sorcerer-healer – or to a knowledgeable voodoo priest. Both these will consult the Fa oracle and try to free their patient from the power of the hostile sorcerer. Like the traditional healer, the *azongbeto*, the *azeto* makes frequent use of *aman*, leaves with curative powers. During treatment the patient must also take a preparation made of ground animal bones and minerals daily, as well as use it to cleanse himself. The aim is detoxication of the patient's body and spirit, a process in which prayer is a significant therapeutic component. To Western understanding, medicine prepared from animal bones and herbs may often be no more than a placebo. But it is well known that placebos can be effective – especially in Benin, where they are are backed up by faith in the power of the voodoo gods.

Most *azetos* are not only expert herbalists but also good psychologists. They know that a good *azeto* must above all see with the heart.

A man in fear of death. Convinced he has been bewitched by malevolent relatives after an inheritance dispute, this farmer has turned for help to the priest of the village of Hontohué. Known as an experienced *azeto*, or sorcerer-healer, the priest will lift the curse by means of a ritual which could continue for more than three weeks. In this case it would end in a cleansing ceremony during a festival in honour of the goddess Mami Wata.

204

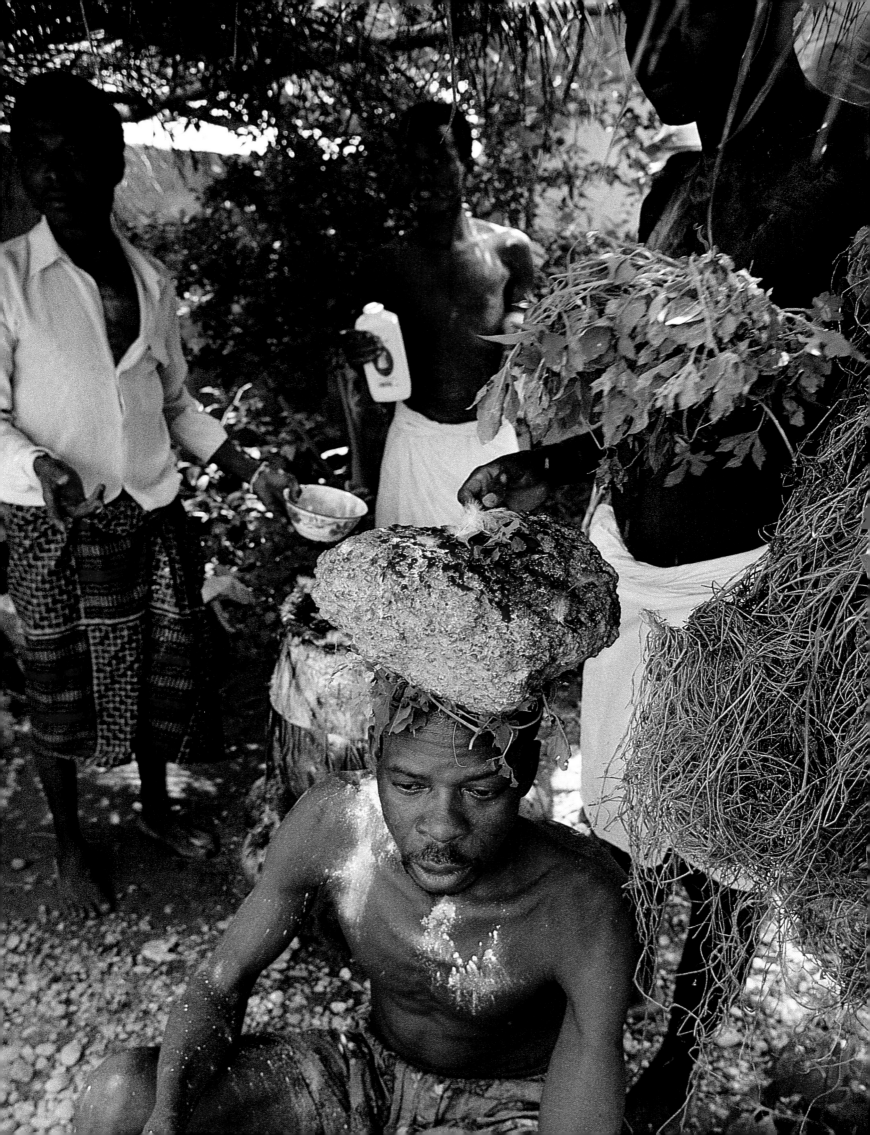

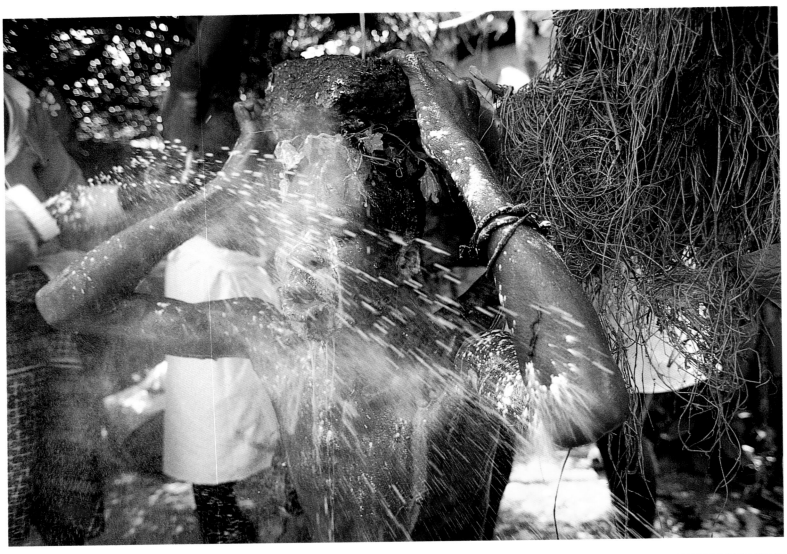

Assistants shake powder onto the kneeling man's face and upper body, and lay *agnagna* and a large stone on his head. The stone, symbolic of the heavy burden and pain he is suffering, was used as an altar for the sacrifice of a chicken at the beginning of the ritual.

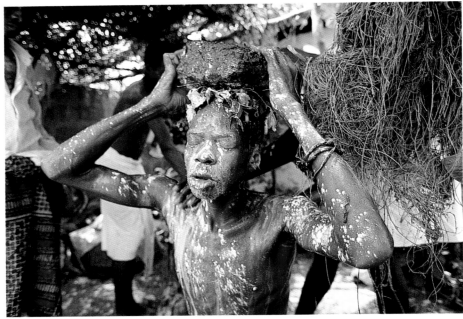

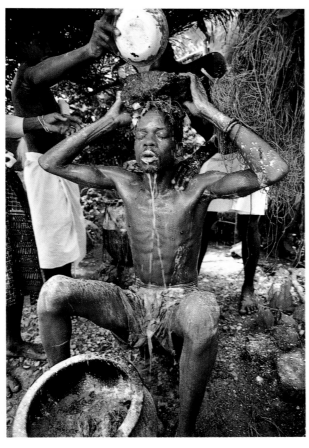

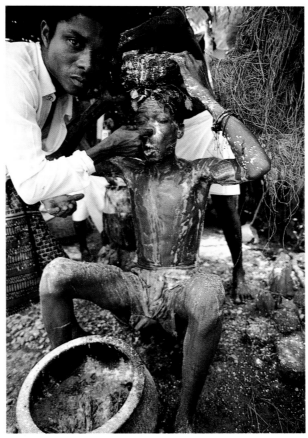

The patient is dowsed in a liquid made up of conse-crated water, a herbal infusion and lemonade. The voodoo goddess Mami Wata, who is being called upon to help free the man from sorcery, is fond of soft drinks and abhors alcohol.

Through the days preceding the cleansing ceremony, healer and patient have repeatedly invoked Mami Wata's support. Prayer is an important part of voodoo therapy.

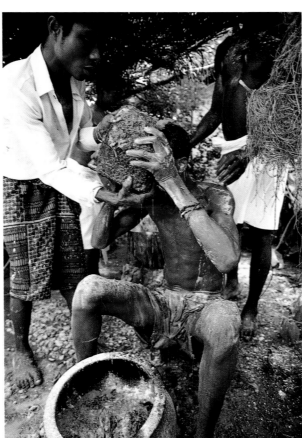

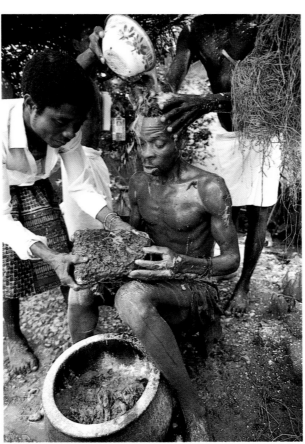

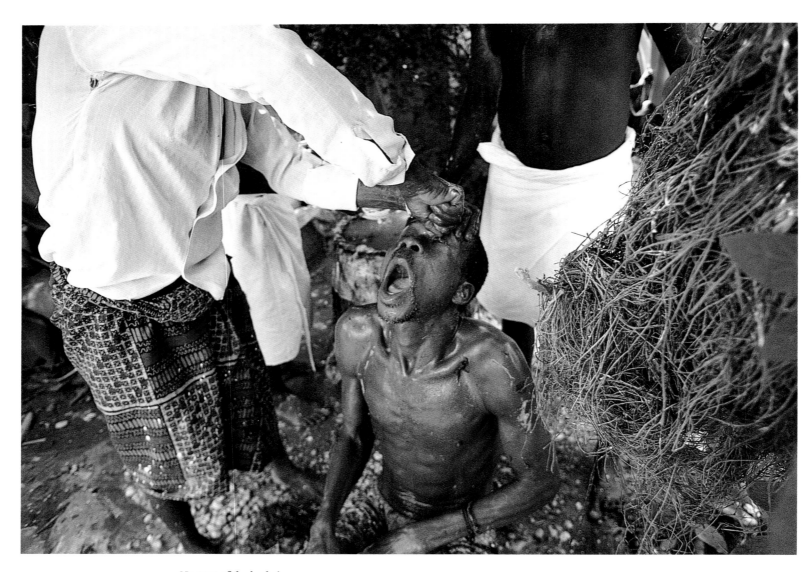

No part of the body is neglected in the cleansing process, not even the eyes. The Western medical profession often ridicules voodoo healers or writes them off as charlatans. The fact is that *azetos*, whose skills are deeply rooted in African tradition, are usually a good deal more effective in treating "the African sickness" – fear of sorcery and black magic – than practitioners of orthodox medicine. Voodoo both produces and removes people's anxieties.

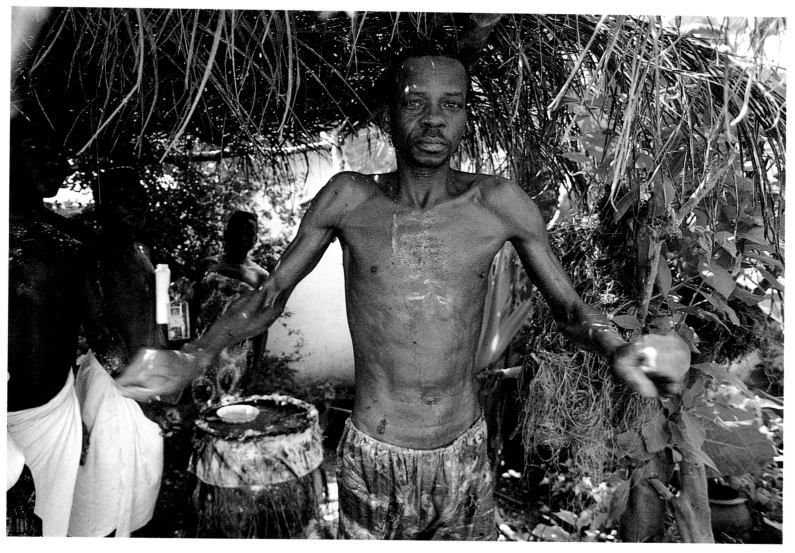

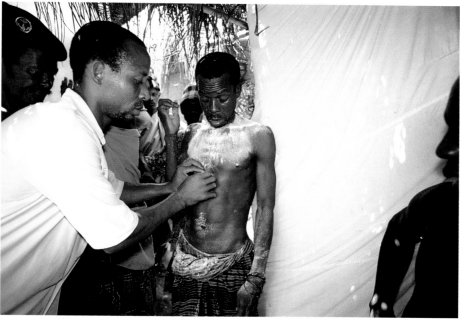

The cleansing process is over; the stone has been removed from the man's head. Still in a weakened state, but with fresh courage towards life, he leaves the place of treatment. An assistant of the healer makes seven light incisions in his chest, back and arms, into which a powder made from a crow's ashes is sprinkled. It is said that witches often use crows as a means of transport. Thus "immunized", the patient is protected against any further attacks from evil spirits.

Is there a herbal cure for aids?

VOODOO MEDICINE

As everywhere in West Africa, traditional arts of healing play a major role in Benin's health system. In the predominantly rural regions of the country there are often no hospitals or Western-trained doctors. And even where both exist, many patients will sooner turn to an *azongbeto*.

A voodoo healer's expertise is usually based on a very considerable knowledge of herbal medicine, collected and passed on over generations. An *azongbeto* understands that he can heal only in alliance with the gods, and before each diagnosis he will consult the Fa oracle, from which he expects advice about treatment.

This involves powders, ointments, teas and herbal liquors, and above all *aman*, "leaves with power." In accordance with the holistic approach of voodoo, an *azongbeto* always aims at "the restoration of harmony at all levels". Both mind and body are addressed in treatment, by means of the repetition of magical sayings or joint prayers, which have a positive effect on the patient's psyche.

Aids is a major problem in Benin. The recorded number of Aids and HIV-positive cases stands at around 60,000, but the actual number must be many times higher. About 80 percent of Benin's active prostitutes are currently HIV-positive; few have a fixed address, and scarcely any are registered. Isaak Saayi, President of the Association of Traditional Healers of Benin, who has a doctorate from the Sorbonne, wishes that traditional healers, practitioners of Western medicine and the voodoo gods could work together to solve the problem of Aids. But barriers of mutual mistrust would first have to be overcome. Western know-how alone could not prevent epidemics, Saayi says; the doctors could not even reach their patients. On the other hand, the work of traditional healers would no doubt benefit from modern medical knowledge.

There have been encouraging signs of cooperation among the different medical traditions in Benin, above all in the education programme about how Aids is spread. The voodoo community, led by Sakpata, god of all infectious and contagious diseases, is taking part in this campaign.

Aman, herbs with special powers, are indispensable to an *azongbeto*, a voodoo healer, when he treats a patient. Casimir Dah-Moussa, a healer from Benin's capital, Porto Novo, also keeps roots, powders, tinctures and secret magical substances in his dispensary. He cures his patients with the help of the voodoo gods; the inner yard of his house serves as his surgery, and here he prepares a herbal tonic. His young patient is so debilitated by fever that he can scarcely hold himself upright in his chair.

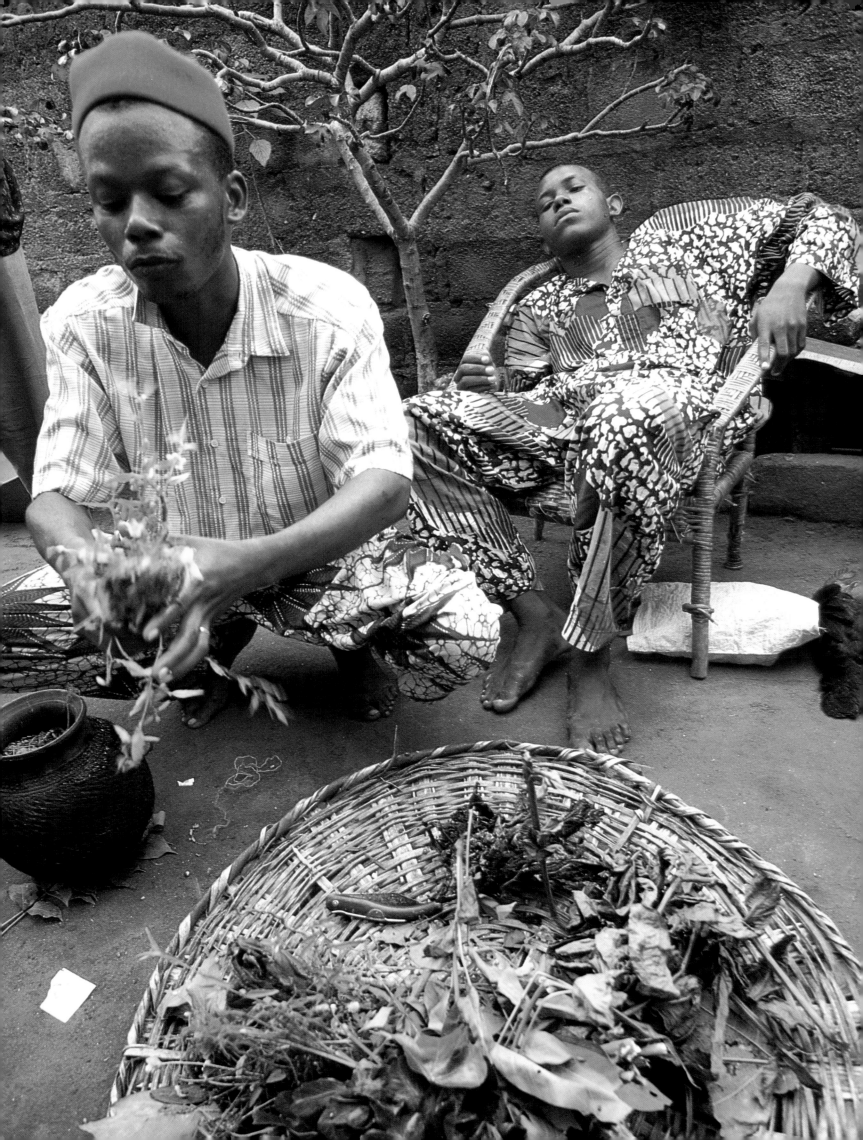

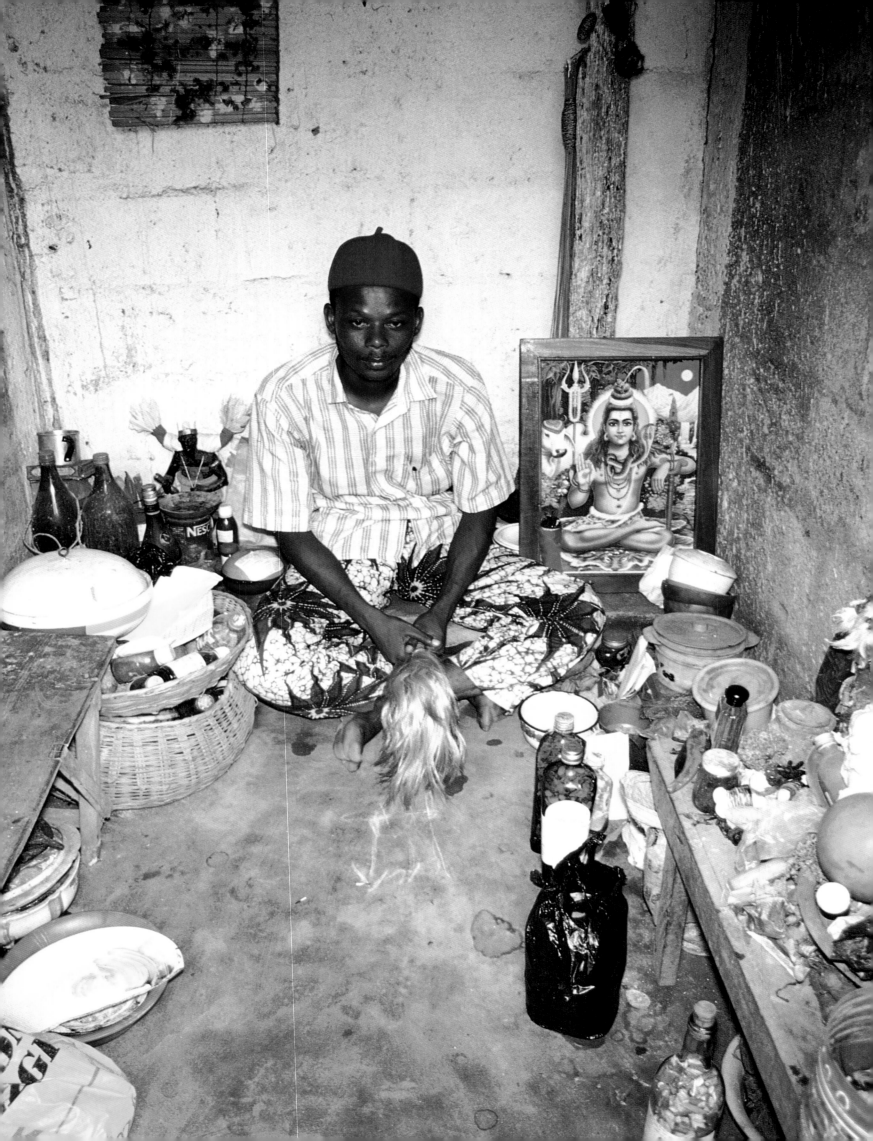

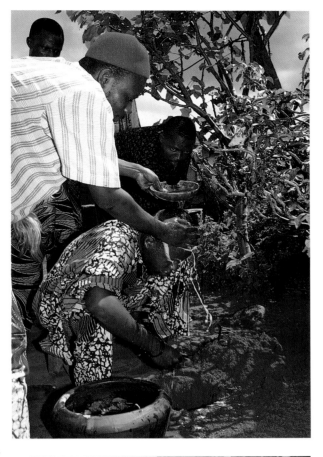

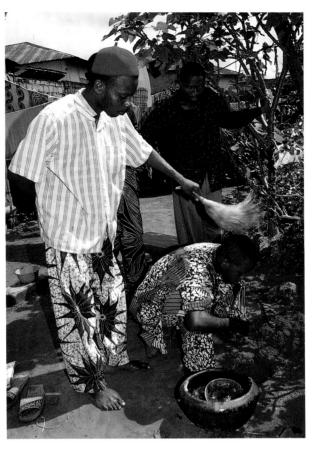

LEFT PAGE:
Before each treatment Dah-Moussa consults the Fa oracle for advice on diagnosis and therapy. For him the picture of Krishna does not depict the Hindu deity but the white-faced water goddess Mami Wata.

Although Dah-Moussa has consulted the oracle, it is not yet clear whether the patient is suffering from malaria or Aids. The young man has no trust in the Western-trained doctors; like many of his fellow-citizens he prefers to consult traditional voodoo healers.

The *azongbeto* pours a herbal tonic over his patient's head while two friends look on, tense with expectation. Murmuring prayers, the healer passes a flywhisk over the sick man's head and then rubs powder into small incisions he has made in his forehead in order to drive his severe headaches away. The patient slumps vomiting over a small hole in the ground containing the tonic in which he has been washed. The hole will later be filled in by the healer, thus symbolically "burying" the sickness.

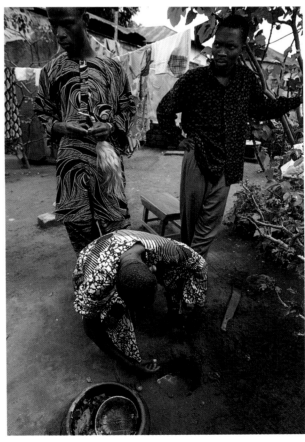

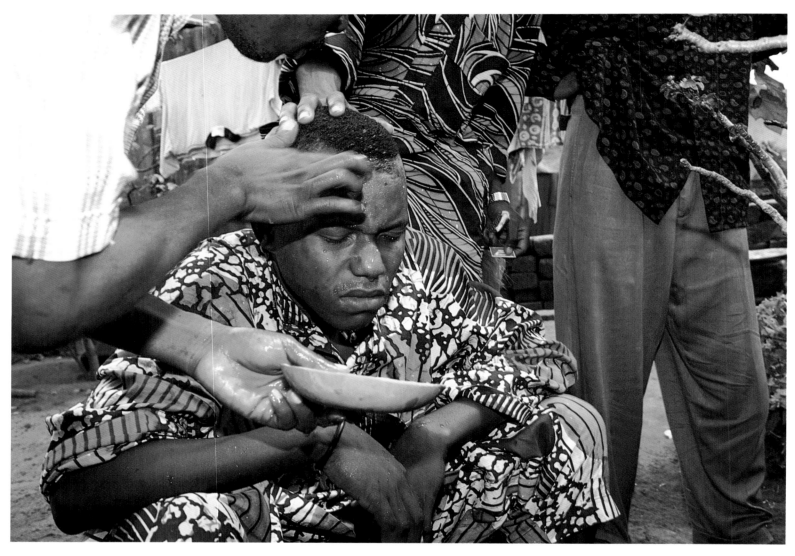

Dah-Moussa's medicine is bitter. More powder is rubbed into the incisions on the patient's forehead. At length the healer slaughters a chicken, and feathers and blood drip onto his personal fetish and onto one to Gu, god of iron and smiths. It consists simply of pieces of scrap metal – voodoo gods are not always represented in human form.

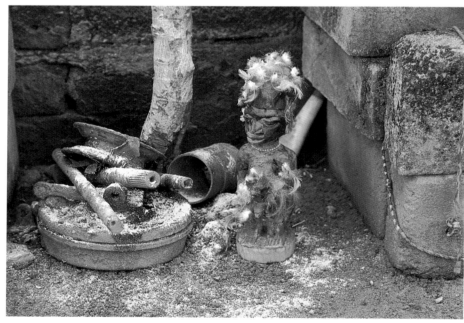

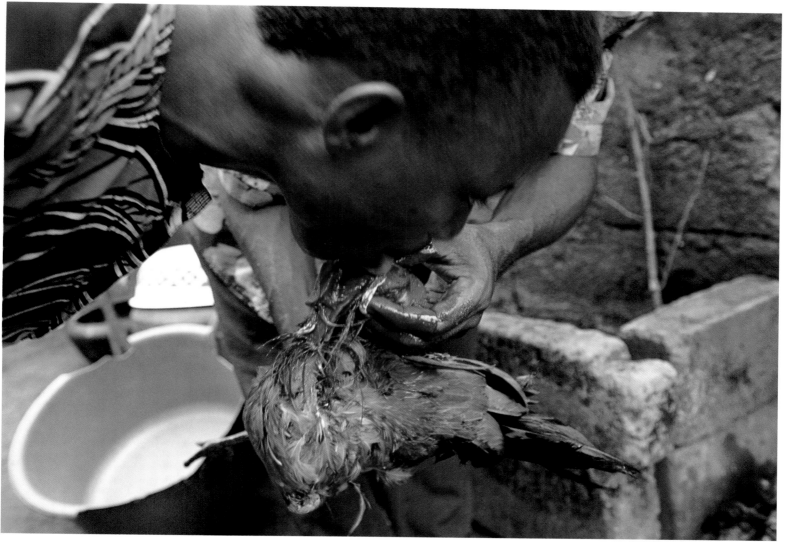

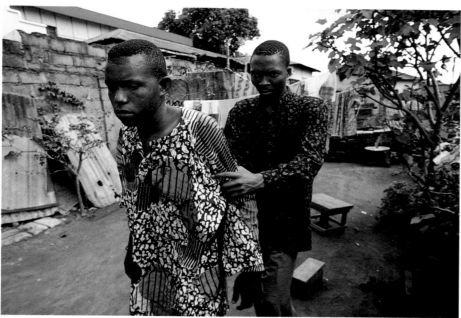

Fresh chicken's blood will hopefully give the patient new strength. A friend takes him home; now he can at least walk again, but he is not yet cured, and treatment will continue. If the patient is really suffering from Aids, even Dah-Moussa will not be able to help him. Voodoo healers, who are very often herbalists of considerable knowledge, are searching for a remedy for Aids like their Western counterparts, but so far in vain.

The laughing water goddess

MAMI WATA

Some voodoo gods are strict, others violent. Mami Wata, however, usually presents a joyful face to her followers, letting them laugh and make all sorts of mischief at ceremonies in her temples. The goddess is often represented as a mermaid, for she is said to have come from the sea. The faces of Mami figures are beautiful and doll-like, and always white – symbolic of divine, spiritual rapture.

The mermaid figure, which originated in Germanic mythology, is completely untypical of a voodoo divinity. Swiss writer Gert Chesi believes it reached the west coast of Africa in the form of figure-heads on European ships, which provided the model for the representation of Mami Wata.

During his studies in south Togo, Chesi found temples to Mami Wata where Indian influence in the representation of the goddess was unmistakable. The priests do allow artists a certain amount of creative freedom in depicting voodoo divinities. Even though Mami Wata may occasionally possess European traits, she is very much an African goddess. And this she remains even when represented, as she frequently is, in the form of Krishna, the Hindu god.

According to Chesi, Mami Wata promises her followers wealth and power, but often at the price of childlessness. In trance her initiates adopt a mien and behaviour imagined as appropriate to the goddess herself: they drink perfume, powder their faces and breasts with talcum powder, and move, when not performing an ecstatic dance, in a strangely stilted manner. Mami Wata is fond of every-thing that is beautiful, and so her initiates wear white for ceremon-ies and make sure that the temple is always swept clean. They believe that the goddess herself decides who shall be her initiates. The mermaid goddess has an overwhelming preference for women, and calls on very few men.

Surrounded by female fel-low believers and children of the village, a young voo-dooist dances to imaginary music, eyes rolling in deep trance. She is possessed by the goddess Mami Wata, who is often depicted as a mermaid.

FOLLOWING PAGES: Participants in a Mami Wata ceremony gather in the village of Hountohué. One group is led by two priest-esses of a very special voo-doo cult known as Malé, whose red and white garb recalls an early Muslim ancestor who was turned into a voodoo god by his descendants' families. The Malé priestesses begin to sing and dance together with the adherents of Mami Wata.

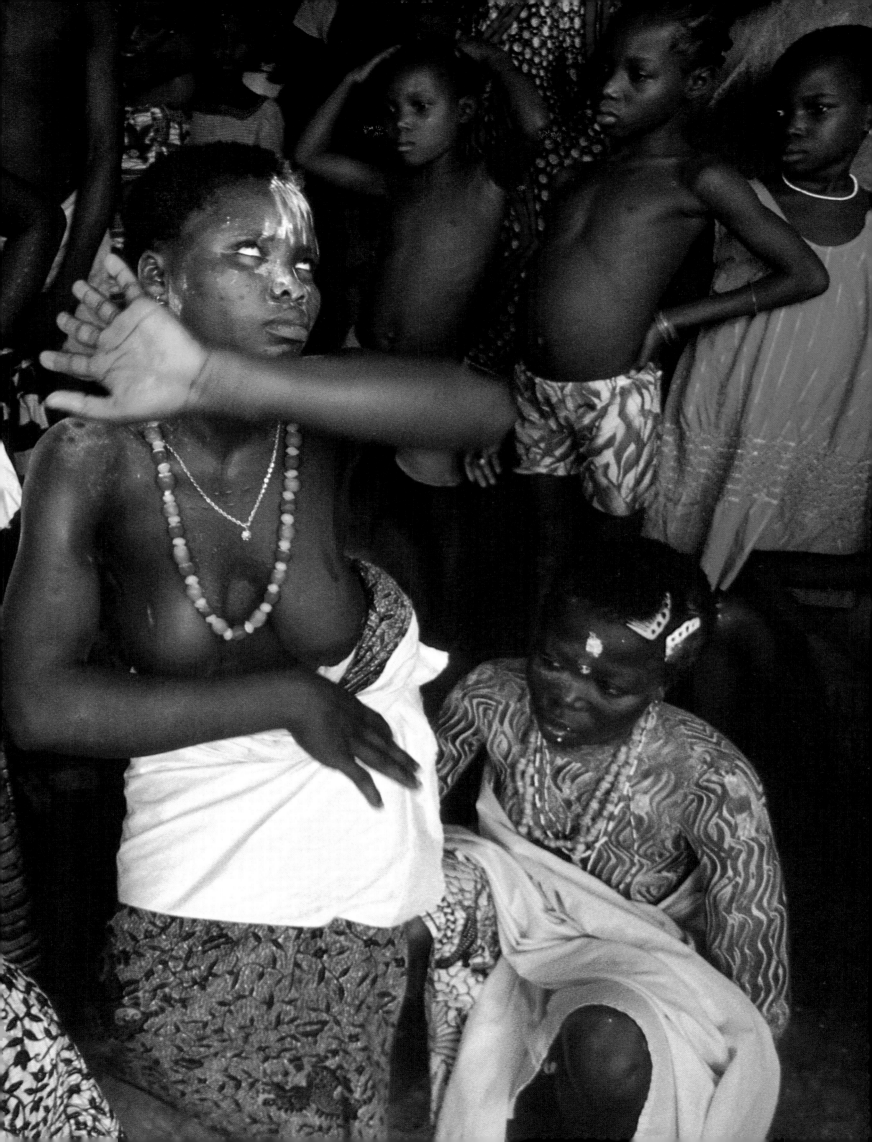

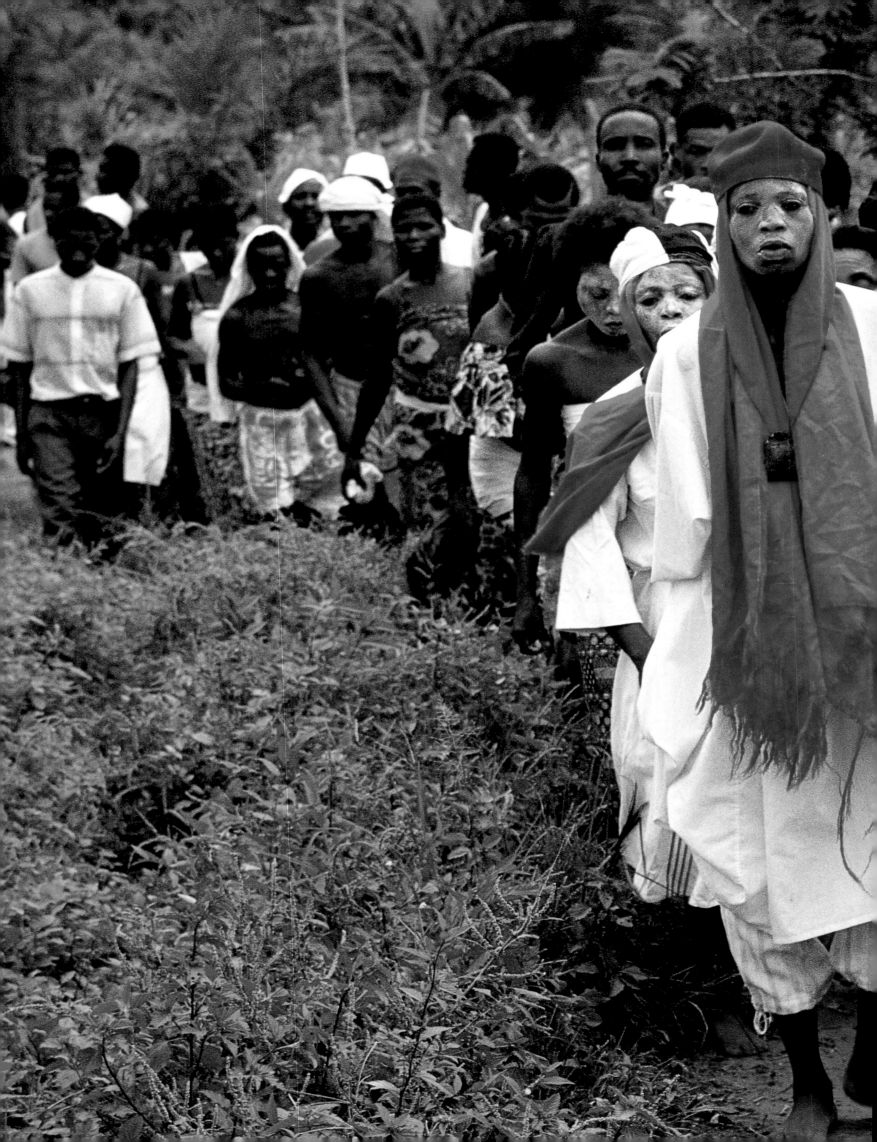

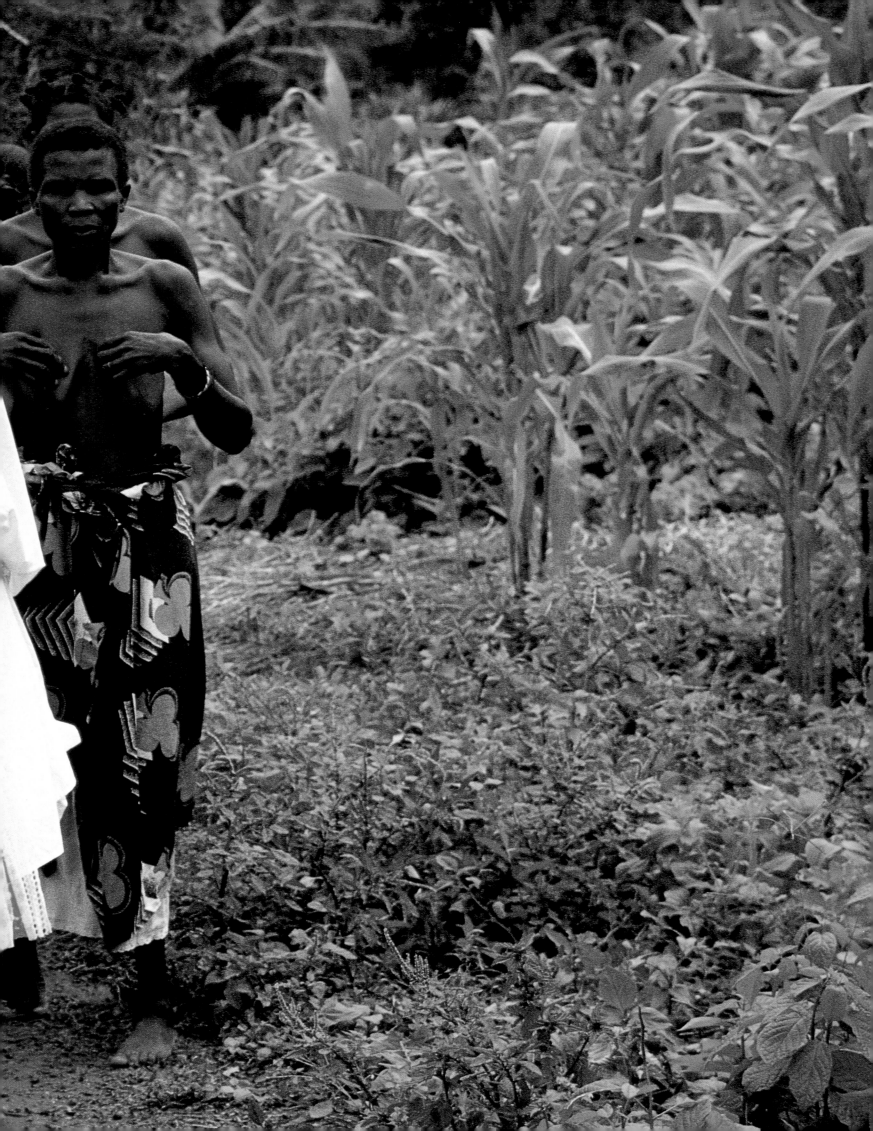

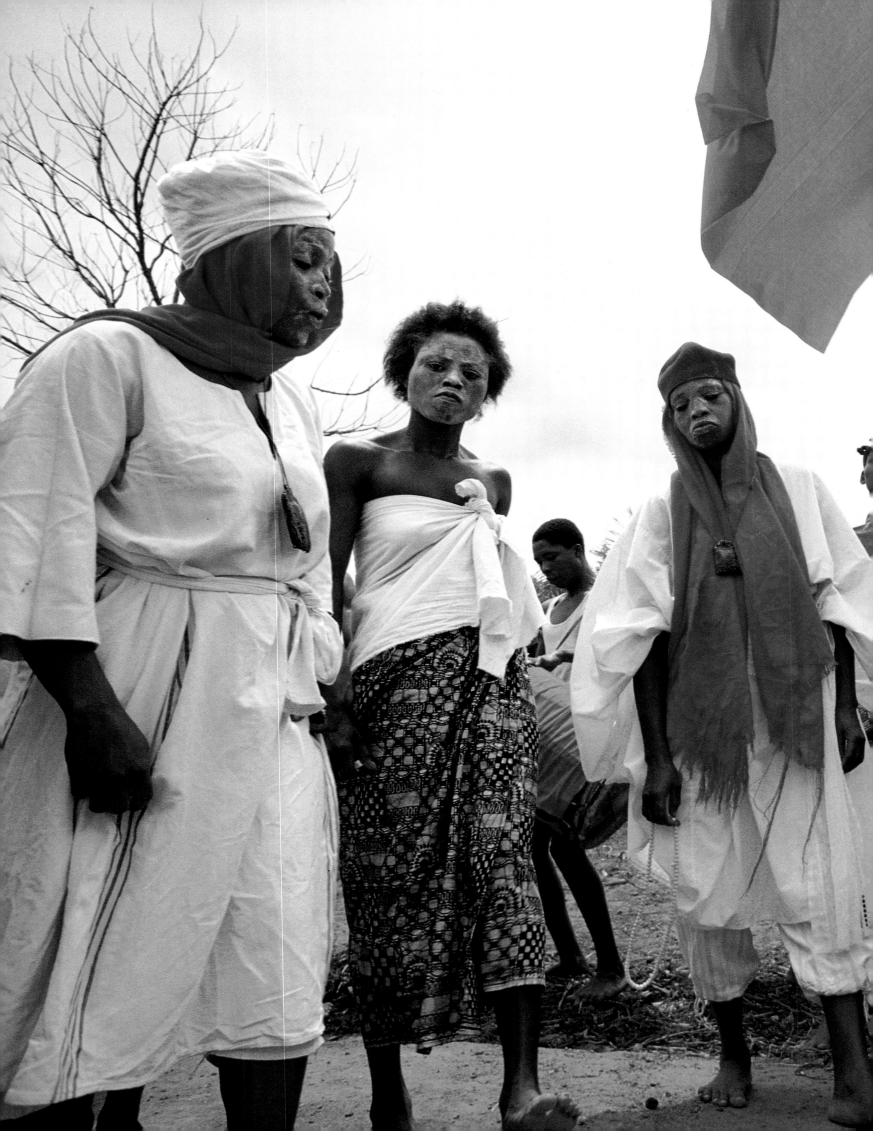

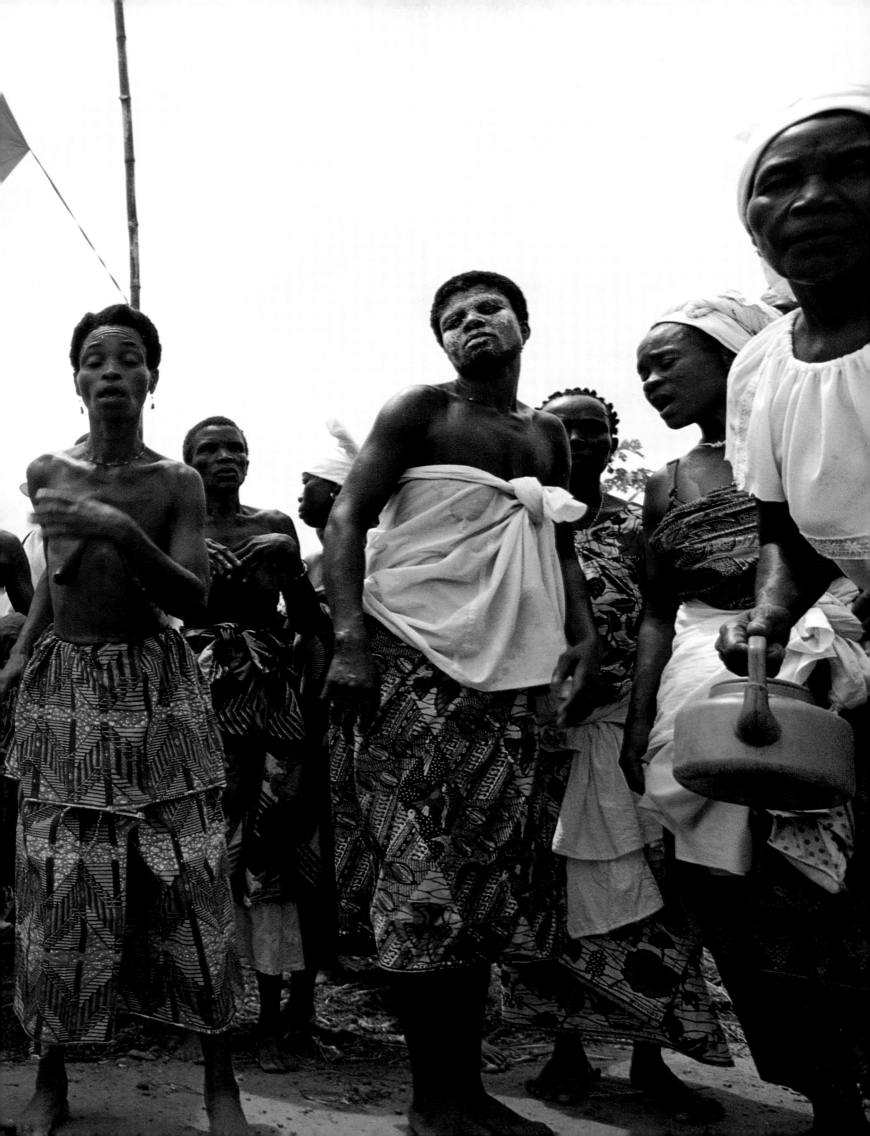

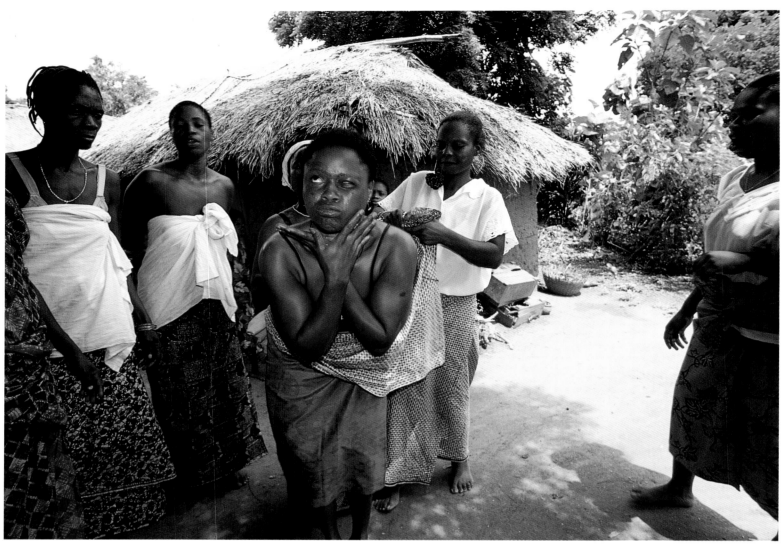

Voodoo worshippers pass
through the village. More
and more fall into trance,
like this woman who was
chatting with her neighbour
when her eyes suddenly
began to roll and she began
to utter piercing cries and
scratch herself on the arms.
Her friend removes her
wrap.

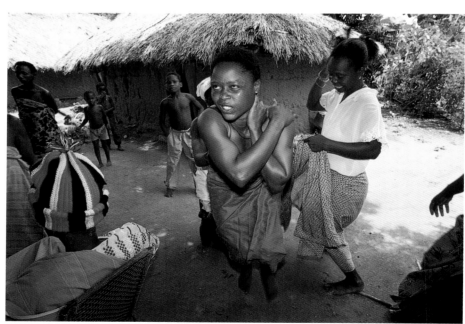

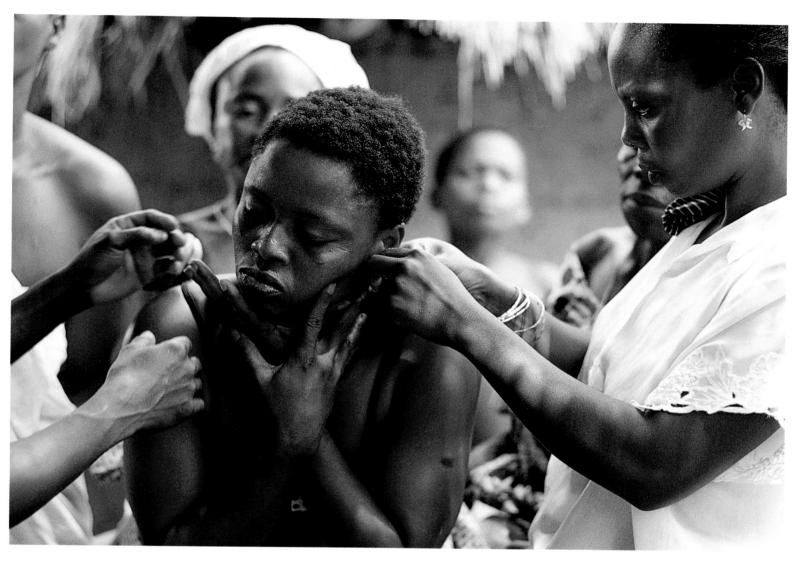

Others take care of those who have fallen into trance and dress them in the white aprons characteristic of their cult. Although people not acquainted with the ritual can be possessed by Mami Wata, the goddess usually enters the bodies of initiates, almost invariably women. When the possessed open unseeing eyes, the process is complete: then, it is said, "the gods look out of their eyes."

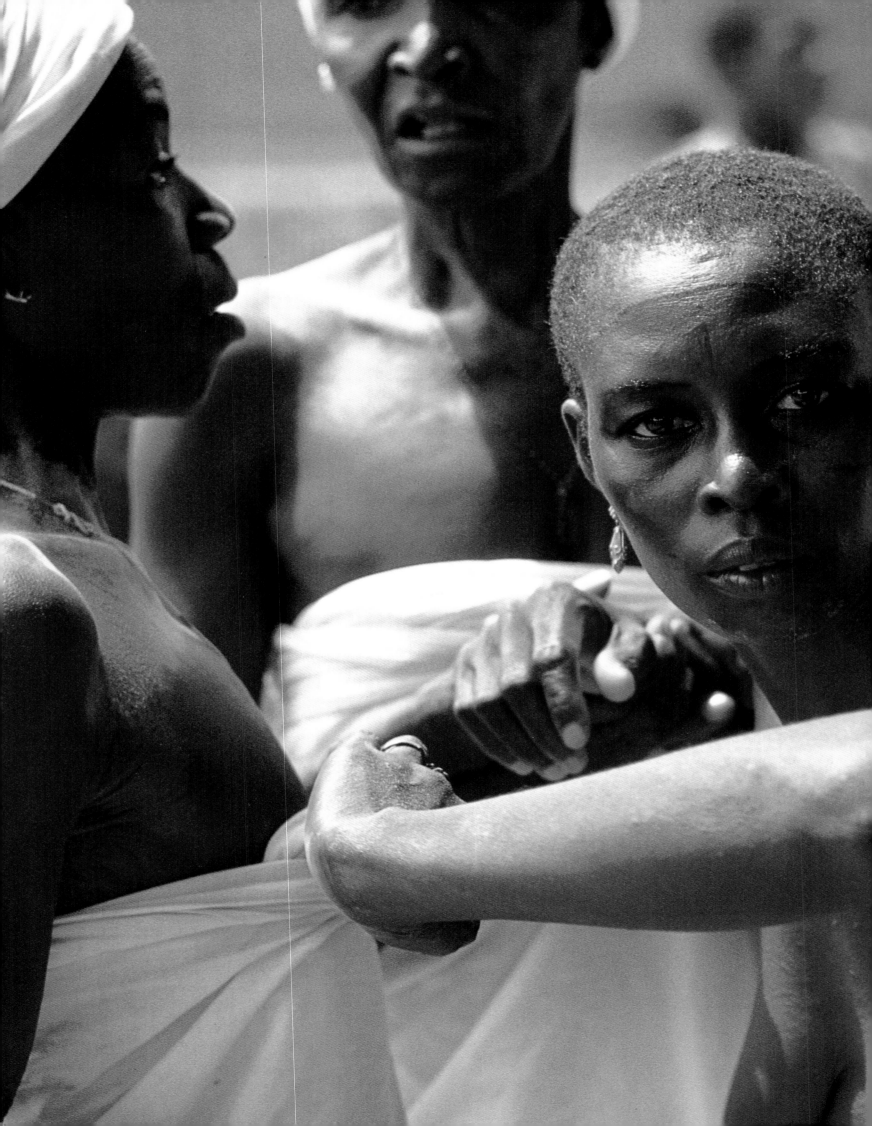

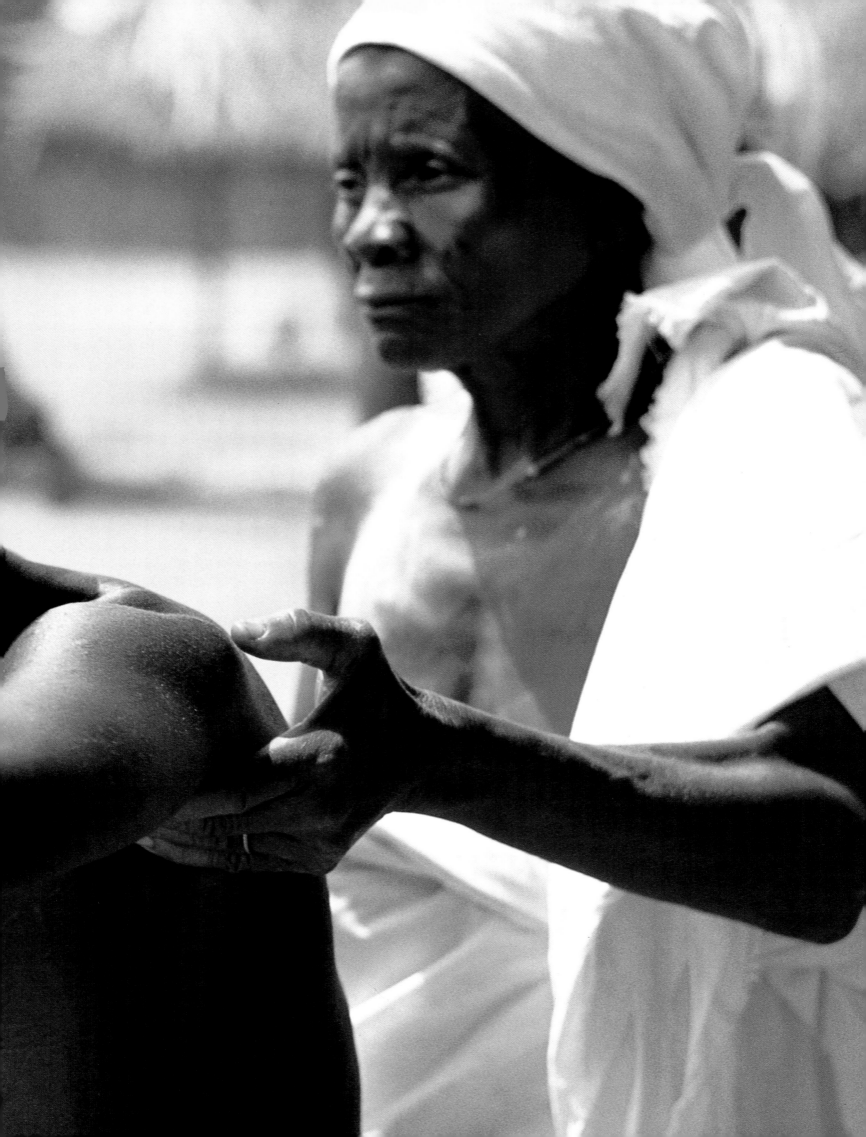

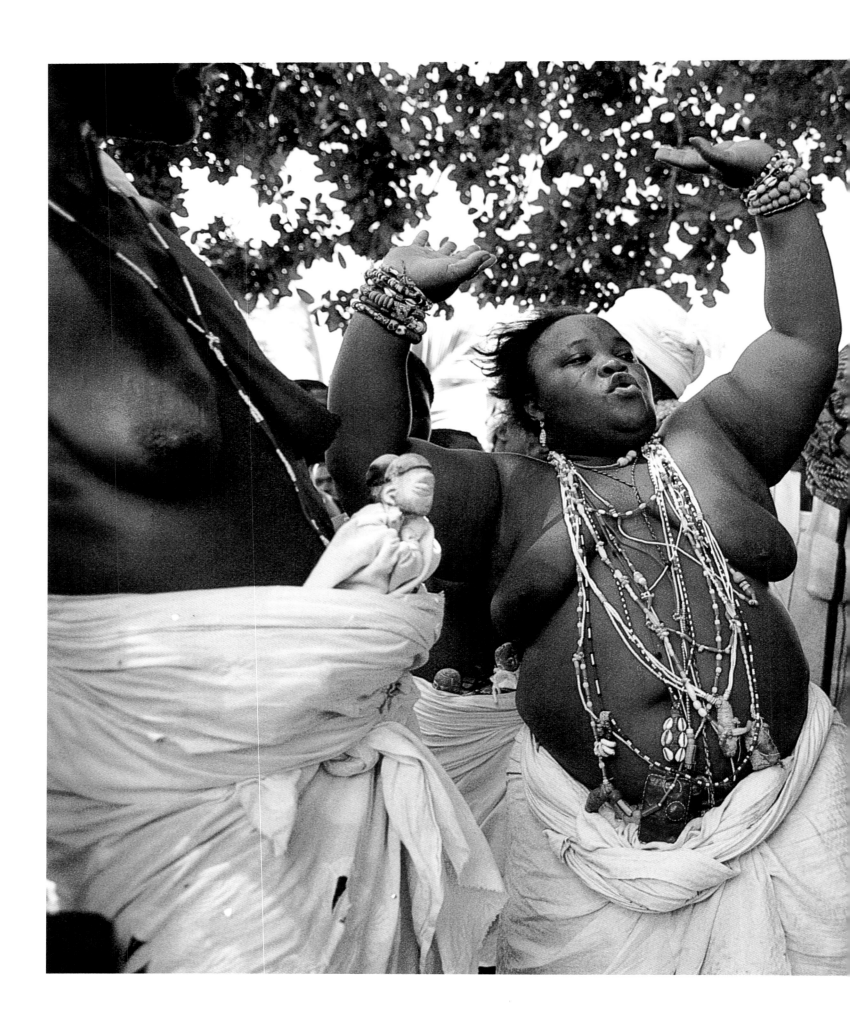

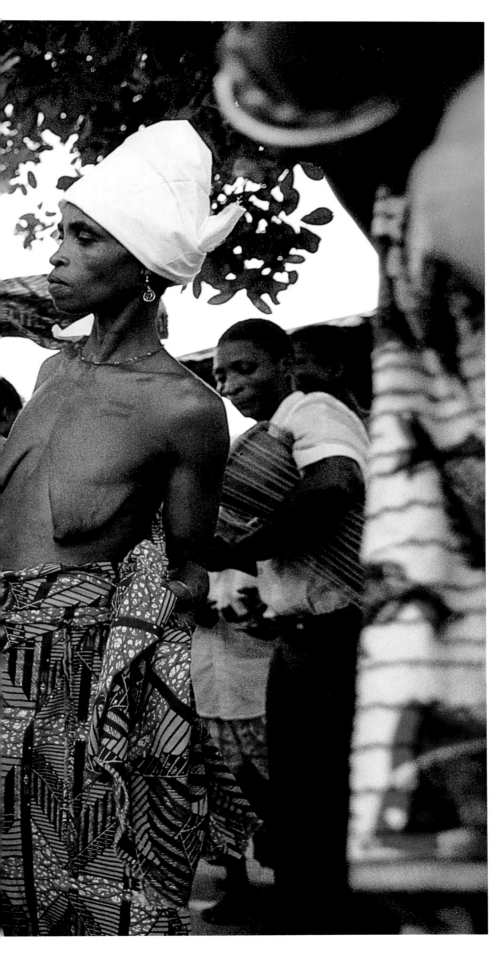

In trance the Mami Wata priestess of the village of Hountohué can scarcely control herself for laughter – the water goddess is evidently of a merry disposition and will entice a medium into all kinds of pranks. Spurred on by the beating of the drums, the priestess constantly interrupts herself with hoots of laughter while performing a piece of informal pantomime. A show of brightly coloured necklaces and wrist-bangles is indispensable for dignitaries of the Mami Wata cult, for the goddess is fond of fine body-decoration.

FOLLOWING PAGES: Priests and their assistants make use of the Mami Wata festival to execute official duties – for example, to receive a young girl, her upper body richly painted for the occasion, into the circle of the water goddess.

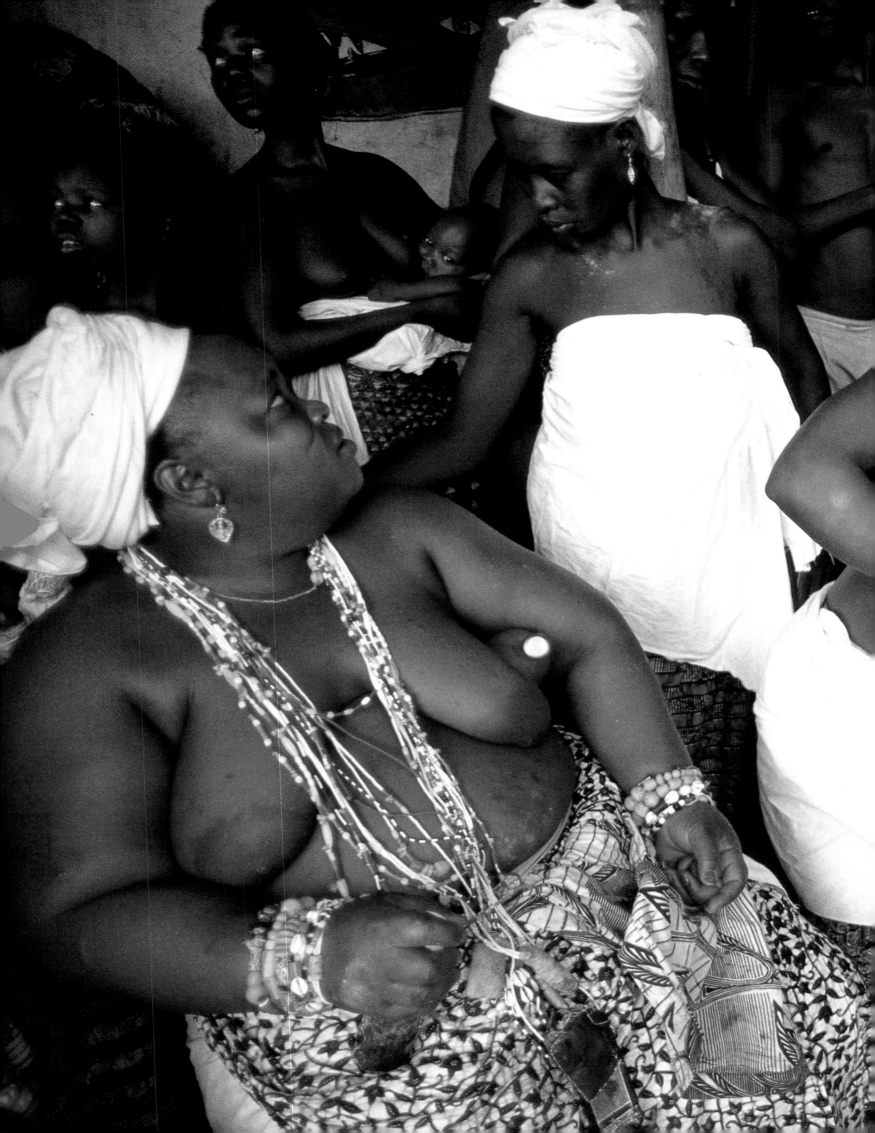

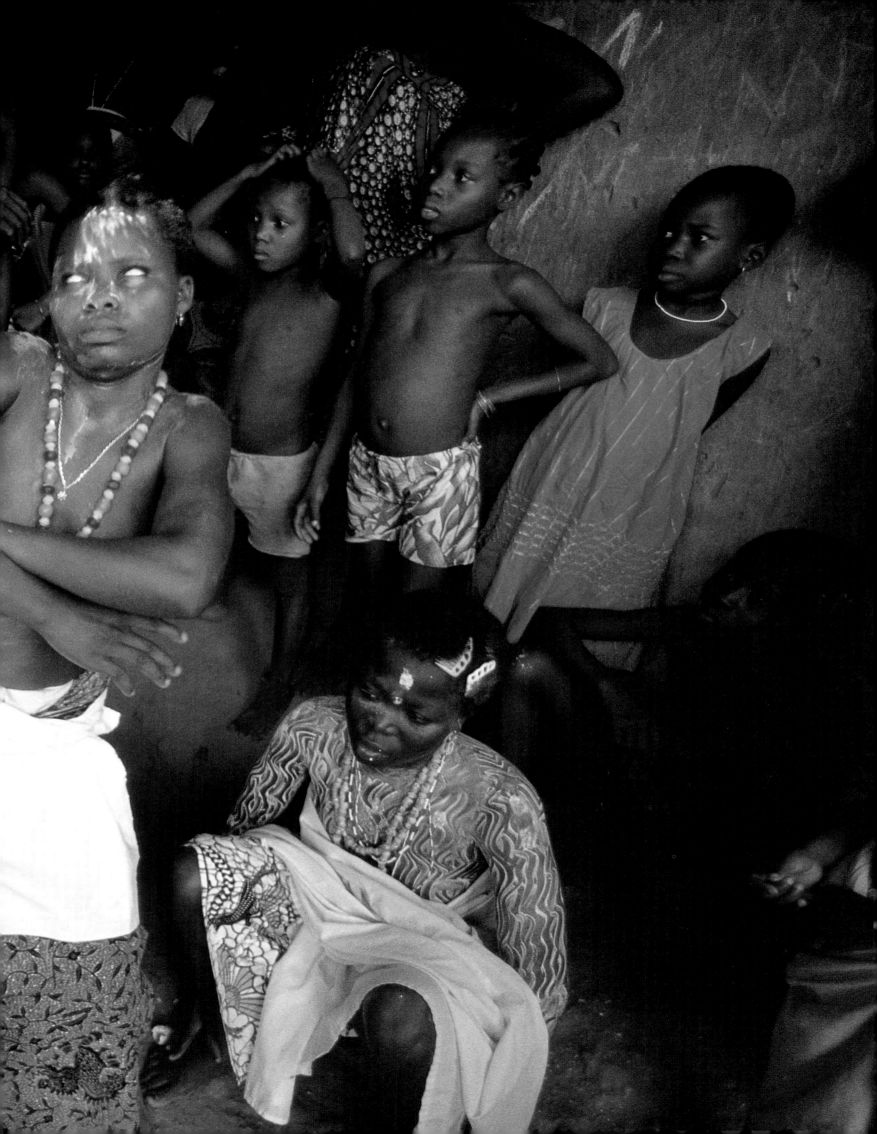

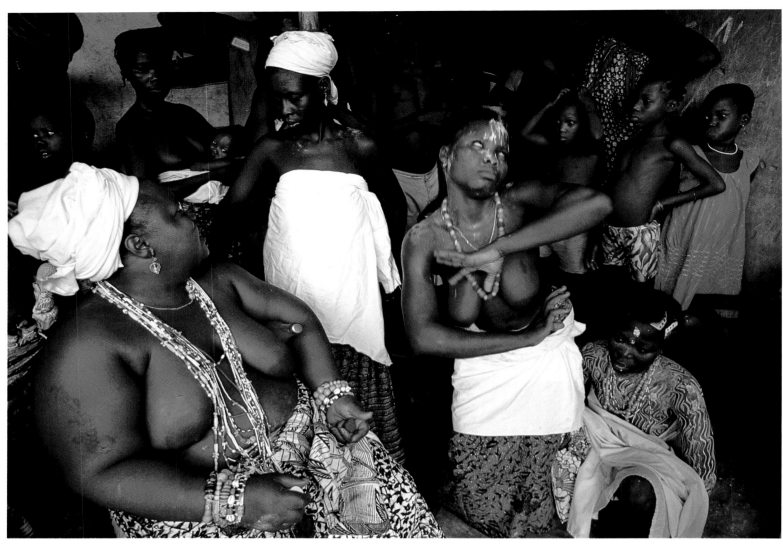

Surrounded by curious vil-
lagers, the priestess cele-
brates the reception of a
new adept. She herself has
just awoken from trance,
but her assistant, gesturing
strangely and speaking
in an unknown tongue,
remains in dialogue with
Mami Wata and transmits
her messages.

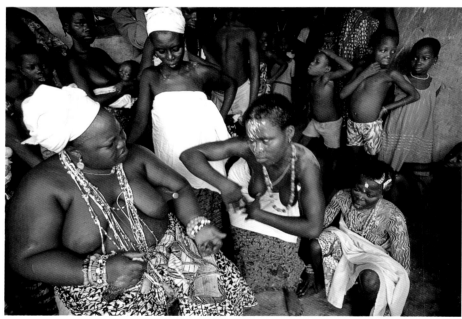

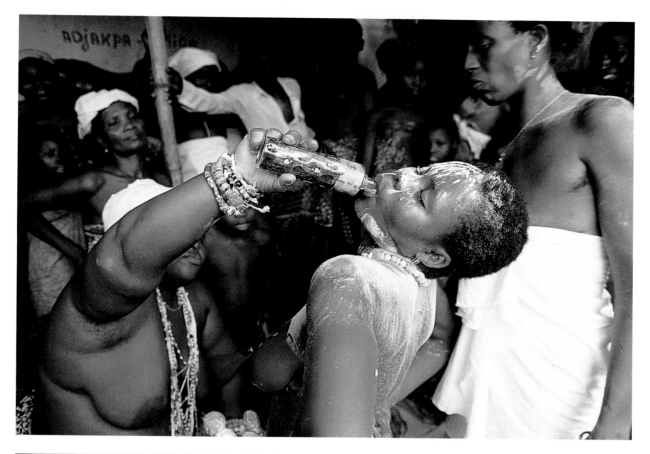

Mami Wata is thirsty. Since she hates alcohol, her medium is given soda to drink – and a good swig from the perfume-bottle. Her face and upper body are sprinkled with more talcum powder, its white colour symbolizing the spiritual purity of voodoo initiates.

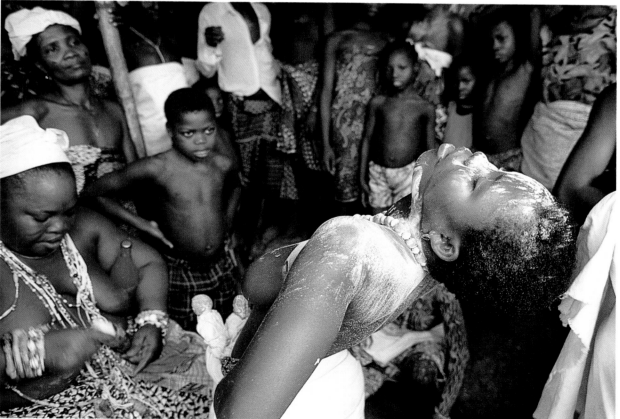

FOLLOWING PAGES:
Mami Wata conducts a court hearing. A young farmer's wife has had her head punitively shaven, having confessed to cooking a meal for another man. By the strict moral code of African villages – and of voodoo – this is tantamount to adultery.

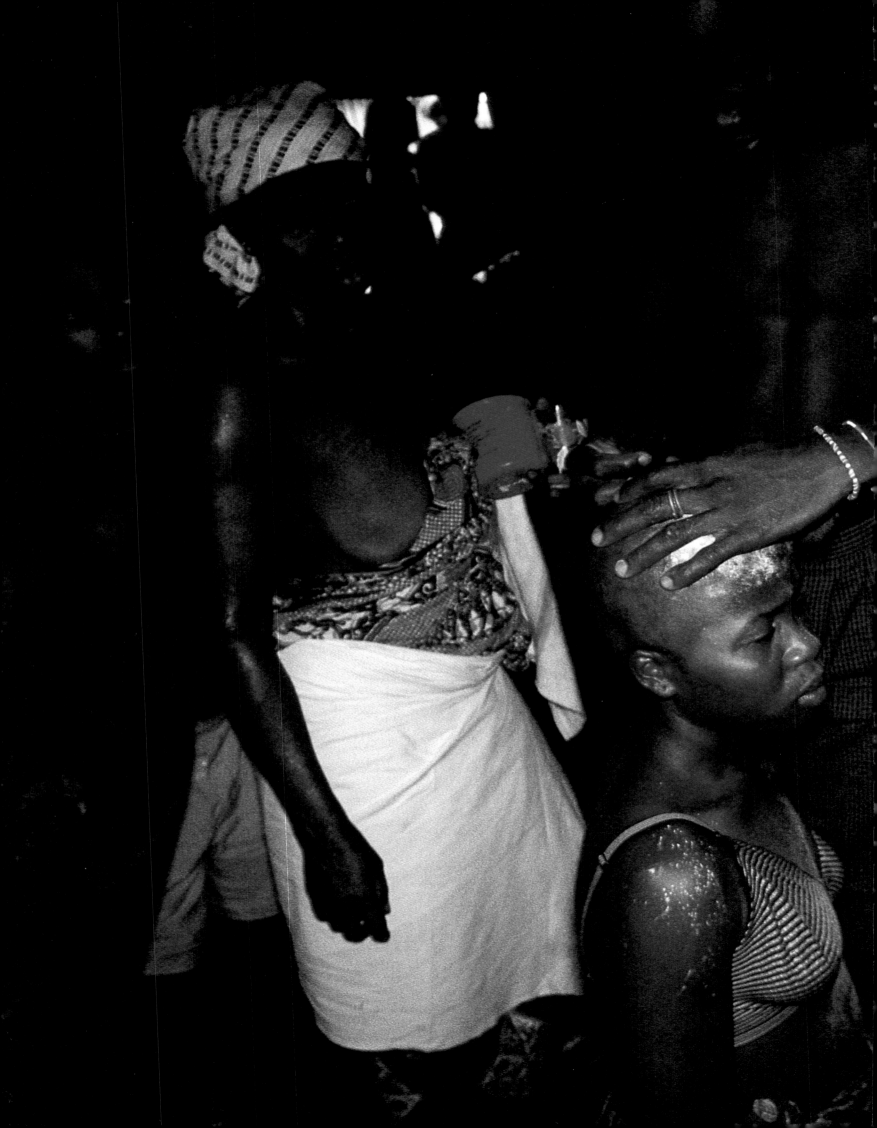

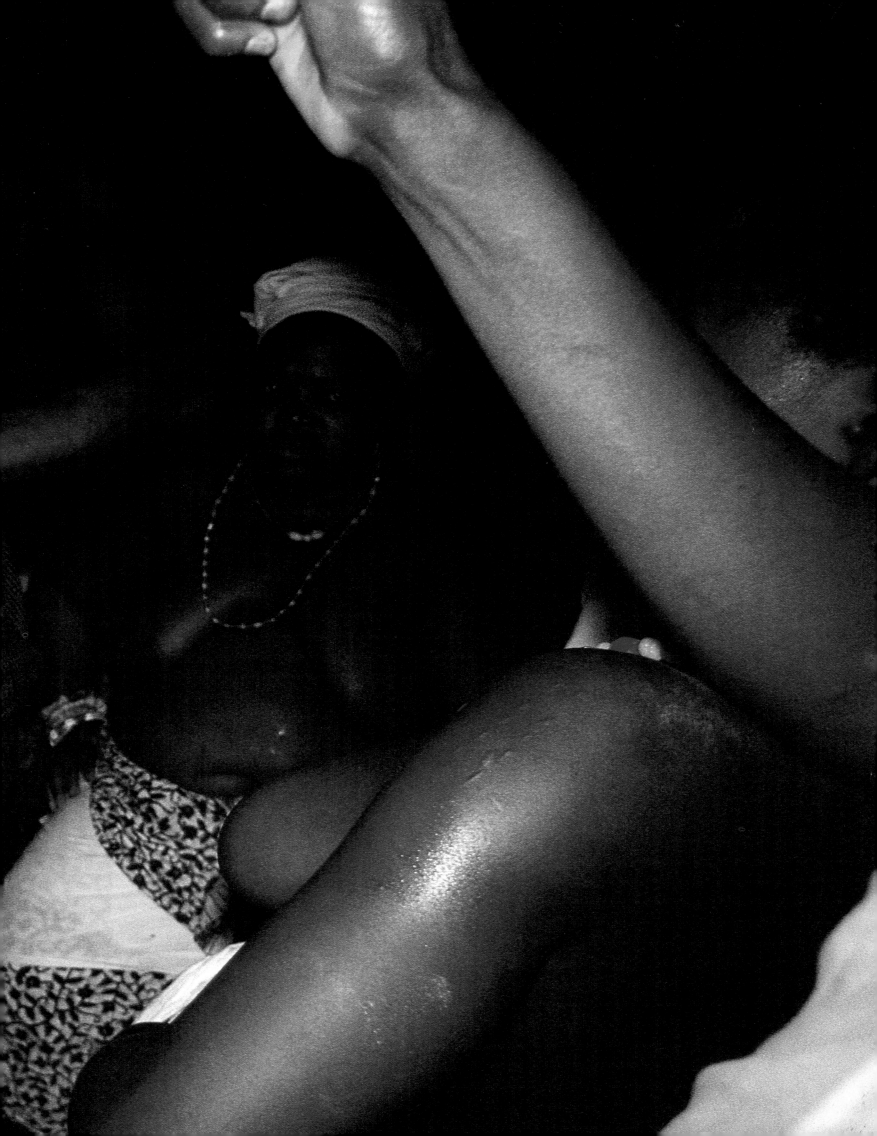

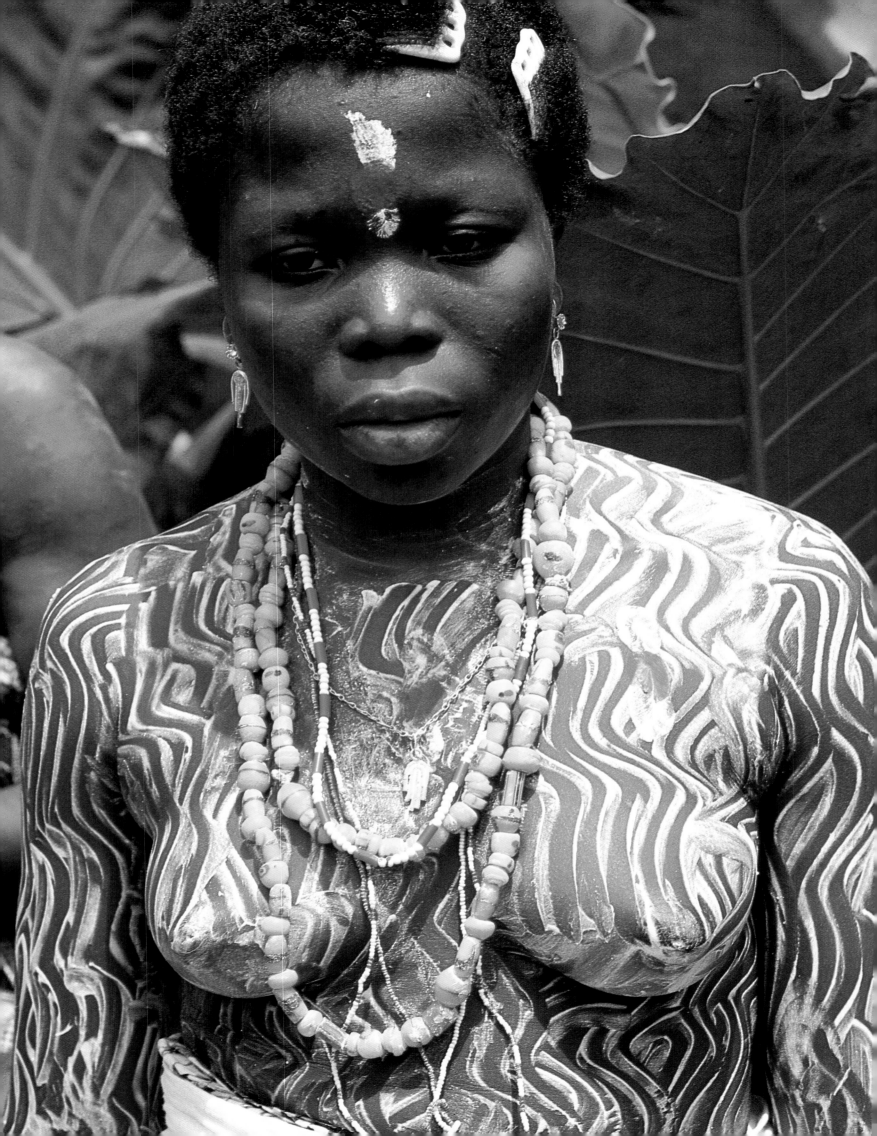

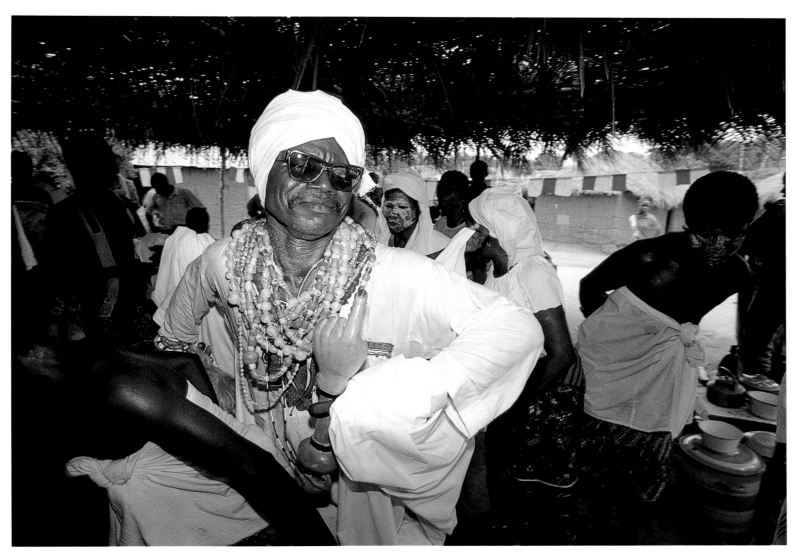

Her upper body painted and adorned with the thin necklaces of the initiate and the yellow beads of Mami Wata, the new member of the voodoo community looks pensive. After being initiated once before, she joined the Celestial Christians, an African Christian sect. In voodoo this is a mortal sin, but because the woman repented and returned to voodoo she was forgiven. Now she serves as living proof that the voodoo gods are more powerful than Christ and the Virgin Mary.

Djalé, priest of the village of Hountohué, dances ecstatically to the rhythm of the drums pervading the village. As an emblem of his office, along with numerous necklaces, he holds a sceptre surmounted by a symbol of the unity of the voodoo community, a wooden hand with extended index finger – five fingers united in one.

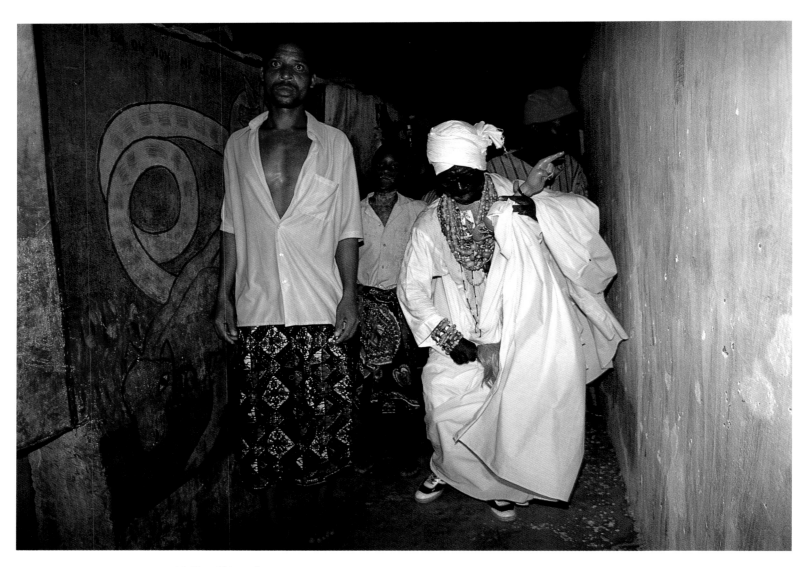

Djalé and his assistants
outside his temple, the walls
of which bear depictions of
voodoo gods. Besides Mami
Wata, the priest especially
venerates the rainbow snake
Dan.

The murky interior of the
temple, filled with fetishes,
sacrificial receptacles and
other cult objects, and
divided by white cloth into
"naves", symbolizes a world
in miniature. A statue of a
soldier guards a community
of fetishes made up of
priests and warriors,
masters and servants,
judges and executioners.

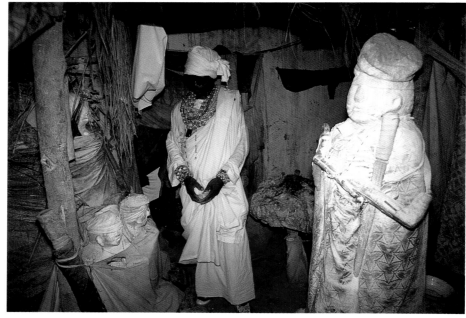

236

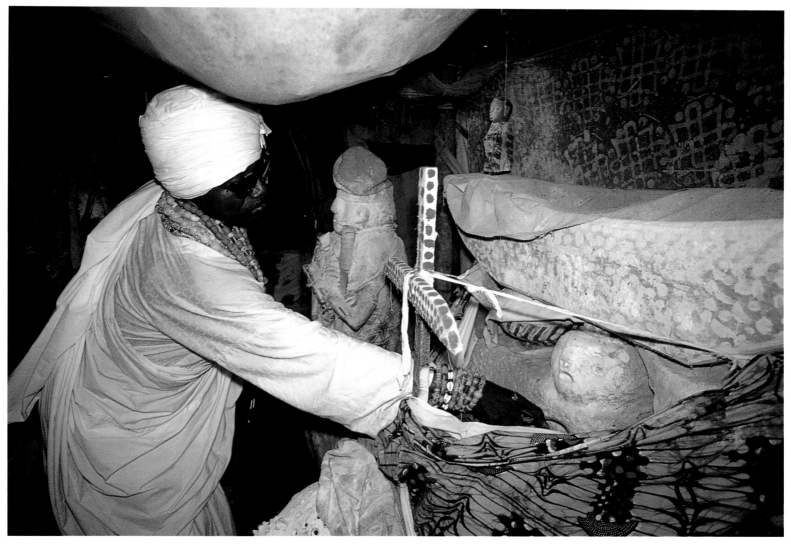

The priest Djalé shows a shrine that he usually keeps concealed under cloth. This voodoo figure is offered only powder, never blood like the fetish of Legba. The messenger of the gods places the priest in contact with numerous voodoo divinities, and in consequence Djalé enjoys a reputation as a powerful man far beyond his home village. Voodoo priests have wide-ranging powers in the shaping of a cult, for their ideas are thought to be inspired by the gods during trance. Nor do they feel inhibitions about contact with other religions, as the cross in Djalé's temple indicates.

FOLLOWING PAGES:
Djalé allots much space to so-called bocio statuettes, which represent the powerful spirits of dead twins and, together with the figure of a sage wearing sunglasses and smoking a pipe, constitute an important source of inspiration when the priest meditates on the mysteries of voodoo.

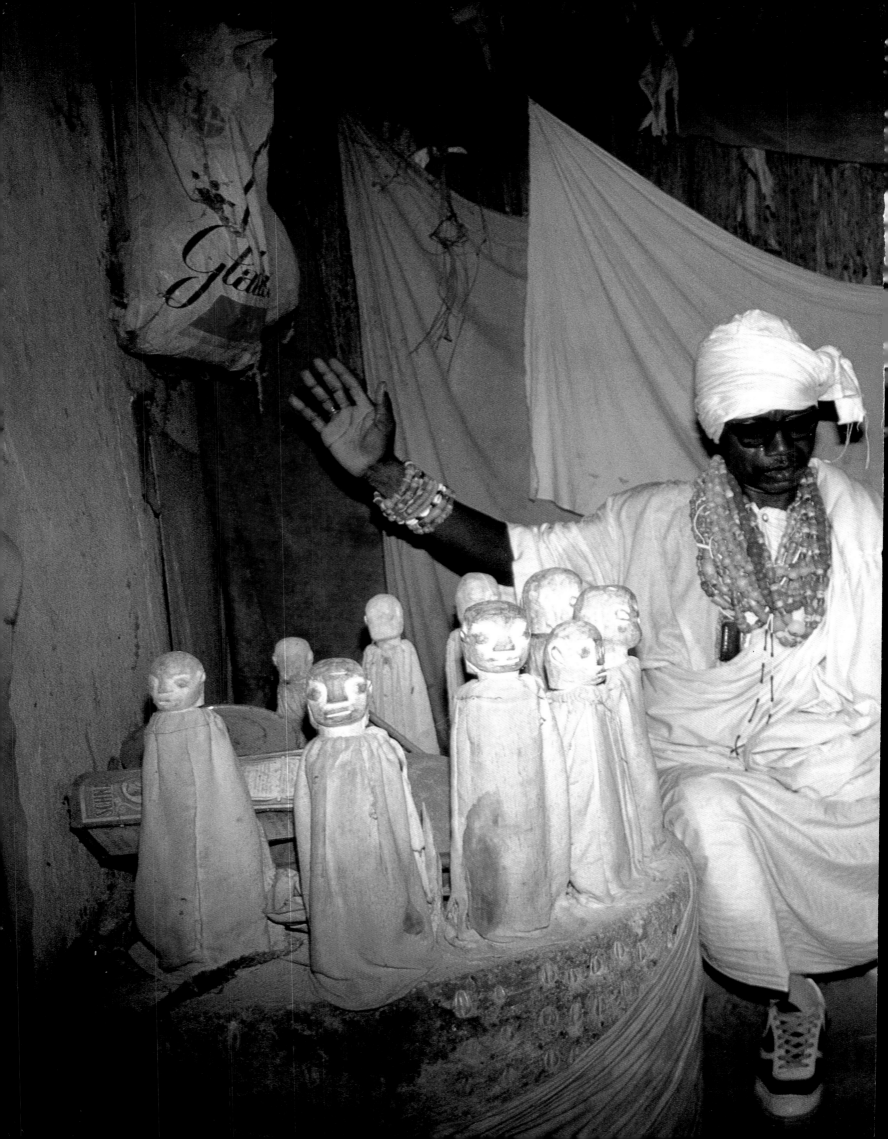

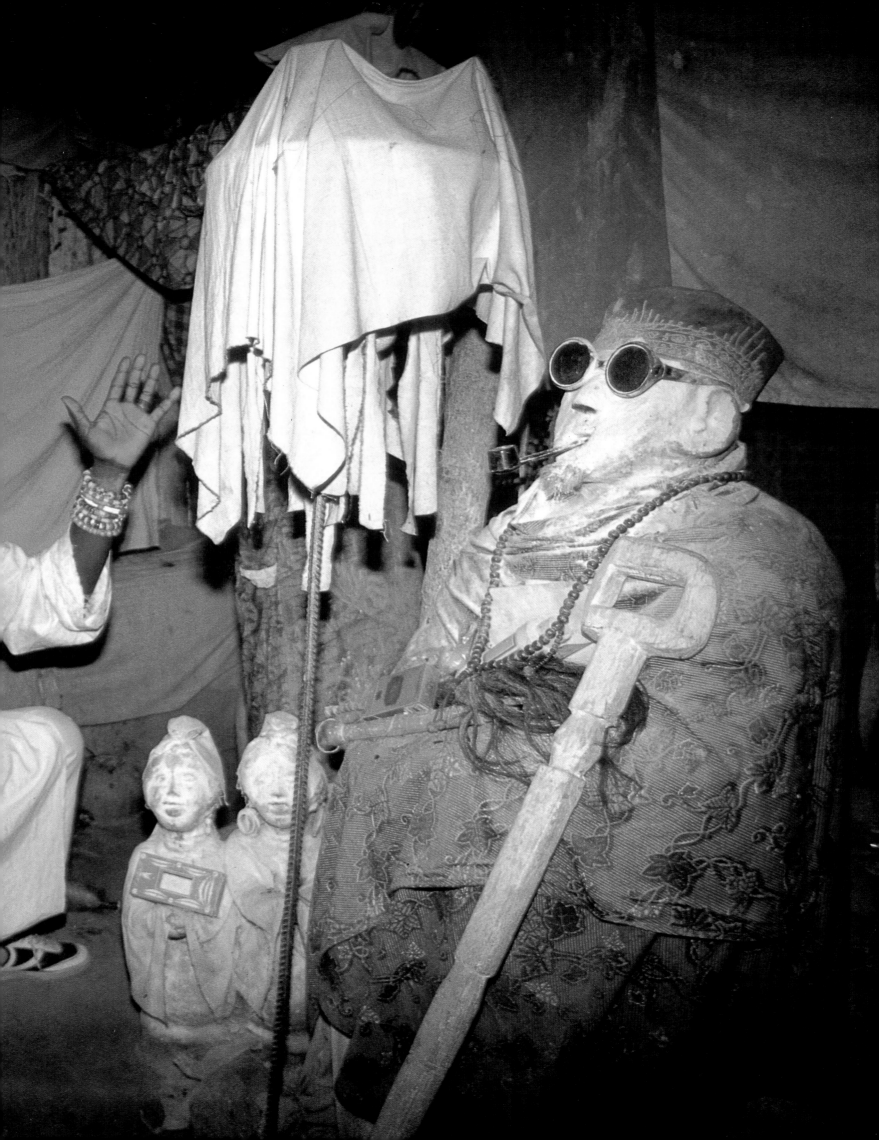

Further Reading

Sources:

Bosmann, William, *A New and Accurate Description of the Coast of Guinea*, London 1705 (reprinted 1967)

Brosses, Charles de, *Du culte des deux fétiches, ou Parallèle de l'ancienne religion de l'Egypte avec la religion actuelle de Nigritie*, Paris 1760

Burton, Richard F., *A Mission to Gelele. King of Dahomey*, London 1864

Maupoil, Bernard, *La géomancie à l'ancienne Côte des Esclaves*, Paris 1943 (reprinted 1981)

Skertchly, J.A., *Dahomey as it is*, London 1874

Monographs and anthologies:

Adoukonou, Barthelemy, *Jalons pour une théologie africaine. Essai d'une herméneutique chrétienne du vodoun dahoméen*, Paris 1980

Agbeti, J. Kofi, *West African Church History, Christian Missions and Church Foundations*, Leiden 1986

Agossou, Mèdéwalé-Jacob, *Christianisme africain*, Paris 1987

Aguessy, Honorat, *Cultures vodoun*, Cotonou no date

Apter, Andrew, *Black Critics and Kings. The Hermeneutics of Power in Yoruba Society*, Chicago (IL) 1992

Babayomi, S.O., *Egungun among the Oya Yoruba*, Ibadan 1980

Bastide, R., *Les religions africaines au Brésil*, Paris 1960

Blakely, Thomas D. et al. (eds), *Religion in Africa. Experience and Expression*, Portsmouth (NH) and London 1984

Blier, Susanne, *African Vodun. Art, Psychology, and Power*, Chicago 1995

Bourgoigni, Georges E., *Les hommes de l'eau. Ethno-écologie du Dahomey lacustre*, Paris 1972

Butt-Thompson, F.W., *West African Societies. Their Organisations, Officials and Teaching*, London 1929

Chesi, Gert, *Voodoo. Afrikas geheimnisvolle Macht*, Wörgl 1979

Cornevin, Robert, *Histoire du Dahomey*, Paris 1962

Davis, Wade, *Passage of Darkness. The Ethnobiology of the Haitian Zombie*, Chapel Hill (NC) and London 1988

De la Torre, Ines, *Le vaudou en Afrique de l'Ouest*, Paris 1991

Drewal, Henry John and Drewal, Margaret Thompson, *Gèléde. Art and Female Power among the Yoruba*, Bloomington 1983

Eliade, Mircea, *The Encyclopedia of Religion*, New York 1987, 9 vols

Elwert, Georg, *Wirtschaft und Herrschaft von Dahome im 18. Jahrhundert*, Munich 1973

Evans-Pritchard, E.E., *Witchcraft, Oracles, and Magic among the Azande*, Oxford 1937

Everett, Susanne, *History of Slavery*, London 1978

Fogg, William 'and Pemberton, J. (eds), *Yoruba, Sculpture of West Africa*, New York 1982

Fraginals, Manuel M. (ed.), *Africa en America Latina*, Mexico 1977 (English ed. New York 1984)

Froelich, Jean-Claude, *Animismes. Les religions païennes de l'Afrique de l'Ouest*, Paris 1964

Galembo, Phyllis, *Divine Inspiration. Benin to Bahia*, Albuquerque (NM) 1993

Gates Jr, Henry Louis, *The Signifying Monkey*, Oxford 1988

Glele, Maurice, *Religion, culture et politique en Afrique Noire*, Paris 1981

Harris, Joseph E., *Global Dimensions of the African Diaspora*, Washington D.C. 1982

Herskovits, Melville J., *Dahomeyan Narrative*, Evanstom (IL) 1958

Herskovits, Melville J., *The Myth of the Negro Past*, Boston (MA) 1958

Hountondji, Paulin J., *African Philosophy. Myth and Reality*, Bloomington 1983

Hurbon, Laennec, *Les mystères du vaudou*, Paris 1993

Irwin, Graham W., *Africans Abroad. A Documentary History of the Black Diaspora in Asia, Latin America, and the Caribbean during the Age of Slavery*, New York 1977

Johnson, G. Wesley (ed.), *Double Impact. France and Africa in the Age of Imperialism*, Westport 1985

Kossou, Basile Kossou, *Se et Gbe. Dynamique de l'existence chez les Fon*, Paris 1983

Lawson, E. Thomas, *Religion of Africa. Traditions in Transformations*, San Francisco 1984

Loth, Heinrich, *Sklaverei. Die Geschichte des Sklavenhandels zwischen Afrika und Amerika*, Wuppertal 1981

Makinde, M. Akin., *African Philosophy, Culture, and Traditional Medicine*, Athens (OH) 1988

Neimark, Philip John, *The Way of Orisa*, San Francisco 1993

Nketia, J.H. Kwabena, *The Music of Africa*, New York 1974

Nooter, Mary H. (ed.), *Secrecy. African Art that Conceals and Reveals*, New York and Munich 1993

Olupona, Jacob K., *African Traditional Religion in Contemporary Society*, New York 1991

Parrinder, E.G., *West African Religion. A Study of the Beliefs and Practices of the Akan, Ewe, Yoruba, Ibo and Kindred Peoples*, London 1961

Pelton, Robert D., *The Trickster in West Africa. A Study of Mythic Irony and Sacred Delight*, Berkeley, Los Angeles and London 1980

Pilaszwicz, Stanislaw, *Woyengii. Die Mutter der Welt. Mythen und Legenden westafrikanischer Völker*, Leipzig and Weimar 1991

Ray, Benjamin C., *African Religion. Symbol, Ritual and Community*, Englewood Cliffs 1976

Rouget, Gilbert, *Music and Trance. A Theory of Relations between Music and Possession*, Chicago (IL) 1986

Savary, Claude, *La pensée symbolique des Fon du Dahomey*, Geneva 1976

Thompson, Robert Farris, *Face of Gods. Art and Altars of Africa*, New York and Munich 1993

Thompson, Robert Farris, *Flash of the Spirit. African and Afro-American Art and Philosophy*, New York 1983

Traore, Dominique, *Comment le Noir se soigne-t-il? Ou médicine et magie africaine*, Paris 1965

Turner, Edith, *Experiencing Ritual. A New Interpretation of African Healing*, Philadelphia (PA) 1992

Turner, Victor, *The Anthropology of Performance*, New York 1986

Verger, Pierre, *Dieux d'Afrique*, Paris 1954

Verger, Pierre, *Notes sur le culte des Orisa et Vodun*, Dakar 1957

Verger, Pierre, *Orisha. Les dieux Yoruba en Afrique et au Nouveau Monde*, Paris 1982

Wardwell, Allen (ed.), *Yoruba. Nine Centuries of African Art and Thought*, New York 1989

Yoder, P. Stanley (ed.), *African Health and Healing Systems*, Los Angeles 1982

Zahan, Dominique, *Religion, spiritualité et pensées africaines*, Paris 1970 (English ed. Chicago 1979)

Articles:

Drewal, Margaret Thompson, "Art and Trance among Shango Devotees", *African Art* 20/1, Los Angeles 1986

Elwert-Kretschmer, Karola, "Befreit Euch von den Zwängen der Religion. Der Wandel der Vodun-Kulte in Benin", *Journal für Geschichte* 6/86, Weinheim 1986

Mercier, Paul, "The Fon of Dahomey", in: Forde, Daryll (ed.), *African Worlds*, London 1954

Sulikowski, Ulrike Davis, "Der durchlöcherte Krug. Politischer Umbruch in der Volksrepublik Benin", *EPN* 6/90, Vienna 1990

Sulikowski, Ulrike Davis, "Eating the Flesh, Eating the Soul. Reflections on Politics, Sorcery, and Vodun in Contemporary Benin", in: Chrétien, J.P., *L'invention religieuse en Afrique*, Paris 1993

Sulikowski, Ulrike Davis, "Sie geben eine Party für die Götter und die Götter kommen. Überlegungen zu Vodun, Besessenheitskulten und dem Diskurs über Afrika", in: Fillitz, T. et al., *Kultur, Identität und Macht*, Frankfurt a/M 1993

Journals:

African Art, Los Angeles

Cahiers des religions africaines, Kinshasa

Journal of Religion in Africa/Religion en Afrique, Leiden from 1967

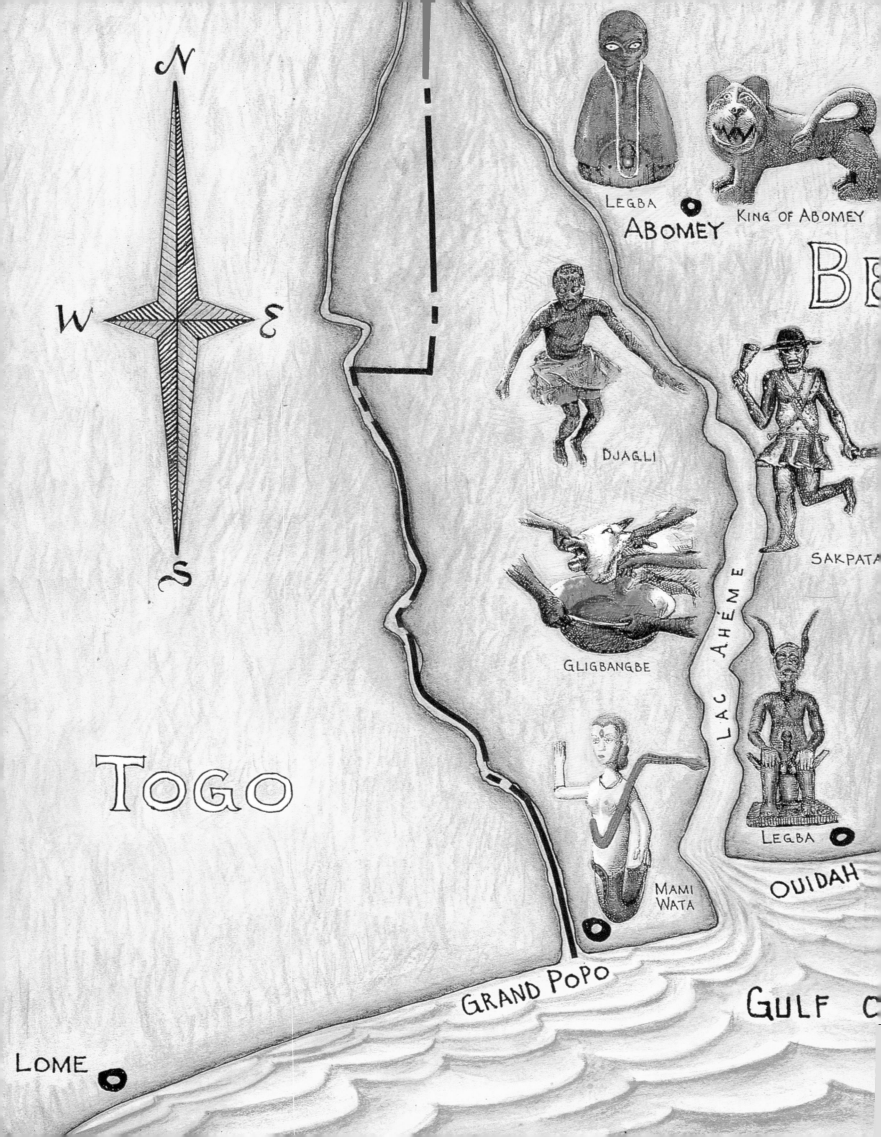

N
W E
S

LEGBA
ABOMEY
KING OF ABOMEY

BE

DJAGLI

SAKPATA

GLIGBANGBE

LAC AHÉMÉ

LEGBA

TOGO

MAMI
WATA

OUIDAH

GRAND POPO

GULF o

LOME